THE
PRINTS OF
ELLSWORTH
KELLY

A CATALOGUE
RAISONNÉ

THE PRINTS OF ELLSWORTH KELLY

A CATALOGUE RAISONNÉ 1949–1985

Richard H. Axsom

with the assistance of
Phylis Floyd

HUDSON HILLS PRESS, NEW YORK

In association with the
American Federation of Arts

TO DALE NAMIO

First Edition

© 1987 by the American Federation of Arts, 41 East 65th Street, New York, New York 10021

Published in the United States by Hudson Hills Press, Inc., Suite 1308, 230 Fifth Avenue, New York, NY 10001-7704.

Distributed in the United States, its territories and possessions, Mexico, and Central and South America by Rizzoli International Publications, Inc.

Distributed in the United Kingdom, Eire, Europe, Israel, and the Middle East by Phaidon Press Limited.

Distributed in Australia by Bookwise International.

Distributed in Japan by Yohan (Western Publications Distribution Agency).

Editor and Publisher: Paul Anbinder
Copy editor: Eve Sinaiko
Indexer: Karla J. Knight
Designer: Betty Binns Graphics/Betty Binns and David Skolkin
Composition: U.S. Lithograph, typographers
Manufactured in Japan by Toppan Printing Company

Library of Congress Cataloguing-in-Publication Data
Axsom, Richard H., 1943–
The prints of Ellsworth Kelly
"Published in conjunction with a retrospective exhibition of Kelly's graphic work, organized by the American Federation of Arts"—
Bibliography: p.
Includes index.
1. Kelly, Ellsworth, 1923– —Catalogues raisonnés.
2. Prints, American—Catalogues. 3. Prints, Modern—
20th century—United States—Catalogues. I. Floyd, Phylis.
II. American Federation of Arts. III. Title.
NE539.K36A4 1987 769.92'4 87-3079

ISBN 0-933920-84-9 (alk. paper)

CONTENTS

FOREWORD 9
ACKNOWLEDGMENTS 11
THE PRINTS OF ELLSWORTH KELLY 13

CATALOGUE RAISONNÉ 35
KEY TO THE CATALOGUE RAISONNÉ 36

1 Untitled 1949 37
2 Red/Blue 1964 37
3 David 1964 38

4–30
SUITE OF TWENTY-SEVEN COLOR LITHOGRAPHS
1964–65 39
4 Black 40
5 Yellow 40
6 Red-Orange 41
7 Green 41
8 Blue and Orange 42
9 Black with White 42
10 Dark Blue with Red 43
11 Green with Red 43
12 Orange with Blue 44
13 Orange with Green 44
14 Light Blue with Orange 45
15 Yellow with Dark Blue 45
16 Blue and Orange and Green 46
17 Blue and Yellow and Red-Orange 46
18 Dark Blue and Red 47
19 Red over Yellow 47
20 Red-Orange over Blue 48
21 Blue over Orange 48
22 Yellow over Dark Blue 49
23 Yellow over Black 49
24 Black over Yellow 50
25 Yellow over Yellow 50
26 Blue over Green 51
27 Orange over Green 51
28 Orange over Blue 52
29 Blue and Green over Orange 52
30 Orange and Blue over Yellow 53

31 Blue with Yellow 1965 53

32–59
SUITE OF PLANT LITHOGRAPHS 1964–66 54
32 Leaves 55
33 Grapefruit 55
34 Tangerine 56
35 Lemon 56
36 Cyclamen I 57
37 Cyclamen II 57
38 Cyclamen III 58
39 Cyclamen IV 58
40 Cyclamen V 59

41 Camellia I 59
42 Camellia II 60
43 Camellia III 60
44 Melon Leaf 61
45 Pear I 61
46 Pear II 62
47 Pear III 62
48 String Bean Leaves I 63
49 String Bean Leaves II 63
50 String Bean Leaves III 64
51 Fig Branch 64
52 Locust 65
53 Seaweed 65
54 Catalpa Leaf 66
55 Oranges 66
56 Magnolia 67
57 Lemon Branch 67
58 Ailanthus Leaves I 68
59 Ailanthus Leaves II 68

60 Black Form 1967 69

61–70
SERIES OF TEN LITHOGRAPHS 1970 70
61 Blue/Yellow/Red 71
62 Red-Orange/Yellow/Blue 71
63 Black/White/Black 72
64 Orange/Green 72
65 Blue/Green 73
66 Yellow/Red-Orange 73
67 Blue/Black 74
68 Black/Green 74
69 Yellow/Black 75
70 Yellow/Orange 75

71 Red-Orange over Black 1970 76
72 Four Panels 1970–71 76
73 Blue, Yellow and Red Squares
1970–71 77
74 Blue/White/Red 1970–71 77
75 Blue/Red-Orange/Green 1970–71 78
76 Blue/Green/Black/Red 1971 78
77 Black/Green II 1970–72 79
78 Green/Black 1970–72 79
79 Black/Brown 1970–72 80
80 Black Curve 1970–72 80
81 Green/White 1970–72 81
82 Blue/Red-Orange 1970–72 81
83 Black/Yellow 1970–72 82
84 Untitled 1972 82
85 Two Whites and Black 1971–73 83
86 Two Blacks and White 1971–73 83
87 White and Black 1971–73 84
88 Black and White Pyramid 1973 84
89 White Bar with Black 1973 85
90 Spectrum 1973 85
91 Blue/Yellow/Red 1970–73 86
92 Untitled 1973 86

93–96
LEAVES 1973–74 87
93 Peach Branch 88
94 Grape Leaves I 88
95 Grape Leaves II 89
96 Grape Leaves III 89

97 Blue with Black I 1972–74 90
98 Blue with Black II 1972–74 90

99–103
FIRST CURVE SERIES 1973–74 91
99 White Curve I 92
100 Black Curve I 92
101 Green Curve with Radius of 20' 93
102 Large Black Curve 93
103 Large Gray Curve 94

104–15
SECOND CURVE SERIES 1973–75 95
104 Blue I 96
105 Blue II 96
106 Red Curve (Radius of 8') 97
107 Yellow 97
108 Two Yellows 98
109 Black Variation I 98
110 Black Variation II 99
111 Black Variation III 99
112 Black Variation IV 100
113 Black Variation V 100
114 Black Variation VI 101
115 Gray Variation 101

116–39
THIRD CURVE SERIES 1973–76 102
116 Conques 103
117 Poitiers 103
118 Serrabone 104
119 Corneilla 104
120 Talmont 105
121 Chauvigny 105
122 Thoronet 106
123 Caen 106
124 Fontenay 107
125 Angers 107
126 Tournus 108
127 Canigou 108
128 Tavant 109
129 Cluny 109
130 Germigny 110
131 Senanque 110
132 Saint-Savin 111
133 Cuxa 111
134 Moissac 112
135 Montmorillon 112
136 Vic 113
137 Brioude 113

138 Fontevrault 114
139 Souillac 114

140 Colors on a Grid, Screenprint 1976
1976 115

141–63
COLORED PAPER IMAGES 1976–77 116
141 Colored Paper Image I 117
142 Colored Paper Image II 117
142a Colored Paper Image II, State 118
143 Colored Paper Image III 118
144 Colored Paper Image IV 119
145 Colored Paper Image V 119
146 Colored Paper Image VI 120
147 Colored Paper Image VII 120
148 Colored Paper Image VIII 121
149 Colored Paper Image IX 121
149a Colored Paper Image IX, State 122
150 Colored Paper Image X 122
151 Colored Paper Image XI 123
152 Colored Paper Image XII 123
153 Colored Paper Image XIII 124
154 Colored Paper Image XIV 124
155 Colored Paper Image XV 125
156 Colored Paper Image XVI 125
157 Colored Paper Image XVII 126
158 Colored Paper Image XVIII 126
159 Colored Paper Image XIX 127
160 Colored Paper Image XX 127
161 Colored Paper Image XXI 128
162 Blue/Green/Yellow/Orange/Red 128
163 Nine Colors 129

164 Nine Squares 1976–77 129

165–76
TWELVE LEAVES 1978 130
165 Leaves 131
166 Leaf I 131
167 Leaf II 132
168 Leaf III 132
169 Leaf IV 133
170 Leaf V 133
171 Leaf VI 134
172 Leaf VII 134
173 Leaf VIII 135
174 Leaf IX 135
175 Leaf X 136
176 Leaf XI 136

177 Wall 1976–79 137
178 Woodland Plant 1979 137
179 Saint Martin Landscape 1976–79 138
179a Saint Martin Landscape, IA 139
179b Saint Martin Landscape, IB 139
179c Saint Martin Landscape, IC 140
180 Dark Gray and White 1977–79 140

181–87a
SERIES OF SEVEN LITHOGRAPHS
1978–80 141
181 Jacmel 142
181a Jacmel (State) 142
182 Grand Case 143
182a Grand Case (State) 143
183 Marigot 144
183a Marigot (State) 144
184 Amden 145
184a Amden (State) 145
185 Braunwald 146
185a Braunwald (State) 146
186 Bordrouant 147
186a Bordrouant (State) 147
187 Bandol 148
187a Bandol (State) 148

188 Daffodil 1979–80 149
189 Sarsaparilla 1979–80 149
190 Mulberry Leaf 1979–80 150
191 Wild Grape Leaf 1979–80 150
192 Saint Martin Tropical Plant
1981–82 151
193 "18 Colors (Cincinnati)" 1979–82 151

194–200a
THE CONCORDE SERIES 1981–82 152
194 Square with Black 153
194a Square with Black (State) 153
195 Diagonal with Black 154
195a Diagonal with Black (State) 154
196 Concorde I 155
196a Concorde I (State) 155
197 Concorde II 156
197a Concorde II (State) 156
198 Concorde III 157
198a Concorde III (State) 157
199 Concorde IV 158
199a Concorde IV (State) 158
200 Concorde V 159
200a Concorde V (State) 159

201 Untitled 1983 160

202–206
SAINT MARTIN SERIES 1983–84 161
202 Cupecoy 162
202a Cupecoy, State I 162
202b Cupecoy, State II 162
203 Cul de Sac 163
203a Cul de Sac, State I 163
203b Cul de Sac, State II 163
204 Baie Rouge 164
204a Baie Rouge, State I 164
204b Baie Rouge, State II 164
205 Orient Beach 165
205c Orient Beach, State III 165
205d Orient Beach, State IV 165
205a Orient Beach, State I 166
205b Orient Beach, State II 166
206 Saint Martin Triptych 167

207–13
SERIES OF PLANT AND FLOWER LITHOGRAPHS
1983–85 168
207 Philodendron I 169
208 Philodendron II 169
209 Calla Lily I 170
210 Calla Lily II 170
211 Calla Lily III 171
212 Dracena I 171
213 Dracena II 172

APPENDIX: RELATED PRINTMAKING
ACTIVITY 173
I GRAPHIC WORK FOR BOOKS AND
EXHIBITION CATALOGUES 174
II POSTERS 181
III MISCELLANEOUS: INVITATIONS,
ANNOUNCEMENTS, AND WINE LABELS 185

CHRONOLOGY 187
GLOSSARY 193
BIBLIOGRAPHY 195
INDEX 197
PHOTOGRAPH CREDITS 200

FOREWORD

While Ellsworth Kelly is best known for his paintings, sculpture, and drawings, *Ellsworth Kelly: A Print Retrospective* presents for the first time another important aspect of this distinguished American artist's work. Both this catalogue raisonné and its accompanying exhibition explore and document the sustained quality of Kelly's printmaking and its crucial reciprocity with his work in other media.

There are many to whom we are deeply grateful for the realization of this project. Foremost is the artist himself, whose cooperative spirit and continual generosity have been an essential underlying force enabling the American Federation of Arts to organize and present it.

We are indebted to Richard H. Axsom, professor of art history at the University of Michigan—Dearborn, who first proposed the project to us. His sensitive interaction with the artist and his enthusiasm and commitment have been crucial to the development and fruition of the project. We are appreciative of Phylis Floyd for her assistance to Mr. Axsom in the task of researching and compiling the existing data for the catalogue raisonné. As well, we wish to thank Henry Persche, Mr. Kelly's assistant; Sidney Felsen, Debra Burchett, Mari Andrews, and William B. Padien of Gemini G.E.L.; and Kenneth Tyler and Barbara Delano at Tyler Graphics Ltd. for their contributions and assistance on the exhibition and publication.

The AFA's work on this exhibition was initiated by my distinguished predecessor, Wilder Green, who deserves special credit for commitment to a project of such importance. I wish to thank Jeffery J. Pavelka, former director of the exhibition program, for his work on the preparation of the exhibition and book. I wish to acknowledge Amy V. McEwen, former exhibition coordinator, for scheduling the tour and Albina De Meio, head registrar, Guillermo Alonso, registrar, and Victoria Hertz, assistant registrar, for overseeing and monitoring the collection, preparation, and safekeeping of the prints during the assembly and throughout the tour of the exhibition. We are appreciative also of the varied skills and contributions at the AFA of Jane S. Tai, associate director for exhibitions; P. Andrew Spahr, exhibition coordinator; Sandra Gilbert, public information director; and Michaelyn Mitchell, assistant to the director and publications coordinator.

This catalogue has been supported by the J. M. Kaplan Fund, the DeWitt Wallace Fund, and the Henry Luce Foundation through the AFA's Revolving Fund for Publications.

Myrna Smoot
Director
The American Federation of Arts

ACKNOWLEDGMENTS

Many individuals contributed to the successful completion of this book. To all of them I express my heartfelt gratitude for their support over the past three years. In the spring of 1984 the American Federation of Arts accepted my proposal to guest-curate a retrospective exhibition and to write a scholarly catalogue devoted to the prints of Ellsworth Kelly. Since this point the AFA has been tireless in its fund-raising and scheduling of a national tour, and unstinting in facilitating my research. I wish to thank former director Wilder Green, under whose tenure the exhibition was organized, Jane Tai, Amy McEwen, Sandra Gilbert, Albina De Meio, Guillermo Alonso, and P. Andrew Spahr. I particularly wish to single out the indispensable participation of Jeffery Pavelka, former exhibition program director, who was the administrative mainstay of the project and who deftly coordinated the efforts of author, artist, and publisher. I thank him for his repeatedly sound professional advice, and for his friendship.

I wish to express my warmest regard for my collaborator, Phylis Floyd, research curator at the Hood Museum, Dartmouth College, who assisted me in the preparation of materials for the catalogue raisonné and appendix, and who compiled the chronology, exhibition histories, and bibliography. Her impeccable archival scholarship, unflagging energy, and sensitivity to the complexities of printmaking unquestionably contributed to the integrity of the book.

From the beginning, Paul Anbinder, president of Hudson Hills Press, was strongly committed to the catalogue raisonné and exhibition, and his appreciation of Kelly considerably predated, in a pleasant coincidence, the current project. While at Harry N. Abrams, Inc., in the early 1970s, he coordinated the publication of Kelly's *Blue/Yellow/Red* (cat. no. 91), which accompanied a deluxe edition of John Coplans's *Ellsworth Kelly*, one of the first major monographs on the artist. It has been my good fortune and great pleasure to work with Paul Anbinder again on what is our second publication together. He respects the modern print, as testified to by his publications, and he understands the travails of gathering material for a catalogue raisonné. As editor and as an informed viewer of modern art, his criticisms exact the very best from an author. I thank him for his generosity and patience. For this project, Hudson Hills Press retained the copy-editing services of Eve Sinaiko, whose counsel could not have been more professional or amicable. Her incisive requests for clarity, cohesiveness, and completeness of argument made the manuscript work.

Gemini G.E.L. and Tyler Graphics Ltd., the two most significant workshops for Kelly's printmaking, were crucial sources of archival documentation and first-hand accounts of the artist's many collaborations. The staffs involved responded to repeated requests for information with an admirable concern for accuracy and, when it appeared that the questions would never cease, with good-humored patience. Sidney Felsen generously shared many memories of Kelly's seventeen-year affiliation with Gemini. During my two extended visits to Los Angeles, he provided invaluable insights, lively anecdotes, and a thoughtful hospitality for which I genuinely wish to thank him. At Gemini I am also grateful for the various contributions of Mari Andrews, Debra Burchett, Ken Farley, Serge Lozingot, William B. Padien, James Reid, Joni Weyl, and Anthony A. Zepeda. I also appreciate the information that was made available to me by printers who were formerly associated with Gemini: Stuart Henderson, Ron McPherson, George Page, and Jeffrey Wasserman.

Kenneth Tyler, who collaborated with Kelly for a decade—at Gemini G.E.L. on the artist's first editions and then, on the east coast, at Tyler Graphics Ltd. —also contributed his own special technical and aesthetic perspectives on Kelly's printmaking. With no technical source available to elucidate the practices at Maeght Editeur in Paris, where Kelly published his first important editions in the mid-1960s, Kenneth Tyler was an invaluable commentator on French presses and zinc lithography. He was able to draw on his own tutelage under Marcel Durassier, the master printer at the Imprimerie Maeght for Kelly's editions. At Tyler Graphics, I also appreciate the contributions of John Wagner and Marabeth Cohen. Very special thanks are due Barbara Delano, who graciously answered numerous technical queries and clarified documentation.

Others who have patiently answered questions include: Brooke Alexander, Brooke Alexander Inc., New York; Pamela Alison, Laguna Art Museum, Laguna Beach, California; Elizabeth Armstrong, Sherri Stearns, and Karen Lovaas, Walker Art Center, Minneapolis; Lynn Bettman, Kennedy Galleries, New York; M. D. Brenner, Anchorage Historical and Fine Arts Museum; Castelli Graphics, New York; Ruth Fine and Carlotta Owens, National Gallery of Art, Washington, D.C.; Marilyn Gasser, Claudia E. Yatsevitch, Jean Hill, and Barbara Reed, Sherman Art Library, Dartmouth College; Pat Gilmour and Warwick Reeder, the Australian National Gallery; Laura F. Griffith, Institute of Contemporary Art, University of Pennsylvania; Darell Harnish, Maeght Lelong Gallery, New York; Eric Himmel, Harry N. Abrams, Inc., New York; Judith Joyce, Albright-Knox Art Gallery, Buffalo; Lisa Kalem, Los Angeles County Museum of Art; Shelley Langdale, SITES,

Washington, D.C.; Roberta LeMay, Whitney Museum of American Art, New York; Jean Mazarella, Dayton Art Institute; Jeffrey McKibben, Ohio State University Art Gallery; Erica Neggers, Van Abbemuseum, Eindhoven, Netherlands; Harriet Rubin and Mary Balaban, the Metropolitan Museum of Art, New York; Gordon Samuel, Redfern Gallery, London; Lynn Sharpless, Margo Leavin Gallery, Los Angeles; Ann Slimon, Emerson Gallery, Hamilton College, Clinton, New York; Swen Parson Gallery, Northern Illinois University; and L. Anthony Wright, Jr., Denver Art Museum. Special thanks are extended to Kathleen Slavin and Wendy Weitman, The Museum of Modern Art, New York; Ellen Sharp and Chris Swensen, Detroit Institute of Arts; Jack Shear; Ruth Back; and Dale McConathy, New York University.

For their constant encouragements I also thank my good friends Deborah Brown, Peter Kauffman, Walter MacDonald, Neil McEachern, and Van Tullis.

The participation of Ellsworth Kelly was central to the vital corroboration of information gathered elsewhere, and to an expansion of the book's scope to include the artist's personal perspectives. To answer lengthy archival questions and to discuss substantive issues raised by his printmaking, the artist invited me to his home studio on three successive occasions, agreed to what became a correspondence of questionnaires, and took numerous phone calls. The accuracy and completeness of information in this catalogue are in large part a result of Kelly's own professional record keeping and his willingness to give me access to his own archives. He also made available his able assistant Henry Persche, who in so many communications was always prompt and accommodating in retrieving and organizing material. For being cooperative, friendly, and open, I am extremely respectful of, and indebted to, Ellsworth Kelly.

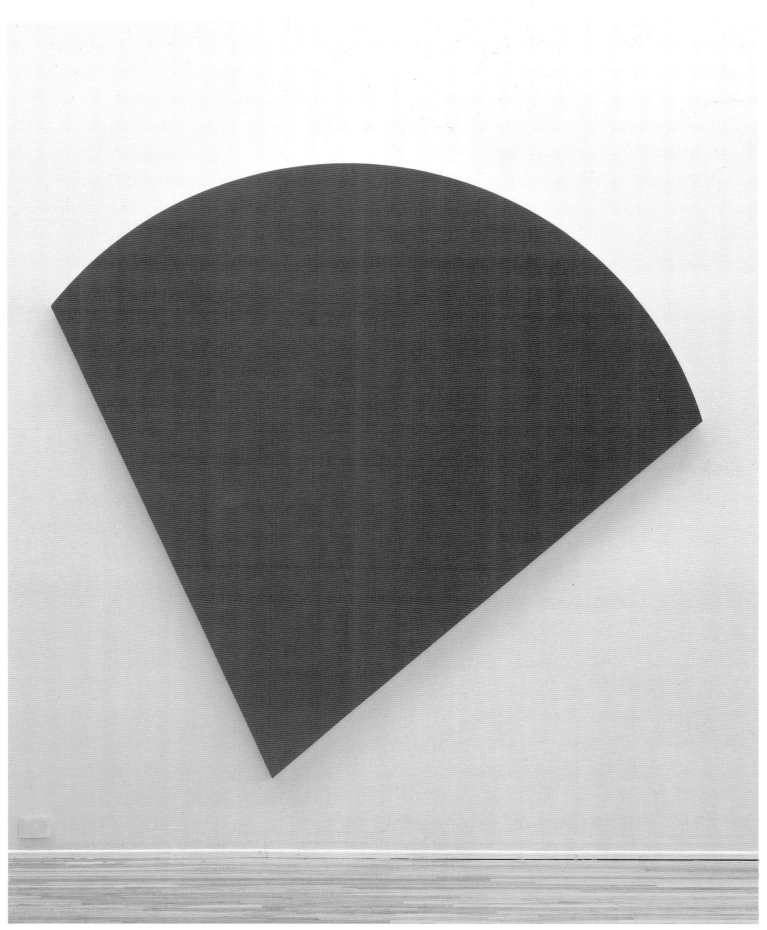

Fig. 1. **Red Panel**, 1985 (EK#699). Oil on canvas, 105¼ x 108
(264.8 x 274.3). Collection Mr. Douglas Cramer, Los Angeles.

THE PRINTS OF ELLSWORTH KELLY

Ellsworth Kelly is an American artist whose independent history confounds expectation. He first came before the public in the early 1960s as a painter and major exemplar of an emerging post-painterly abstraction. Yet at this point, when his painting entered contemporary art history, its essential style and Kelly's characteristic manner of working had been established for well over a decade. Though it came to be associated with New York abstraction in the 1960s, ironically its formulation took place in Paris between 1949 and 1954. Kelly's art as it developed during this period held nothing in common with the progressive American and European expressionist tendencies that prevailed in the 1950s. In the 1960s such designations for the new abstraction as hard-edge, Color Field, and Minimalist were firmly linked with Kelly's work, and placed it in the mainstream. Although these terms are not without limited pertinence to his art, the Formalist criticism that engendered them and that described and promoted the new abstraction now seems, in retrospect, to be implicitly at logger-heads with it. Formalism understands and evaluates a work of art as a set of purely visual characteristics whose organization and controlled tensions it seeks to describe. The Formalist critic's role was to increase the work of art's legibility by describing how it works visually as a function of a discerned network of decisions made by the artist. During the 1960s Formalism placed strong premiums upon reductivist abstraction: simplified, often geometric, forms stripped of visual incident, representation, and narrative or symbolic interpretation. The work of art was prized that did not depict or refer to anything but itself. In light of these stipulations, it is not difficult to see how Kelly's art might be understood to accommodate, even to be a paradigm of the Formalist prescription for an autonomous image. There is, however, one factor that complicates matters and leads to other questions of meaning. Kelly's art is based upon perception. He appropriates fragments of chanced-upon visual experience—bits of architecture, the human figure, water reflections, shadows—and abstracts them into taut, iconic images of broadly articulated shape and saturated color, lyrical and serenely self-confident in effect. His art is an act of distillation from the seen; its sources are rooted not in the mind, but in nature.

What Kelly takes from nature, however, remains the primary subject of his art: shape. Above all else Kelly's art is about the declaration of a precise, simplified form, either alone or in interaction with others. The physical work of art is presented as a pure shape in its own right, not as a vehicle for depicting something. The theme of shape is further made unequivocal by assertive color and monumental scale. Color, be it spectral, pastel, black, or white, is always immaculately smooth and flat as it is applied to and made inseparable from a single form. The resulting colored forms derive their strength and visual presence from a seamless unity of color and shape.

Kelly's nonobjective art, with its array of flat, sharp-edged forms and unmodulated color, figures significantly in the history of nongestural abstraction. Yet its relationship to both of the major mainstreams within this tradition, the geometric and the biomorphic, is ambiguous. Ostensibly affiliated with geometric abstraction, initiated in the second decade of this century by the Suprematist and De Stijl movements, Kelly's forms are, however, more intuitive. The calculated geometries of Piet Mondrian, for example, have never appealed to Kelly, who resists what he terms their "rigidities."[1] Although his art was first discussed and placed during the early 1960s within such contexts as post-painterly abstraction, Color Field painting, even Op art, it is Minimal art, a later phase of geometric abstraction that developed during the second half of the 1960s, with which his work is most often affiliated. Yet here again, the fit is not perfect. Both Kelly and the Minimalist artists shared a preference for greatly simplified, geometric shape that was flat, clean-finished, and often serialized. But Minimalist form as a whole was more severely geometrical and immersed within conceptual frameworks. The cerebral bent of Minimalism, with its attention to the artist's processes of making as well as the completed work, was essentially foreign to Kelly's art. Finally, Kelly's brilliantly hedonistic color of the 1960s found no correlation in Minimalism's subdued, nearly colorless palette.

If Kelly's curvilinear shapes of the later 1950s and early 1960s suggest the biomorphic forms of the abstract Surrealists, their organic qualities are mitigated by the incorporation of angular components or by regularized design. Pure curved shape, when it appeared at this point, and

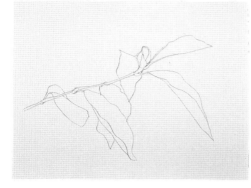

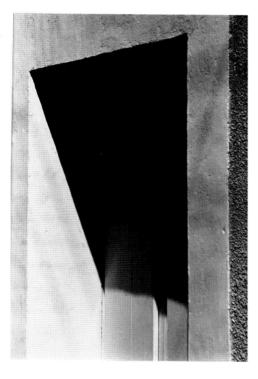

Fig. 2. **Magnolia**, 1986 (EK#P34.86). Pencil on paper, 22 x 28 (55.9 x 71.1). Collection Henry Persche, Ghent, New York.

Fig. 3. **Doorway, Belle-Isle**, 1977 (EK#PH77.01). Original silver print, 12⅝ x 8⅜ (32.0 x 21.0). Collection of the artist.

Fig. 4. **Concorde IV (State)**, 1982. Etching and aquatint. Cat. no. 199a.

later, when it dominated his sculptures, paintings, and prints of the mid-1970s, appeared as parabolas, ellipses, and circle segments, rather than metamorphosed animate form. Nevertheless, if Kelly drew upon and often amalgamated both the geometric and biomorphic traditions, he arrived at an art that has remained bound, in its inspiration and in a most important aspect of its character, to the more figurative biomorphism of Jean Arp, Joan Miró, Constantin Brancusi, Francis Picabia, and Alexander Calder, all of whom he met in France between 1950 and 1952; indeed, Kelly identifies the American painter and sculptor Calder as his most important influence. That quality which separates Kelly's deceptive geometric abstraction from other systems that emphasize rational structures and allies it to biomorphic abstraction is the source of its inner vitality. Form has a life of its own. It is elusive, not predictable. Shape is ambiguous: curved squares, skewed squares, isosceles triangles comprising pairs of right triangles, sectioned parallelograms composed of three rhombuses, shapes appearing to be a fragment of a far greater whole. The viewer is also confronted with a host of unfamiliar polygons and elliptical sections, including trapeziums (quadrilaterals with no parallel sides), circle segments not containing a radius, and other geometric exotica that strain the descriptive Euclidean vocabulary. Shape misbehaves, refuses to be inert, inviting simultaneous readings as both recessional and flat form. The tendency of irregular forms to warp and rotate is countered by flat color that arrests movement. It is the tension between flatness and spatial liveliness, between common and eccentric shape, that breeds the spontaneous energy of Kelly's art and removes it far from the stuff of analytical theorem and structure most usually associated with the geometric tradition. The diversity and unpredictability of his contradictory images are the source of Sidney Felsen's claim that "Kelly can just make a shape better than anyone else."[2]

Formalist criticism and Minimalist aesthetics have sought since the 1960s to dissect this visual distinctiveness, naming Kelly's forms with a highly refined descriptive and analytical language that eschews emotional and metaphorical readings. A brief excerpt from John Coplans's comparison of two of Kelly's paintings from the mid-1960s reveals the characteristic tone and subject of Formalistic discourse:

Thus *Spectrum II* is more environmental in size than *Spectrum IV* and occupies a greater arc of the spectator's peripheral vision. In *Spectrum IV* the elongated colors are compacted, enhancing each other's presence by reciprocally interacting and creating a high degree of optical activity. In contrast, the greater lateral width of each panel in *Spectrum II* slows down the rhythm of color interaction so that the color effect is softer, less sharp on the eye.[3]

This species of language, which Kelly himself uses when he makes statements about his art, suits discussion of highly sophisticated abstract shape and color, whose subtleties demand thoughtful and exacting description. However, to identify Formalist description as a work of art's sole source of meaning limits interpretation and resonance. Kelly's art does not, of course, have early abstraction's theosophical or Surrealist foundation, or Constructivism's pragmatic design orientation; nor does it share the mystical and psychological roots of Abstract Expressionism. None of these systems of expression and function is plausibly evoked by the artist's imagery or his ideas. What does identify Kelly's art with the historical wellspring of meaning in abstraction is the address made to nature. Abstraction has its roots in landscape painting and in a belief that nature is a repository of greater spiritual realities. Wassily Kandinsky and Mondrian sought to render in images, in abstract equivalents of color and shape, nature's underlying rhythms and laws, to "make visible the invisible," as Paul Klee said of modern art. The domain of early abstraction is clearly metaphysical. The course of later abstraction does not entirely foresake this focus. Although Formalist rhetoric did much to overlook it, painters such as Dorothea Rockburne, Brice Marden, Robert Mangold, and Al Held may be said to have created in their art conceptual and symbolic mappings of nature's mechanics. Kelly's art, it will be argued, is not entirely separate from these concerns, but what fundamentally distinguishes his relationship to nature from that of other abstract artists, from that of the Minimalists, is its initial and crucial basis in actual perceptions of the world. This can best be seen in his drawings and lithographs of plants and flowers and in his photographs. Kelly's eye is directed in these images to shapes whose transcriptions in pencil, ink, lithographic crayon, or film emphasize abstract form. In this body of work, we can see Kelly's translation of observed form to pure shape in progress.

The genesis of Kelly's art lies in acts of visual contemplation. A particular shape, most usually a fragment of a larger whole, seizes his attention: an open doorway, the gentle curve of a hill, shadows across a flight of steps. Although Kelly is selective as he accepts one shape, rejects another, his first encounters are always accidental. In this respect, his art is not only connected at the outset to nature but also to nature's laws of chance, which lie beyond his control. Chance as well as vision unite Kelly to the world.

For Kelly, the abstracting of a visual motif involves the emptying of its original volume, mass, texture, and color and its reduction to a pure configuration, a two-dimensional shape that is then assigned a solid color or set of colors. All marks made by the artist's hand are deliberately removed. Kelly sees any such marks as unacceptable traces of a personal sensibility that

bind the image to a specific individual and fix it in time as the record of an act—effects he generally wishes to avoid. (Texture and apparent gesture do appear in the later sculpture and prints, as we shall see, where Kelly introduces them as part of a particular program of exploration.) In a few instances apparent gestures by the artist, such as the brushstrokes and textures of the Saint Martin Series, were generated by printers in the studio, using techniques subject to chance. Kelly's physical presence is registered by the impress of his shoe in the left-hand panel of the *Saint Martin Triptych* (cat. no. 206A) and in *Orient Beach* (cat. no. 205), both from the Saint Martin Series. The shoe mark was left in the images only because the artist accidentally stepped backward onto the plate as it lay on the floor at Gemini. The shoe mark is, however, in no way a personal signature; had someone else accidentally left a footprint, Kelly would have accepted it if, as was the case with his own, it worked with the image. All of Kelly's strategies to distill nature into abstract shape involve choices that of course reflect personal temperament, including the decision to allow accident to play a role. Still, he chooses to work with images he understands as anonymous, with no trace of anecdote, association, or self.

The Prints

It became evident during the 1970s that Kelly's achievements were not limited to canvas alone. A historically significant retrospective exhibition of contemporary American art, entitled *New*

Fig. 5. **Green**, 1965. Lithograph. Cat. no. 7.

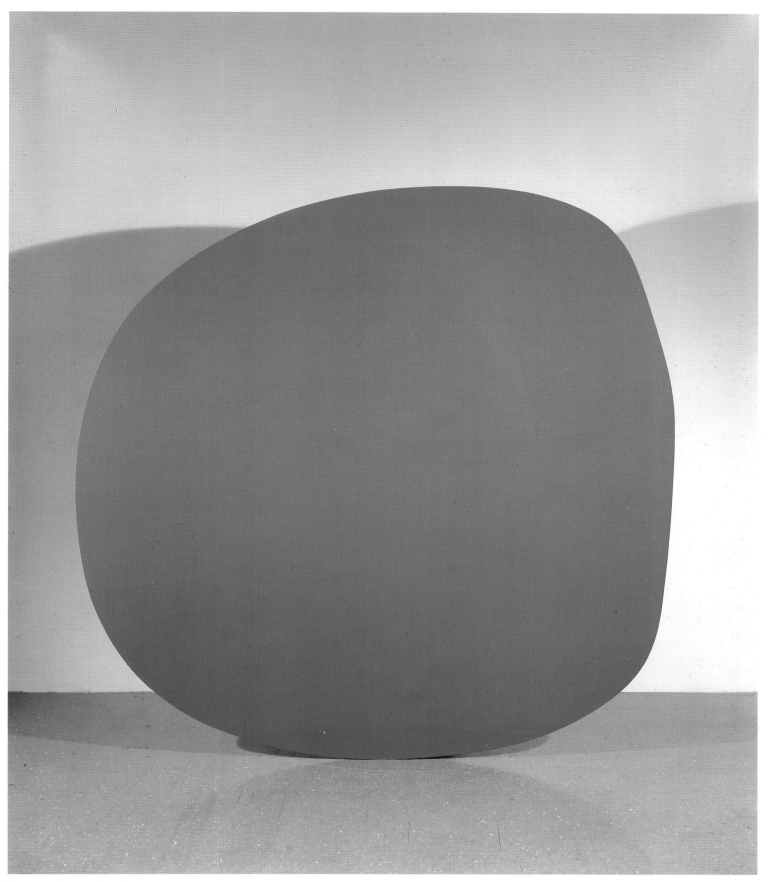

Fig. 6. **Blue Disk**, 1963 (EK#S323). Painted aluminum, 70 x
72 (177.8 x 182.9). Collection Mr. and Mrs. Sidney R. Bass,
Fort Worth, Texas.

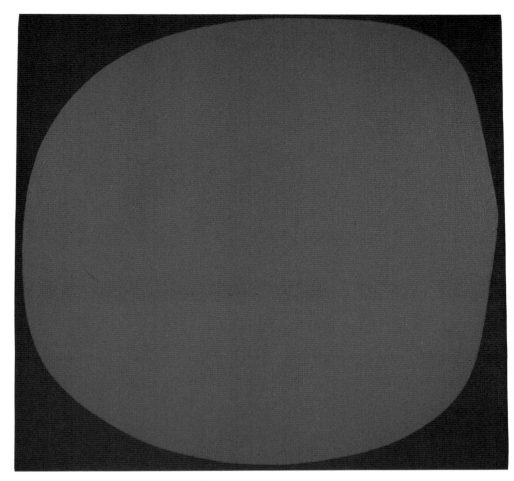

Fig. 7. **Green Blue**, 1959 (EK#192). Oil on canvas, 22 x 32 (55.9 x 81.3). Collection of the artist.

York Painting and Sculpture: 1940–1970, was organized by Henry Geldzahler at the Metropolitan Museum of Art in 1969. It presented not only Kelly's paintings but also his sculpture and plant drawings. Many who were familiar only with the paintings were thus alerted to his accomplishments in other areas, and these were increasingly acknowledged, during the new decade, as integral to his art as a whole. As a sculptor, he has altered our understanding of modern three-dimensional form; as a draftsman his representational pencil and ink renderings of plants and flowers have nobly elaborated upon the tradition of Pablo Picasso and Henri Matisse's contour drawings.

At the time of the Metropolitan Museum exhibition, Kelly already had a history of making prints: sixty editions in all, although none of them was included in the show. Earlier in the 1960s he had published two major series of lithographs with Maeght Editeur in Paris and had contributed single prints to two important American portfolios. During the year the Metropolitan Museum's exhibition opened, he had made plans to collaborate with Gemini G.E.L. in Los Angeles, a lithography workshop. The issue of his first working sessions at Gemini, the Series of Ten Lithographs, published in 1970, marks the beginning of the period during which Kelly turned to printmaking, as he would also turn to sculpture, as a

sustained endeavor. Known primarily on the occasion of the Metropolitan exhibition as a significant American painter, Kelly afterward increased the scope and productivity of his artmaking to become equally well known as a printmaker and sculptor. The nearly 250 editions of prints he has amassed to the present constitute an extensive and serious body of work that embellishes our understanding of his art while standing as a bona fide achievement in its own right.

Like the prints of Jasper Johns and Frank Stella, Kelly's are intimately related to his work in other media. They may be realized shortly after the completion of a painting or sculpture from which they are derived, or made considerably later. The prints have, therefore, served a pronounced and distinctive retrospective function. The connection, however, between the prints and the paintings and sculpture is not simple.

Kelly develops his paintings and sculptures from carefully wrought drawings and collages in a variety of media. These preliminary studies are created in preparation for specific works, but they are also meticulously preserved to form a repository of ideas that Kelly may return to and reissue. Although many of the prints appear to be directly related to certain paintings or sculptures, it is more accurate to say that they are taken from the same initial collages and drawings, the mother lode of Kelly's art. Still, certain prints stand alone, without any counterpart in other media, while some drawings and collages may be realized first as prints, followed only later by an affiliated painting or sculpture. Kelly

also experiments a good deal with the range of relationships possible between a print and another work. A print may exactly repeat the configurations and colors of a painting or sculpture, but often the artist makes spare, subtle, or sharp alterations in one or two aspects of an image, so that the print may be a color or proportional variation, and thus a unique statement.

The majority of the prints reflect Kelly's abstract imagery, but his figurative collages and drawings and his plant drawings have also provided sources for, and have established other categories within, his graphic oeuvre. *Saint Martin Landscape* (cat. no. 179), with its collaged female nude imposed on a Caribbean landscape, is a photolithograph and screenprint based on one of the numerous postcard collages that the artist has made since the mid-1950s. Two lithographic figure studies (cat. nos. 1 and 3) reflect, respectively, Kelly's early interest in the human figure as he refracted it through French modernism and ancient Mediterranean art, and his habit of making portraits of friends over the years—the latter a development within Kelly's work less visible to the public, although it follows the simplifications and contour style of his better-known plant drawings.

Since 1949 Kelly has made over one thousand finished pencil and ink renderings of plants, flowers, and fruits, known generically as his plant drawings. They have figured no less importantly in the graphic work. Nearly a quarter of his prints are transfer lithographs devoted to the artist's flora. These drawings and lithographs present their subject, be it a calla lily, grapefruit, or magnolia, enlarged in scale with a simple contour line. The plant forms may be rendered in detail, modeled or filled in with flat color, or greatly simplified, in some cases to a few strokes of the pencil, pen, or lithographic crayon. They may be drawn in ink with an almost Oriental delicacy or with the lithographic crayon in broad, greasy strokes. Kelly may apply an even line to paper with a steady pressure of the hand, or he may develop a nuanced system of thin and thick lines as in, for example, the lithograph *Camellia III* (cat. no. 43). Most of his subjects are drawn from life; often Kelly begins with a series of preliminary sketches from which he derives the finished drawing or lithograph; a few have been drawn directly on transfer paper or from memory. *Catalpa Leaf* (cat. no. 54), the most abstract of all the plant pictures, was executed in two strokes of the crayon on lithographic transfer paper, in the artist's words, "to see if it could be done." In style and in subject, the extraordinary variety of the plant drawings and lithographs is directed, nevertheless, to a clearly defined goal. In 1969 Kelly stated that "the drawings from plant life seem to be a bridge to the way of seeing that brought about the paintings of 1949 that are the basis for all my later work."[4] This bridge is also apparent in the photographs Kelly has intermit-

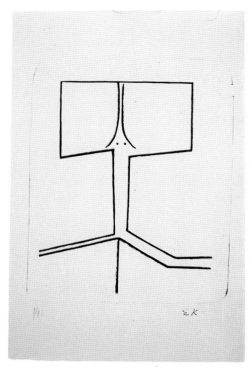

Fig. 8. **Untitled**, 1949. Lithograph. Cat. no. 1.

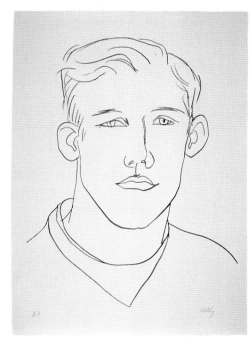

Fig. 9. **David**, 1964. Transfer lithograph. Cat. no. 3.

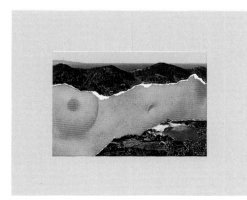

Fig. 10. **Saint Martin Landscape**, 1979. Offset lithograph and screenprint. Cat. no. 179.

tently made. Photography has served both to document motifs that have been the basis for paintings or sculptures, and to record visual phenomena that interest him; in the latter, the photograph, whose subject may be unrealized in other media, stands alone as a work of art in its own right. The abstracting process apparent in the plant drawings and lithographs and the photographs reveals the manner in which Kelly converts the literally perceived to the abstract. His long-term cultivation of the plant drawings and lithographs and his less-well-known preoccupation with photography have allowed him to be refreshed periodically at the source of his art: vision.

Kelly has made his prints in a number of places and in collaboration with several workshops, but he has been most closely identified with two, Gemini G.E.L. and Tyler Graphics Ltd. With the exception of a series of linoleum-cut prints he made for the covers of his junior-high-school magazine and the instructional silkscreen posters on camouflage for which he cut stencils for the army during World War II, Kelly's first editioned print was an unpublished lithograph he made at the Ecole des Beaux-Arts in 1949 (cat. no. 1). His first editioned and published prints date to 1964: the screenprint *Red/Blue* (cat. no. 2) from the Wadsworth Atheneum portfolio *Ten Works x Ten Painters* and the Maeght series of lithographs (cat. nos. 4–30, 32–59). In the intervening sixteen years, the artist did, however, come to familiarize himself with, and to show a predilection for, the printed image in two issues of the Parisian art journal *Derrière le miroir* (App. Ia, b) and in a number of posters and invitations he made for exhibitions of his work (App. IIa–c, IIIa–f).

For the latter he provided artwork and oversaw layout and design. The printed matter that typically surrounds such presentations of an artist's work has always interested Kelly. He has continued since this period to participate actively in the creation of posters, and later was involved with the design of monographs on his art.[5]

For the issues of *Derrière le miroir*, which were published for exhibitions of his work in 1958 and 1964 at the Galerie Maeght in Paris, Kelly provided artwork for the printers to adapt to full-sheet lithographic insert pages. This manner of inviting an artist to make original lithographs for the issues of *Derrière* was a tradition of Aimé

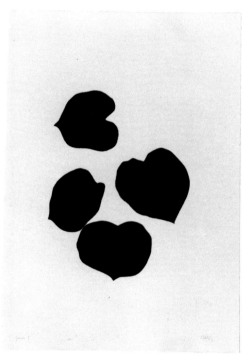

Fig. 12. **Grape Leaves III**, 1974. Transfer lithograph. Cat. no. 96.

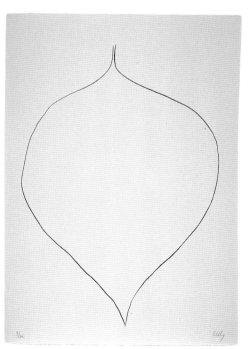

Fig. 11. **Catalpa Leaf**, 1966. Transfer lithograph. Cat. no. 54.

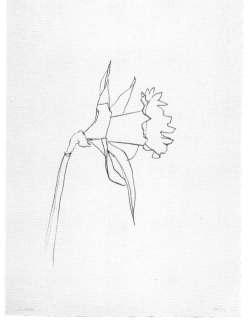

Fig. 13. **Daffodil**, 1980. Transfer lithograph. Cat. no. 188.

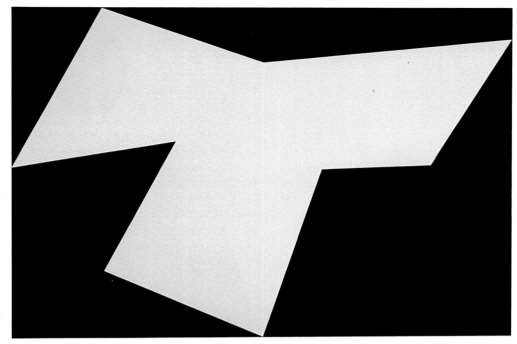

Fig. 14. **Untitled**, 1958 (from *Derrière le miroir*). Lithograph. App. Ia, pp. 10–11.

and Marguerite Maeght. Although most of Kelly's images were based upon previously executed collages and paintings, he showed his sensitivity to what otherwise might have been simple reproductions by making certain readjustments of shape and by carefully approving color at the time of printing. For a black and white double-page lithograph from the 1958 issue, based upon the painting *Cowboy* and three collages of the same year, Kelly laterally attenuated the original configuration to accommodate it to the horizontal spread of the paper, to "adapt the image to a different space." From his earliest serious in-

volvement with printmaking Kelly has shown such concern with decision making and a keen graphic sensibility. In the posters, invitations, and issues of *Derrière le miroir* at this time the artful disposition of image and text on the page, the consciousness of the page as a special space in which to make marks, was a sign of the naturalness of Kelly's growing commitment to the editioned and signed print. His later, intensive collaborations with publishers, printers, and printmaking facilities at Maeght Editeur, Gemini G.E.L., and Tyler Graphics Ltd. were the fruit of an interest early established.

Before undertaking the Wadsworth Atheneum and Maeght projects in 1964, Kelly had, earlier in

the same year, met with Tatyana Grosman at Universal Limited Art Editions (ULAE) in West Islip, Long Island. Jasper Johns and Robert Rauschenberg, among other important American artists, were making prints with her, and this, along with the encouragement of friends to participate in new printmaking developments that had recently surfaced in the United States, prompted Kelly to explore the possibility of initiating a project at ULAE.[6] He visited Grosman, but difficulties were immediately apparent. Kelly came prepared with a project in mind that he wished to pursue, a preconceived series of prints derived from his paintings of the past decade and forming color variations on a set of basic shapes. According to Kelly, Grosman was not particularly happy that he had a preset plan. Her own tastes, bred within the context of Abstract Expressionism, favored improvisation and an on-the-spot reciprocity between artist and materials. She held a very personal notion of lithography, infused with Expressionist aesthetics, that lavished attention on a single, unique image and prized a spontaneous working with the stone, autographic drawing, and painterly washes of ink on assertive printmaking papers.[7] These attitudes and techniques were antithetical to Kelly's art and to his proposed serialized project. Although chance and intuition played a role in his sketches, in his discoveries of motifs in nature, and in his choice of color, Kelly's art, unlike Abstract Expressionism, was, in its physical realization, preplanned. Kelly developed a work of art fully in his head and in working drawings and collages before executing it. For his part, Grosman's "listening to the stone" was not his cup of tea. As the nature of her philosophy toward art and printmaking became clear to him, he realized a collaboration would be unsatisfac-

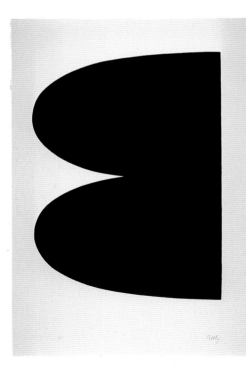

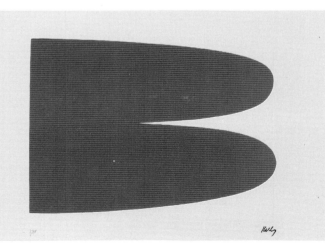

Fig. 16. **Red-Orange**, 1965 (from the Suite of Twenty-Seven Color Lithographs). Lithograph. Cat. no. 6.

Fig. 15. **Black**, 1965 (from the Suite of Twenty-Seven Color Lithographs). Lithograph. Cat. no. 4.

tory and did not pursue the matter. The proposed project for ULAE later developed into Kelly's first major printmaking project, the Maeght Series of Twenty-Seven Color Lithographs (cat. nos. 4–30).

In late 1964 Kelly initiated this project in concert with the Suite of Plant Lithographs (cat. nos. 32–59). Together they stated in a broad gesture the abstract and representational polarities of his art. The plant series evolved after a particularly productive year, during which the artist had created over one hundred plant drawings. The series of abstract lithographs was retrospective and traced a sequence of forms that had been prominent in the paintings since his return to New York in 1954. The first print in the series, *Black* (cat. no. 4), was related to the first painting he made upon his arrival from France. Earlier in 1963 Kelly had begun to concern himself with the relationships of images to each other. The result, which he had presented to Grosman in embryonic form, was the Maeght series. It stood as an alphabet of basic shapes, a personal code that he had developed over the past decade, and as a serialized work of art in which images were related by variables of color and shape. Because of the smaller scale of the prints, in contrast to the paintings, the variations could be endlessly reshuffled for new comparisons. The Maeght color lithographs were Kelly's first serialized work of art. Previous paintings, because of similar shape, often fell into loosely knit groupings, but Kelly never conceived them as a specific set of variations to be presented together. The scale of the prints allowed this, and—along with Frank Stella, who at the time had fashioned a number of painting series—Kelly was one of the first Americans to develop serialized work, an achievement, little acknowledged, that influenced his

future directions and that set no small precedent for the Minimalists later in the decade.

The two Maeght series were begun with Maeght Editeur in Paris at the time of the artist's last one-man exhibition with the Galerie Maeght in 1964. Aimé and Marguerite Maeght, whom Kelly had known since 1951, had directed a gallery of contemporary art, the publishing house Maeght Editeur, and a lithography workshop since 1945. They were early champions of Kelly's paintings and sculpture, and they showed the young artist's work on a number of occasions during the 1950s and early 1960s.

Marcel Durassier was the noted master printer for Maeght. He had collaborated on lithographic projects with many School of Paris artists, including Georges Braque, Joan Miró, Alberto Giacometti, Marc Chagall, and Henri Matisse. He worked with Kelly, supervising, proofing, and editioning the Series of Twenty-Seven Color Lithographs and the first twelve prints of the Suite of Plant Lithographs. Maeght made Miró's luxurious apartment above the lithographic studio available to Kelly during his month-long stay in Paris. (Miró resided there while he collaborated on print projects for Maeght.) Kelly worked upstairs, going back and forth to the printers below, actively involved on a full-time, daily basis with making preliminary collages and drawings, drawing with lithographic crayon on the stones, helping to carry them, and carefully following the proofing stages. He remembers the challenge posed for Durassier by his large, plain areas and blocks of pure color. Durassier, who was accustomed to traditional lithography, with its emphasis on drawing and hand gesture, had never printed broad flats of color before. He did them to Kelly's great satisfaction. He also achieved for Kelly a quality of line in the plant lithographs that the artist has always admired: a richly printed

black crayon line resulting from the type of transfer paper used, the use of zinc plates, and simple good craftsmanship.

With the exception of an unpublished portrait lithograph that Durassier printed privately for Kelly in 1964 (cat. no. 3) and a plant lithograph that was included in a memorial edition of *Derrière le miroir* in honor of the Maeghts in 1982 (App. Ic), the two series Kelly did with Durassier were effectively his last projects with the Maeghts, marking the end of a long and productive affiliation. Kelly's connection with the French printmaking scene, maintained by the Maeght shows and prints for a full decade after his return from Paris to New York in 1954, was at an end. Henceforth, Kelly made prints in the United States.

Earlier in 1964 he had contributed a print, his first screenprint (*Red/Blue*, cat. no. 2), to an American portfolio entitled *10 Works x 10 Painters*, which was published by the Wadsworth Atheneum in Hartford, Connecticut, under the supervision of Samuel Wagstaff, Jr. (Shortly before, in late 1963, Wagstaff, who was one of the first admirers of the plant drawings, had had one entitled *Brier* made into a holiday card—the first of Kelly's printed plant images.) The screenprint was printed under the direction of the Ives–Sillman workshop in New Haven, Connecticut, after collages Kelly had submitted. This was followed by a series of three collaborative portfolio projects, published in New York over the next decade by Irwin Hollander at the Hollander Workshop (cat. no. 60), by Brooke Alexander with Paul Narkiewicz (cat. no. 84), and by Experiments in Art and Technology with the Styria Studio (cat. no. 92).

These portfolio projects were symptomatic of a new period in the history of American printmak-

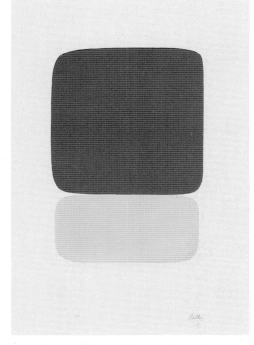

Fig. 17. **Red over Yellow**, 1965 (from the Suite of Twenty-Seven Color Lithographs). Lithograph. Cat. no. 19.

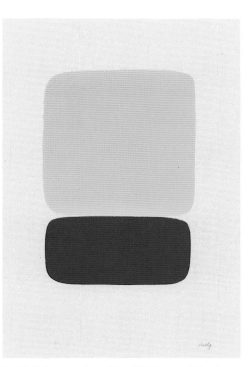

Fig. 18. **Yellow over Dark Blue**, 1965 (from the Suite of Twenty-Seven Color Lithographs). Lithograph. Cat. no. 22.

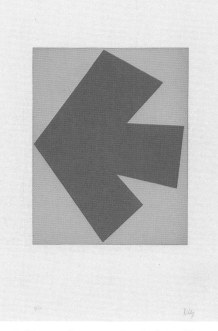

Fig. 19. **Blue over Green**, 1965 (from the Suite of Twenty-Seven Color Lithographs). Lithograph. Cat. no. 26.

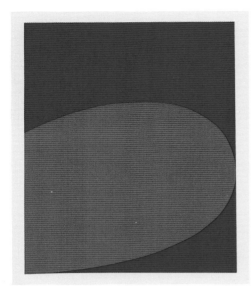

Fig. 20. **Red/Blue**, 1964. Screenprint. Cat. no. 2.

ing. Frequently referred to as the "American Print Renaissance," it initially entailed a revival of lithography and the setting up of new workshops, the training of technical directors in the tradition of the European master printer, an active seeking of collaborations between workshops and promising or established contemporary artists, and the appearance of new audiences avid to collect affordable contemporary art. The impetus for this development came largely from June Wayne at the Tamarind Lithography Workshop in Los Angeles and from Tatyana Grosman at ULAE. The emphasis at these shops was on lithography, but elsewhere, by the mid-1960s, screenprinting was appropriated by Pop artists, in large part because of its associations with commercial printing. These artists saw the screenprint as an authentic vehicle for their media-based iconography, while the hard-edge and Color Field painters liked the medium's adaptability to blocky sheets of saturated color, so suited to the Formalist aesthetic of the period. Later, during the 1970s, American artists and workshops began to expand their interests and explore etching and woodcut printing. The new American print—often large-scaled, brilliantly colored, and technically innovative—was brought into the fold of contemporary art history.

Although Kelly did not find ULAE a workshop receptive to his ideas, he and other hard-edge abstractionists, such as Josef Albers and Frank Stella, benefited from a lithography studio in Los Angeles that was eager to collaborate with them. Kenneth Tyler, formerly the technical director at Tamarind, had opened the Gemini press in Los Angeles with his wife, Kay Tyler, in 1965. The following year they incorporated with Sidney Felsen and Stanley Grinstein to found Gemini

G.E.L. Gemini's goal, like ULAE's, was to invite the very best contemporary artists to make prints. The differences between the shops lay in Gemini's more accepting attitude, spearheaded by the creative resolves of Tyler, toward technical innovation and the unorthodox print. Pop art and the new abstraction posed no problems for him. As a function of the modern artist's needs, Gemini was prepared to redefine printmaking.

Artists began to arrive at Gemini's shop on Melrose Avenue to do just that: first came Albers in 1966 (although in absentia, working with Tyler from the East Coast); then Rauschenberg and Stella in 1967; Claes Oldenburg, Johns, and Roy Lichtenstein followed in 1968. Late in 1968 Gemini sent a letter of invitation to Kelly. At the urging of Stella and his wife, Barbara Rose, Kelly pursued the matter. A dinner was arranged in New York for Gemini's principals and Kelly, during which an agreement was reached. In January 1970 Kelly began his first working sessions at Gemini. Even though Tyler left in 1973, Kelly has continued ever since to make prints with Gemini and its many printers: 133 editions over a fifteen-year period.[8] In addition to his graphic work at Gemini, and closely related to it, Kelly has made editioned sculptures: *Mirrored Concorde* of 1972, the Painted Wall Sculptures of 1982, and the Metal Wall Reliefs of 1985. Kelly's long-standing relationship with Gemini may be explained in part by the willingness of the directors and printers to let the artist do what he wants, by their generous accommodation of his needs, and by a southern California informality that creates an affable and relaxed environment, in which Kelly has found it easy to work.

Kelly's collaborations with Gemini on a single print or series may last a month to two years. During these periods he usually visits Gemini intermittently to work on a project for a few days at a time or for several weeks, with typical stays of one week. He may bring preliminary drawings and collages with him to the shop, or, more spontaneously, he may get his ideas in the shop (this has been particularly true of the plant lithographs). During the first working sessions he sets shapes and color for first proofs. These proofs are usually sent to him later at his home in Spencertown, New York, for approval or for revisions that may be implemented by phone calls to Gemini or during return visits to Los Angeles. The process of making prints entails for Kelly a slow series of deliberations. His judgments are not preconceived or calculated, but intuited. The prints, as much as the paintings and sculptures—and with equal care and attention —are crafted within this context. Collaboration is not a natural method for him. He does take part in the collaborative aspect of printmaking at Gemini, the give-and-take between printers and artist, but his decision making is essentially private. When Kelly began working at Gemini in the early 1970s he was somewhat hesitant in his working relationships with the printers. He is far

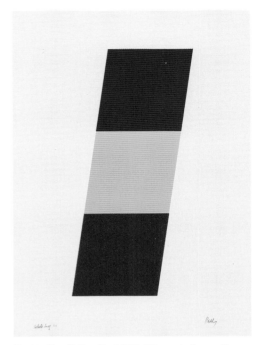

Fig. 21. **Blue/Yellow/Red**, 1970. Lithograph. Cat. no. 61.

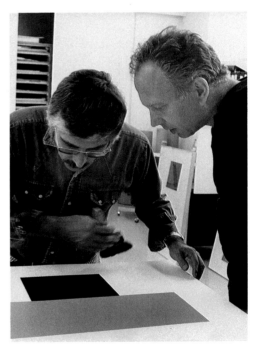

Fig. 22. Ellsworth Kelly and Kenneth Tyler examining **Red-Orange over Black** (cat. no. 71) at Gemini G.E.L., Los Angeles, 1970.

Fig. 23. Sidney Felsen (center) with (from left to right) the printers James Reid, Anthony Zepeda, Alan Holoubek, and Serge Lozingot at Gemini G.E.L., Los Angeles, 1984. They are examining a template for **Baie Rouge** (cat. no. 204), from the Saint Martin Series.

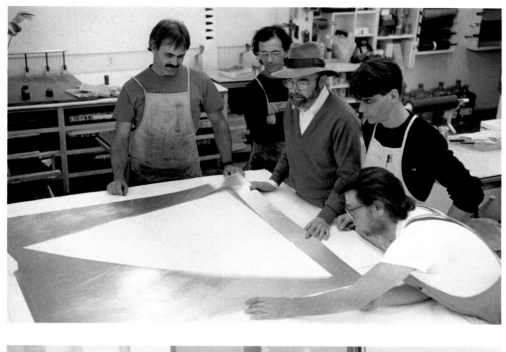

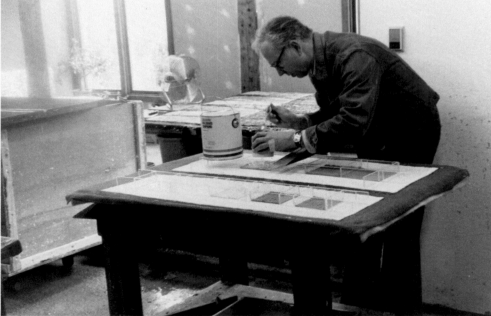

more relaxed today in the shop but still shows a certain shyness when collaborating.

Kenneth Tyler left Gemini in 1973 to set up his own shop in Bedford, New York, one hour's drive north of Manhattan. During the period from 1976 to 1980 Kelly collaborated with Tyler Graphics Ltd. to produce a number of projects that took him in new directions. At that time he continued making plant lithographs with Tyler, but he also made his first etching, *Wall* (cat. no. 177), his first collage prints (cat. nos. 179, 180), and the experimental handmade-paper pieces entitled Colored Paper Images (cat. nos. 141–63).

The twenty-three Colored Paper Images were Kelly's first major project at Bedford. Tyler had already shown a strong interest in handmade paper and its manipulations into contemporary works of art.[9] While at Gemini, one of his last projects had been a collaboration with Rauschenberg that resulted in the Pages and Fuses of 1973–74, which was carried out in France at the Moulin à Papier Richard de Bas. Upon opening his new workshop, Tyler, in collaboration with papermakers John and Kathleen Koller at the HMP Paper Mill in Woodstock, Connecticut, began handmade paper series with Ronald Davis and Frank Stella. Kelly's Colored Paper Images of 1976 were also made in cooperation with the Kollers, but unlike the Davis and Stella series, which variously incorporated mixed media—printing, hand painting, paper casting, and collage—they consisted solely of pressed and colored paper pulp. Each piece began with a wet sheet of unpigmented paper pulp. Molds of varying shapes, made out of joined Lucite panels or bent metal rulers, were positioned on the sheet and served to contain colored, wet pulp that was ladled into them. The molds were then removed and the base sheet, with its colored-pulp shapes, was placed in a press, so that under

Fig. 24. Ellsworth Kelly spooning colored paper pulp into a mold for **Blue/Green/Yellow/Orange/Red** (cat. no. 162), at HMP Paper Mill, Woodstock, Connecticut, 1977.

Fig. 25. **Blue/Green/Yellow/Orange/Red**, 1977. Colored and pressed paper pulp. Cat. no. 162.

Fig. 26. **Colors for a Large Wall**, 1951 (EK#46). Oil on canvas, 96 x 96 (243.8 x 243.8). The Museum of Modern Art, New York.

pressure the two came together to form a single panel of textured paper. Although not prints in the conventional sense, the Colored Paper Images are considered part of Kelly's graphic work because they are editioned, and because the procedures for creating them involved the fusion of paper and image using a press, and the making of multiple impressions of a single image from a master matrix, in this instance the Lucite and bent-ruler molds.

By the later 1970s papermaking in America, fostered in large part by Tyler, came to preoccupy many contemporary artists. This movement boasted Kelly's Colored Paper Images as one of its central and most influential achievements. Within the artist's own work at the time, they were an unexpected departure, with their crusted surfaces and smeared color edges. They were instrumental in encouraging Tyler to set up his own in-house papermaking facility in 1978, and their beauty prompted David Hockney to begin his historic Paper Pools series in the same year.[10] Although Kelly's production during the time at Tyler Graphics—the lithographs, screenprints, collage prints, the single etching, and the paper pieces—constitutes a brief episode in the artist's printmaking, it figures among his strongest and most experimental.

In retrospect, the development of Kelly's art appears to be a function of the artist's continuous elaboration over time of a repository of images and ideas he established for himself during his sojourn in France in the early 1950s. The subject of the paintings, sculptures, and prints as they evolved out of this body of work has always been, as argued earlier, distinctive shape. Kelly's intense concentration on and elaboration of this theme has bred a consistency, a homogeneity that reveals, within the sharpness of his focus, a remarkable variety and a distinct stylistic chronology.

The joined and unjoined monochromatic panel paintings and the chance collages, drawings, and paintings of Kelly's Paris period led, upon his return to New York in 1954 and for the next decade, to the larger single-panel figure–ground paintings, with their magnified and cropped biomorphic and angular shapes. At the time of the Maeght editions of 1964–66, the Suite of Twenty-Seven Color Lithographs summarized and brought to a close these interests. For the remainder of the decade Kelly's art moved to re-explore the joined-panel and unjoined single-panel canvases in a return to a more strictly straight-edge style. The geometries of this period, if derived from the French panel paintings,

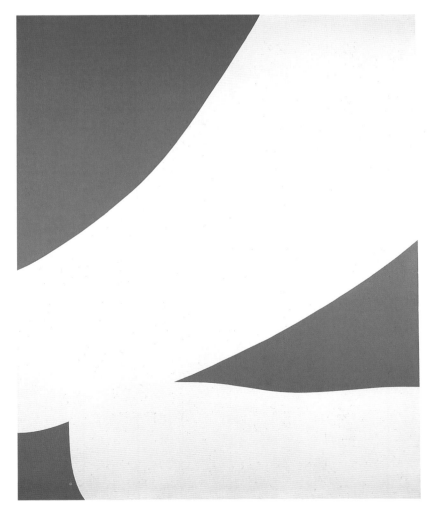

Fig. 27. **White Blue**, 1960 (EK#257). Oil on canvas, 85 x 68 (215.9 x 172.7). Art Gallery of Ontario. Toronto.

Fig. 28. **Red Green**, 1968 (EK#388). Oil on canvas, 112 x 130 (284.5 x 330.2). Collection Mr. and Mrs. C. David Robinson, San Francisco.

Fig. 29. **White Curve I**, 1972 (EK#480). Oil on canvas, 100 x 100 (254.0 x 254.0). Stedelijk Museum, Amsterdam.

were more ambiguous and illusionistic than earlier work, and were an expansion of Kelly's lexicon of rectangular shapes to include a full array of quadrilaterals, triangles, and abutted triangles and rectangles. By the early 1970s and through the new decade conventional geometric shapes gave way to increasingly eccentric circle segments and trapeziums and to single-panel paintings. The curve now reappeared, frequently inscribed within quadrilateral shapes. Spectral color during this period was effaced in favor of blacks, whites, grays, and subdued color. With the early 1980s, bright color returned in the paintings, and Kelly's vocabulary of shape from the previous decade was enlarged upon with spherical triangles and quadrilaterals that suggest a renewed, though rephrased, interest in biomorphic form.

This brief chronology demonstrates that Kelly's stylistic preoccupations have evolved in the paintings in a steady fashion, while remaining true to his ongoing search for assertively articulated shape; the prints have paralleled these shifts, but, in a more complex chronological dialectic, have often come after the paintings and have both echoed their innovations and revived earlier forms. As he appropriates or varies the shape from an existing painting or collage, Kelly scrupulously adjusts it to the printed image, taking into account new reciprocities among shape, printed colored inks, paper, and scale. In these reassessments, in his establishment of working methods, in his preference for

certain print media and processes, and in his attitudes toward the printed transposition of his imagery, Kelly has been fairly constant in his concerns as a printmaker. There is, of course, a chronology of developments within the printmaking too; it is effected primarily by stylistic shifts in the paintings that are registered by the prints, by the artist's exploration of new print media, and by his growing interest during the 1970s, reflected in the sculpture but not in the paintings, in textured surfaces. But given the recurring concerns of Kelly as he transposes his forms into print media, and the more complex chronological relationship of the prints to the paintings, it is more useful in identifying the basic character of the prints to treat separately a series of issues relevant to our understanding of them, rather than to trace Kelly's printmaking experiences over time.

In the initiation of a print, Kelly produces, as he does for paintings and sculptures, a body of preliminary studies, which are developed and refined in a series of working drawings and collages. The drawings are made in an assortment of media that includes pencil, ink, gouache, and oil, on a range of papers. The collages are cutouts of colored stock papers adhered to a base sheet. In most cases a carefully finished collage provides the maquette with which the printers begin preparing hand-cut negatives or stencils for photo plates or screens, respectively. For the plant lithographs, Kelly may make preliminary pencil drawings from life that serve as a basis for the drawings on transfer paper, or he may draw directly on the transfer paper itself, a challenging task in which no erasures are possible. Transfer paper is also very portable; it lets the artist work privately in his own studio.

Although Kelly has made screenprints and etchings and has used paper itself as a medium in the Colored Paper Images, three fourths of his prints are lithographs. The implied preference reflects his formative printmaking experiences with Maeght and the American lithography revival of the 1960s. As importantly, Kelly likes the qualities of the medium. He likes lithographs made from metal plates and printed on direct presses such as the French cylinder press that Maeght and Durassier used, or the direct hydraulic lithographic presses, designed by Tyler, that are installed at Gemini and at Tyler Graphics. Offset lithography, despite certain advantages over direct lithography, has never interested him. In direct lithography the image is reversed if the artist draws directly on the plate or stone; an offset press corrects this, as does Kelly's use of transfer paper and hand-cut negatives. As the drawing is transferred from the paper to the plate or stone it is reversed, but will right itself when printed. Hand-cut plastic negatives of an image are simply flipped on the plate for processing, again resolving the reversal problem. Even at Tyler Graphics, where most lithography is

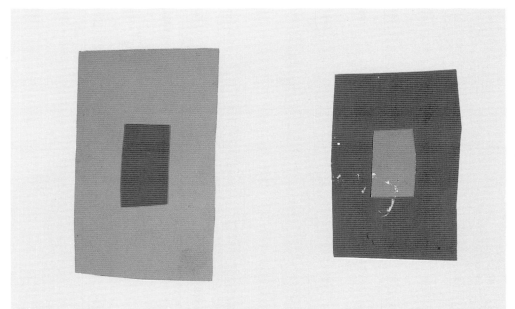

Fig. 30. **Red Blue and Blue Red**, 1964 (EK#PS105), study for Maeght lithographs. Collage. Collection of the artist.

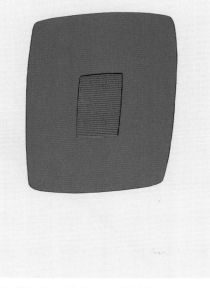

Fig. 31. **Light Blue with Orange**, 1965. Lithograph. Cat. no. 14.

done on an offset press, Kelly's lithographs—with the exception of the offset lithographic base sheet for *Saint Martin Landscape* (cat. no. 179) and the grid pattern for *Colors on a Grid, Screenprint 1976* (cat. no. 140) and *Nine Squares* (cat. no. 164)—were made on a direct press. His first projects had been made on direct presses, and Gemini, his primary workshop for making prints, has never had an offset press in the shop. The choice to work with direct lithography stems from Kelly's long-term familiarity with its processes and his wish to keep within his own traditions.

Most of the abstract lithographs have been made with photo plates. Using Kelly's collages as models, printers cut out the shapes in negative from sheets of plastic film, with trade names such as Rubylith and Amberlith, which are then placed on photosensitive aluminum plates. After these plates have been exposed to light, so that the shapes are "burned" into them, they are processed so that the forms on the plate are ink-receptive and printable. Printers may burn several plates for a given shape during the editioning of a print; the hand-cut negative in effect becomes the master element rather than the plate.

With Kelly's use of hand-cut negatives and transfer paper, the handling of the lithographic plate is indirect. Yet in several instances he has worked directly on printing elements: the zinc plates for the Maeght Suite of Twenty-Seven Color Lithographs, as already cited; the aluminum plates for the Series of Seven Lithographs (cat. nos. 181–87a), on which he drew scored outlines with a colored pencil; and the copper plates for *Wall* (cat. no. 177) and the Concorde Series (cat. nos. 194–200), on which he drew with a drypoint tool. Kelly has used transfer paper, photo plates, and hand-cut negatives for most of his lithographs, however, for the simple reason that they are the technical means by which he most effectively achieves the desired quality of image.[11] Although precisely edged flat shapes may be drawn and filled in directly on a lithographic plate with tusche crayons, the use of hand-cut negatives and photoprocessing corrects the reversal problem and allows for a harder edge and for a greater control of line and surface; these are extremely important considerations for Kelly.

In most of the screenprints—in particular, *Four Panels* (cat. no. 72), *Blue, Yellow and Red Squares*

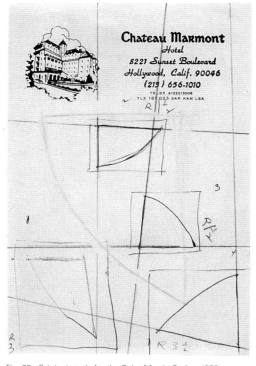

Fig. 32. Original study for the Saint Martin Series, 1983 (EK#83.47a). Pencil on paper, 6 x 4 (15.2 x 10.2). Collection of the artist.

Fig. 33. Study for **Baie Rouge**, 1984 (EK#83.50). Pencil on paper, 11½ x 12 (29.2 x 30.5). Collection of the artist.

Fig. 34. Orient Beach, 1983–84. Lithograph. Cat. no. 205.

(cat. no. 73), *Spectrum* (cat. no. 90), *Large Black Curve* and *Large Gray Curve* (cat. nos. 102, 103), and *Colors on a Grid, Screenprint 1976* (cat. no. 140)—the medium was selected because of the need for large scale, which could be achieved by the use of screenprinting frames that were larger than available lithography presses. Kelly, who made nearly two dozen screenprints during the early 1970s but none since, has always held certain reservations about the medium. He prefers lithography to screenprinting for the same reasons he prefers oil to acrylic paints on canvas. Screenprinting inks, like acrylics, can be too loud and flat. They tend to rest on the surface of the paper more than lithographic inks, which are absorbed; he sees them as too inert. Greasy lithographic inks have the richness of oil paints and an appealing, subdued lightness. It is the transparency and luminosity of these media that Kelly likes because of the liveliness and radiance they lend his images.

Etching appears later in Kelly's oeuvre. Just as Kelly has been spurred to make screenprints by the desire for large scale and by the availability of Gemini's in-house screenprinting facility, in place between 1970 and 1974, his interest in etching was stimulated by the intaglio revival that was taking place in American printmaking during the mid-1970s. At that time his plans for the etching *Wall* were being set at Tyler Graphics. On the other hand, a more important factor in Kelly's art was at stake. At about this time, Kelly had become interested in discernible and random surface effects in his sculpture, brought about by his use of weathering steel, with its natural blemishing by the elements, and of wood, with its various grains and textures. He never transposed these properties to his paintings, but he did allow them to enter his prints, first and most dramatically in the textured handmade paper and bleeding color of the Colored Paper Images. In *Wall* the dense surfaces, irregular edges, and modulated tones of gray and white effected by the hand wiping of portions of the plate were also utterly new to Kelly's articulation of forms in finished works of art. These qualities were emulated with even more aggravated surface incidence in the aquatints of the Concorde Series of 1981–82 (cat. nos. 194–200a). The lithographs themselves finally and monumentally appropriated the gestural interests of the etchings in the Saint Martin Series of 1983–84 (cat. nos. 202–206).

In technical terms alone, the Colored Paper Images, with the intensive researches into the pigmenting of paper pulp that preceded their creation, and the Saint Martin Series, with their intricate plate preparation, processing, and collaging, are without doubt the most innovative and complex works in Kelly's print oeuvre. Nevertheless, when measured against the bravura techniques of contemporary printmaking, Kelly's are conservative for the greater majority of his prints. Still, the prints have not been without their problematical aspects within the context of

traditional printmaking practice. The placing of precise color shapes immediately adjacent to others, without space between or excessive overlap that would distort color, requires exacting color registration and the careful adjustment of separate printing elements to ensure proper alignment of colored shapes. Even more important, given Kelly's aesthetic, is the problem of producing immaculate surfaces that exhibit even densities of color. Flats are difficult to print. The printer must have a continuous concern for blemishes, such as dents and marks pushed into the paper, roller marks, uneven inking or screening, and excessive texturings. Care for the perfect flat of color may even require blotting of surfaces after printing. It is normal that in the editioning of prints a number of unacceptable impressions are rejected. With the demands made by Kelly's imagery, attrition is always high during this phase.

The true challenge for Kelly is the image itself, the success of the printed rather than painted or fabricated work of art. Whether the image is appropriated directly from the paintings and sculptures, is a variation of its source, or is an invented image realized only as a print, Kelly's prints are never merely reproductive of the paintings, nor do the printers work from a maquette submitted to them by Kelly, replicating it as a print without the artist's active supervision. For Kelly the making of a good print involves a series of intuitive decisions about shape, color, the relationship of color to shape, and the relationship of colored shape to the field of paper it rests on. This process necessitates continuous and creative adjustments of all elements of the image. If such calibrations cannot be successfully made, the image fails, regardless of the artist's choice of medium or the demanding nature of his techniques. The image is Kelly's key concern.

Because they are more immediately available than the paintings or sculptures—largely a function of multiple impressions and lower prices —Kelly's prints disseminate his art to a large audience. They thus have an important role in "getting the work out," as Kelly says. But the relationship of the prints to his larger enterprise of making art is more serious than this. Kelly's prints share a language of form and color with the paintings and sculptures, but they have their own integrity, which extends beyond the obvious distinctions arising from the use of different media. The authenticity of the prints resides in how well they take Kelly's aesthetic, in how they offer an alternative and valid vision of Kelly's world of shapes and ideas. Just as printmaking and its processes have allowed Jasper Johns to elaborate upon his ambitions to replicate and refigure imagery, and Frank Stella to wed his love of technology to a medium other than painting, the printed image has allowed Kelly to *re-present* his art; indeed, as it will be argued, it suits its essential character. The print is, for Kelly, "an important fragment of what I am trying to say."

Fig. 35. **Spectrum**, 1973. Screenprint. Cat. no. 90.

Fig. 36. **Wall**, 1979. Etching. Cat. no. 177.

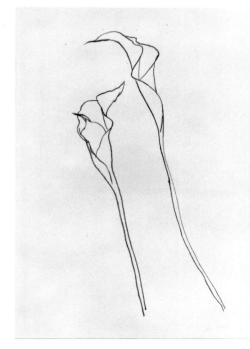

For example, with a few qualified exceptions, none of the plants, flowers, and fruits that Kelly has drawn with lithographic crayon specifically reproduces any of the pencil or ink plant drawings. For those lithographs that were derived from finished drawings, for example, *Lemon Branch* (cat. no. 57), Kelly has always readjusted the contours of the original drawing, using the lithographic crayon for further explorations of shape. The lithographs also extend the ink and pencil drawings with additional specimens, and in the most important aesthetic departure, with new qualities of line. Because lithographic inks are absorbed by printing papers, line in the lithographs is less immediate, more sublimated than the fresh marks of the artist's pencil or pen. Yet the lithographic crayon, unlike ink or pencil, produces an idiosyncratic mark that can broaden, skip, or smear as it delineates form. The lithographic drawing can also be printed with certain types of transfer paper and with zinc plates to achieve a rich and dense black line. The properties of the lithographic crayon as cultivated by Kelly, and in contrast to the tighter energies of his pencil and pen, produce a more spontaneous line. The plant and flower contour drawings change tone as they are realized in pencil, ink, and lithographic crayon. Kelly's plant lithographs, although related to the pencil and ink drawings, are a distinct body of expressive material.

In setting imagery for his abstract works, Kelly arrives at and settles shape first. He is extremely sensitive to shapes and the subtleties of their geometries. The chance fragment of vision, which Kelly calls a "flash," becomes the basis for an "alphabet of forms," first expressed in a single shape, which he then simplifies and abstracts. (This may later generate other related shapes

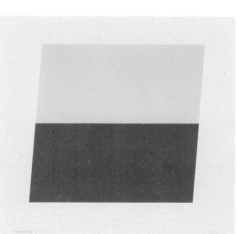

Fig. 38. **Yellow/Red-Orange**, 1970. Lithograph. Cat. no. 66.

that do not come directly from something seen.) The initial form snared by Kelly's penetrating and selective eye is often fixed in his very first thumbnail sketches. As it is enlarged and clarified in working drawings, either mechanically or by hand, its character changes very little.[12]

Kelly does not resolve color in the same way; in a general sense it may be worked out simultaneously with shape but is more usually determined afterward. In preliminary drawings and collages Kelly thinks of "naming the color"; that is, roughly identifying a hue, a generic blue, yellow, or red, for example. It is only when he does the print (or painting or polychrome sculpture) that he "finds the color." In the prints the finding is done during the proofing stage, when various mixings of a color or even several different colors are tested.

Fig. 37. **Calla Lily II**, 1985. Transfer lithograph. Cat. no. 210.

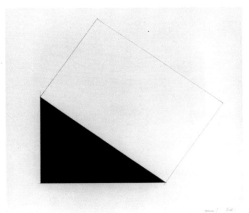

Fig. 39. "18 Colors (Cincinnati)," 1982. Lithograph. Cat. no. 193.

Kelly is a joyous colorist. The paintings and sculptures of the 1960s, upon which his critical reputation was first made, have forever linked his name with bright, ebullient color. Although his use of color may seem a simple matter of selecting generic primaries and secondaries, it is more varied and complex. Reds may be bluish or yellowish, yellows may be greenish or orangey in and of themselves, or colors may be modified by adjacent colors. The viewer's general impression of Kelly's palette is of saturated, pure hues, so it is something of a surprise to discover slate blues, pastels, and low-key greens, even browns. The wide range of hues, the great variety of reds, blues, and greens, so unexpected until identified, is the result of Kelly's intuitive search for the right colors—those that will bring into accord one shape with another, color and shape, color and color. The overall impression of radiant, primal color that is sustained despite this subtle diversity arises from a number of factors: the absence of drab or eccentric color; the fact that we usually confront an individual painting, sculpture, or print, and only rarely are able to compare, for example, the green of one painting with the green of another; and, most important, that the works of art comprise broad areas of unmodulated, immaculate color, which is often set off by the white walls of a museum or gallery or, in the prints, by the white sheet.

The final choice of color in the prints can entail a long period of deliberation. The proofing of *Black/Brown* (cat. no. 79) at Gemini is an early example. It took three printers five days and several gallons of ink to mix the right brown. Although this was an extreme case, it attests to Kelly's meticulous judgments of color.[13] Color proofs are usually sent to Kelly at his home for consideration. He may pin up a proof on his studio wall, regarding it intermittently over time and gradually coming to a decision about how successful particular values and saturations of colors will be. Kelly pondered a color proof of *"18 Colors (Cincinnati)"* (cat. no. 193) for nearly a year before he gave the master printer Serge Lozingot approval to proceed. In another instance, color proofs in dark blue, green, and purple for *Untitled* (cat. no. 201) were sent to Spencertown.

Only after a long interval, during which he solicited the reactions of the Gemini staff, did Kelly decide on the dark blue (which, for the record, was not the consensus of the workshop). Kelly is as sensitive to color as he is to shape. Sidney Felsen at Gemini one day saw Kelly staring at a yellow wall outside his office. He paid no immediate heed, but as he came and went through the shop he caught Kelly still looking at the wall. When Felsen asked Kelly what he was doing, the artist replied: "There are a thousand yellows in that wall, a thousand colors."[14] Although so different in their styles, Claude Monet and Kelly share an intense regard for chromatic complexity: the color of something is not a simple color. With his capacity to discriminate the most subtle nuances of color, Kelly matches color to shape. And color must be exactly right. For the artist this means that shape and color must compose an effortless unit. Color cannot overwhelm a shape, and shape cannot make color appear secondary or "added" to shape.[15]

Like certain colorists—Matisse, most pertinently, in the twentieth century—Kelly is a masterful handler of black: black in conjunction with color, black alone, or with white. In all media, Kelly has worked from the very beginning of his career in black and white. During the initial period in which he resolves an image, when the configuration is established and ready to receive color, he may first realize his chosen shape in black. For Kelly, at this point, "form and color are thought of in terms of value revealed initially as black. Color can take over if chosen first."

Black is pervasive in Kelly's 241 editioned prints. Counting the figurative, plant, and abstract prints, two thirds of Kelly's graphic oeuvre is in black and white. In the sequence of abstract lithographs, screenprints, etchings, and paperworks, black is used alone or paired with color in one hundred instances. The emphasis on black and white in the prints reflects the period when Kelly began devoting himself fully to printmaking. Shortly after he began his collaborations with Gemini in the early 1970s, he reduced his intense optical colors of the 1960s in favor of a predominantly black, white, and gray pallete in the paintings, and he moved from the earlier, brightly painted and lacquered aluminum sculptures to the rusts, grays, blacks, and browns of weathering steel and wood. The prints echo this direction. Color

still appears in full strength in many of the Gemini editions of the early 1970s, but black grows steadily in importance and color considerably less so after the middle of the decade. The Colored Paper Images of 1976 were the last great concerted color statement. Of the seventy-seven prints made since 1976 only seven are in color. And although color returns to the paintings and

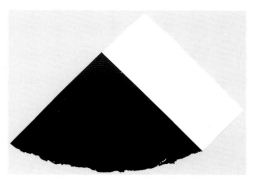

Fig. 40. **Dark Gray and White**, 1979. Screenprint and collage. Cat. no. 180.

Fig. 41. **Amden**, 1980. Lithograph. Cat. no. 184.

sculpture in the 1980s, only two recent prints have addressed color: "18 Colors (Cincinnati)," 1982, and Untitled, 1983.

Why the predominance of black and white in the prints, when no bias of similar proportions is found in the paintings and sculpture? Perhaps most telling are Kelly's sensitivity to the importance of monochrome in the history of printmaking and his own personal response to the black-and-white print as being "more about the classic printed image." As a painter he esteems Matisse's admixtures of black and color; as a printmaker he also marvels at Matisse's lithographic blacks. For example, the heavier, black crayoned line of the Maeght plant lithographs and of David (cat. no. 3) reflects the quality of line associated with Matisse's lithographic contour-drawing prints.

Kelly's choices of paper for the lithographs, etchings, and screenprints have never been disinterested. With the exception of the deliberately cultivated rough surface of the Colored Paper Images—a property of handmade paper—he does not care for paper that is excessively textured or smooth. He desires "an anonymous quality with no obvious characteristics." For the abstract prints the paper has usually been pure white; for the plant lithographs it varies from white to buff. Above all else, the paper must not call attention to itself. It must "work with color and not interfere."

During preparations of the Series of Ten Lithographs at Gemini in 1970, Tyler actively sought to provide Kelly with a paper appropriate to his needs. Working with the Arjomari–Prioux paper mill in France, Tyler helped to develop several new papers, not only for Kelly, but for other artists working at Gemini. Special Arjomari paper, a generic name for custom-made papers, was the result. The Special Arjomari paper created for Kelly was highly finished, with no pronounced color and no discernible texture. His paper was also sized to be less absorbent, so that inks sit somewhat higher on its surface and read more strongly. Tyler's experiments with Special Arjomari papers eventually led in 1973 to a standard paper named Arches 88, for which Tyler wrote the specifications. A paper frequently selected by printmakers for both lithography and screenprinting, and now available commercially, Arches 88 has been Kelly's choice for many projects, as well as the standard Arches Cover and Rives BFK.

The prints range in scale from the miniature, twelve-by-nine-inch Untitled, 1973 (cat. no. 92), to the monumental Saint Martin Triptych (cat. no. 206), whose dimensions when framed measure more than five by thirteen feet. Kelly's prints are large in comparison to traditional prints:

Fig. 42. **Untitled**, 1973. Screenprint. Cat. no. 92.

average sheet measurements are approximately thirty by forty inches or thirty inches square; indeed, three of the screenprints and the ninety-inch-long lithograph "18 Colors (Cincinnati)" (cat. no. 193) present an extended horizontal format averaging seven feet in length. These dimensions reflect the move made during the 1960s in American workshops toward large scale, although in comparison to the grandiose scale of some contemporary prints, Kelly's are not the biggest. The plant lithographs are comparable in size to Kelly's pencil and ink drawings; scale is not a variable that influences imagery from medium to medium in his work. The abstract prints, however, are considerably smaller than the paintings and sculptures. Kelly's art is usually thought of in terms of its monumentality and its vast fields of color; what happens, then, to imagery in the prints when it is reduced in scale? The image's frame of reference abruptly shifts, of course, from the wall or open space to the white sheet. Kelly adjusts the size of the shape in relationship to the sheet so that shape asserts itself, has its own scale within this context. Yet imagery, if it sustains a relatively powerful presence, shifts in character. The ener-

gies of shape in the paintings are centrifugal. Color explodes out to the edges of shape with such force that the eye works to deduce exact geometries at play—a task often complicated by ambiguous shape. In the prints, because of smaller scale, shape is contained by the sheet; we comprehend it more immediately. Geometry, in effect, grows more important. Energies are centripedal in the prints. What may be forfeited in extroversion is gained in intimacy. The prints significantly rephrase the paintings and sculptures.[16]

The problem for Kelly of how paper is to be used is not limited to its texture or size. There are crucial decisions to be made concerning the exact positioning of forms on the sheet, the size of the forms in relationship to the dimensions of the paper, and the nature of the resulting unprinted areas and margins. The significance of these choices rests in Kelly's avid attention, in the prints, paintings, and sculptures, to the relationship of figure to ground—to how the salient shape on which the eye focuses relates to the surrounding background from which it is distinguished. The prints distinctively articulate this reciprocity, and stand apart in their resolutions from the paintings and sculpture.

The paintings of the period from 1954 to 1965 contained figure–ground relationships, as does traditional and much modern painting. Kelly positioned a shape or shapes on a rectangular color field that read as background, and he magnified his forms so that they were tangential to, and seemingly cropped by, the framing edges of the canvas. But earlier on, in France and again in the mid-1960s, he worked to dislodge form from this system. He did this by making single and multiple monochrome panel paintings. This solution has been a paradigm for his art over the past two decades. In a set of remarks that were written for an exhibition catalogue in 1974, Kelly gave his reasons for this move:

I have wanted to free shape from its ground, and then to work the shape so that it has a definite relationship to the space around it; so that it has a clarity and a measure within itself of its parts (angles, curves, edges, amount of mass); and so that, with color and tonality, the shape finds its own space and always demands its freedom and separateness.[17]

Fig. 43. **Large Gray Curve**, 1974. Screenprint with debossing. Cat. no. 103.

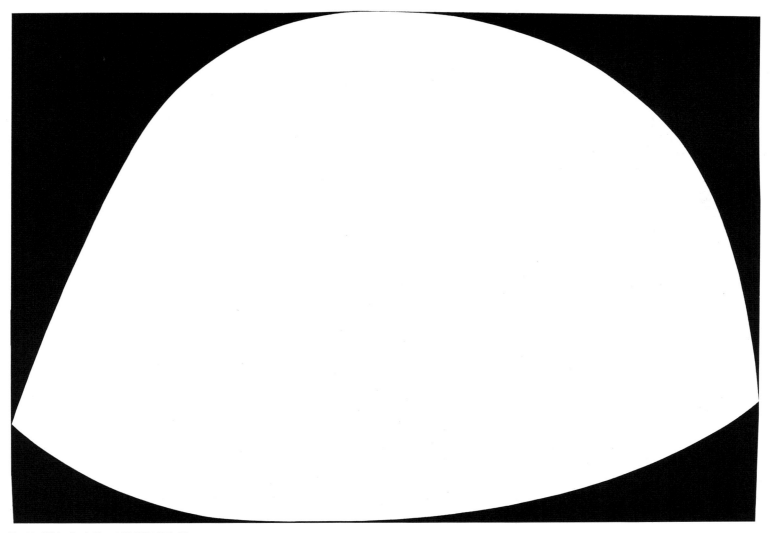

Fig. 44. **White Dark Blue**, 1961 (EK#267). Oil on canvas, 55½ x 79 (141.0 x 200.7). Collection Mr. Irving Blum, New York.

For the paintings, the figure is the canvas itself; the ground now becomes identified with the wall. For sculpture, the ground is the space around it or the wall on which it is placed. Wall and surrounding space are actively engaged by the work of art, now an autonomous object that interacts with its environment, not a self-contained representation of an image that bears no relationship to its physical location.

Kelly wrote in 1969: "In my painting, negative space [the ground] is never arbitrary (I believe lithographs to be colored marks printed on a ground and the marks are [all] to be considered of equal importance)."[18] In marked contrast to the particular rephrasing of the traditional figure–ground relationship in the paintings, the prints explore a new reciprocity between shape (open and linear or colored and solid) and the paper it is printed upon: the sheet is the ground. The majority of the prints (there are a few exceptions that echo the paintings) present an active relationship between image and sheet; indeed, this relationship is key. Many of the prints have a rectangular image that sets up a dialogue with

the rectangular form of the sheet. In these instances, shape both organizes and is organized by the rectangular dimensions of the paper. More eccentric, nonrectilinear shapes, however, float free, as it were, on the sheet, and their positioning and scale have a more ambiguous or organic relationship to the ground. Thus, the margins of the prints are, as Kelly says, "thought out as much as color and shape—much more so when shape is not rectangular." As a result, the value of the paper as a ground for the image is increased: too much white space and the image would be diminished; too little and the paper would appear leftover, with the image simply pinned to it. The sheet must actively work with the image to establish tensions between the two. Kelly brings his judgment to bear—and it is a vital point of interest for him—on these subtleties of balance among elements. The sheet plays a pivotal role in containing shape, bracing it, and giving it scale and presence.[19]

This strategy was established early in the Maeght Series of Twenty-Seven Color Lithographs of 1964–65, a series that anticipated the major change in his paintings of the time. Kelly's first editioned abstract print, the screenprint *Red/Blue* of 1964 (cat. no. 2), immediately preceded the Maeght

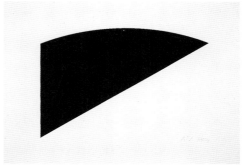

Fig. 45. **Untitled**, 1983. Lithograph. Cat. no. 201.

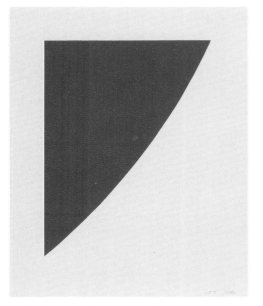

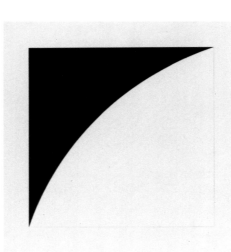

Fig. 46. **Red Curve (Radius of 8')**, 1975. Lithograph with embossing. Cat. no. 106.

Fig. 47. **White Curve I**, 1973. Lithograph with pencil. Cat. no. 99.

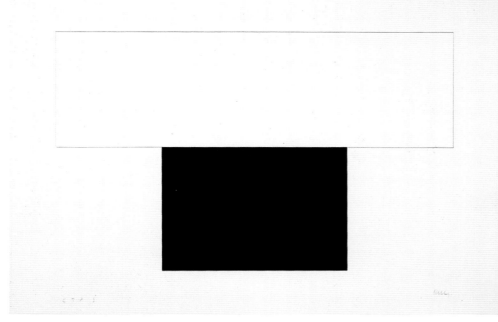

Fig. 48. **White Bar with Black**, 1973. Color trial proof of cat. no. 89.

series. The rectangular figure–ground image, with its red form on a blue field, is squared to the vertical sheet and given a small margin all around. The white margin does not assign an active space or role to the sheet; it only suggests a neutral background on which the image indifferently rests. Although striking for its strong graphic quality and candid punches of color, *Red/Blue* has a reproductive look. The Maeght series followed later that year, and Kelly's resolutions, so different in regard to figure, ground, and sheet, set a precedent for all the ensuing prints.

In the decade before the Maeght prints were made, during the period after Kelly had returned to New York from Paris, his paintings contained their own internal figure–ground relationships, a shift in itself from the Paris paintings of 1949–54, in which Kelly had felt he had "achieved the separation of form and ground in a series of joined-panel paintings," where the ground was "transferred from the surface of the canvas to the wall." In the New York paintings large biomorphic or eccentric, geometric shapes or figures on monochromatic grounds pressed against and were cropped by the framing edge of rectangular canvases. As early as the late 1950s, Kelly had pried these forms free of all sense of ground in a series of freestanding painted-aluminum sculptures. He later did the same with many of the shapes in the Maeght print series, loosening them from the rectangular edges of colored grounds and allowing them to assert themselves, unattached to a framing edge, within a spacious field of white. In the year following the Maeght series, he applied a comparable solution to the paintings that has governed them ever since. Figure was separated completely from ground. The "ground" was shifted to the wall itself, and the figure, now an independent form, floated free on it as it first had in the sculptures and prints.

Figure can further be separated from ground in the prints by means that have no counterpart in the paintings or sculptures. Kelly sometimes uses embossed, debossed, and drawn lines to create and emphasize the edges of shapes. In *Wall* and the Concorde Series, the plate mark (the imprint of the edge of the plate in the paper, produced by the intense pressures of intaglio printing) stamps out rectangular images that contain gray-toned or white sections. The debossed plate mark serves to distinguish the unprinted white component of the image from the paper. The edge of the gumdrop shape in Kelly's single linecut print, *Black Curve* (cat. no. 80), was indented into the paper when the raised form etched on the magnesium plate passed through the press. Embossed and debossed edges in the screenprints and lithographs—raised and recessed edges that define shape—are also created with shaped plastic dies that are placed over or under the paper, which is then burnished by hand to create a line. These embossed and debossed lines are primarily used by Kelly to define the otherwise problematical demarcation

of white shape on white paper. In the 1970 lithograph *Black/White/Black* (cat. no. 63), the white area was printed in ink, but in all succeeding instances white shapes, whose color is that of the unprinted paper, are defined with no more than either an embossed or debossed line.

In two lithographs from the First Curve Series, *White Curve I* and *Black Curve I* (cat. nos. 99, 100), and in the lithograph *White Bar with Black* (cat. no. 89), an alternative to embossed and debossed edges was a hand-drawn black line, on the sheet, that similarly established white shapes within an image. More distinctly visible than the embossed and debossed line, this drawn mark is nevertheless highly refined, so that shape appears strung with the thinnest of threads. In a series of working proofs for these prints, Kelly experimented with colored-pencil lines, combining different colors in a single image. These remarkable proofs, never editioned, synthesize several salient Kelly components: independent line, edge of shape, and color. Tantalizingly left unexplored, they are the only instances in which Kelly has drawn with color.

The embossing and debossing in the prints is extremely delicate (and nearly impossible to photograph). It creates an ambiguous distinction between the white shape it defines and the surrounding white ground, both of which consist of unprinted white paper. The evanescence of Kelly's embossed and debossed shapes is un-matched in his other work.[20] There is no equivalent in the paintings or sculptures of, for example, the elusive relationships of line, shape, and ground in the squared, embossed ovoid of *Gray Variation* (cat. no. 115) or in the last six variations of the Third Curve Series (cat. nos. 134–39). In these the white paper of the margins and forms, the light, almost invisible grays, and the paradoxical play of a line shared by two forms, so that the embossed edge of one is the debossed edge of the other, conjoin to produce some of the most sublime imagery Kelly has ever created.

The prints' original phrasings of Kelly's forms also include the artist's relatively recent interest in the textures of surfaces. Kelly's paintings and the painted-aluminum sculptures have always carried immaculately smooth applications of solid color. But in the 1970s the weathering steel and wood sculptures introduced palpable texture and gesture to surfaces diversified with patterns of wood graining and oxidized markings. The prints, like these later sculptures, have also pursued surface textures and streaked and mottled gesture, most notably in the Colored Paper Images, the etchings, and the Saint Martin Series. In this they depart from the paintings. Nevertheless, most of the prints have emulated the pristine surfaces of the paintings, although the quality of surface is naturally different, and reveals what may be the most idiosyncratic attribute of the prints.

Fig. 49. **Untitled**, 1978 (EK#S583). Weathering steel, 79½ x 88⅜ (202.0 x 225.0). Collection of the artist.

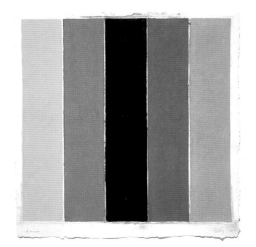

Fig. 50. **Colored Paper Image XIII**, 1976. Colored and pressed paper pulp. Cat. no. 153.

Fig. 51. **Cupecoy**, 1984. Lithograph. Cat. no. 202.

Kelly's shapes, as they are realized in the paintings and in the relief and freestanding sculptures, are adamantly flat: pure shapes, defined in one plane and theoretically immaterial. The sculptures and paintings, however, manifest their shapes as solid, tangible objects in three dimensions: canvas and stretchers, aluminum, weathering steel, bronze, and wood. Although, of course, they too are material objects, the prints present Kelly's shapes as utterly flat and disembodied: essentially pure surfaces. They are films of colored inks on paper with no mass, weight, or measurable volume. A related but little-noticed shift in Kelly's paintings of the 1970s bears explanation here. Until 1974 or 1975 Kelly trimmed the edges of his stretched canvases with color, creating, in effect, rectangular colored slabs that stressed the objecthood of the paintings. Since then, he has stopped painting his edges. When unframed, as they most usually are, the paintings reveal a surround of unpainted canvas. This change was deliberately made by Kelly to emphasize the surface of a painting and to minimize its identity as an object. The paintings aspire to, and may have been influenced by, the effortless achievement of the prints: immaterial colored shape.

The Mysterious Object

Kelly desires his art to lie outside of time and personal circumstance. His statement that painting "was made to exist forever in the present" pertains equally to the sculpture and prints. Nevertheless, in his determination to remove the particulars of history and personality from his work, Kelly is striving for more than timelessness and objectivity.

The relationship of his art to the world preoccupies Kelly, from its initial sources in nature and the role played by chance to its final relationship to the space around it—the ground or, in the paintings and sculptures, the actual physical environment. When the work of art is installed for viewing, the beholder's contemplation of it recapitulates the artist's intense scrutiny of nature, which brought the image into existence. Kelly's concern for the relationship of his art to the viewer and to the world at large also extends to a still broader relationship: that with the inexplicable.

Kelly speaks of the shadows cast by an object, a frequent source for his shapes, as inherently enigmatic. They are cast by material objects, yet have their own intangible reality as forms void of all volume and specific identity. Kelly surmises that early man's awareness of shadows—the casting, for example, of the shadow of one tree trunk across the trunk of another tree—may have contributed to the development of abstract thinking, to interest in conceptual realities that lie beyond the senses.

The appeal for Kelly of the ineffable nature of these realities is suggested by his attraction to Korean ceramics, whose austerity of design he describes as the result of an "emptying of all." The affinities between this particular Asian tradition and Kelly's art are striking: not only the premium placed upon utter simplicity, but also the prizing of chance effects and irregularities within standard geometric shapes. At that point when "everything" is figuratively removed in the fashioning of the ceramic vessel, when shape, color, and pattern have been reduced to a bare minimum, Kelly observes that "something else happens; it becomes a mysterious object." The Korean teacup, bowl, or jar has the qualities he desires for his art.

Kelly has also been drawn to Chinese Bi forms, spare, irregular disks of jade with centered holes that are symbols of the universe. The Bi objects are relevant to his art both for their simplicity of form and for their iconic power. Kelly initially connects with the physical world, but ultimately we are taken beyond it. With an interest in shape that is markedly transcendental in character, Kelly's less is more; his art has a metaphysics.

Kelly's prints, paintings, and sculptures, his "mysterious objects," display a high degree of iconicity, an attribute that suggests the visual qualities associated with the traditional Christian icon and with Byzantine style: emblematic large scale, frontality, flatness, and directness.[21] The holy icon unequivocally declares the presence of a spiritual reality strictly distinct from the mundane; the autonomy of Kelly's abstract shapes—which, as figures divorced from their ground, assert themselves as objects in their own right, not depictions of something else —makes a comparable statement. Light reflected off the glass tesserae of the Byzantine mosaic, or off the burnished gold of a panel painting, is metaphorically holy, its radiance that of the sacred. Even with the advent of Renaissance illusionism, light itself, now portrayed rather than immanent, remained an indicator of spirituality and sanctity. Kelly's art is imbued with a sense of light not located in one area, but pouring from the whole work—a light that is not depicted but that emanates from bright, clear

Fig. 52. **Yellow**, 1975. Lithograph. Cat. no. 107.

Fig. 53. Korean jar. Yi dynasty, white porcelain. Height 14 (35.6). Founders Society Purchase, G. Albert Lyon Fund, L. A. Young Fund, and funds from Mr. and Mrs. George M. Endicott, Detroit Institute of Arts.

Fig. 54. Matthias Grünewald, **Resurrection**, wing of the Isenheim Altarpiece, ca. 1512–15. Oil on panel, 106 x 56 (269.2 x 142.2). Musée Unterlinden, Colmar, France.

Fig. 55. Project for a "Folding Painting," 1952 (Sketchbook #17). Pencil and ink, 5¼ x 8¼ (13.3 x 21.0). Collection of the artist.

spectral color and pure white. Indeed, the vivid, sharp fields of color create light. Black, which figures so importantly in Kelly's art, absorbs all light and reflects none. It is an absence of light, characterized by Kelly (in reference to the truncated black rectangle of the Concorde motif) as a shade drawn against the light.[22] In the black and more somber-hued paintings and prints an elegiac aura is evoked, particularly when juxtaposed in our minds with the chromatic saturations of the colored work, by our sense of a metaphorical loss of light.

In addition to his interest in Asian art, Kelly has long been drawn to other styles outside of those associated with the Western classical and Renaissance traditions —most especially primal, ancient Mediterranean, Romanesque, early Gothic, and Byzantine.[23] Although these and other traditions have been profitably discussed as sources for Kelly's art in formal terms, they collectively divulge a religious context that is not immaterial to the issues raised here. When Kelly moved to France in 1948, he began to search out this art in museums and then, the following spring, to visit Romanesque and Gothic sites in the countryside. Immediately upon his arrival in Paris, he had traveled to Colmar to see Matthias Grünewald's

Isenheim Altarpiece, on which he had written an essay while a student at the School of the Museum of Fine Arts in Boston. Eugene C. Goossen describes Kelly's enthusiasm for this work and its relationship to the artist's involvement with window, shutter, and door shapes as they influenced the development of his panel paintings.[24] He also documents Kelly's fascination with the power of Grünewald's golden light, which for Goossen suggests that the altarpiece had meanings for Kelly and his art that transcended the purely formal. In relationship to the Isenheim Altarpiece, Goossen discusses a small notebook sketch that Kelly made in 1952, the pencil-and-colored-ink Project for a "Folding Painting." Outside panels of black and white for this proposed painting open to reveal a triptych of the primaries —red, yellow, and blue. Not only in its altarpiece format but also in its revelation of primal radiant color, this unexecuted painting confirms our suspicions that the visual iconicity of Kelly's art has a spiritual core.

Kelly's confident, taut forms are ultimately interfaces between the momentary, everyday apprehension of the world through vision and the inexpressible. Although abstracted and pointing toward the unknowable, the paintings, sculptures, and prints are physical objects and a part

of our sphere. His serene art, then, like the Byzantine icon, is a conduit between two realms: the phenomenal and the transcendental. It takes us to the still center of Zen philosophies, where opposites are reconciled and harmony is attained, and where our intuitive rapport with nature is refreshed. Kelly sacralizes our connection to the world. Compelling shape and arresting color, however satisfying, are only the means toward a greater end in his art: that is, an effortless spiritual strength. This is revealed in every medium Kelly uses. The prints, no less than the paintings and sculptures, have their own distinctive voice in this matter. They exchange the totemic presence, the tangible physicality, and public assertiveness of the paintings and sculptures for qualities no less genuine in registering Kelly's vision: intimacy, delicacy, and, in nearly immaterial veils of shape and color, an unmatched ethereality.

Fig. 56. Ellsworth Kelly at Gemini G.E.L., Los Angeles, 1984.

Notes

1. Ellsworth Kelly, in conversation with the author. Unless otherwise noted, all statements by the artist were made during interviews with the author in Spencertown, New York, in March and August 1985, and November 1986.

2. Conversation with Sidney Felsen, co-owner of Gemini G.E.L., a printmaking and publishing workshop in Los Angeles, August 1986.

3. John Coplans, *Ellsworth Kelly* (New York: Harry N. Abrams, Inc., 1973), 88.

4. Barbara Rose and Ellsworth Kelly, *Ellsworth Kelly: Paintings and Sculptures 1963–1979* (Amsterdam: Stedelijk Museum, 1979), 30.

5. Kelly was instrumental in the layout and design for John Coplans's *Ellsworth Kelly* (New York: Harry N. Abrams, Inc., 1973) and for the cover of Patterson Sims and Emily R. Pulitzer's *Ellsworth Kelly: Sculpture* (New York: Whitney Museum of American Art, 1982). He also designed the cover for Eugene C. Goossen's *Ellsworth Kelly* (New York: Museum of Modern Art, 1973).

6. Dale McConathy made the arrangements for Kelly and Grosman to meet. McConathy was then the associate director of the Betty Parsons Gallery in New York, which had represented Kelly between 1956 and 1963. He wrote essays for the November 1964 issue of *Derrière le miroir*, which served as the exhibition catalogue for Kelly's one-man exhibition at the Galerie Maeght, and for Maeght's 1965 exhibition catalogue of the Suite of Twenty-Seven Color Lithographs (Appendix Ib). The details of the artist's encounter with Grosman were gotten from Kelly and in a May 1987 conversation with McConathy, who is now the chairman of the Department of Art and Art Education at New York University, New York.

7. Grosman purportedly told Kelly that his work was "a denial of everything lithography is," a statement of which the artist has no recollection. Grosman passed this comment on to Samuel Wagstaff, Jr., who conveyed it to Pat Gilmour. See Gilmour, *Kenneth Tyler —Master Printer—and the American Print Renaissance* (New York: Hudson Hills Press, 1986), 22.

8. After Kenneth Tyler left Gemini, the role of master printer was assumed, most importantly for Kelly, by Ron McPherson and then Serge Lozingot. Both of these men have supervised collaborations for the artist, although other printers, notably James Reid, Alan Holoubek, Doris Simmelink, and Mark Stock, have also coordinated projects for him. For a discussion of Kelly's collaborations with Gemini, see Ruth E. Fine, *Gemini G.E.L.: Art and Collaboration* (New York: Abbeville Press; Washington, D.C.: National Gallery of Art, 1984), 127–43.

9. Ruth E. Fine, *Tyler Graphics: The Extended Image* (New York: Abbeville Press; Minneapolis: Walker Art Center, 1987), 203–6.

10. Fine, *Tyler Graphics*, 217.

11. Although printmaking has from the beginning been tied to the history of technology, there has been a historical lag among critics in accepting new technologies in printmaking. This critical blind spot derives from the common notion that there is a natural antipathy between the artistic and the technological. It is reflected in the traditional need to play down the mechanical and reproductive dimensions of printmaking and in the traditional definition of an "original print" that insists upon the artist's direct marking of the image on the print element. Photomechanical processes and transfer lithography, as well as screenprinting, offset lithography, and the mixed-media print, have been and remain problematical in some quarters. In the nineteenth century, James McNeill Whistler's transfer lithographs provoked quarrels over the issue of originality. The French tradition, however, has had a distinguished history of transfer lithography that includes the prints of Pierre-Auguste Renoir, Camille Pissarro, Alfred Sisley, and Henri Matisse. Kelly's early plant lithographs for Maeght arise from that tradition.

12. Kelly's acute sense of shape is well illustrated by the following anecdote: Kelly and a group of printers at Gemini looked at a shape and attempted to guess the angle of one portion of it. When it was measured Kelly had named it within a few degrees, demonstrating the visual equivalent of perfect pitch. (Conversation with Bill Padien, former curator at Gemini G.E.L., Los Angeles, August 1986.)

13. Conversation with Serge Lozingot, Gemini G.E.L., Los Angeles, August 1986.

14. Conversation with Sidney Felsen, Gemini G.E.L., Los Angeles, August 1986.

15. As an example of Kelly's concern for color, as well as for the quality of line, he remains dissatisfied with the green in the lithograph *Green Curve with Radius of 20'*, 1974 (cat. no. 101). He feels that the green is too yellow and that a drawn, not an embossed, line should have been used.

16. The personal nature of the prints is also suggested by their titles. A number of the prints name places, rather than colors and shapes. Through the early 1960s Kelly frequently assigned place names to his paintings and sculptures; he then abandoned the practice altogether in favor of shape and color titles. He continued, however, to use place names in titling some of the prints: the lithographs of the Third Curve Series are named after Romanesque sites in France and Spain he had visited; the prints in the Series of Seven Lithographs and the Saint Martin Series also designate places he has traveled to in Europe and the Caribbean. These names, Kelly explains, are not simple geographical references, but places whose landmarks have interested him in terms of his art, or locations where he has enjoyed himself with friends; they stimulate private memories and fond associations.

17. Ellsworth Kelly, *Ellsworth Kelly* (Los Angeles: Margo Leavin Gallery; New York: Leo Castelli Gallery, 1974), 3.

18. Rose and Kelly, *Ellsworth Kelly*, 34.

19. A similar interest in using the sheet as an active element in the composition is found in Frank Stella's album prints of the late 1960s and early 1970s. With configurations placed off center the sheet could not be read as a neutral background.

20. Precedents for the embossed line may exist in Kelly's early low-relief sculptures made in Paris in 1950 (Sims and Pulitzer, cat. nos. 1, 11). In the Metal Wall Reliefs of 1985, in which white shapes are relieved from white grounds, edge is defined by shadow, approximating the ephemeral line of the embossed prints. The wall reliefs are the closest a series of works comes to reflecting an idiosyncratic aspect of the prints, and it cannot be coincidental that they were derived at Gemini from the Saint Martin Series, a group of lithographs that did not incorporate embossing, but did utilize intricate collaging of shapes during processing and editioning that produced comparably subtle edges.

21. These stylistic aspects, in sum deliberately antinaturalistic, were officially prescribed for presenting holy figures. Iconicity, as discussed by Joseph Masheck in *Historical Present: Essays of the 1970s* (ed. Donald Kuspit, Contemporary American Art Critics, no. 3 [Ann Arbor: UMI Research Press, 1984], 143–228), is a quality exhibited by modernist abstraction in general and contributes to a reading of the history of abstraction as a spiritual endeavor.

22. Sims and Pulitzer, 68.

23. Since 1960 Kelly has collected banner stones of the Adena, a Native American culture of the Late Archaic Period whose origins archaeologists now date to 4000–3000 B.C. The original function of the small, unadorned stones, found in the upper Midwest, may have been ceremonial. Kelly regards them as the first works of abstract American art and feels that he carries their reductivist and mysterious qualities forward in his own work.

24. Goossen, *Ellsworth Kelly*, 45–46.

CATALOGUE RAISONNÉ

Sequence Print series and single prints are arranged chronologically in order of publication. (For the purposes of this catalogue, publication may denote the completion, announcement, or distribution of the printed edition.) Within a series, prints are ordered by numerical titles, by publisher's print identification numbers (for series published by Gemini G.E.L. and Tyler Graphics Ltd.), or in accordance with the artist's preference.

Dates Dates for series and individual prints reflect the period of time during which a project was first conceived by the artist, developed with printers at a workshop, completed, and published. When bracketed dates are used (e.g., 1970–72), the second date indicates publication, which in certain instances may postdate the artist's completion of a project. For more detailed chronological information on the development of a print or series, see the Chronology.

Documentation Information derives from written records provided by the publisher of each print and has been augmented in consultation with the artist, publishers, and printers. Although documentation procedures have varied in completeness over time and among publishers, the documentation is as complete as possible at this time.

Titles The titles of series have been provided or approved by the artist. Titles of individual prints reflect the artist's preferred titles and may vary from titles used at the time of publication. Following the primary title, alternative titles or titles under which the print has been published previously are listed in parentheses. When the new title differs from the original publication title only in punctuation or format, the earlier version is not included.

Media The term "lithograph" denotes a work printed on a direct-process lithographic press. When "offset lithograph" is specified, the work has been printed on a flat-bed offset lithographic press, as distinguished from commercial offset lithographs printed on a rotary press. The term "transfer lithograph" denotes a lithograph produced from an original drawing on transfer paper.

Measurements Height precedes width, in inches; measurements in centimeters follow in parentheses. Measurements indicate the size of the sheet. In the case of prints with a clear margin, two sets of measurements are listed, one for the image or plate mark and the second for the sheet. The measurements of prints reflect the largest dimensions of archival proofs, but slight variations may occur within an edition.

Signatures and Inscriptions Information on the content and location of signatures, inscriptions, and chop marks is given for prints inscribed and/or stamped consistently within the edition.

Printing Sequence The printing sequence consists of any number of runs, that is, single operations during which the paper receives an inked impression from a printing element or the paper is altered by embossing, debossing, the adherence of collage elements, or drawing. The following format has been used to detail individual runs: first, the ink color for each printed element is given; next, the printing element is designated; information on how the element was created, inked, printed, or reused may follow.

Proofs Terms and abbreviations employed by Gemini G.E.L. and Tyler Graphics Ltd. have been adapted for use in this catalogue. They are defined below, in the order in which they appear.

AP Artist's Proof. A print outside the numbered edition but equal in quality to it; usually signed, inscribed, and numbered on the margin as "AP I," and so forth.

TP Trial Proof. A print pulled during proofing to document image changes.

CTP Color Trial Proof. Related to Trial Proof but usually designating color variations distinct from the regular edition.

WP Working Proof. A proof on which the artist has added work by hand.

RTP Right-to-Print. The first impression in the proofing period that meets the standards set for the edition.

PPII Printer's Proof. A proof pulled for the printer(s) responsible for printing the edition.

SP Special Proof. A special dedication image.

HC *Hors Commerce*. Literally, "not for sale"; a special proof produced outside of the edition for presentation purposes.

S State Proof. An impression that is a variation on the editioned image. Such a proof may form the basis for a separate edition.

O Other. Undesignated.

A Archive. Edition-quality impression reserved for the publisher's archive for exhibition purposes.

GEL Gemini G.E.L. Archive proofs reserved by the Gemini G.E.L. workshop. These are signed and inscribed *Gemini I, II,* or *III.*

NGA National Gallery of Art Proof. Between 1981 and 1984, Gemini G.E.L. designated one proof from each edition for the archive of Gemini G.E.L. at the National Gallery of Art, Washington, D.C. Since 1984 the more traditional designation SP, Special Proof, has been used for these prints.

C Cancellation. An impression demonstrating the destruction of the plates and/or screens. When elements are reused within a series the cancellation proof is documented with the final editioned image.

Publishers For prints published by Gemini G.E.L. and Tyler Graphics Ltd. the workshop's print identification number and catalogue-raisonné number are given. Four publishers —Gemini G.E.L., Hollander Workshop, Ives-Sillman, and Tyler Graphics Ltd.—marked editions with house logos.

Literature Full citations to the abbreviated references can be found in the Bibliography section at the end of the catalogue. Citations are listed chronologically, then alphabetically by author within a year.

Comments Comments on individual prints may include the derivation and correlation of printed imagery to work in other media, information on the other artists represented in a portfolio, or the occasion of the print's publication. Full citations to abbreviated references included in the comments can be found in the Bibliography. In addition, the comments may include an EK number referring to a work by Kelly in another medium. Since 1949 Kelly has assigned coded numbers prefaced by "EK#" to each painting, sculpture, plant drawing, and preliminary study in his oeuvre.

Untitled 1949

Lithograph on off-white wove paper

Sheet: Dimensions vary from 15 x 11 (38.1 x 27.9) to 19¾ x 12¾ (50.2 x 32.3)

Image: 12 x 9½ (30.5 x 24.1)

Signed in pencil, lower right: *Kelly* (with the exception of 1/16, which is signed in ink, lower right: *EK*). Impressions 5/16 and 6/16 are additionally signed in the stone, upper right: *Kelly* (printed in reverse). All impressions are numbered in pencil, lower left.

Edition: 16 (including various states)

Proofs: None

Printed by the artist, Paris

Published privately by the artist

1 run from 1 stone
1 black

Literature: Waldman 1971, no. 1, 252; Sims and Pulitzer 1982, no. 9, 47

Comments: During the year that Kelly was enrolled at the Ecole des Beaux-Arts, Paris, he used the school's printmaking facilities to make this untitled print, his first lithograph. Impressions within the edition vary in sheet dimensions, paper, and image, the last the result of the artist's reworking of the stone for the addition of lines, nostril dots, and signature. Although Kelly numbered impressions consecutively to establish an edition, his modifications of the stone effectively produced state prints. The print was derived from a pencil drawing (EK#49.334). It is also related to a sheet of ink and pencil drawings, *Studies for Window Frame Sculptures*, 1949 (EK#49.333A), and to the artist's anthropomorphic wood cutouts of 1949–50, particularly *Cutout in Wood*, 1950 (EK#S12; Sims and Pulitzer 1982, no. 9).

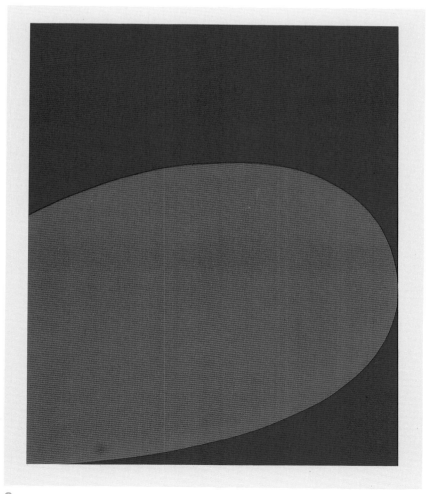

1

Red/Blue (Untitled) 1964

Screenprint on Mohawk Superfine Cover paper

Sheet: 24 x 20 (61.0 x 51.0)

Image: 22 x 18 (55.9 x 45.7)

Unsigned and unnumbered. Blind stamp, lower right, logo of Ives-Sillman

Edition: 500

Proofs: 10 AP

Printed by Scirocco Screenprinters, supervised by Ives-Sillman, Inc., New Haven, Connecticut

Published by the Wadsworth Atheneum, Hartford, Connecticut

2 runs from 2 screens
1 red; screen, from hand-cut stencil
2 blue; screen, from hand-cut stencil

Literature: Waldman 1971, no.3, 253; Stetson 1979, 9; Castleman 1985, 65

Comments: This is one of ten screenprints in the portfolio *Ten Works x Ten Painters*, which includes the work of Gene Davis, Robert Indiana, Ellsworth Kelly, Roy Lichtenstein, Robert Motherwell, George Ortman, Larry Poons, Ad Reinhardt, Frank Stella, and Andy Warhol, published under the direction of Samuel Wagstaff, Jr. Each of the five hundred copies of the portfolio is numbered on the colophon page.

Kelly's first screenprint repeats the composition and color of the painting *Red Blue*, 1964 (EK#335; Goossen 1973, 72). Both were derived from a series of untitled ink and pencil drawings and collages (EK#63.13–15). An alternate color scheme for the print that was based upon the painting *Yellow Blue*, 1963 (EK#311; Coplans 1973, pl. 162), was proofed but rejected. The shape and rectangular ground of the print and the paintings also appeared in a painted-aluminum relief sculpture, *Blue on Blue*, 1963 (EK#S317; Sims and Pulitzer 1982, no. 37).

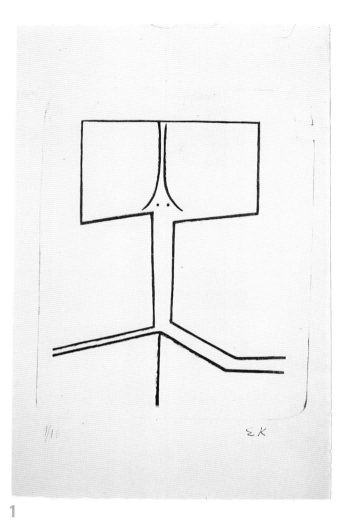

2

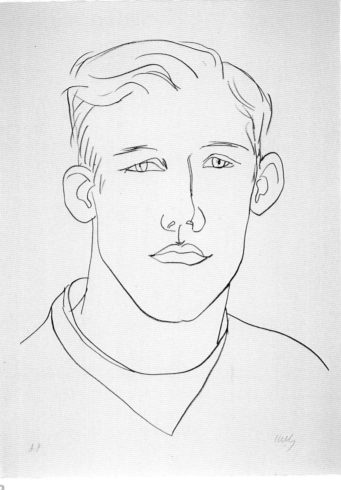

3

David 1964

Transfer lithograph on Rives BFK paper

Sheet: 35⅜ x 24¾ (89.9 x 62.9)

Signed in pencil, lower right: *Kelly*; numbered in pencil, lower left

Edition: 20

Proofs: AP

Printed by Marcel Durassier at Imprimerie Maeght, Levallois-Perret

Published privately by the artist

1 run from 1 plate
1 black; aluminum plate, from lithographic-crayon drawing on transfer paper

Literature: Waldman 1971, no. 2, 252

Comments: The subject of this portrait is David McCorkle. In the fall of 1964 Kelly traveled with McCorkle and another American friend, Dale McConathy, to Paris. The occasion was the opening of a retrospective exhibition, organized by the Galerie Maeght, that was devoted to the artist's work since 1958. The lithograph *David*, which Kelly made while in Paris, is related to a series of drawings of McCorkle and to the general body of numerous pencil and ink portraits of friends that the artist has made during his career.

While Kelly was in France in late 1964, he began two major series of lithographs for Aimé and Marguerite Maeght, who were Parisian publishers of art books and fine-art prints and co-owners of the Galerie Maeght. The first set of prints, the Suite of Twenty-Seven Color Lithographs, was published in early 1965. The second group, twenty-eight prints, the Suite of Plant Lithographs (cat. nos. 32–59), was completed in the spring of 1966.

Proofs and *hors commerce* impressions exist for the Suite of Twenty-Seven Color Lithographs, but the exact number of impressions and types of proofs is difficult to ascertain because of the inaccessibility of records that Maeght Editeur may or may not have kept. The documentation presented here accounts for known proofs only. Certain impressions may carry an inscription by the artist on the verso that indicates, with an arabic numeral, the place of the lithograph in the sequence of the series. The parenthetical titles listed here for each print are the original titles published by Maeght Editeur. They were derived from the Maeght exhibition catalogue for the series (McConathy 1965), which was published on the occasion of its first showing in Paris in June 1965.

Literature: McConathy 1965; Peltin 1965, 62; Harrison 1967, 274–76; Hoag 1968, 52; Livingston 1968, 61; Waldman 1971, nos. 6–32, 255–62; Castleman 1973, n.p.; Goossen 1973, 54; Castleman 1976, 197; Castleman 1985, 105

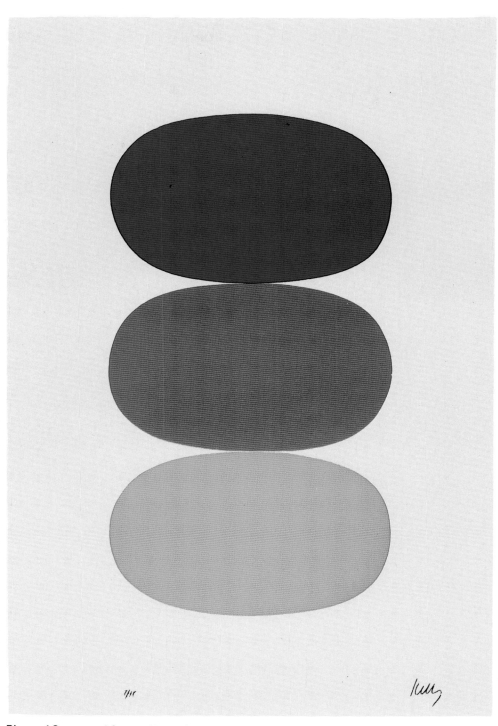

Blue and Orange and Green, 1964–65 (cat. no. 16)

4–30
SUITE OF TWENTY-SEVEN COLOR LITHOGRAPHS 1964–65

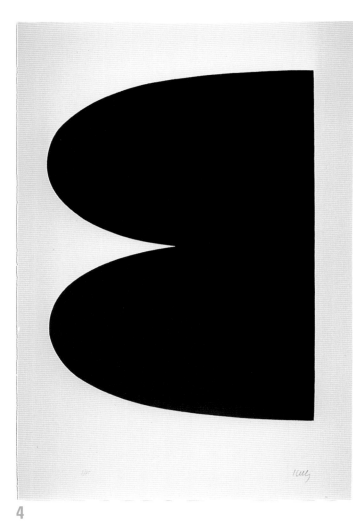

4

Black (I.1. Black; Noir Série I, No. 1) 1964–65

Lithograph on Rives BFK paper

Sheet: 35¼ x 24¼ (89.5 x 61.6)

Signed in pencil, lower right: *Kelly*; numbered in pencil, lower left

Edition: 75

Proofs: 10 AP

Printed by Marcel Durassier at Imprimerie Maeght, Levallois-Perret

Published by Maeght Editeur, Paris

1 run from 1 plate
1 black; zinc plate

Literature: Waldman 1971, no. 7, 255

Comments: *Black* was based on the painting *Black White*, 1963 (EK#305), of which *Black White*, 1966 (EK#353; Coplans 1973, pl. 157), is a larger version. It is related to a preliminary drawing, *Study for Black Curves* (EK#63.17) and to an earlier painting, *Black Curves*, 1954 (EK#67). It is also a color and proportional variation of the 1963 paintings *Black White* (EK#304) and *Red White (EK#307)* and of the lithographs *Yellow* (cat. no. 5) and *Red-Orange* (cat. no. 6).

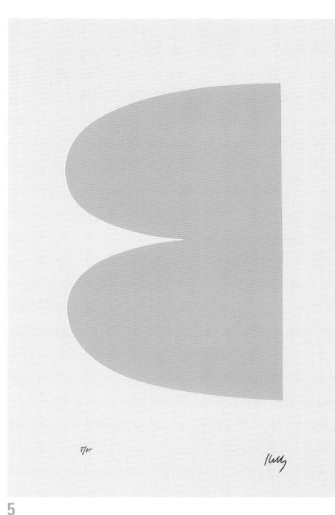

5

Yellow (II.2. Yellow; Jaune Série II, No. 2) 1964–65

Lithograph on Rives BFK paper

Sheet: 35¼ x 23¾ (89.5 x 60.3)

Signed in pencil, lower right: *Kelly*; numbered in pencil, lower left

Edition: 75

Proofs: 9 AP, 2 CTP (black, blue)

Printed by Marcel Durassier at Imprimerie Maeght, Levallois-Perret

Published by Maeght Editeur, Paris

1 run from 1 plate
1 yellow; zinc plate

Literature: Waldman 1971, no. 8, 255; Castleman 1973, n.p.

Comments: *Yellow* is related to a preliminary drawing, *Study for Black Curves* (EK#63.17) and to an earlier painting, *Black Curves,* 1954 *(EK#67)*. It is also a color and proportional variation of the paintings *Black White*, 1963 (EK#304), and *Red White*, 1963 (EK#307), and the lithographs *Black* (cat. no. 4) and *Red-Orange* (cat. no. 6).

Red-Orange (III.3. Red-Orange; Rouge-Orange Série III, No. 3) 1964–65

Lithograph on Rives BFK paper

Sheet: 23⅝ x 35¼ (60.0 x 89.5)

Signed in pencil, lower right: *Kelly*; numbered in pencil, lower left

Edition: 75

Proofs: 10 AP

Printed by Marcel Durassier at Imprimerie Maeght, Levallois-Perret

Published by Maeght Editeur, Paris

1 run from 1 plate
1 red-orange; zinc plate

Literature: Waldman 1971, no. 6, 255

Comments: *Red-Orange*, like *Black* (cat. no. 4) and *Yellow* (cat. no. 5), is related to the general series of double-parabola paintings. It is also a color and proportional variation of the lithographs *Black* (cat. no. 4) and *Yellow* (cat. no. 5). *Red-Orange* was the basis for the painting *Red White*, 1966 (EK#354; Coplans 1973, pl. 158).

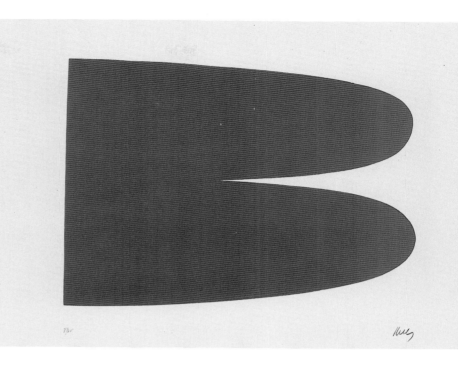

6

Green (IV.4. Green; Vert Série IV, No. 4) 1964–65

Lithograph on Rives BFK paper

Sheet: 35¼ x 23¾ (89.5 x 60.3)

Signed in pencil, lower right: *Kelly*; numbered in pencil, lower left

Edition: 75

Proofs: 10 AP, CTP

Printed by Marcel Durassier at Imprimerie Maeght, Levallois-Perret

Published by Maeght Editeur, Paris

1 run from 1 plate
1 green; zinc plate

Literature: Waldman 1971, no. 9, 256; Bell 1986, 9

Comments: The biomorphic ovoid of the lithograph *Green* is derived from the painting *Green White*, 1961 (EK#269), which in turn is related to a series of paintings from 1959: *White Disk I* (EK#192), *Green Disk on Blue* (EK#209), and *White Disk II* (EK#212). Variations of the shape were used in two sculptures: *White Disk III*, 1961 (EK#S276; Sims and Pulitzer 1982, no. 35), and *Blue Disk*, 1963 (EK#S323; Sims and Pulitzer 1982, no. 43). Kelly completed his use of this shape with the lithograph *Green*.

7

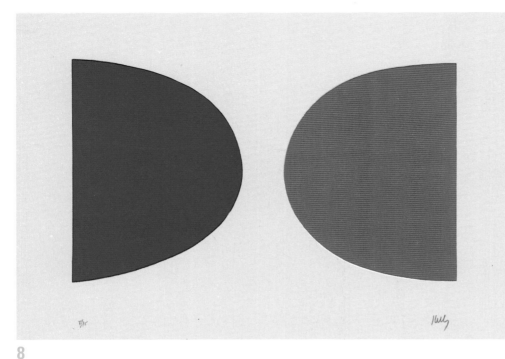

Blue and Orange (V.5. Blue and Orange; Bleu et Orange Série V, No. 5) 1964–65

Lithograph on Rives BFK paper

Sheet: 23⅝ x 35⁵⁄₁₆ (60.0 x 89.7)

Signed in pencil, lower right: *Kelly*; numbered in pencil, lower left

Edition: 75

Proofs: 6 AP, 7 CTP

Printed by Marcel Durassier at Imprimerie Maeght, Levallois-Perret

Published by Maeght Editeur, Paris

2 runs from 2 plates
1 blue; zinc plate
2 orange; zinc plate

Literature: Waldman 1971, no. 19, 258

Comments: Although the motif of opposing parabolic shapes may be traced to the 1951 collage *Green Curves* (EK#51.55; Waldman 1971, pl. 54), the immediate source for the lithograph *Blue and Orange* was the 1964 painted-aluminum relief sculpture *Two Curves: Blue Red* (EK#S325; Sims and Pulitzer 1982, no. 44). In the artist's graphic oeuvre, the motif was later developed in the 1976 *Dark Green Curves* and *Green Curves* (cat. nos. 142, 142a).

8

Black with White (VI.6. Black with White; Noir avec Blanc Série VI, No. 6) 1964–65

Lithograph on Rives BFK paper

Sheet: 35¼ x 23⅝ (89.5 x 60.0)

Signed in pencil, lower right: *Kelly*; numbered in pencil, lower left

Edition: 75

Proofs: 6 AP; plate used for cat. nos. 10–15

Printed by Marcel Durassier at Imprimerie Maeght, Levallois-Perret

Published by Maeght Editeur, Paris

1 run from 1 plate
1 black; zinc plate

Literature: Waldman 1971, no. 16, 257

Comments: The concentric, biomorphic rectangles of *Black with White* are given six color variations in the series (cat. nos. 10–15). Although the image has no precedent in the paintings or sculptures, it is related to an unexecuted metal cutout sculpture for which a pencil drawing survives (EK#64.16). The forms of this lithograph are related to *Blue with Yellow* (cat. no. 31), which was published in an *édition avant la lettre* and as a poster that announced an exhibition of the Suite of Twenty-Seven Color Lithographs at the Galerie Maeght in June 1965.

9

Dark Blue with Red (VI.7. Dark Blue with Red; Bleu Foncé avec Rouge Série VI, No. 7) 1964–65

Lithograph on Rives BFK paper

Sheet: 35¼ x 23⁹⁄₁₆ (89.5 x 59.8)

Signed in pencil, lower right: *Kelly*; numbered in pencil, lower left

Edition: 75

Proofs: 10 AP; plate 1 used for cat. nos. 9, 11–15; plate 2 used for cat. nos. 11–15

Printed by Marcel Durassier at Imprimerie Maeght, Levallois-Perret

Published by Maeght Editeur, Paris

2 runs from 2 plates
1 blue; zinc plate, same as cat. nos. 9, 11/1–15/1
2 red; zinc plate, same as cat. nos. 11/2–15/2

Literature: Waldman 1971, no. 15, 257

Comments: See cat. no. 9

10

Green with Red (VI.8. Green with Red; Vert avec Rouge Série VI, No. 8) 1964–65

Lithograph on Rives BFK paper

Sheet: 35⅝ x 23⅝ (90.5 x 60.0)

Signed in pencil, lower right: *Kelly*; numbered in pencil, lower left

Edition: 75

Proofs: 9 AP; plate 1 used for cat. nos. 9, 10, 12–15; plate 2 used for cat. nos. 10, 12–15

Printed by Marcel Durassier at Imprimerie Maeght, Levallois-Perret

Published by Maeght Editeur, Paris

2 runs from 2 plates
1 green; zinc plate, same as cat. nos. 9, 10/1, 12/1–15/1
2 red; zinc plate, same as cat. nos. 10/2, 12/2–15/2

Literature: Waldman 1971, no. 12, 256

Comments: See cat. no. 9

11

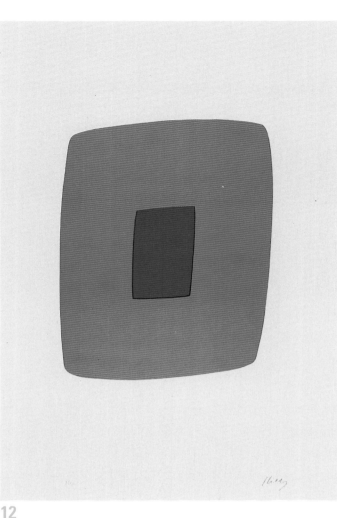

12

Orange with Blue (VI.9. Orange with Blue; Orange avec Bleu Série VI, No. 9) 1964–65

Lithograph on Rives BFK paper

Sheet: 35⁵/₁₆ x 23⁹/₁₆ (89.7 x 59.8)

Signed in pencil, lower right: *Kelly*; numbered in pencil, lower left

Edition: 75

Proofs: 7 AP, 7 CTP; plate 1 used for cat. nos. 9–11, 13–15; plate 2 used for cat. nos. 10, 11, 13–15

Printed by Marcel Durassier at Imprimerie Maeght, Levallois-Perret

Published by Maeght Editeur, Paris

2 runs from 2 plates
1 orange; zinc plate, same as cat. nos. 9, 10/1–11/1, 13/1–15/1
2 blue; zinc plate, same as cat. nos. 10/2, 11/2, 13/2–15/2

Literature: Waldman 1971, no. 10, 256

Comments: See cat. no. 9. A preliminary colored-paper collage (EK#63.PS105) exists for this lithograph.

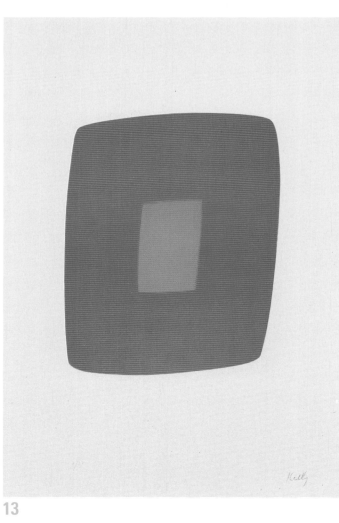

13

Orange with Green (VI.10. Orange with Light Green; Orange avec Vert Clair Série VI, No. 10) 1964–65

Lithograph on Rives BFK paper

Sheet: 35¼ x 23⁵/₈ (89.5 x 60.0)

Signed in pencil, lower right: *Kelly*; numbered in pencil, lower left

Edition: 75

Proofs: 8 AP; plate 1 used for cat. nos. 9–12, 14, 15; plate 2 used for cat. nos. 10–12, 14, 15

Printed by Marcel Durassier at Imprimerie Maeght, Levallois-Perret

Published by Maeght Editeur, Paris

2 runs from 2 plates
1 orange; zinc plate, same as cat. nos. 9, 10/1–12/1, 14/1, 15/1
2 green; zinc plate, same as cat. nos. 10/2–12/2, 14/2, 15/2

Literature: Waldman 1971, no. 13, 257

Comments: See cat. no. 9

Light Blue with Orange (VI.11. Light Blue with Orange; Bleu Clair avec Orange Série VI, No. 11) 1964–65

Lithograph on Rives BFK paper

Sheet: 34¼ x 23⅝ (87.0 x 60.0)

Signed in pencil, lower right: *Kelly*; numbered in pencil, lower left

Edition: 75

Proofs: 11 AP; plate 1 used for cat. nos. 9–13, 15; plate 2 used for cat. nos. 10–13, 15

Printed by Marcel Durassier at Imprimerie Maeght, Levallois-Perret

Published by Maeght Editeur, Paris

2 runs from 2 plates
1 light blue; zinc plate, same as cat. nos. 9, 10/1–13/1, 15/1
2 orange; zinc plate, same as cat. nos. 10/2–13/2, 15/2

Literature: Waldman 1971, no. 11, 256

Comments: See cat. no. 9. A preliminary oil study on paper, signed and dated 20 November 1964 (EK#64.30; Waldman 1971, pl. 130) and a colored-paper collage (1963; EK#PS105) exist for this lithograph.

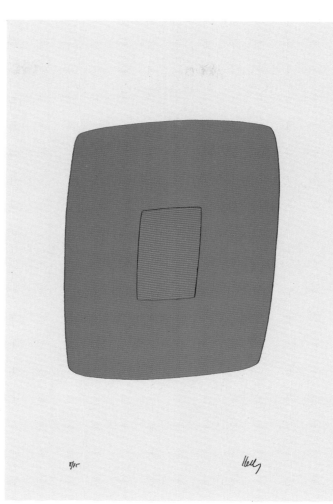

14

Yellow with Dark Blue (VI.12. Light Yellow with Dark Blue; Jaune Clair avec Bleu Foncé Série VI, No. 12)

1964–65

Lithograph on Rives BFK paper

Sheet: 34¼ x 23⅝ (87.0 x 60.0)

Signed in pencil, lower right: *Kelly*; numbered in pencil, lower left

Edition: 75

Proofs: 6 AP, 7 CTP; plate 1 used for cat. nos. 9–14; plate 2 used for cat. nos. 10–14

Printed by Marcel Durassier at Imprimerie Maeght, Levallois-Perret

Published by Maeght Editeur, Paris

2 runs from 2 plates
1 light yellow; zinc plate, same as cat. nos. 9, 10/1–14/1
2 dark blue; zinc plate, same as cat. nos. 10/2–14/2

Literature: Waldman 1971, no. 14, 257

Comments: See cat. no. 9

15

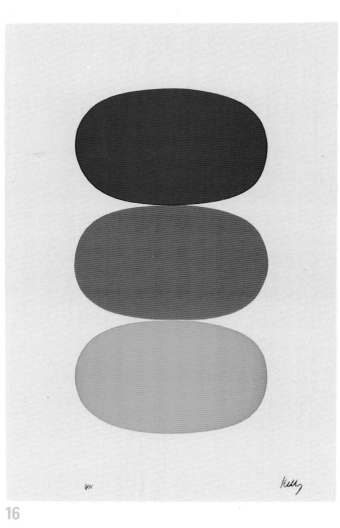

16

Lithograph on Rives BFK paper

Sheet: 35⅜ x 23⅞ (89.9 x 60.6)

Signed in pencil, lower right: *Kelly*; numbered in pencil, lower left

Edition: 75

Proofs: 6 AP; plates used for cat. no. 17

Printed by Marcel Durassier at Imprimerie Maeght, Levallois-Perret

Published by Maeght Editeur, Paris

Printed from zinc plates in dark blue, red-orange, and blue; exact color sequence and number of plates unknown; same plates used for cat. no. 17

Literature: Waldman 1971, no. 17, 258

Comments: The colors and shapes of *Blue and Orange and Green* are not repeated in any painting. They are generally related, however, to the stacked-ovoid paintings of the early 1960s, as represented by *Orange White*, 1961 (EK#275; Coplans 1973, pl. 148). Related and preliminary oil-on-newsprint studies for the lithograph include *Blue Red Green* (EK#61.15), *Study for a Lithograph* (EK#64.39), and *Red Yellow Blue, Angers* (EK#64.50). *Blue and Orange and Green* is a color variation of *Blue and Yellow and Red-Orange* (cat. no. 17).

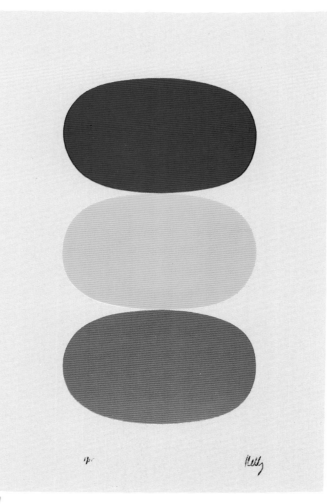

17

Lithograph on Rives BFK paper

Sheet: 35¼ x 23¾ (89.5 x 60.3)

Signed in pencil, lower right: *Kelly*; numbered in pencil, lower left

Edition: 75

Proofs: 10 AP, 2 CTP; plates used for cat. no. 16

Printed by Marcel Durassier at Imprimerie Maeght, Levallois-Perret

Published by Maeght Editeur, Paris

Printed from zinc plates in blue, yellow, and red-orange. Exact color sequence and number of plates unknown. Same plates used for cat. no. 16

Literature: Waldman 1971, no. 18, 258

Comments: See cat. no. 16

Dark Blue and Red (VIII.15. Dark Blue and Red; Bleu Foncé et Rouge Série VIII, No. 15) 1964–65

Lithograph on Rives BFK paper

Sheet: 23⅝ x 35¼ (60.0 x 89.5)

Edition: 75

Signed in pencil, lower right: *Kelly*; numbered in pencil, lower left

Proofs: 6 AP

Printed by Marcel Durassier at Imprimerie Maeght, Levallois-Perret

Published by Maeght Editeur, Paris

2 runs from 2 plates
1 red; zinc plate
2 dark blue; zinc plate

Literature: Waldman 1971, no. 32, 262

Comments: *Dark Blue and Red* was not based upon a previous work. Although its shapes are freely drawn, the print is related to the artist's geometric joined-panel paintings of the mid-1960s.

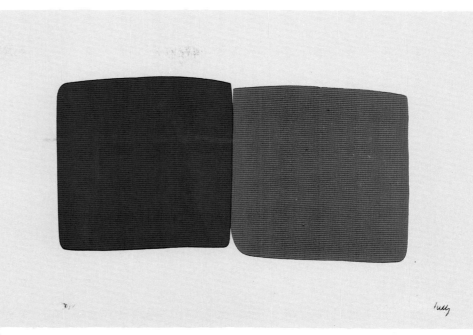

18

Red over Yellow (IX.16. Red over Light Yellow; Rouge sur Jaune Série IX, No. 16) 1964–65

Lithograph on Rives BFK paper

Sheet: 35¼ x 23½ (89.5 x 59.7)

Signed in pencil, lower right: *Kelly*; numbered in pencil, lower left

Edition: 75

Proofs: 5 AP; same plates used for cat. nos. 20–25

Printed by Marcel Durassier at Imprimerie Maeght, Levallois-Perret

Published by Maeght Editeur, Paris

2 runs from 2 plates
1 red; zinc plate, same as cat. nos. 20/1–25/1
2 light yellow; zinc plate, same as cat. nos. 20/2–25/2

Literature: Waldman 1971, no. 22, 260

Comments: *Red over Yellow* and its six color variations (cat. nos. 20–25) are invented images with no precedents in the paintings or sculptures. Related studies include the oil-on-newsprint drawing *Two Oranges and Yellow* (EK#61.17).

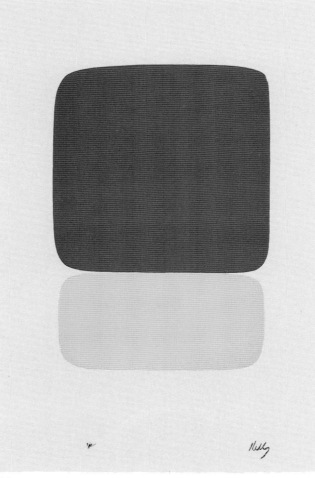

19

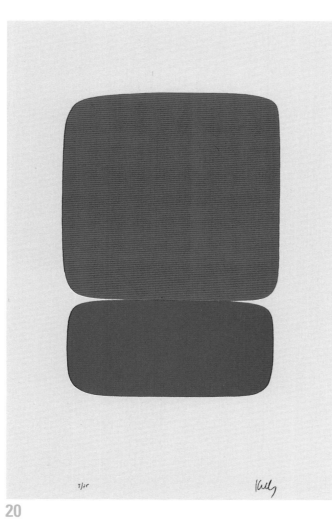

20

Red-Orange over Blue (IX.17. Red-Orange over Blue; Rouge-Orange sur Bleu Série IX, No. 17) 1964–65

Lithograph on Rives BFK paper

Sheet: 35¼ x 23½ (89.5 x 59.7)

Signed in pencil, lower right: *Kelly*; numbered in pencil, lower left

Edition: 75

Proofs: 10 AP; same plates used for cat. nos. 19, 21–25

Printed by Marcel Durassier at Imprimerie Maeght, Levallois-Perret

Published by Maeght Editeur, Paris

2 runs from 2 plates
1 red-orange; zinc plate, same as cat. nos. 19/1, 21/1–25/1
2 blue; zinc plate, same as cat. nos. 19/2, 21/2–25/2

Literature: Waldman 1971, no. 25, 260

Comments: See cat. no. 19

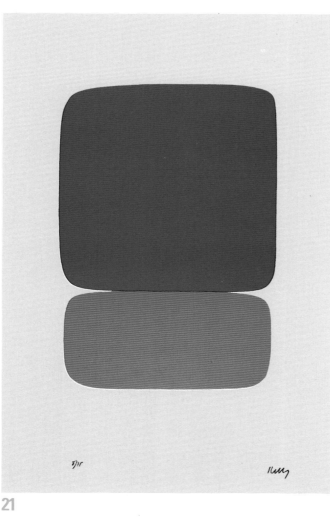

21

Blue over Orange (IX.18. Blue over Orange; Bleu sur Orange Série IX, No. 18) 1964–65

Lithograph on Rives BFK paper

Sheet: 35⅜ x 23⅝ (89.9 x 60.0)

Signed in pencil, lower right: *Kelly*; numbered in pencil, lower left

Edition: 75

Proofs: 6 AP; same plates used for cat. nos. 19–20, 22–25

Printed by Marcel Durassier at Imprimerie Maeght, Levallois-Perret

Published by Maeght Editeur, Paris

2 runs from 2 plates
1 blue; zinc plate, same as cat. nos. 19/1, 20/1, 22/1–25/1
2 orange; zinc plate, same as cat. nos. 19/2, 20/2, 22/2–25/2

Literature: Waldman 1971, no. 29, 261

Comments: See cat. no. 19

Yellow over Dark Blue (IX.19. Yellow over Dark Blue; Jaune sur Bleu Foncé Série IX, No. 19) 1964–65

Lithograph on Rives BFK paper

Sheet: 35¼ x 23⅝ (89.5 x 60.0)

Signed in pencil, lower right: *Kelly*; numbered in pencil, lower left

Edition: 75

Proofs: 8 AP; same plates used for cat. nos. 19–21, 23–25

Printed by Marcel Durassier at Imprimerie Maeght, Levallois-Perret

Published by Maeght Editeur, Paris

2 runs from 2 plates
1 yellow; zinc plate, same as cat. nos. 19/1–21/1, 23/1–25/1
2 dark blue; zinc plate, same as cat. nos. 19/2–25/2

Literature: Waldman 1971, no. 23, 260

Comments: See cat. no. 19

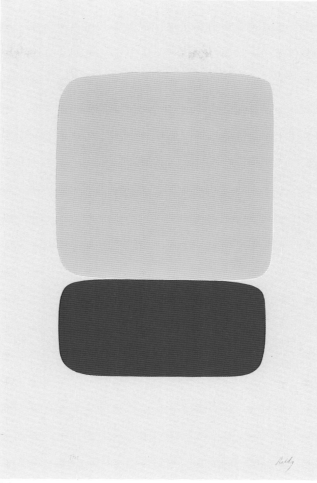

22

Yellow over Black (IX.20. Yellow over Black; Jaune sur Noir Série IX, No. 20) 1964–65

Lithograph on Rives BFK paper

Sheet: 35¼ x 23⅝ (89.5 x 60.0)

Signed in pencil, lower right: *Kelly*; numbered in pencil, lower left

Edition: 75

Proofs: 5 AP; same plates used for cat. nos. 19–22, 24, 25

Printed by Marcel Durassier at Imprimerie Maeght, Levallois-Perret

Published by Maeght Editeur, Paris

2 runs from 2 plates
1 yellow; zinc plate, same as cat. nos. 19/1–22/1, 24/1, 25/1
2 black; zinc plate, same as cat. nos. 19/2–22/2, 24/2, 25/2

Literature: Waldman 1971, no. 24, 260

Comments: See cat. no. 19

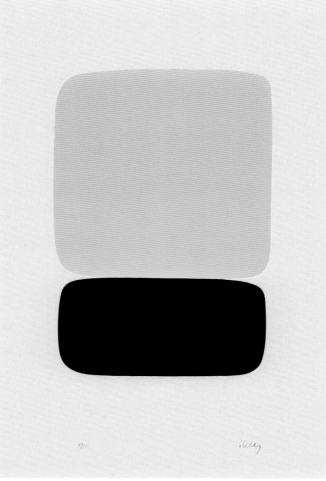

23

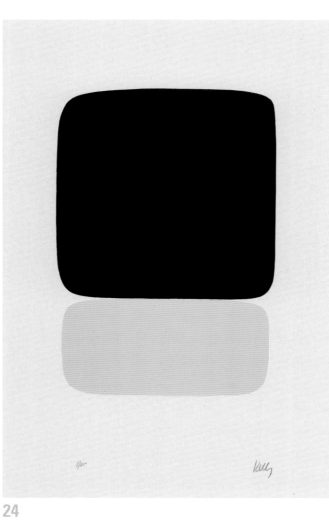

24

Black over Yellow (IX.21. Black over Light Yellow; Noir sur Jaune Clair Série IX, No. 21) 1964–65

Lithograph on Rives BFK paper

Sheet: 35¼ x 23½ (89.5 x 59.7)

Signed in pencil, lower right: *Kelly*; numbered in pencil, lower left

Edition: 75

Proofs: 6 AP; same plates used for cat. nos. 19–23, 25

Printed by Marcel Durassier at Imprimerie Maeght, Levallois-Perret

Published by Maeght Editeur, Paris

2 runs from 2 plates
1 black; zinc plate, same as cat. nos. 19/1–23/1, 25/1
2 light yellow; zinc plate, same as cat. nos. 19/2–23/2, 25/2

Literature: Waldman 1971, no. 28, 261

Comments: See cat. no. 19

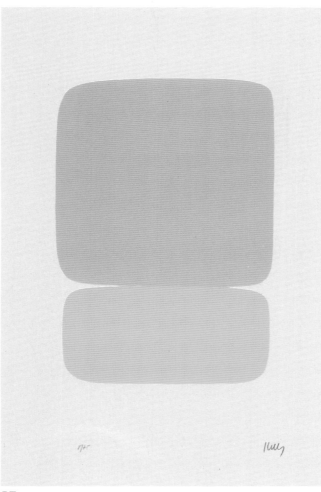

25

Yellow over Yellow (IX.22. Yellow over Light Yellow; Jaune sur Jaune Clair Série IX, No. 22) 1964–65

Lithograph on Rives BFK paper

Sheet: 35¼ x 23½ (89 5 x 59.7)

Signed in pencil, lower right: *Kelly*; numbered in pencil, lower left

Edition: 75

Proofs: 8 AP, 7 CTP; same plates used for cat. nos. 19–24

Printed by Marcel Durassier at Imprimerie Maeght, Levallois-Perret

Published by Maeght Editeur, Paris

2 runs from 2 plates
1 yellow-orange; zinc plate, same as cat. nos. 19/1–24/1
2 yellow; zinc plate, same as cat. nos. 19/2–24/2

Literature: Waldman 1971, no. 26, 261

Comments: See cat. no. 19

Blue over Green (X.23. Light Blue over Light Green; Bleu Clair sur Vert Clair Série X, No. 23) 1964–65

Lithograph on Rives BFK paper

Sheet: 35¼ x 23⅝ (89.5 x 60.0)

Image: 20⅜ x 15¾ (51.7 x 40.0)

Signed in pencil, lower right: *Kelly*; numbered in pencil, lower left

Edition: 75

Proofs: 7 AP, 3 CTP; same plates used for cat. nos. 27, 28

Printed by Marcel Durassier at Imprimerie Maeght, Levallois-Perret

Published by Maeght Editeur, Paris

2 runs from 2 plates
1 light blue; zinc plate, same as cat. nos. 27/1, 28/1
2 light green; zinc plate, same as cat. nos. 27/2, 28/2

Literature: Waldman 1971, no. 30, 262

Comments: *Blue over Green* reproduces, with a tighter adjustment of the blue figure to the edges of its green ground, the painting *Blue Green*, 1962 (EK#289; Coplans 1973, pl. 138). *Orange over Green* (cat. no. 27) and *Orange over Blue* (cat. no. 28) are color variations.

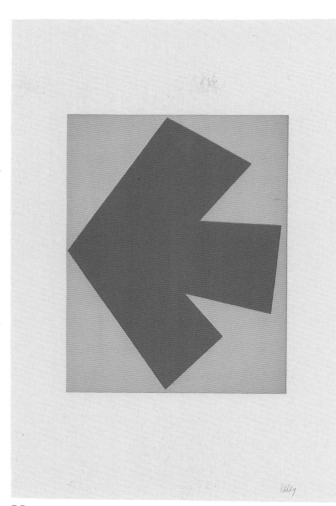

26

Orange over Green (X.24. Orange over Light Green; Orange sur Vert Clair Série X, No. 24) 1964–65

Lithograph on Rives BFK paper

Sheet: 35¼ x 23¾ (89.5 x 60.3)

Image: 20⅜ x 15¾ (51.7 x 40.0)

Signed in pencil, lower right: *Kelly*; numbered in pencil, lower left

Edition: 75

Proofs: 4 AP, 7 CTP; same plates used for cat. nos. 26, 28

Printed by Marcel Durassier at Imprimerie Maeght, Levallois-Perret

Published by Maeght Editeur, Paris

2 runs from 2 plates
1 orange; zinc plate, same as cat. nos. 26/1, 28/1
2 light green; zinc plate, same as cat. nos. 26/2, 28/2

Literature: Waldman 1971, no. 27, 261

Comments: See cat. no. 26

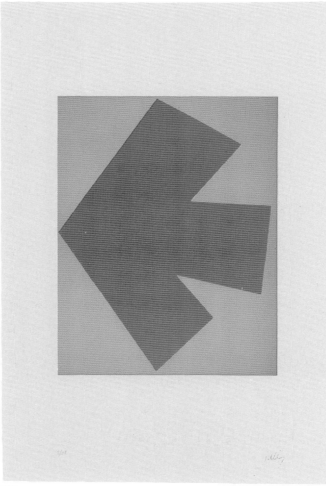

27

28

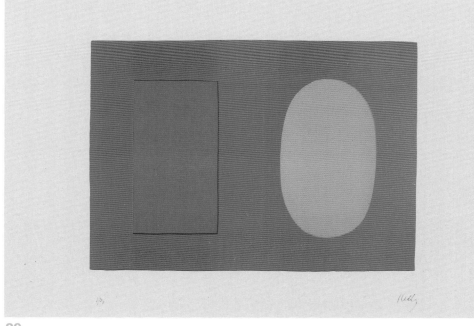

29

Orange over Blue (X.25. Orange over Blue; Orange sur Bleu Série X, No. 25) 1964–65

Lithograph on Rives BFK paper

Sheet: 35¼ x 23¾ (89.5 x 60.3)

Image: 20⅜ x 15¾ (51.7 x 40.0)

Signed in pencil, lower right: *Kelly*; numbered in pencil, lower left

Edition: 75

Proofs: 7 AP; same plates used for cat. nos. 26, 27

Printed by Marcel Durassier at Imprimerie Maeght, Levallois-Perret

Published by Maeght Editeur, Paris

2 runs from 2 plates
1 orange; zinc plate, same as cat. nos. 26/1, 27/1
2 blue; zinc plate, same as cat. nos. 26/2, 27/2

Literature: Waldman 1971, no. 31, 262

Comments: See cat. no. 26

Blue and Green over Orange (XI.26. Light Blue and Green over Orange; Bleu Clair et Vert sur Orange Série XI, No. 26) 1964–65

Lithograph on Rives BFK paper

Sheet: 23¹⁵⁄₁₆ x 35¼ (60.8 x 89.5)

Image: 16⅞ x 23⅛ (42.8 x 58.7)

Signed in pencil, lower right: *Kelly*; numbered in pencil, lower left

Edition: 75

Proofs: 7 AP, 8 CTP; same plates used for cat. no. 30

Printed by Marcel Durassier at Imprimerie Maeght, Levallois-Perret

Published by Maeght Editeur, Paris

2 runs from 2 plates
1 orange; zinc plate, same as cat. no. 30/1
2 light blue, green, zinc plate, same as cat. no. 30/2

Literature: Waldman 1971, no. 21, 259

Comments: *Blue and Green over Orange* is related to the painting *Green Blue Red*, 1963 (EK#310; Coplans 1973, pl. 150), although the rectangle and ovoid are smaller and more centered in the print. Related preliminary work includes the oil-on-paper *Study for "Green Blue Red"* (EK#63.45). The lithograph *Orange and Blue over Yellow* (cat. no. 30) is a color variation.

Orange and Blue over Yellow (XI.27. Orange and Blue over Yellow; Orange et Bleu sur Jaune Série XI, No. 27)

1964–65

Lithograph on Rives BFK paper

Sheet: 23⅝ x 35⅜ (60.0 x 89.9)

Image: 16⅞ x 23⅛ (42.8 x 58.7)

Signed in pencil, lower right: *Kelly*; numbered in pencil, lower left

Edition: 75

Proofs: 10 AP, 7 CTP; same plates used for cat. no. 29

Printed by Marcel Durassier at Imprimerie Maeght, Levallois-Perret

Published by Maeght Editeur, Paris

2 runs from 2 plates
1 yellow; zinc plate, same as cat. no. 29/1
2 orange, blue; zinc plate, same as cat. no. 29/2

Literature: Waldman 1971, no. 20, 259

Comments: *Orange and Blue over Yellow* is a color variation of the lithograph *Blue and Green over Orange* (cat. no. 29).

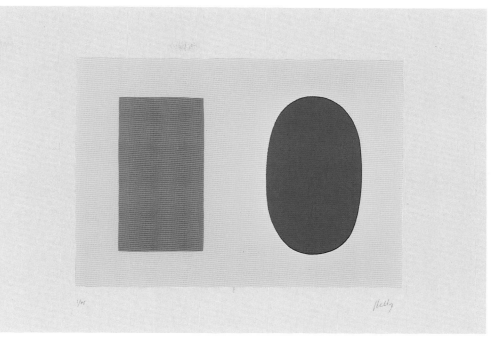

30

Blue with Yellow (Untitled) 1965

Lithograph on Arches paper

Sheet: 25¼ x 19⅛ (65 x 48.6)

Signed in pencil, lower right: *Kelly*; numbered in pencil, lower left

Edition: 90

Printed by Marcel Durassier at Imprimerie Maeght, Levallois-Perret

Published by Galerie Adrien Maeght, Paris

2 runs from 2 plates
1 blue; zinc plate
2 yellow; zinc plate

Comments: *Blue with Yellow*, published in an *édition avant la lettre*, was the basis for a poster (App. IID) that announced an exhibition of Kelly's lithographs at the Galerie Adrien Maeght in June 1965. The exhibition included work drawn from the Suite of Twenty-Seven Color Lithographs and the Suite of Plant Lithographs, the first twelve of which had been released. The squared ovoid with a centered interior rectangle is a variant image of cat. nos. 9–15, from the Suite of Twenty-Seven Color Lithographs.

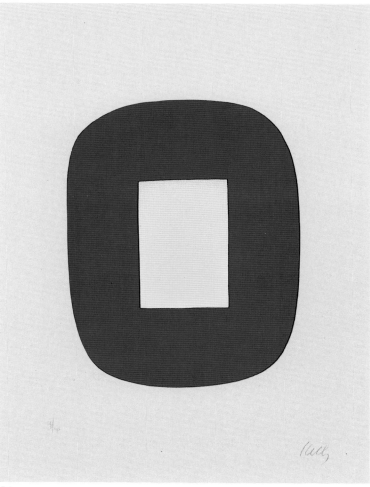

31

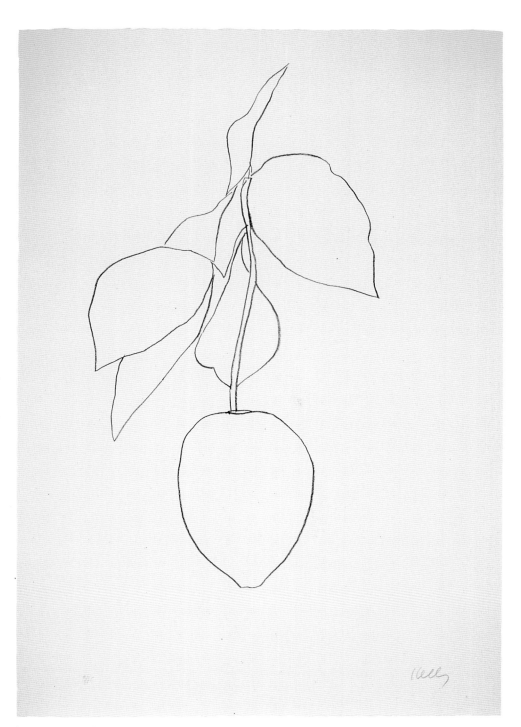

Lemon, 1964–65 (cat. no. 35)

32–59
SUITE OF PLANT LITHOGRAPHS
1964–66

In late 1964, at the same time that he initiated the Suite of Twenty-Seven Color Lithographs (cat. nos. 4–30) for Aimé Maeght in Paris, Kelly also began work on a second project, the Suite of Plant Lithographs, which was produced in two stages. The first twelve prints, printed by Marcel Durassier at Imprimerie Maeght in a suburb northwest of Paris, were ready for release in early 1965; the remaining sixteen were printed in Paris at the Imprimerie Arte and published in the spring of 1966.

When completed, the series included twenty-eight lithographic drawings of leaves, fruits, and flowers. For the majority of the prints, Kelly gathered preliminary pencil studies in sketchbooks, which he then redrew and reworked in a larger scale on lithographic transfer paper. For several of the lithographs, the artist drew directly on transfer paper without an intermediate sketch. The pencil studies and transfer drawings were made in Paris, Brittany, the Cévennes, Provence, and New York.

Proofs and *hors commerce* impressions exist for the Suite of Plant Lithographs but the exact number of impressions and types of proofs is difficult to ascertain because of the inaccessibility of records that Maeght Editeur may or may not have kept. The documentation presented here accounts for artist's proofs only. Certain impressions may carry an inscription by the artist on the verso that indicates, with an arabic numeral, the place of the lithograph in the sequence of the series and the title of the print, which may slightly vary from the titles listed in the catalogue raisonné.

Literature: Harrison 1967, 275; Hoag 1968, 52; Livingston 1968, 61; Waldman 1971, nos. 33–60, 263–71; Debs 1972, 75

Leaves (Feuilles) 1964–65

Transfer lithograph on Rives BFK paper

Sheet: 35⅜ x 25 (89.9 x 63.5)

Signed in pencil, lower right: *Kelly*; numbered in pencil, lower left

Edition: 75

Proofs: 10 AP

Printed by Marcel Durassier at Imprimerie Maeght, Levallois-Perret

Published by Maeght Editeur, Paris

1 run from 1 plate
1 black; zinc plate, from lithographic-crayon drawing on transfer paper

Literature: Waldman 1971, no. 33, 264; Johnson 1973, no. 32 (as *Feuilles*)

Comments: The original pencil study for *Leaves* (EK#64.14) was drawn on a napkin in a Parisian café in December 1964. Two finished pencil drawings (EK#P72.64 and EK#P73.64), each entitled *Leaves*, are related to the lithograph.

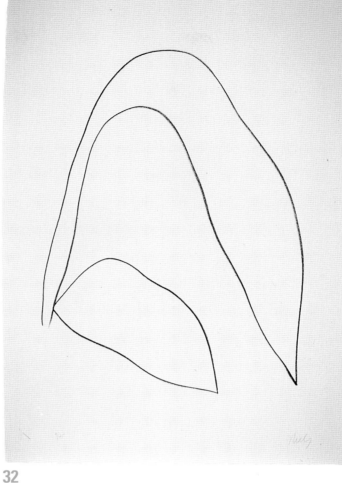

32

Grapefruit (Pamplemousse) 1964–65

Transfer lithograph on Rives BFK paper

Sheet: 35½ x 24⅛ (90.1 x 61.3)

Signed in pencil, lower right: *Kelly*; numbered in pencil, lower left

Edition: 75

Proofs: 10 AP

Printed by Marcel Durassier at Imprimerie Maeght, Levallois-Perret

Published by Maeght Editeur, Paris

1 run from 1 plate
1 black; zinc plate, from lithographic-crayon drawing on transfer paper

Literature: Waldman 1971, no. 38, 264

Comments: Kelly drew the original pencil study for *Grapefruit* at Saint-Paul-de-Vence, in southern France, in late December 1964. It is included in an album labeled "Sketchbook #6/ Paris–St. Paul/November–December 1964."

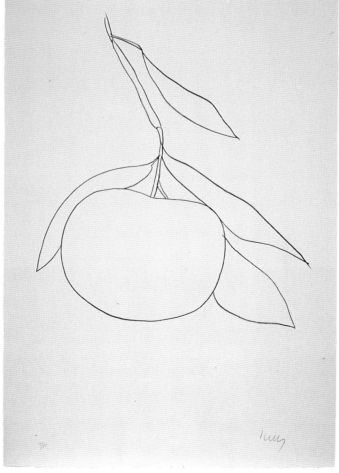

33

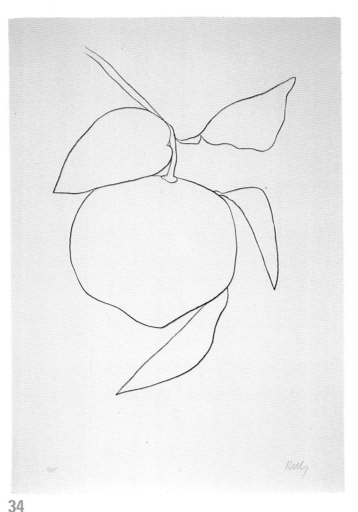

34

Tangerine (Mandarine) 1964–65

Transfer lithograph on Rives BFK paper

Sheet: 35⅜ x 24¼ (89.9 x 61.6)

Signed in pencil, lower right: *Kelly*; numbered in pencil, lower left

Edition: 75

Proofs: 10 AP

Printed by Marcel Durassier at Imprimerie Maeght, Levallois-Perret

Published by Maeght Editeur, Paris

1 run from 1 plate
1 black; zinc plate, from lithographic-crayon drawing on transfer paper

Literature: Waldman 1971, no. 42, 265

Comments: Kelly drew the original pencil study for *Tangerine* at Saint-Paul-de-Vence, in southern France, in late December 1964. It is included in an album labeled "Sketchbook #6/Paris–St. Paul/November–December 1964."

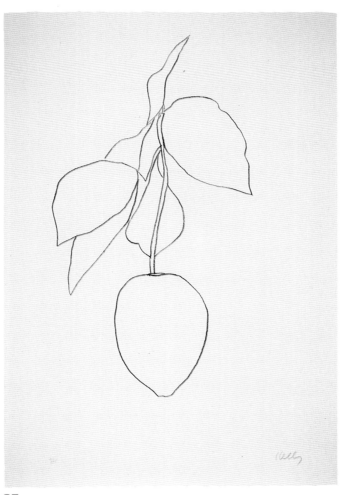

35

Lemon (Citron) 1964–65

Transfer lithograph on Rives BFK paper

Sheet: 35⅜ x 24¼ (89.9 x 61.6)

Signed in pencil, lower right: *Kelly*; numbered in pencil, lower left

Edition: 75

Proofs: 10 AP

Printed by Marcel Durassier at Imprimerie Maeght, Levallois-Perret

Published by Maeght Editeur, Paris

1 run from 1 plate
1 black; zinc plate, from lithographic-crayon drawing on transfer paper

Literature: Livingston 1968, 61; Waldman 1971, no. 43, 265

Comments: The artist drew the original pencil study for *Lemon* at Saint-Paul-de-Vence, in southern France, in late December 1964. It is included in an album labeled "Sketchbook #6/Paris–St. Paul/November–December 1964."

Cyclamen I 1964–65

Transfer lithograph on Rives BFK paper

Sheet: 35⅜ x 24¼ (89.9 x 61.6)

Signed in pencil, lower right: *Kelly*; numbered in pencil, lower left

Edition: 75

Proofs: 10 AP

Printed by Marcel Durassier at Imprimerie Maeght, Levallois-Perret

Published by Maeght Editeur, Paris

1 run from 1 plate

1 black; zinc plate, from lithographic-crayon drawing on transfer paper

Literature: Waldman 1971, no. 33, 263

Comments: Kelly drew the original pencil studies for the Cyclamen sequence (cat. nos. 36–40) at an *orangerie* outside of Paris in December 1964. They are included in an album labeled "Sketchbook #6/Paris–St. Paul/November–December 1964."

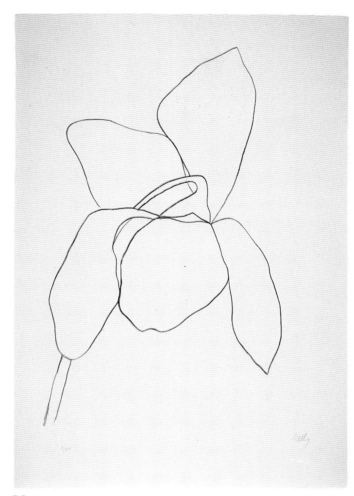

36

Cyclamen II 1964–65

Transfer lithograph on Rives BFK paper

Sheet: 35⅜ x 24¼ (89.9 x 61.6)

Signed in pencil, lower right: *Kelly*; numbered in pencil, lower left

Edition: 75

Proofs: 10 AP

Printed by Marcel Durassier at Imprimerie Maeght, Levallois-Perret

Published by Maeght Editeur, Paris

1 run from 1 plate

1 black; zinc plate, from lithographic-crayon drawing on transfer paper

Literature: Waldman 1971, no. 34, 263; Goldman 1985, 13

Comments: See cat. no. 36

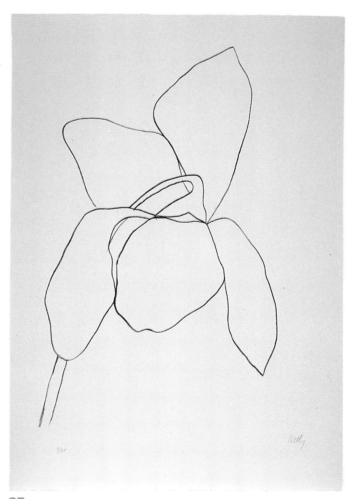

37

Cyclamen III 1964–65

Transfer lithograph on Rives BFK paper

Sheet: 35⅝ x 24¼ (90.5 x 61.6)

Signed in pencil, lower right: *Kelly*; numbered in pencil, lower left

Edition: 75

Proofs: 10 AP

Printed by Marcel Durassier at Imprimerie Maeght, Levallois-Perret

Published by Maeght Editeur, Paris

1 run from 1 plate

1 black; zinc plate, from lithographic-crayon drawing on transfer paper

Literature: Waldman 1971, no. 36, 264

Comments: See cat. no. 36

38

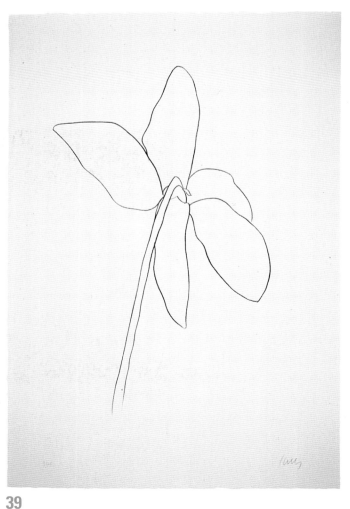

Cyclamen IV 1964–65

Transfer lithograph on Rives BFK paper

Sheet: 35¼ x 24⅛ (89.5 x 61.3)

Signed in pencil, lower right: *Kelly*; numbered in pencil, lower left

Edition: 75

Proofs: 10 AP

Printed by Marcel Durassier at Imprimerie Maeght, Levallois-Perret

Published by Maeght Editeur, Paris

1 run from 1 plate

1 black; zinc plate, from lithographic-crayon drawing on transfer paper

Literature: Waldman 1971, no. 37, 264

Comments: See cat. no. 36

39

Cyclamen V 1964–65

Transfer lithograph on Rives BFK paper

Sheet: 35⅝ x 24¼ (90.5 x 61.6)

Signed in pencil, lower right: *Kelly*; numbered in pencil, lower left

Edition: 75

Proofs: 10 AP

Printed by Marcel Durassier at Imprimerie Maeght, Levallois-Perret

Published by Maeght Editeur, Paris

1 run from 1 plate
1 black; zinc plate, from lithographic-crayon drawing on transfer paper

Literature: Waldman 1971, no. 35, 263

Comments: See cat. no. 36. The finished pencil drawing *Cyclamen* (EK#P71.64) is specifically related to this lithograph.

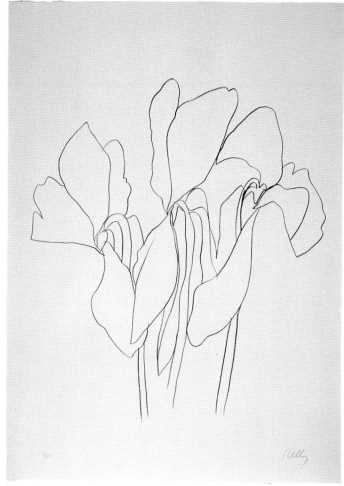

40

Camellia I 1964–65

Transfer lithograph on Rives BFK paper

Sheet: 35¼ x 24¼ (89.5 x 61.6)

Signed in pencil, lower right: *Kelly*; numbered in pencil, lower left

Edition: 75

Proofs: 10 AP

Printed by Marcel Durassier at Imprimerie Maeght, Levallois-Perret

Published by Maeght Editeur, Paris

1 run from 1 plate
1 black; zinc plate, from lithographic-crayon drawing on transfer paper

Literature: Waldman 1971, no. 44, 266

Comments: Kelly drew the original pencil studies for the sequence of Camellia prints (cat. nos. 41–43) at Saint-Paul-de-Vence, in southern France, in December 1964. They are included in an album labeled "Sketchbook #6/Paris–St. Paul/November–December 1964."

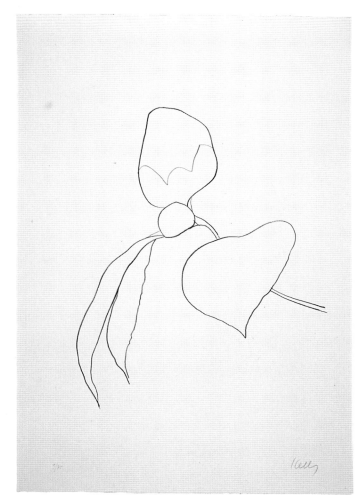

41

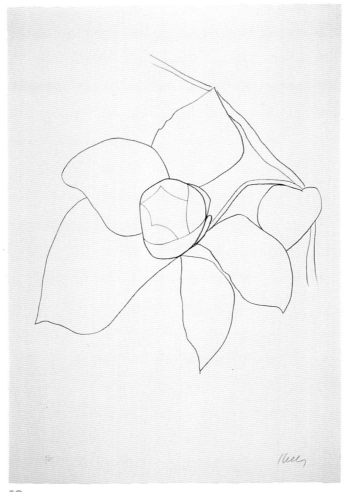

42

Camellia II 1964–65

Transfer lithograph on Rives BFK paper

Sheet: 35⅝ x 24¼ (90.5 x 61.6)

Signed in pencil, lower right: *Kelly*; numbered in pencil, lower left

Edition: 75

Proofs: 10 AP

Printed by Marcel Durassier at Imprimerie Maeght, Levallois-Perret

Published by Maeght Editeur, Paris

1 run from 1 plate
1 black; zinc plate, from lithographic-crayon drawing on transfer paper

Literature: Waldman 1971, no. 41, 265

Comments: See cat. no. 41

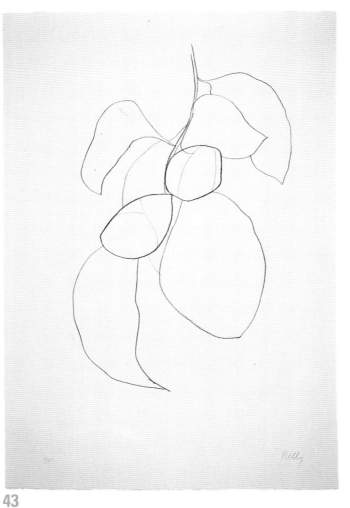

43

Camellia III 1964–65

Transfer lithograph on Rives BFK paper

Sheet: 35⅜ x 24¼ (89.9 x 61.6)

Signed in pencil, lower right: *Kelly*; numbered in pencil, lower left

Edition: 75

Proofs: 10 AP

Printed by Marcel Durassier at Imprimerie Maeght, Levallois-Perret

Published by Maeght Editeur, Paris

1 run from 1 plate
1 black; zinc plate, from lithographic-crayon drawing on transfer paper

Literature: Waldman 1971, no. 40, 265

Comments: See cat. no. 41

Melon Leaf (Feuille de Melon) 1965–66

Transfer lithograph on Rives BFK paper

Sheet: 35⅝ x 24¾ (90.5 x 62.9)

Signed in pencil, lower right: *Kelly*; numbered in pencil, lower left

Edition: 75

Proofs: 10 AP, 2 TP

Printed at Imprimerie Arte, Paris

Published by Maeght Editeur, Paris

1 run from 1 plate
1 black; zinc plate, from lithographic-crayon drawing on
 transfer paper

Literature: Waldman 1971, no. 53, 269

Comments: Kelly drew the original pencil study for *Melon
Leaf* at La Salle, in the Cévennes, during the summer of 1965.
It is included in an album labeled "Sketchbook #8/France–
Dordogne/July–August 1965." It is related to the pencil
drawing *Melon*, 1965 (EK#P80.65). Kelly brought the transfer
drawing he made in France from the original pencil study to
New York, where he reworked it on new transfer paper. He
then took the final drawing with him back to Paris in the
spring of 1966 for proofing and editioning.

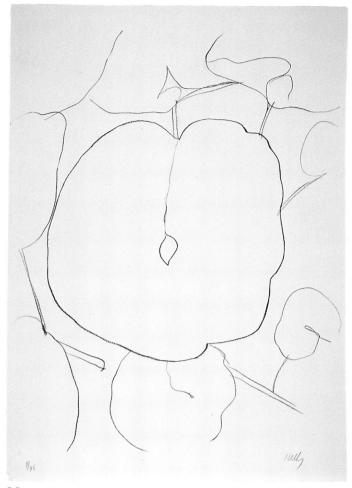

44

Pear I (Poire I) 1965–66

Transfer lithograph on Rives BFK paper

Sheet: 35⅝ x 24½ (90.5 x 62.3)

Signed in pencil, lower right: *Kelly*; numbered in pencil, lower left

Edition: 75

Proofs: 10 AP

Printed at Imprimerie Arte, Paris

Published by Maeght Editeur, Paris

1 run from 1 plate
1 black; zinc plate, from lithographic-crayon drawing on
 transfer paper

Literature: Waldman 1971, no. 14, 269

Comments: Kelly drew the original pencil studies for the
sequence of Pear lithographs (cat. nos. 45–47) at Le Grand
Bois, Aimé Maeght's farm near La Salle, in the Cévennes.
They are included in an album labeled "Sketchbook #8/
France–Dordogne/July–August 1965." Kelly brought the trans-
fer drawings he made from the studies to New York, where
he reworked them on new transfer paper. He then took the
final set of drawings back to Paris in the spring of 1966 for
proofing and editioning.

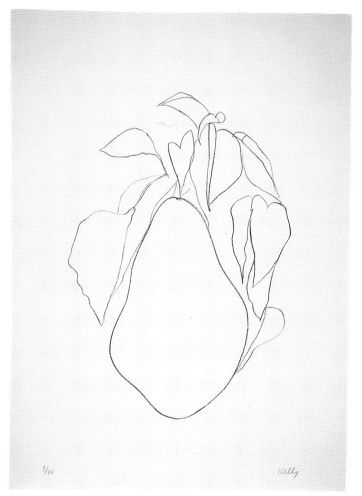

45

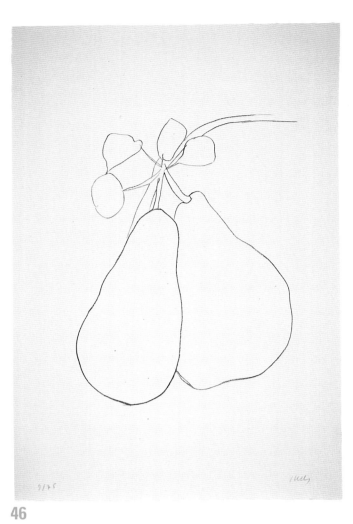

46

Pear II (Poire II) 1965–66

Transfer lithograph on Rives BFK paper

Sheet: 34⅝ x 23⅜ (87.9 x 59.4)

Signed in pencil, lower right: *Kelly*; numbered in pencil, lower left

Edition: 75

Proofs: 10 AP

Printed at Imprimerie Arte, Paris

Published by Maeght Editeur, Paris

1 run from 1 plate

1 black; zinc plate, from lithographic-crayon drawing on transfer paper

Literature: Waldman 1971, no. 49, 268

Comments: See cat. no. 45

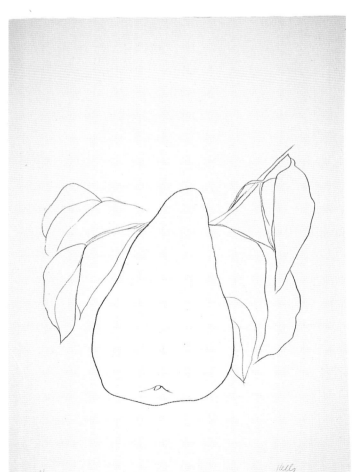

47

Pear III (Poire III) 1965–66

Transfer lithograph on Rives BFK paper

Sheet: 34⅝ x 24¾ (87.9 x 62.9)

Signed in pencil, lower right: *Kelly*; numbered in pencil, lower left

Edition: 75

Proofs: 10 AP

Printed at Imprimerie Arte, Paris

Published by Maeght Editeur, Paris

1 run from 1 plate

1 black; zinc plate, from lithographic-crayon drawing on transfer paper

Literature: Waldman 1971, no. 48, 268

Comments: See cat. no. 45

String Bean Leaves I
(Haricot Vert I) 1965–66

Transfer lithograph on Rives BFK paper

Sheet: 35⅜ x 24⅝ (89.9 x 62.5)

Signed in pencil, lower right: *Kelly*; numbered in pencil, lower left

Edition: 75

Proofs: 10 AP

Printed at Imprimerie Arte, Paris

Published by Maeght Editeur, Paris

1 run from 1 plate

1 black; zinc plate, from lithographic-crayon drawing on transfer paper

Literature: Waldman 1971, no. 51, 268

Comments: Kelly drew the original pencil studies for the sequence of String Bean Leaves lithographs (cat. nos. 48–50) at Le Grand Bois, Aimé Maeght's farm near La Salle, in the Cévennes. They are included in an album labeled "Sketch-book #8/France–Dordogne/July–August 1965." Kelly brought the transfer drawings he made from the studies to New York, where he reworked them on new transfer paper. He then took the final set of drawings back to Paris in the spring of 1966 for proofing and editioning.

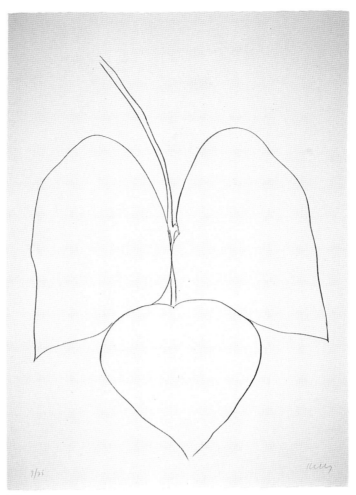

48

String Bean Leaves II
(Haricot Vert II) 1965–66

Transfer lithograph on Rives BFK paper

Sheet: 35⅝ x 24⅝ (90.5 x 62.5)

Signed in pencil, lower right: *Kelly*; numbered in pencil, lower left

Edition: 75

Proofs: 10 AP

Printed at Imprimerie Arte, Paris

Published by Maeght Editeur, Paris

1 run from 1 plate

1 black; zinc plate, from lithographic-crayon drawing on transfer paper

Literature: Waldman 1971, no. 50, 268

Comments: See cat. no. 48

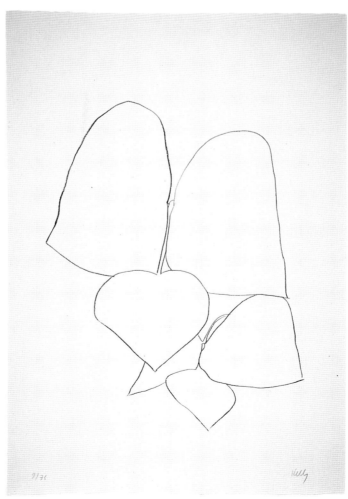

49

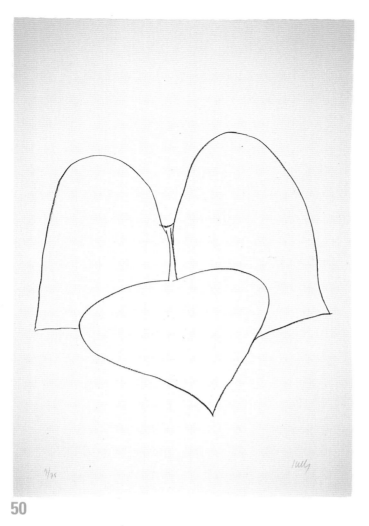

50

String Bean Leaves III
(Haricot Vert III) 1965–66

Transfer lithograph on Rives BFK paper

Sheet: 35⅝ x 24½ (90.5 x 62.3)

Signed in pencil, lower right: *Kelly*; numbered in pencil, lower left

Edition: 75

Proofs: 10 AP

Printed at Imprimerie Arte, Paris

Published by Maeght Editeur, Paris

1 run from 1 plate

1 black; zinc plate, from lithographic-crayon drawing on
 transfer paper

Literature: Waldman 1971, no. 54, 269

Comments: See cat. no. 48

Fig Branch (Figue) 1965–66

Transfer lithograph on Rives BFK paper

Sheet: 34½ x 24 (87.6 x 60.9)

Signed in pencil, lower right: *Kelly*; numbered in pencil, lower left

Edition: 75

Proofs: 10 AP

Printed at Imprimerie Arte, Paris

Published by Maeght Editeur, Paris

1 run from 1 plate

1 black; zinc plate, from lithographic-crayon drawing on
 transfer paper

Literature: Waldman 1971, no. 55, 269

Comments: Kelly drew the original pencil study for *Fig Branch*
at Le Grand Bois, Aimé Maeght's farm near La Salle, in the
Cévennes. It is included in an album labeled "Sketchbook
#8/France–Dordogne/July–August 1965." It is related to the
pencil drawing *Fig*, 1965 (EK#P77.65). Kelly brought the
transfer drawing he made from the study to New York, where
he reworked it on new transfer paper. He then took the new
drawing back to Paris in the spring of 1966 for proofing and
editioning.

51

Locust (Acacia) *1965–66*

Transfer lithograph on Rives BFK paper

Sheet: 24 x 35⅜ (60.9 x 89.9)

Signed in pencil, lower right: *Kelly*; numbered in pencil, lower left

Edition: 75

Proofs: 10 AP

Printed at Imprimerie Arte, Paris

Published by Maeght Editeur, Paris

1 run from 1 plate

1 black; zinc plate, from lithographic-crayon drawing on transfer paper

Literature: Waldman 1971, no. 46, 267; Debs 1972, 77; Goldman 1985, 13

Comments: *Locust* was based on a finished pencil drawing (EK#P58.65) that Kelly made at Le Grand Bois, Aimé Maeght's farm near La Salle, in the Cévennes. It is included in an album labeled "Sketchbook #8/France–Dordogne/July–August 1965." Kelly brought the transfer drawing he made from the study to New York, where he reworked it on new transfer paper. He then took the new drawing back to Paris in the spring of 1966 for proofing and editioning.

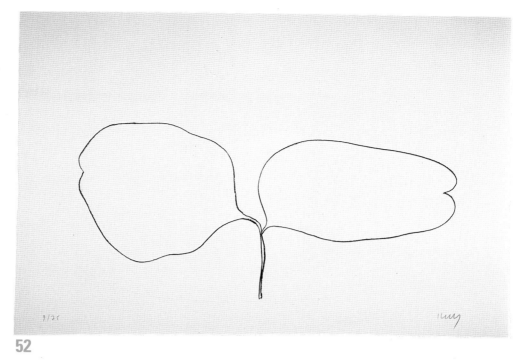

52

Seaweed (Algue) *1965–66*

Transfer lithograph on Rives BFK paper

Sheet: 35⅝ x 24¾ (90.5 x 62.9)

Signed in pencil, lower right: *Kelly*; numbered in pencil, lower left

Edition: 75

Proofs: 10 AP

Printed at Imprimerie Arte, Paris

Published by Maeght Editeur, Paris

1 run from 1 plate

1 black; zinc plate, from lithographic-crayon drawing on transfer paper

Literature: Waldman 1971, no. 45, 266

Comments: Kelly drew the original pencil study for *Seaweed* in Brittany. It is included in an album labeled "Sketchbook 7/France–Brittany/July 1965." He brought the transfer drawing he made from the study to New York, where he reworked it on new transfer paper. He then took the new drawing back to Paris in the spring of 1966 for proofing and editioning.

53

54

Catalpa Leaf (Feuille) 1965–66

Transfer lithograph on Rives BFK paper

Sheet: 35⅜ x 24⅝ (89.9 x 62.5)

Signed in pencil, lower right: *Kelly*; numbered in pencil, lower left

Edition: 75

Proofs: 10 AP

Printed at Imprimerie Arte, Paris

Published by Maeght Editeur, Paris

1 run from 1 plate

1 black; zinc plate, from lithographic-crayon drawing on transfer paper

Literature: Waldman 1971, no. 47, 267

Comments: Kelly drew *Catalpa Leaf* in France, from memory, directly on transfer paper, without a preliminary pencil study. He brought the original transfer drawing he made from the study to New York, where he reworked it on new transfer paper. He then took the new drawing back to Paris in June of 1966 for proofing and editioning.

55

Oranges 1965–66

Transfer lithograph on Rives BFK paper

Sheet: 24⅜ x 32⅜ (61.9 x 82.2)

Signed in pencil, lower right: *Kelly*; numbered in pencil, lower left

Edition: 75

Proofs: 10 AP

Printed at Imprimerie Arte, Paris

Published by Maeght Editeur, Paris

1 run from 1 plate

1 black; zinc plate, from lithographic-crayon drawing on transfer paper

Literature: Waldman 1971, no. 60, 271

Comments: Kelly drew *Oranges* directly on transfer paper in New York in the spring of 1966. The lithograph is based upon a series of four finished drawings, one of which, in pencil, is titled *Oranges*, 1966 (EK#P11.66).

Magnolia 1966

Transfer lithograph on Rives BFK paper

Sheet: 24¼ x 34¾ (61.6 x 88.3)

Signed in pencil, lower right: *Kelly*; numbered in pencil, lower left

Edition: 75

Proofs: 10 AP

Printed at Imprimerie Arte, Paris

Published by Maeght Editeur, Paris

1 run from 1 plate
1 black; zinc plate, from lithographic-crayon drawing on transfer paper

Literature: Waldman 1971, no. 59, 271

Comments: In the spring of 1966 Kelly gathered several branches of magnolia at Palisades Park in New Jersey that he brought back to his studio to draw. He made a transfer drawing after one of these pencil drawings (EK#P30.66) for the lithograph *Magnolia*. He took the transfer drawing to Paris in June for proofing and editioning.

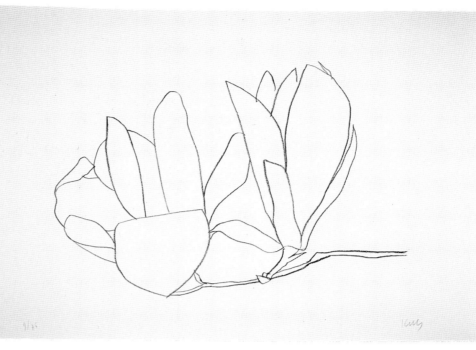

56

Lemon Branch (Branche de Citron)
1965–66

Transfer lithograph on Rives BFK paper

Sheet: 35⅜ x 24⅛ (89.9 x 61.3)

Signed in pencil, lower right: *Kelly*; numbered in pencil, lower left

Edition: 75

Proofs: 10 AP

Printed at Imprimerie Arte, Paris

Published by Maeght Editeur, Paris

1 run from 1 plate
1 black; zinc plate, from lithographic-crayon drawing on transfer paper

Literature: Waldman 1971, no. 58, 270

Comments: The lithograph *Lemon Branch* is closely related to an earlier pencil drawing, *Lemon Branch*, 1964 (EK#P61.64; Waldman 1971, pl. 147). Kelly reworked it on transfer paper in the spring of 1966 and took it with him to Paris in June of that year for proofing and editioning.

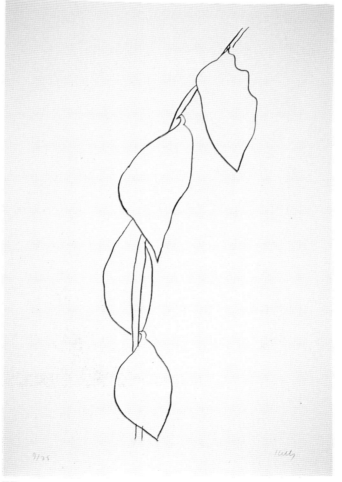

57

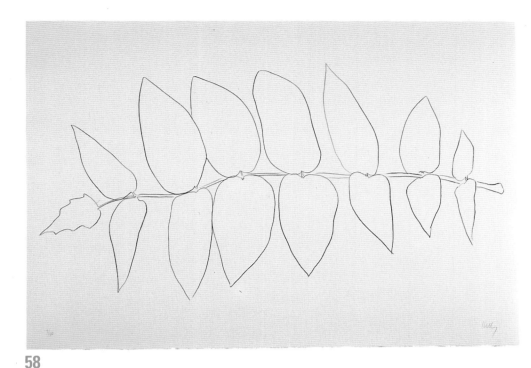

58

Ailanthus Leaves I (Vernis du Japon I) 1966

Transfer lithograph on Chiffon de Mandeure paper

Sheet: 28⅝ x 41⅜ (72.7 x 105.1)

Signed in pencil, lower right: *Kelly*; numbered in pencil, lower left

Edition: 50

Proofs: 10 AP

Printed at Imprimerie Arte, Paris

Published by Maeght Editeur, Paris

1 run from 1 plate

1 black; zinc plate, from lithographic-crayon drawing on transfer paper

Literature: Waldman 1971, no. 56, 270

Comments: During his stay in Paris in the spring of 1966, Kelly gathered ailanthus branches from the courtyard at Imprimerie Arte and brought them back to his hotel. Placing them for several days in a bathtub filled with water, he later drew them directly on transfer paper without any preliminary studies, creating this and cat. no. 59.

Ailanthus Leaves II (Vernis du Japon II) 1966

Transfer lithograph on Chiffon de Mandeure paper

Sheet: 41⅜ x 28⅝ (105.1 x 72.7)

Signed in pencil, lower right: *Kelly*; numbered in pencil, lower left

Edition: 50

Proofs: 10 AP

Printed at Imprimerie Arte, Paris

Published by Maeght Editeur, Paris

1 run from 1 plate

1 black; zinc plate, from lithographic-crayon drawing on transfer paper

Literature: Waldman 1971, no. 57, 270

Comments: See cat. no. 58

59

Black Form 1967

Lithograph on Rives BFK paper

Sheet: 16¾ x 22¼ (42.5 x 56.5)

Signed in pencil, lower right: *Kelly*; numbered in pencil, lower left. Blind stamp, lower right: logo of Hollander Workshop

Edition: 100

Proofs: CTP, 20 HC

Printed by Irwin Hollander

Published by the Hollander Workshop, New York

1 run from 1 stone
1 black; stone

Literature: Waldman 1971, no. 4, 253

Comments: This is one of nine lithographs in the portfolio *9*, which includes the work of Willem de Kooning, Sam Francis, Ellsworth Kelly, Roy Lichtenstein, Richard Lindner, Robert Motherwell, Louise Nevelson, Henry Pearson, and Saul Steinberg.

Black Form, which is not based upon a specific painting or sculpture, is related to *Black White*, 1962 (EK#292; Coplans 1973, pl. 160), and to the figure–ground parabola paintings of the early 1960s. Preliminary work for the print includes the collage *Study for Hollander Lithograph* (EK#67.53).

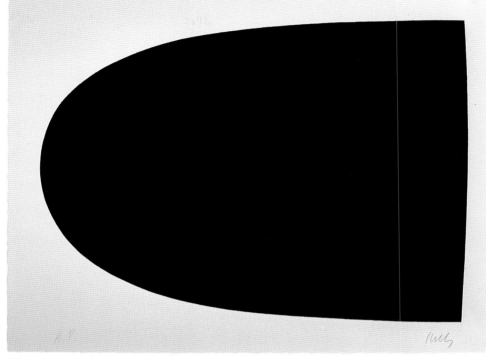

60

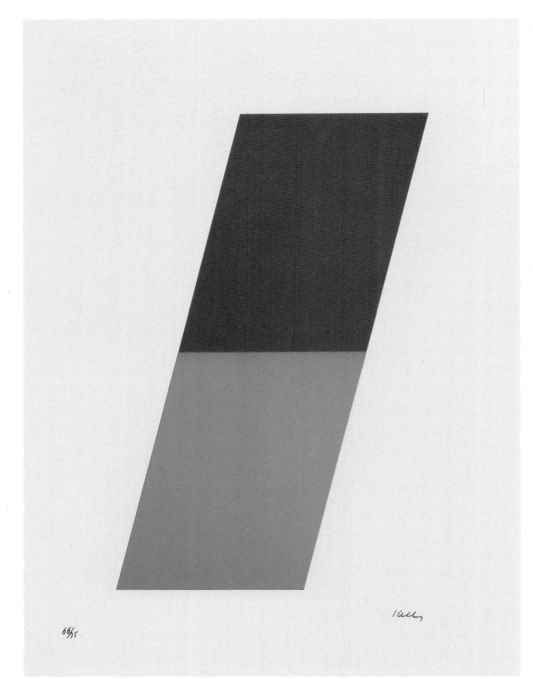

Orange/Green, 1970 (cat. no. 64)

61–70
SERIES OF TEN LITHOGRAPHS 1970

The ten lithographs of this series were the artist's first prints to be published by Gemini G.E.L. in Los Angeles. They are related to eight other lithographs that Kelly initiated at Gemini in early 1970 but that he completed at various intervals between 1970 and 1972. The Series of Ten Lithographs and the affiliated eight prints (cat. nos. 74, 75, 77–79, 81–83) are, as a group, derived from the artist's work of 1967–70. In a departure from the curvilinear shapes and figure–ground compositions that Kelly had cultivated since his return to New York from Paris in 1954, he now pursued strict geometric form and solid-color panel painting. Although this new direction entailed an elaboration of the joined, rectilinear panel paintings that he had evolved in France, it also led to the invention of more eccentrically shaped polygonal canvases.

Literature: Coplans 1970; "Prints and Portfolios," *Print Collector's Newsletter* 1970, 87; Castleman 1971, 27, 65–66; Waldman 1971, nos. 61–70, 272–75

Blue/Yellow/Red 1970

Lithograph on Special Arjomari paper

Sheet: 42½ x 30 (108.0 x 76.2)

Signed in pencil, lower right: *Kelly*; numbered in pencil, lower left. Blind stamp, lower right: logo of Gemini G.E.L.,©. Inscribed in pencil on verso: *EK70–330*. Stamped on verso: *Gemini G.E.L. Los Angeles, Calif.*

Edition: 75

Proofs: 9 AP, TP, RTP, PPII, 3 GEL, C

Collaboration and supervision: Kenneth Tyler. Proofing and processing: Stuart Henderson, Ron McPherson, Dan Freeman, Ron Adams, George Page. Edition printing: Andrew Vlady, assisted by Ron Olds.

Published by Gemini G.E.L., Los Angeles (Gemini 230)

3 runs from 3 plates
1 red; aluminum photo plate, from hand-cut negative
2 yellow; aluminum photo plate, from hand-cut negative
3 blue; aluminum photo plate, from hand-cut negative

Literature: Waldman 1971, no. 66, 273

Comments: *Blue/Yellow/Red* is a color variation of two trisected-parallelogram paintings of 1968, *Red White Blue* (EK#407) and *Red Yellow Blue* (EK#408), and four lithographs, cat. nos. 62, 63, 74, and 75.

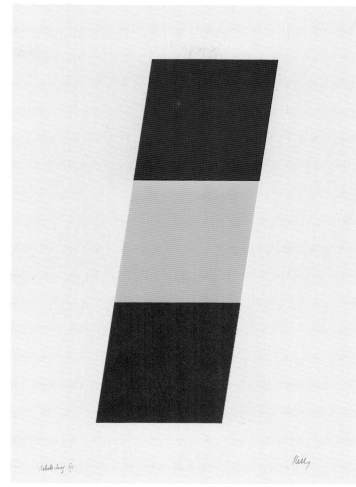

61

Red-Orange/Yellow/Blue 1970

Lithograph on Special Arjomari paper

Sheet: 42½ x 30 (108.0 x 76.2)

Signed in pencil, lower right: *Kelly*; numbered in pencil, lower left. Blind stamp, lower right: logo of Gemini G.E.L.,©. Inscribed in pencil on verso: *EK70–331*. Stamped on verso: *Gemini G.E.L. Los Angeles, Calif.*

Edition: 75

Proofs: 9 AP, TP, RTP, PPII, 3 GEL, C

Collaboration and supervision: Kenneth Tyler. Proofing and processing: Stuart Henderson, Ron Olds. Edition printing: Ron Olds, assisted by Dan Freeman.

Published by Gemini G.E.L., Los Angeles (Gemini 231)

3 runs from 3 plates
1 red-orange; aluminum photo plate, from hand-cut negative
2 yellow; aluminum photo plate, from hand-cut negative
3 blue; aluminum photo plate, from hand-cut negative

Literature: Waldman 1971, no. 64, 273; Baro 1976, no. 150, 65

Comments: *Red-Orange/Yellow/Blue* is related to the trisected-parallelogram paintings of 1968. It repeats the colors and forms of the painting *Red Yellow Blue*, 1968 (EK#408), and is a color variation of cat. nos. 61, 63, 74, and 75.

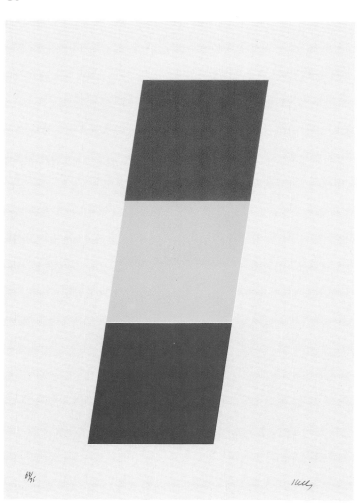

62

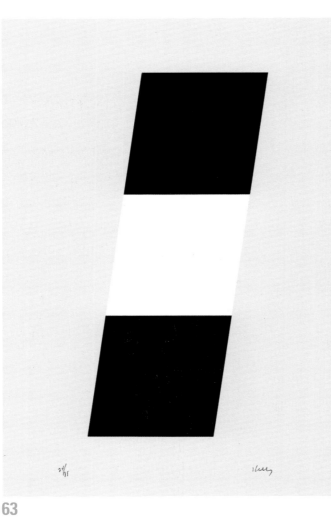

63

Black/White/Black 1970

Lithograph on Special Arjomari paper

Sheet: 42½ x 30 (108.0 x 76.2)

Signed in pencil, lower right: *Kelly*; numbered in pencil, lower left. Blind stamp, lower right: logo of Gemini G.E.L., ©. Inscribed in pencil on verso: *EK70–333*. Stamped on verso: *Gemini G.E.L. Los Angeles, Calif.*

Edition: 75

Proofs: 9 AP, TP, RTP, PPII, 3 GEL, C

Collaboration and supervision: Kenneth Tyler. Proofing and processing: Ron Adams. Edition printing: Ron Adams, assisted by Paul Clinton, Dan Freeman.

Published by Gemini G.E.L., Los Angeles (Gemini 232)

2 runs from 3 plates

1 white; aluminum photo plate, from hand-cut negative
2 black; aluminum photo plate, from hand-cut negative
3 blue-black; aluminum photo plate, from hand-cut negative

Literature: Goldman 1971, 30; Waldman 1971, no. 63, 273

Comments: *Black/White/Black* is a color variation of two trisected-parallelogram paintings of 1968, *Red White Blue* (EK#407) and *Red Yellow Blue* (EK#408), and four lithographs, cat. nos. 61, 62, 74, and 75.

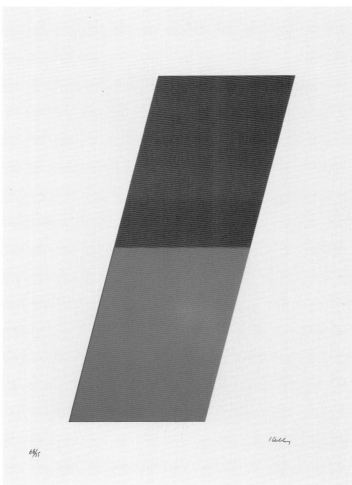

64

Orange/Green 1970

Lithograph on Special Arjomari paper

Sheet: 41½ x 30¼ (105.4 x 76.8)

Signed in pencil, lower right: *Kelly*; numbered in pencil, lower left. Blind stamp, lower right: logo of Gemini G.E.L., ©. Inscribed in pencil on verso: *EK70–335*. Stamped on verso: *Gemini G.E.L. Los Angeles, Calif.*

Edition: 75

Proofs: 9 AP, TP, RTP, PPII, 3 GEL, C

Collaboration and supervision: Kenneth Tyler. Proofing and processing: Kenneth Tyler, George Page, Ron McPherson, Stuart Henderson. Edition printing: George Page, assisted by Ron Adams.

Published by Gemini G.E.L., Los Angeles (Gemini 233)

2 runs from 2 plates

1 orange; aluminum photo plate, from hand-cut negative
2 green; aluminum photo plate, from hand-cut negative

Literature: Waldman 1971, no. 65, 273

Comments: *Orange/Green* is related to a series of four bisected-parallelogram paintings of 1967–68 that begins with *Black White*, 1967 (EK#400; Coplans 1973, pl. 199). The lithograph is a color variation of cat. no. 78.

Blue/Green 1970

Lithograph on Special Arjomari paper

Sheet: 39½ x 37¾ (100.3 x 95.9)

Signed in pencil, lower right: *Kelly*; numbered in pencil, lower left. Blind stamp, lower right: logo of Gemini G.E.L., ©. Inscribed in pencil on verso: *EK70–336*. Stamped on verso: *Gemini G.E.L. Los Angeles, Calif.*

Edition: 75

Proofs: 9 AP, TP, RTP, PPII, 3 GEL, C

Collaboration and supervision: Kenneth Tyler. Proofing and processing: Charles Ritt, Dan Freeman, Ron Adams. Edition printing: Dan Freeman, assisted by Ron McPherson.

Published by Gemini G.E.L., Los Angeles (Gemini 234)

2 runs from 2 plates
1 blue; aluminum photo plate, from hand-cut negative
2 green; aluminum photo plate, from hand-cut negative

Literature: Waldman 1971, no. 68, 274

Comments: The shapes of *Blue/Green* repeat the joined isoceles triangles in the painted-aluminum sculpture *Green Blue*, 1968 (EK#S414; Sims and Pulitzer 1982, no. 47). The image in *Blue/Green* is also related to the abutted color triangles of the paintings *Red Blue*, 1968 (EK#404), and *Green Blue*, 1969 (EK#424). In the print oeuvre, this lithograph is a color variation of cat. no. 79.

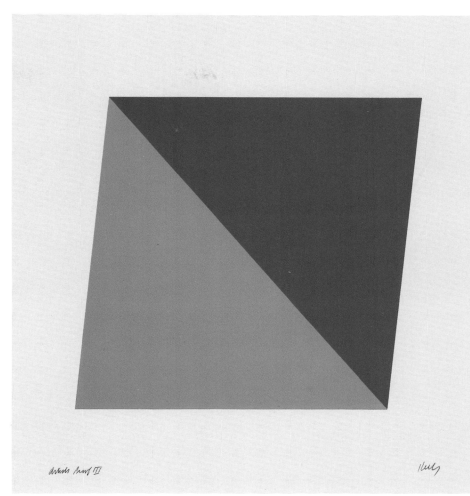

65

Yellow/Red-Orange 1970

Lithograph on Special Arjomari paper

Sheet: 35¼ x 36¼ (89.5 x 92.1)

Signed in pencil, lower right: *Kelly*; numbered in pencil, lower left. Blind stamp, lower right: logo of Gemini G.E.L., ©. Inscribed in pencil on verso: *EK70–340*. Stamped on verso: *Gemini G.E.L. Los Angeles, Calif.*

Edition: 75

Proofs: 9 AP, TP, RTP, PPII, 3 GEL, C

Collaboration and supervision: Kenneth Tyler. Proofing and processing: Stuart Henderson. Edition printing: Stuart Henderson, assisted by Ron Adams.

Published by Gemini G.E.L., Los Angeles (Gemini 235)

2 runs from 2 plates
1 yellow; aluminum photo plate, from hand-cut stencil
2 red; aluminum photo plate, from hand-cut stencil

Literature: Waldman 1971, no. 69, 275

Comments: No source in the paintings or sculpture exists for this lithograph.

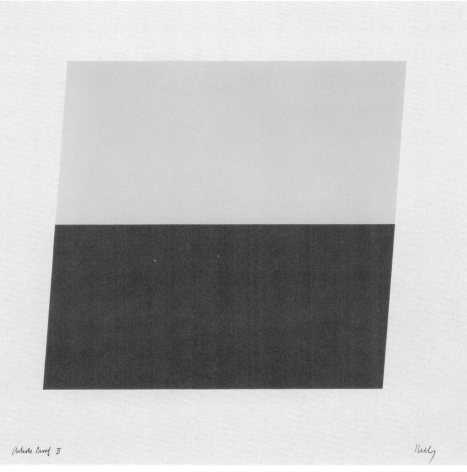

66

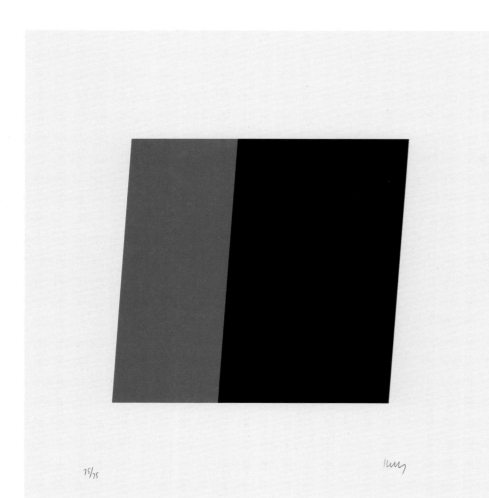

Blue/Black 1970

Lithograph on Special Arjomari paper

Sheet: 36 x 34½ (91.4 x 87.6)

Signed in pencil, lower right: *Kelly*; numbered in pencil, lower left. Blind stamp, lower right: logo of Gemini G.E.L., ©. Inscribed in pencil on verso: *EK70–341*. Stamped on verso: *Gemini G.E.L. Los Angeles, Calif.*

Edition: 75

Proofs: 9 AP, TP, RTP, PPII, 3 GEL, C

Collaboration and supervision: Kenneth Tyler. Proofing and processing: Ron McPherson, Stuart Henderson. Edition printing: Charles Ritt, assisted by Ron Adams.

Published by Gemini G.E.L., Los Angeles (Gemini 236)

2 runs from 2 plates
1 blue; aluminum photo plate, from hand-cut stencil
2 black; aluminum photo plate, from hand-cut stencil

Literature: Waldman 1971, no. 70, 275

Comments: No source in the paintings or sculpture exists for this lithograph.

67

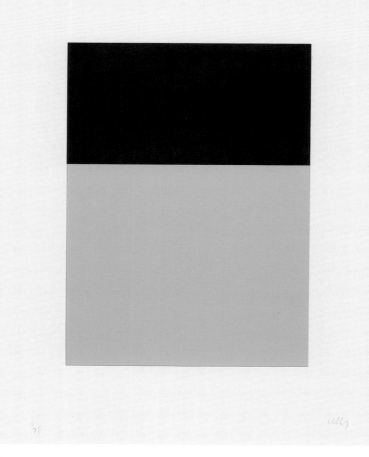

Black/Green 1970

Lithograph on Special Arjomari paper

Sheet: 23¼ x 19 (59.1 x 48.3)

Image: 15½ x 11¹¹⁄₁₆ (39.4 x 29.8)

Signed in pencil, lower right: *Kelly*; numbered in pencil, lower left. Blind stamp, lower right: logo of Gemini G.E.L., ©. Inscribed in pencil on verso: *EK70–343*. Stamped on verso: *Gemini G.E.L. Los Angeles, Calif.*

Edition: 75

Proofs: 9 AP, TP, RTP, PPII, 3 GEL, C

Collaboration and supervision: Kenneth Tyler. Proofing and processing: Stuart Henderson, Tim Isham. Edition printing: Ron McPherson, assisted by Dan Freeman.

Published by Gemini G.E.L., Los Angeles (Gemini 237)

2 runs from 2 plates
1 green; aluminum photo plate, from hand-cut stencil
2 black; aluminum photo plate, from hand-cut stencil

Literature: Waldman 1971, no. 61, 273

Comments: The lithograph *Black/Green* is a proportional variation of *Black/Green II*, 1972, cat. no. 77.

68

Yellow/Black 1970

Lithograph on Special Arjomari paper

Sheet: 41⅜ x 36 (105.1 x 91.4)

Signed in pencil, lower right: *Kelly*; numbered in pencil, lower left. Blind stamp, lower right: logo of Gemini G.E.L.,©. Inscribed in pencil on verso: *EK70–344*. Stamped on verso: *Gemini G.E.L. Los Angeles, Calif.*

Edition: 75

Proofs: 9 AP, TP, RTP, PPII, 3 GEL, C

Collaboration and supervision: Kenneth Tyler. Proofing and processing: Tim Huchthausen, Tim Isham. Edition printing: Tim Huchthausen, assisted by Tim Isham.

Published by Gemini G.E.L., Los Angeles (Gemini 238)

2 runs from 2 plates

1 yellow; aluminum photo plate, from hand-cut stencil, same as cat. no. 70/1
2 black; aluminum photo plate, from hand-cut stencil, same as cat. no. 70/2

Literature: Waldman 1971, no. 62, 272; Baro 1976, no. 151, 66

Comments: *Yellow/Black* is related to the illusionistic cube paintings of 1968, including *Red Yellow* (EK#411), *Black Green* (EK#412), and *Blue Yellow* (EK#413). It repeats and rotates the shapes of the lithograph *Yellow/Orange* (cat. no. 70).

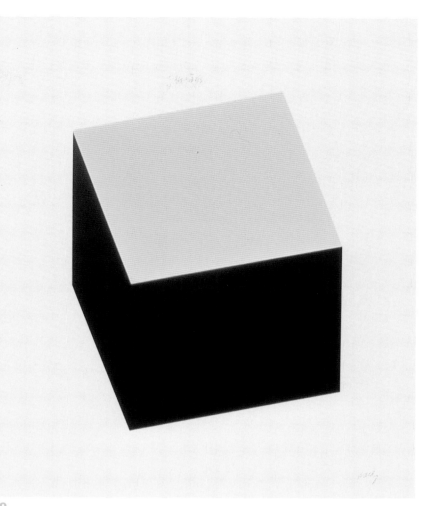

69

Yellow/Orange 1970

Lithograph on Special Arjomari paper

Sheet: 35 x 41⅜ (88.9 x 105.1)

Signed in pencil, lower right: *Kelly*; numbered in pencil, lower left. Blind stamp, lower right: logo of Gemini G.E.L.,©. Inscribed in pencil on verso: *EK70–345*. Stamped on verso: *Gemini G.E.L. Los Angeles, Calif.*

Edition: 75

Proofs: 9 AP, TP, RTP, PPII, 3 GEL, C

Collaboration and supervision: Kenneth Tyler. Proofing and processing: Paul Clinton, Ron Olds. Edition printing: Paul Clinton, assisted by Ron Olds.

Published by Gemini G.E.L., Los Angeles (Gemini 239)

2 runs from 2 plates

1 yellow; aluminum photo plate, from hand-cut stencil, same as cat. no. 69/2
2 orange; aluminum photo plate, from hand-cut stencil, same as cat. no. 69/1

Literature: Waldman 1971, no. 67, 274

Comments: *Yellow/Orange* is related to the illusionistic cube paintings of 1968, including *Red Yellow* (EK#411), *Black Green* (EK#412), and *Blue Yellow* (EK#413). It repeats and rotates the shapes of the lithograph *Yellow/Black* (cat. no. 69).

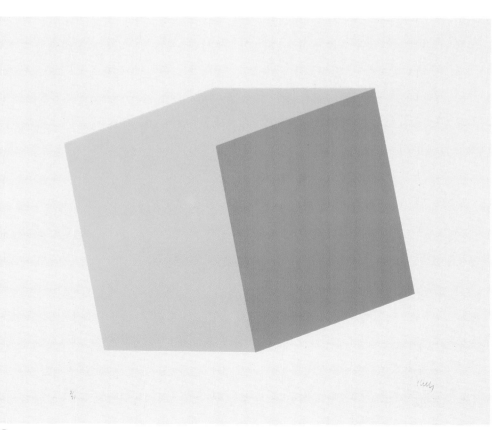

70

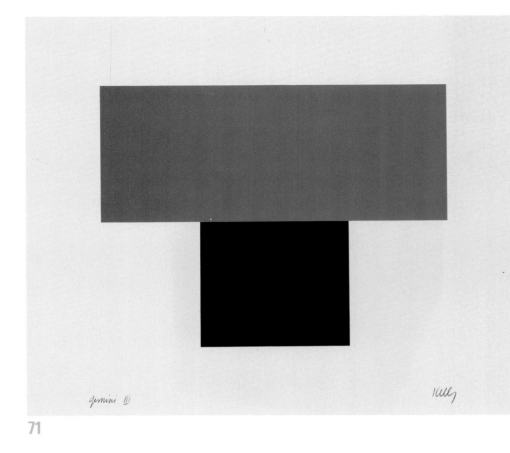

71

Red-Orange over Black 1970

Screenprint on Special Arjomari paper

Sheet: 25 x 30 (63.5 x 76.2)

Signed in pencil, lower right: *Kelly*; numbered in pencil, lower left. Blind stamp, lower right: logo of Gemini G.E.L.,©. Inscribed in pencil on verso: *EK70–364*. Stamped on verso: *Gemini G.E.L. Los Angeles, Calif.*

Edition: 250

Proofs: 25 AP, 2 TP, RTP, PPII, 3 GEL, C

Collaboration and supervision: Kenneth Tyler. Proofing, processing, and edition printing: Jeff Wasserman, Robert Dressen.

Published by Ellsworth Kelly and Gemini G.E.L., Los Angeles (Gemini 240)

2 runs from 2 screens

1 black; screen, from hand-cut stencil
2 red-orange; screen, from hand-cut stencil

Literature: Waldman 1971, no. 5, 254; Konheim 1978, no. 21, 29

Comments: *Red-Orange over Black* is related to a 1970–71 series of crossbar paintings. It is a proportional variation of the painting *Black with Red Bar*, 1970 (EK#448), and a color and proportional variation of the lithograph *White Bar with Black*, 1973 (cat. no. 89).

72

Four Panels 1970–71

Screenprint on Special Arjomari paper

Sheet: 36¾ x 62 (93.3 x 157.5)

Image: 28¾ x 54 (73.0 x 137.2)

Signed in pencil, lower right: *Kelly*; numbered in pencil, lower right. Blind stamp, lower right: logo of Gemini G.E.L.,©. Inscribed in pencil on verso: *EK71–5001*. Stamped on verso: *Gemini G.E.L. Los Angeles, Calif.*

Edition: 50

Proofs: 9 AP, RTP, PPII, 3 GEL, C

Collaboration and supervision: Kenneth Tyler. Proofing, processing, and edition printing: Jeff Wasserman, Robert Dressen.

Published by Gemini G.E.L., Los Angeles (Gemini 263)

4 runs from 1 screen

1 green; screen, from hand-cut stencil
2 black; same element as 1
3 red; same element as 1
4 blue; same element as 1

Literature: "Prints and Portfolios," *Print Collector's Newsletter* 1971, 35

Comments: *Four Panels* repeats the color and forms of the painting *Green Black Red Blue*, 1966 (EK#362; Coplans 1973, pl. 179).

Blue, Yellow and Red Squares 1970–71

Screenprint on Special Arjomari paper

Sheet: 34 x 82 (86.4 x 208.3)

Image: 24 x 72 (61.0 x 182.9)

Signed in pencil, lower right, under image: *Kelly*; numbered in pencil, lower right. Blind stamp, lower right: logo of Gemini G.E.L.,©. Inscribed in pencil on verso: *EK71–5000*. Stamped on verso: *Gemini G.E.L. Los Angeles, Calif.*

Edition: 50

Proofs: 9 AP, RTP, PPII, 3 GEL, C

Collaboration and supervision: Kenneth Tyler. Proofing, processing, and edition printing: Jeff Wasserman, Robert Dressen.

Published by Gemini G.E.L., Los Angeles (Gemini 264)

3 runs from 1 screen
1 yellow; screen, from hand-cut stencil
2 orange; same element as 1
3 blue; same element as 1

Literature: "Prints and Portfolios," *Print Collector's Newsletter* 1971, 35

Comments: *Blue, Yellow and Red Squares* repeats the forms but reverses the color sequence of the painting *Red Yellow Blue III*, 1966 (EK#367; Coplans 1973, pl. 190).

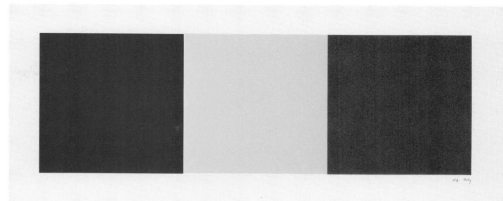

73

Blue/White/Red 1970–71

Lithograph on Special Arjomari paper

Sheet: 42½ x 30 (108.0 x 76.2)

Signed in pencil, lower right: *Kelly*; numbered in pencil, lower left. Blind stamp, lower right: logo of Gemini G.E.L., ©. Inscribed in pencil on verso: *EK70–332*. Stamped on verso: *Gemini G.E.L. Los Angeles, Calif.*

Edition: 54

Proofs: 9 AP, RTP, PPII, 3 GEL, C

Collaboration and supervision: Kenneth Tyler. Proofing, processing, and edition printing: Andrew Vlady, Ron Olds.

Published by Gemini G.E.L., Los Angeles (Gemini 265)

3 runs from 3 plates
1 white; aluminum photo plate, from hand-cut negative
2 blue; aluminum photo plate, from hand-cut negative
3 red; aluminum photo plate, from hand-cut negative

Comments: *Blue/White/Red* and seven other lithographs (cat. nos. 75, 77–79, 81–83) are related to the Series of Ten Lithographs (1970). Kelly conceived all eighteen prints in preparation for his first collaboration with the Gemini workshop in early 1970. He based the prints on paintings from the late 1960s. Ten completed prints from this project were gathered to constitute the Series of Ten Lithographs, Kelly's first publication with Gemini G.E.L. The remaining lithographs outside of this series were variously proofed, editioned, and published as individual prints between 1970 and 1972.

 Blue/White/Red is related to the trisected-parallelogram paintings of 1968. It repeats the forms but reverses the color sequence of the painting *Red White Blue*, 1968 (EK#407). In the print oeuvre, it is related to cat. nos. 61–63 and 75.

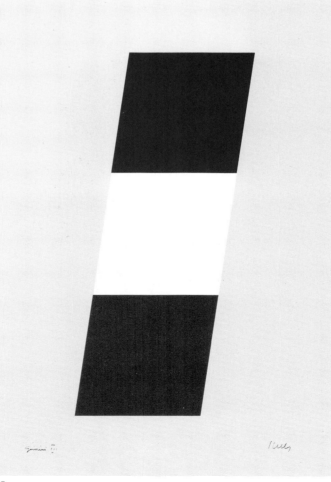

74

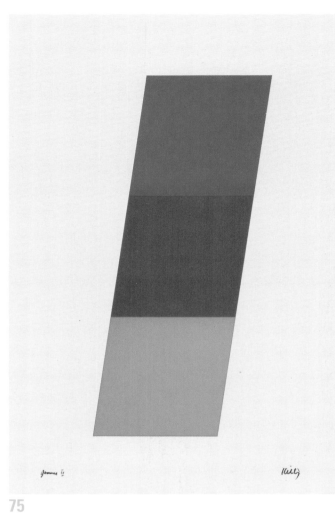

75

Blue/Red-Orange/Green 1970–71

Lithograph on Special Arjomari paper

Sheet: 42½ x 30 (108.0 x 76.2)

Signed in pencil, lower right: *Kelly;* numbered in pencil, lower left. Blind stamp, lower right: logo of Gemini G.E.L.,©. Inscribed in pencil on verso: *EK70–346.* Stamped on verso: *Gemini G.E.L. Los Angeles, Calif.*

Edition: 64

Proofs: 9 AP, TP, RTP, PPII, 3 GEL, C

Collaboration and supervision: Kenneth Tyler. Proofing and processing: Timothy Huchthausen, Dan Freeman, Ron McPherson, Stuart Henderson. Edition printing: Dan Freeman, Ron Adams.

Published by Gemini G.E.L., Los Angeles (Gemini 266)

3 runs from 3 plates

1 blue; aluminum photo plate, from hand-cut negative
2 red-orange; aluminum photo plate, from hand-cut negative
3 green; aluminum photo plate, from hand-cut negative

Literature: Fine 1984, no. 46, 128–30

Comments: *Blue/Red-Orange/Green* and seven other lithographs (cat. nos. 74, 77–79, 81–83) are related to the Series of Ten Lithographs (1970). Kelly conceived all eighteen prints in preparation for his first collaboration with the Gemini workshop in early 1970. He based the prints on paintings from the late 1960s. Ten completed prints from this project were gathered to constitute the Series of Ten Lithographs, Kelly's first publication with Gemini G.E.L. The remaining lithographs outside of this series were variously proofed, editioned, and published as individual prints between 1970 and 1972.
 Blue/Red-Orange/Green is a color variation of two trisected-parallelogram paintings of 1968, *Red Blue White* (EK#407) and *Red Yellow Blue* (EK#408) and of four lithographs, cat. nos. 61–63 and 74.

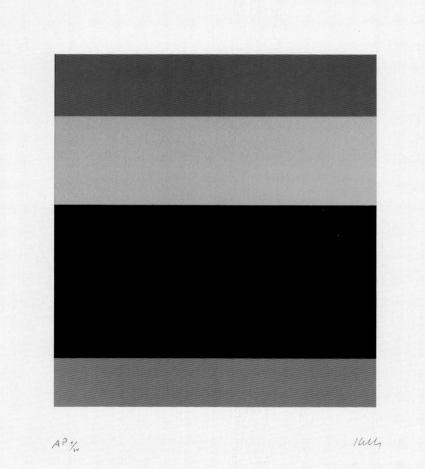

Blue/Green/Black/Red 1971

Lithograph on Arches Cover paper

Sheet: 30 x 27¾ (76.2 x 70.5)

Image: 22 x 19½ (55.9 x 49.5)

Signed in pencil, lower right: *Kelly;* numbered in pencil, lower left

Edition: 100

Proofs: 20 AP

Printed by Mourlot Graphics, Ltd., New York

Published by Paul Bianchini, New York

Printed from aluminum photo plates in blue, green, black, and red. Exact color sequence and number of plates unknown.

Literature: "Prints and Portfolios," *Print Collector's Newsletter* 1972, 128

Comments: This lithograph accompanied a one-hundred-copy deluxe edition of Diane Waldman's *Ellsworth Kelly: Drawings, Collages, Prints* (Greenwich, Connecticut: New York Graphic Society, 1971). It repeats the same color sequence but squares the curved shapes of the oil painting *West Coast Landscape,* 1960 (EK#259).

Black/Green II 1970–72

Lithograph on Special Arjomari paper

Sheet: 28½ x 24½ (72.4 x 62.2)

Image: 26 x 22 (66.0 x 55.9)

Signed in pencil, lower right: *Kelly*; numbered in pencil, lower left. Blind stamp, lower right: logo of Gemini G.E.L.,©. Inscribed in pencil on verso: *EK70–347*. Stamped on verso: *Gemini G.E.L. Los Angeles, Calif.*

Edition: 50

Proofs: 9 AP, RTP, PPII, 3 GEL, C

Collaboration and supervision: Kenneth Tyler. Proofing and processing: Stuart Henderson. Edition printing: Ron Adams, Lloyd Baggs.

Published by Gemini G.E.L., Los Angeles (Gemini 336)

2 runs from 2 plates

1 green; aluminum photo plate, from hand-cut negative
2 black; aluminum photo plate, from hand-cut negative

Comments: *Black/Green II* and seven other lithographs (cat. nos. 74, 75, 78, 79, and 81–83) are related to the Series of Ten Lithographs (1970). Kelly conceived all eighteen prints in preparation for his first collaboration with the Gemini workshop in early 1970. He based the prints on paintings from the late 1960s. Ten completed prints from this project were gathered to constitute the Series of Ten Lithographs, Kelly's first publication with Gemini G.E.L. The remaining lithographs outside of this series were variously proofed, editioned, and published as individual prints between 1970 and 1972.

 Black/Green II repeats the forms and colors of the painting *Black Green*, 1970 (EK#431). Both are related to a preliminary collage, *Study for Black Green*, 1970 (EK#70.03; Waldman 1971, pl. 140). The lithograph is a proportional variation of *Black/Green*, 1970, cat. no. 68.

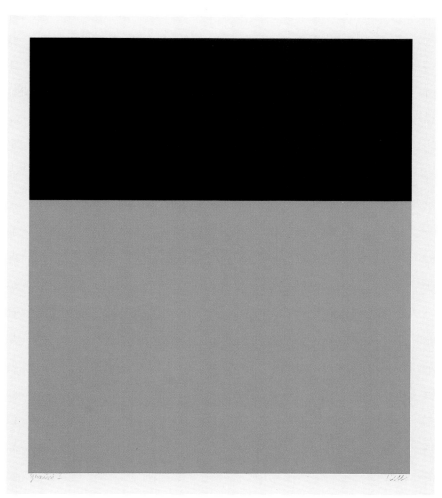

77

Green/Black 1970–72

Lithograph on Special Arjomari paper

Sheet: 40½ x 30¼ (102.9 x 76.8)

Signed in pencil, lower right: *Kelly*; numbered in pencil, lower left. Blind stamp, lower right: logo of Gemini G.E.L.,©. Inscribed in pencil on verso: EK70–334. Stamped on verso: *Gemini G.E.L. Los Angeles, Calif.*

Edition: 50

Proofs: 9 AP, RTP, PPII, 3 GEL, C

Collaboration and supervision: Kenneth Tyler. Proofing and processing: Ron McPherson, Dan Freeman, Paul Clinton, Serge Lozingot. Edition printing: Ron Olds, Ron Adams, Dan Freeman.

Published by Gemini G.E.L., Los Angeles (Gemini 337)

2 runs from 2 plates

1 green; aluminum photo plate, from hand-cut negative
2 black; aluminum photo plate, from hand-cut negative

Comments: *Green/Black* and seven other lithographs (cat. nos. 74, 75, 77, 79, and 81–83) are related to the Series of Ten Lithographs (1970). Kelly conceived all eighteen prints in preparation for his first collaboration with the Gemini workshop in early 1970. He based the prints on paintings from the late 1960s. Ten completed prints from this project were gathered to constitute the Series of Ten Lithographs, Kelly's first publication with Gemini G.E.L. The remaining lithographs outside of this series were variously proofed, editioned, and published as individual prints between 1970 and 1972.

 Green/Black is related to a series of bisected-parallelogram paintings of 1967–68. In particular, it repeats the composition and color of *Green Black*, 1968 (EK#399). In the print oeuvre, *Green/Black* is a color variation of *Orange/Green*, 1970, cat. no. 64.

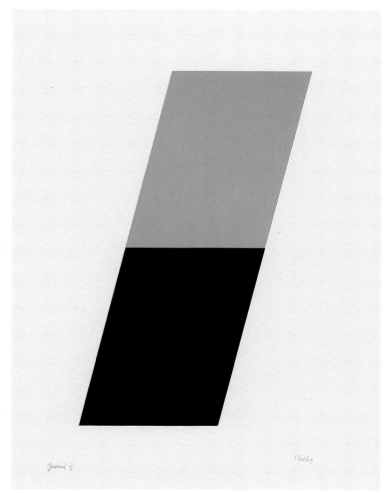

78

Black/Brown 1970–72

Lithograph on Special Arjomari paper

Sheet: 39½ x 37½ (100.3 x 95.3)

Signed in pencil, lower right: *Kelly*; numbered in pencil, lower left. Blind stamp, lower right: logo of Gemini G.E.L., ©. Inscribed in pencil on verso: *EK70–337*. Stamped on verso: *Gemini G.E.L. Los Angeles, Calif.*

Edition: 50

Proofs: 9 AP, TP, RTP, PPII, 3 GEL, C

Collaboration and supervision: Kenneth Tyler. Proofing and processing: Timothy Huchthausen, Dan Freeman, Stuart Henderson, Serge Lozingot, George Page. Edition printing: Dan Freeman, Stuart Henderson.

Published by Gemini G.E.L., Los Angeles (Gemini 338)

2 runs from 2 plates
1 brown; aluminum photo plate, from hand-cut negative
2 black; aluminum photo plate, from hand-cut negative

Comments: *Black/Brown* and seven other lithographs (cat. nos. 74, 75, 77, 78, and 81–83) are related to the Series of Ten Lithographs (1970). Kelly conceived all eighteen prints in preparation for his first collaboration with the Gemini workshop in early 1970. He based the prints on paintings from the late 1960s. Ten completed prints from this project were gathered to constitute the Series of Ten Lithographs, Kelly's first publication with Gemini G.E.L. The remaining lithographs outside of this series were variously proofed, editioned, and published as individual prints between 1970 and 1972.
 Black/Brown repeats the joined isoceles triangles of the painted-aluminum sculpture *Green Blue*, 1968 (EKS#414; Sims and Pulitzer 1982, no. 47). The image in *Black/Brown* is also related to the abutted color triangles of the paintings *Red Blue*, 1968 (EK#404), and *Green Blue*, 1969 (EK#424). In the print oeuvre, this lithograph is a color variation of cat. no. 65.

Black Curve 1970–72

Linecut with debossing on Special Arjomari paper

Sheet: 29 x 29 (73.7 x 73.7)

Signed in pencil, lower right: *Kelly*; numbered in pencil, lower left. Blind stamp, lower right: logo of Gemini G.E.L., ©. Inscribed in pencil on verso: *EK70–348*. Stamped on verso: *Gemini G.E.L. Los Angeles, Calif.*

Edition: 75

Proofs: 9 AP, TP, RTP, PPII, 3 GEL, C

Collaboration and supervision: Kenneth Tyler. Proofing, processing, and edition printing: George Page.

Published by Gemini G.E.L., Los Angeles (Gemini 339)

1 run from 1 plate
1 black; photo-etched magnesium plate, from hand-cut positive

Comments: *Black Curve* is not related to any painting. It was derived from a pencil-and-ink drawing entitled *Study for a Lithograph* (EK#70.4). The debossing of the image, which was not a separate operation, resulted from the vertical pressure of a platen press, which brought the etched plate into contact with the paper under great pressure.

Green/White 1970–72

Lithograph with embossing on Special Arjomari paper

Sheet: 27½ x 44⅜ (69.9 x 112.7)

Signed in pencil, lower right: *Kelly*; numbered in pencil, lower left. Blind stamp, lower right: logo of Gemini G.E.L., ©. Inscribed in pencil on verso: *EK70–338*. Stamped on verso: *Gemini G.E.L. Los Angeles, Calif.*

Edition: 60

Proofs: 9 AP, TP, RTP, PPII, 3 GEL, C

Collaboration and supervision: Kenneth Tyler. Proofing and processing: Ron McPherson, Stuart Henderson. Edition printing: Stuart Henderson, Ron Olds.

Published by Gemini G.E.L., Los Angeles (Gemini 340)

3 runs from 2 plates and 1 die

1 green; aluminum photo plate, from hand-cut negative
2 white; aluminum photo plate, from hand-cut negative
3 embossing (outline of image); sheet hand-burnished over plastic die

Comments: *Green/White* and seven other lithographs (cat. nos. 74, 75, 77–79, 82, and 83) are related to the Series of Ten Lithographs (1970). Kelly conceived all eighteen prints in preparation for his first collaboration with the Gemini workshop in early 1970. He based the prints on paintings from the late 1960s. Ten completed prints from this project were gathered to constitute the Series of Ten Lithographs, Kelly's first publication with Gemini G.E.L. The remaining lithographs outside of this series were variously proofed, editioned, and published as individual prints between 1970 and 1972.
 Green/White repeats the forms and colors of the painting *Green/White*, 1968 (EK#391; Coplans 1973, pl. 196).

81

Blue/Red-Orange 1970–72

Lithograph on Special Arjomari paper

Sheet: 36¼ x 36½ (92.1 x 92.7)

Signed in pencil, lower right: *Kelly*; numbered in pencil, lower left. Blind stamp, lower right: logo of Gemini G.E.L., ©. Inscribed in pencil on verso: *EK70–339*. Stamped on verso: *Gemini G.E.L. Los Angeles, Calif.*

Edition: 50

Proofs: 9 AP, TP, RTP, PPII, 3 GEL, C

Collaboration and supervision: Kenneth Tyler. Proofing and processing: Ron McPherson. Edition printing: Charles Ritt, Andrew Vlady, Paul Clinton, James Webb, Marie Porter, Henry Adams.

Published by Gemini G.E.L., Los Angeles (Gemini 341)

2 runs from 2 plates

1 orange; aluminum photo plate, from hand-cut negative
2 blue; aluminum photo plate, from hand-cut negative

Comments: *Blue/Red-Orange* and seven other lithographs (cat. nos. 74, 75, 77–79, 81, and 83) are related to the Series of Ten Lithographs (1970). Kelly conceived all eighteen prints in preparation for his first collaboration with the Gemini workshop in early 1970. He based the prints on paintings from the late 1960s. Ten completed prints from this project were gathered to constitute the Series of Ten Lithographs, Kelly's first publication with Gemini G.E.L. The remaining lithographs outside of this series were variously proofed, editioned, and published as individual prints between 1970 and 1972.
 There is no specific source in the paintings or sculpture for this lithograph.

82

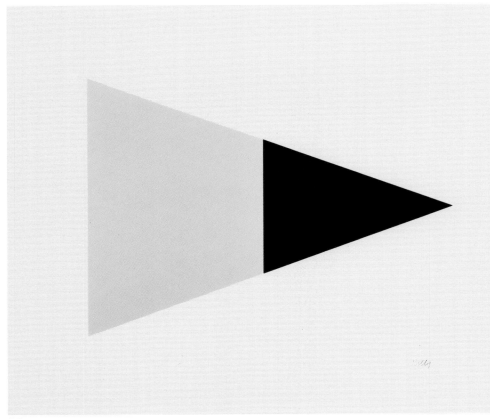

83

Black/Yellow 1970–72

Lithograph on Special Arjomari paper

Sheet: 34 x 39¾ (86.4 x 101.0)

Signed in pencil, lower right: *Kelly*; numbered in pencil, lower right. Blind stamp, lower right: logo of Gemini G.E.L., ©. Inscribed in pencil on verso: *EK70–342*. Stamped on verso: *Gemini G.E.L. Los Angeles, Calif.*

Edition: 55

Proofs: 9 AP, TP, RTP, PPII, 3 GEL, C

Collaboration and supervision: Kenneth Tyler. Proofing and processing: James Webb, Serge Lozingot. Edition printing: Ron Adams, Ron Olds.

Published by Gemini G.E.L., Los Angeles (Gemini 342)

2 runs from 2 plates

1 yellow; aluminum photo plate, from hand-cut negative
2 black; aluminum photo plate, from hand-cut negative

Comments: *Black/Yellow* and seven other lithographs (cat. nos. 74, 75, 77–79, 81, 82) are related to the Series of Ten Lithographs (1970). Kelly conceived all eighteen prints in preparation for his first collaboration with the Gemini workshop in early 1970. He based the prints on paintings from the late 1960s. Ten completed prints from this project were gathered to constitute the Series of Ten Lithographs, Kelly's first publication with Gemini G.E.L. The remaining lithographs outside of this series were variously proofed, editioned, and published as individual prints between 1970 and 1972.

Black/Yellow repeats the forms and colors of the painting *Black Yellow*, 1968 (EK#393; Coplans 1973, pl. 197).

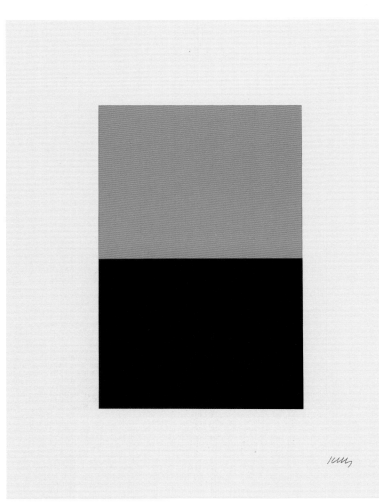

84

Untitled 1972

Lithograph on Rives BFK paper

Sheet: 34⅜ x 27 (87.3 x 68.6)

Image: 21½ x 14⅛ (54.6 x 35.9)

Signed in pencil, lower right: *Kelly*; numbered in pencil, lower left

Edition: 125

Proofs: 20 AP, WP, RTP, 2 PPII

Printed by Paul Narkiewicz, New York

Published by Brooke Alexander Inc., New York

2 runs from 2 plates

1 orange; aluminum photo plate, from hand-cut negative
2 black; aluminum photo plate, from hand-cut negative

Comments: This print is from the portfolio *Prints for Phoenix House*, which also includes the work of Joseph Cornell, Adolph Gottlieb, David Hockney, Alex Katz, R. B. Kitaj, and James Rosenquist. To raise funds on behalf of Phoenix House, a drug rehabilitation organization, Brooke Alexander, a New York art dealer, and Henry Geldzahler, curator of twentieth-century art at the Metropolitan Museum of Art, solicited prints from these seven artists, who donated them.

Untitled is related to the artist's series of double-rectangular panel paintings. In the print oeuvre it is related to cat. nos. 68, 77, and 92.

Two Whites and Black 1971-73

Screenprint with embossing on Special Arjomari paper

Sheet: 23¼ x 47¼ (59.1 x 120.0)

Image: 12 x 36 (30.5 x 91.4)

Signed in pencil, lower right, under image: *Kelly*; numbered in pencil, lower right, under image. Blind stamp, lower right: logo of Gemini G.E.L., ©. Inscribed in pencil on verso: *EK72–5029*. Stamped on verso: *Gemini G.E.L. Los Angeles, Calif.*

Edition: 75

Proofs: 9 AP, RTP, PPII, 3 GEL, C

Collaboration and supervision: Kenneth Tyler. Proofing, processing, and edition printing: Ron McPherson, Bruce Walker.

Published by Gemini G.E.L., Los Angeles (Gemini 458)

2 runs from 1 screen and 1 die
1 black; screen, from hand-cut stencil
2 embossing (outline of two unprinted white squares); sheet hand-burnished over plastic die

Comments: *Two Whites and Black* repeats the composition and colors of the painting *Black, Two Whites*, 1953 (EK#66A; Coplans 1973, pl. 90).

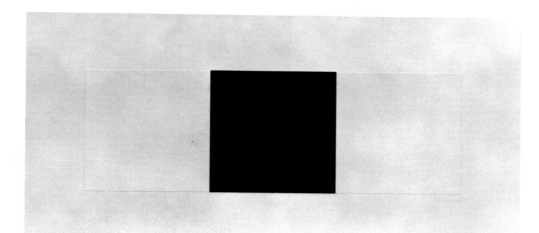

85

Two Blacks and White 1971-73

Screenprint with embossing on Special Arjomari paper

Sheet: 23¼ x 47¼ (59.1 x 120.0)

Image: 12 x 36 (30.5 x 91.4)

Signed in pencil, lower right, under image: *Kelly*; numbered in pencil, lower right, under image. Blind stamp, lower right: logo of Gemini G.E.L., ©. Inscribed in pencil on verso: *EK72–5031*. Stamped on verso: *Gemini G.E.L. Los Angeles, Calif.*

Edition: 75

Proofs: 9 AP, RTP, PPII, 3 GEL, C

Collaboration and supervision: Kenneth Tyler. Proofing, processing, and edition printing: Robert Knisel, Ron McPherson.

Published by Gemini G.E.L., Los Angeles (Gemini 459)

3 runs from 2 screens and 1 die
1 black; screen, from hand-cut stencil
2 black; screen, from hand-cut stencil
3 embossing (outline of unprinted white square); sheet hand-burnished over plastic die

Comments: *Two Blacks and White* repeats the composition and colors of the painting *White, Two Blacks*, 1953 (EK#66B; Coplans 1973, pl. 89).

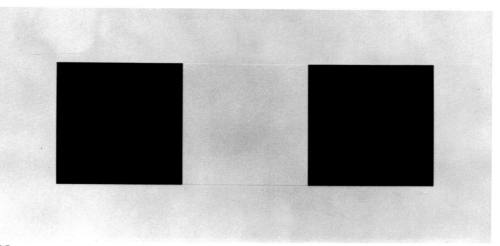

86

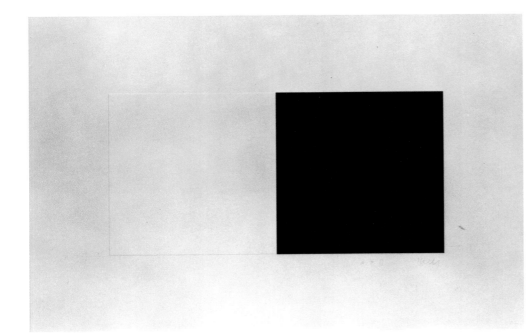

White and Black 1971–73

Screenprint with embossing

Sheet: 23½ x 35½ (59.7 x 90.2)

Image: 12 x 24 (30.5 x 61.0)

Signed in pencil, lower right, under image: *Kelly*; numbered in pencil, lower right, under image. Blind stamp, lower right: logo of Gemini G.E.L.,©. Inscribed in pencil on verso: *EK72–5030.* Stamped on verso: *Gemini G.E.L. Los Angeles, Calif.*

Edition: 75

Proofs: 9 AP, RTP, TP, PPII, 3 GEL, C

Collaboration and supervision: Kenneth Tyler. Proofing, processing, and edition printing: Robert Knisel, Ron McPherson.

Published by Gemini G.E.L., Los Angeles (Gemini 460)

2 runs from 1 screen and 1 die
1 black; screen, from hand-cut stencil
2 embossing (outline of unprinted white square); sheet hand-burnished over plastic die

Comments: *White and Black* repeats the composition but reverses the color sequence of the painting *Black White*, 1966 (EK#368; Coplans 1973, pl. 180).

87

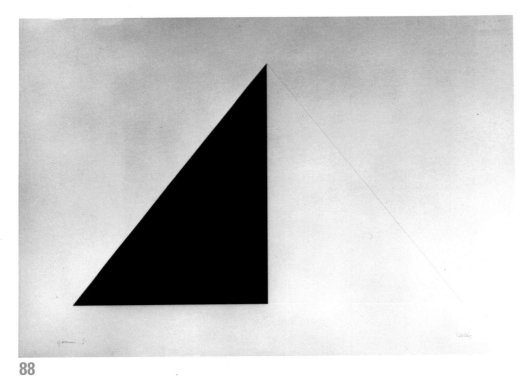

Black and White Pyramid 1973

Screenprint with embossing

Sheet: 32⁹⁄₁₆ x 46 (82.7 x 116.8)

Signed in pencil, lower right: *Kelly*; numbered in pencil, lower left. Blind stamp, lower right: logo of Gemini G.E.L., ©. Inscribed in pencil on verso: *EK72–5032.* Stamped on verso: *Gemini G.E.L. Los Angeles, Calif.*

Edition: 75

Proofs: 9 AP, RTP, PPII, 2 SP, 3 GEL, C

Collaboration and supervision: Kenneth Tyler. Proofing and processing: Kenneth Tyler. Edition printing: Gary Reams.

Published by Gemini G.E.L., Los Angeles (Gemini 461)

2 runs from 1 screen and 1 die
1 black; screen, from hand-cut stencil
2 embossing (outline of unprinted white right triangle); sheet hand-burnished over plastic die

Comments: *Black and White Pyramid* repeats the composition and colors of *Black White*, 1970 (EK#436; Coplans 1973, pl. 195).

88

White Bar with Black 1973

Lithograph with pencil on Special Arjomari paper

Sheet: 29⅝₆ x 42⅛ (74.5 x 107.0)

Signed in pencil, lower right: *Kelly*; numbered in pencil, lower left. Blind stamp, lower right: logo of Gemini G.E.L., ©. Inscribed in pencil on verso: *EK72–574*. Stamped on verso: *Gemini G.E.L. Los Angeles, Calif.*

Edition: 50

Proofs: 9 AP, TP, 2 CTP (with colored-pencil lines), RTP, PPII, SP, 3 GEL, C

Collaboration and supervision: Kenneth Tyler. Proofing, processing, and edition printing: Donna Rae Hirt, Jim Webb.

Published by Gemini G.E.L., Los Angeles (Gemini 464)

2 runs from 1 plate and pencil
1 black; aluminum photo plate, from hand-cut negative
2 lines; graphite pencil, hand-drawn by artist

Comments: *White Bar with Black* is related to a 1970–71 series of crossbar paintings. It is a proportional variation of the painting *Black and White Bar II*, 1971 (EK#499), and a color variation of the lithograph *Red-Orange over Black*, 1970 (cat. no. 71).

89

Spectrum 1973

Screenprint on Arches 88 paper

Sheet: 33⅞ x 83½ (86.0 x 212)

Image: 17½ x 67³⁄₁₆ (44.5 x 170.7)

Signed in pencil, lower right, under image: *Kelly*; numbered in pencil, lower left, under image. Blind stamp, lower right: logo of Gemini G.E.L., ©. Inscribed in pencil on verso: *EK73–5067*. Stamped on verso: *Gemini G.E.L. Los Angeles, Calif.*

Edition: 34

Proofs: 9 AP, 6 TP, RTP, PPII, 2 SP, 3 GEL, C

Collaboration and supervision: Kenneth Tyler. Proofing, processing, and edition printing: Robert Knisel, Gary Reams.

Published by Gemini G.E.L., Los Angeles (Gemini 465)

14 runs from 2 screens
1 white (interstice bars); screen 1, from hand-cut stencil
2 yellow-orange; screen 2, from hand-cut stencil
3 yellow-green; screen 2, from hand-cut stencil
4 purple; screen 2, from hand-cut stencil
5 blue-purple; screen 2, from hand-cut stencil
6 blue; screen 2, from hand-cut stencil
7 blue-green; screen 2, from hand-cut stencil
8 green; screen 2, from hand-cut stencil
9 light green; screen 2, from hand-cut stencil
10 red-purple; screen 2, from hand-cut stencil
11 magenta; screen 2, from hand-cut stencil
12 red; screen 2, from hand-cut stencil
13 red-orange; screen 2, from hand-cut stencil
14 orange; screen 2, from hand-cut stencil

Literature: Larson 1974, 12

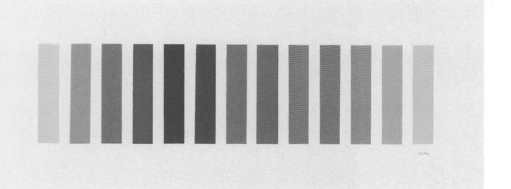

90

Comments: *Spectrum* is related to, but does not specifically reproduce, six Spectrum paintings that Kelly executed in 1953 and between 1967 and 1969 (EK#59, 379, 383, 384, 422, 423). Four of these paintings consist of joined panels. Two, like *Spectrum*, present a sequence of unjoined panels. All of the paintings and the screenprint bracket their exploration of the spectrum with yellow. In the screenprint, white interstice bars were printed to reduce paper glare that would interfere with the ability of the color bars to hold a single plane. The print is derived from a colored-paper collage *Study for "Spectrum"* (EK#72.04).

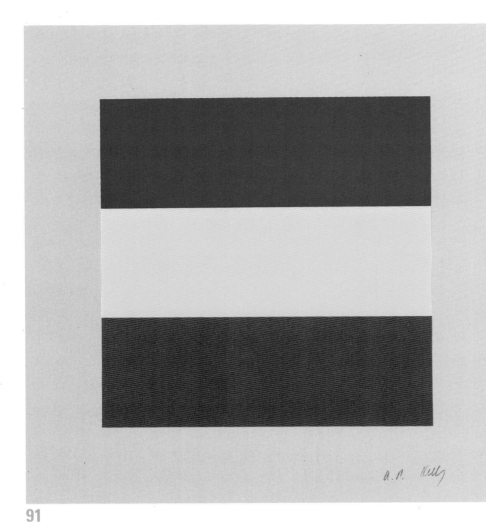

91

Blue/Yellow/Red (Untitled) 1970–73

Screenprint on Strathmore Fairfield Opaque Number 8 paper

Sheet: 26 x 25½ (66.0 x 64.8)

Image: 18 x 17½ (45.7 x 44.5)

Signed in pencil, lower right: *Kelly*; numbered in pencil, lower right

Edition: 100

Proofs: 10 AP, TP, 2 CTP, 4 WP

Printed by Maurel Studios, New York

Published by Harry N. Abrams, Inc., New York

Printed from screens and hand-cut stencils in red, blue, and yellow. Exact number and sequence of screens and stencils unknown.

Comments: This print, which was completed in 1971, accompanied a one-hundred-copy deluxe edition of John Coplans's *Ellsworth Kelly* (New York: Harry N. Abrams, Inc., 1973). It repeats the composition and colors of two paintings: one a larger version, *Blue Yellow Red*, 1971 (EK#451); the other a smaller version, *Blue Yellow Red*, 1972 (EK#470). The screenprint is also related in color and design to *Colored Paper Image XVI* (cat. no. 156). Kelly derived the paintings and prints from a series of collages done in Paris in 1953: *Study for "Train Landscape"* (EK#53.54), *Study for "Three Color Panels"* (EK#53.55), *Study for "Three Color Panels"* (EK#53.56), and *Study for "Three Color Panels"* (EK#53.57).

92

Untitled 1973

Screenprint on Rives BFK paper

Sheet: 12 x 9 (30.5 x 22.9)

Signed in pencil, lower right: *Kelly*; numbered in pencil, lower left. Stamped on verso: *Copyright 1973 by Ellsworth Kelly Printed at Styria Studio*

Edition: 300

Proofs: 25 AP

Printed by Styria Studio, Inc., New York

Published by Experiments in Art and Technology, Inc., New York

1 run from 1 screen
1 black; screen, from hand-cut stencil

Comments: This is one of thirty prints in the portfolio *Works by Artists in the New York Collection for Stockholm*, which also includes contributions by Lee Bontecou, Robert Breer, John Chamberlain, Walter de Maria, Jim Dine, Mark di Suvero, Oyvind Fahlström, Dan Flavin, Red Grooms, Hans Haacke, Alex Hay, Donald Judd, Sol LeWitt, Roy Lichtenstein, Robert Morris, Louise Nevelson, Kenneth Noland, Claes Oldenburg, Nam June Paik, Robert Rauschenberg, Larry Rivers, James Rosenquist, George Segal, Richard Serra, Keith Sonnier, Richard Stankiewicz, Cy Twombly, Andy Warhol, and Robert Whitman. The New York Collection for Stockholm is a collection of paintings and sculpture by New York artists that was initiated by Experiments in Art and Technology, Inc., for the Moderna Museet, Stockholm. The artists represented in the portfolio were selected for the Collection by K. G. P. Hultén. The project was directed by Billy Klüver.

Untitled is related to the artist's series of double horizontal panel paintings and, in the print oeuvre, to cat. nos. 68, 77, and 84.

In addition to the plant, flower, and fruit drawings that Kelly did with Maeght Editeur in the mid-1960s and with Tyler Graphics in the late 1970s, three botanical series of lithographic drawings were published by Gemini G.E.L. between 1973 and 1985. Leaves was the first, followed by Twelve Leaves, 1978 (cat. nos. 165–76), and the Series of Plant and Flower Lithographs, 1985 (cat. nos. 207–13). Kelly's lithographic studies of flora are all contour drawings, with the one exception in Leaves of *Grape Leaves III*, which consists of detached silhouetted shapes. This particular presentation of plant form has precedents in the artist's ink and pencil drawings. For the Grape Leaves sequence, which was drawn at his home studio in Spencertown, New York, Kelly began with pencil studies. In preparing the series in Los Angeles at Gemini, he added *Peach Branch*, which was drawn directly on transfer paper without any preliminary drawing.

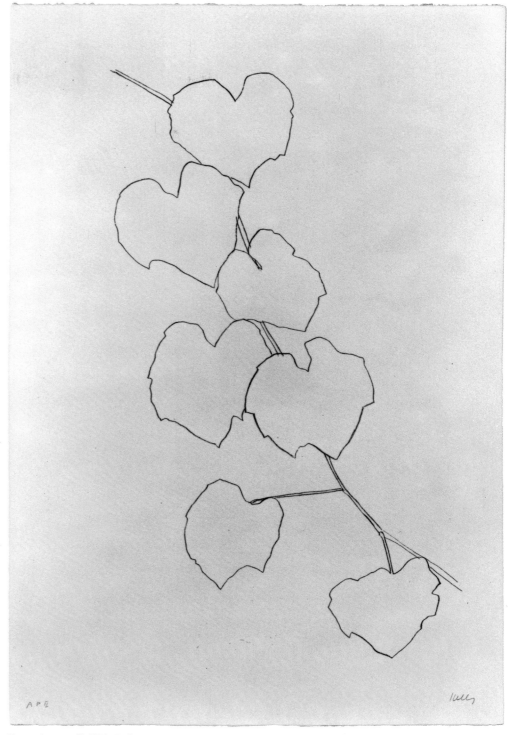

Grape Leaves II, 1973–74 (cat. no. 95)

93–96
LEAVES 1973–74

93

Peach Branch 1973–74

Transfer lithograph on 300-gram Arches paper

Sheet: 47¼ x 31½ (120.0 x 80.0)

Signed in pencil, lower right: *Kelly*; numbered in pencil, lower left. Blind stamp, lower right: logo of Gemini G.E.L., ©. Inscribed in pencil on verso: *EK73–586.* Stamped on verso: *Gemini G.E.L. Los Angeles, Calif.*

Edition: 50

Proofs: 15 AP, TP, RTP, PPII, 3 GEL, C

Collaboration and supervision: Kenneth Tyler. Proofing and processing: Kenneth Tyler, Bruce Porter. Edition printing: Bruce Porter, Robbin Geiger, Marie Porter.

Published by Gemini G.E.L., Los Angeles (Gemini 529)

1 run from 1 plate
1 black; aluminum plate, from lithographic-crayon drawing
 on transfer paper

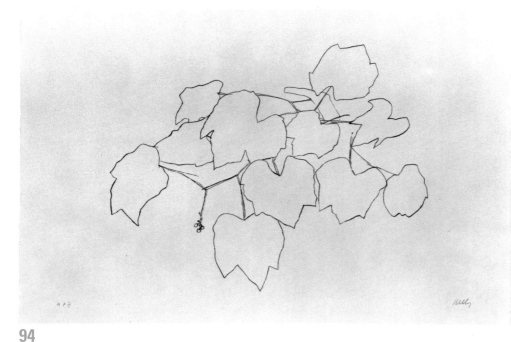

94

Grape Leaves I 1973–74

Transfer lithograph on 300-gram Arches paper

Sheet: 31½ x 47¼ (80.0 x 120.0)

Signed in pencil, lower right: *Kelly*; numbered in pencil, lower left. Blind stamp, lower right: logo of Gemini G.E.L., ©. Inscribed in pencil on verso: *EK73–587.* Stamped on verso: *Gemini G.E.L. Los Angeles, Calif.*

Proofs: 15 AP, TP, RTP, PPII, 3 GEL, C

Collaboration and supervision: Kenneth Tyler. Proofing and processing: Kenneth Tyler, Bruce Porter. Edition printing: Kenneth Tyler.

Published by Gemini G.E.L., Los Angeles (Gemini 530)

1 run from 1 plate
1 black; aluminum plate, from lithographic-crayon drawing
 on transfer paper

Grape Leaves II 1973–74

Transfer lithograph on 300-gram Arches paper

Sheet: 47¼ x 31½ (120.0 x 80.0)

Signed in pencil, lower right: *Kelly*; numbered in pencil, lower left. Blind stamp, lower right: logo of Gemini G.E.L., ©. Inscribed in pencil on verso: *EK73–588*. Stamped on verso: *Gemini G.E.L. Los Angeles, Calif.*

Edition: 50

Proofs: 15 AP, TP, RTP, PPII, 3 GEL, C

Collaboration and supervision: Kenneth Tyler. Proofing and processing: Kenneth Tyler, Bruce Porter. Edition printing: Dan Freeman, Edward Henderson.

Published by Gemini G.E.L., Los Angeles (Gemini 531)

1 run from 1 plate
1 black; aluminum plate, from lithographic-crayon drawing on transfer paper

Literature: Bell 1986, 9

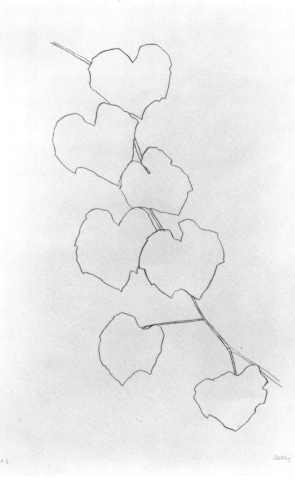

95

Grape Leaves III 1973–74

Transfer lithograph on 300-gram Arches paper

Sheet: 47¼ x 31½ (120.0 x 80.0)

Signed in pencil, lower right: *Kelly*; numbered in pencil, lower left. Blind stamp, lower right: logo of Gemini G.E.L., ©. Inscribed in pencil on verso: *EK73–589*. Stamped on verso: *Gemini G.E.L. Los Angeles, Calif.*

Edition: 50

Proofs: 15 AP, TP, RTP, PPII, 3 GEL, C

Collaboration and supervision: Kenneth Tyler. Proofing and processing: Kenneth Tyler, Bruce Porter. Edition printing: Jim Webb.

Published by Gemini G.E.L., Los Angeles (Gemini 532)

1 run from 1 plate
1 black; aluminum plate, from lithographic-crayon drawing on transfer paper

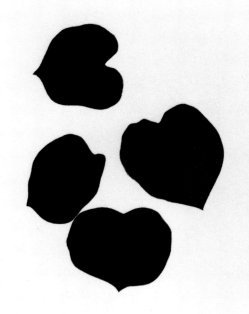

96

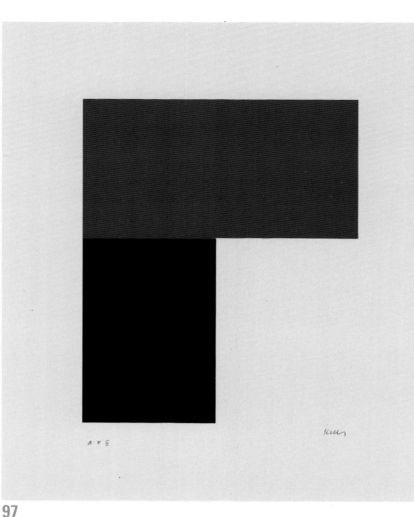

97

Blue with Black I 1972–74

Lithograph on Special Arjomari paper

Sheet: 42½ x 37⁵⁄₁₆ (108.0 x 94.8)

Signed in pencil, lower right: *Kelly*; numbered in pencil, lower left. Blind stamp, lower right: logo of Gemini G.E.L., ©. Inscribed in pencil on verso: *EK72–453*. Stamped on verso: *Gemini G.E.L. Los Angeles, Calif.*

Edition: 50

Proofs: 9 AP, TP, RTP, PPII, 3 GEL, C

Collaboration and supervision: Kenneth Tyler. Proofing and processing: Ron McPherson. Edition printing: Dan Freeman, Jim Webb.

Published by Gemini G.E.L., Los Angeles (Gemini 533)

2 runs from 2 plates
1 blue; aluminum photo plate, from hand-cut negative
2 black; aluminum photo plate, from hand-cut negative

Comments: *Blue with Black I* and *Blue with Black II* (cat. no. 98) are related to a series of works, entitled the Chatham Paintings, that the artist executed between 1971 and 1972. The compositional theme for the series was that of two rectangles abutting at right angles.

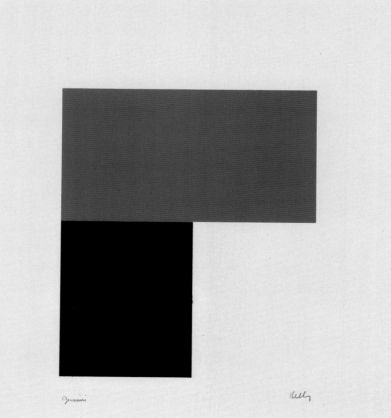

98

Blue with Black II 1972–74

Screenprint on Special Arjomari paper

Sheet: 30½ x 27⅞ (77.5 x 70.8)

Signed in pencil, lower right: *Kelly*; numbered in pencil, lower left. Blind stamp, lower right: logo of Gemini G.E.L., ©. Inscribed in pencil on verso: *EK72–5045*. Stamped on verso: *Gemini G.E.L. Los Angeles, Calif.*

Edition: 50

Proofs: 9 AP, TP, RTP, PPII, 3 GEL, C

Collaboration and supervision: Kenneth Tyler. Proofing, processing, and edition printing: Bob Dressen, Jeff Wasserman.

Published by Gemini G.E.L., Los Angeles (Gemini 534)

2 runs from 2 screens
1 blue; screen, from hand-cut stencil
2 black; screen, from hand-cut stencil

Comments: *Blue with Black II* restates *Blue with Black I* (cat. no. 97) on a smaller scale and in variant proportions and medium.

In April 1973 Kelly began work on three print series that reflected his renewed interest in curved form, recently, and for the first time since 1964, manifested in the paintings and sculpture. These three projects, the First, Second, and Third Curve Series, were published in 1974, 1975, and 1976 respectively. The First Curve Series is composed of three lithographs and two screenprints. The characteristic motif of the series, echoed in two prints in the Second Curve Series (cat. nos. 106, 109), is the circle section inscribed within a square or rectangle. In the First Curve Series the circle section may be inscribed with a pencil or an embossed line, the latter previously used in cat. nos. 85–87 to delineate white form on the paper without colored inks. The embossed or penciled line in this series, however, does not create shape so much as set up a rectangular format, the equivalent of the squared paintings from which the prints were derived.

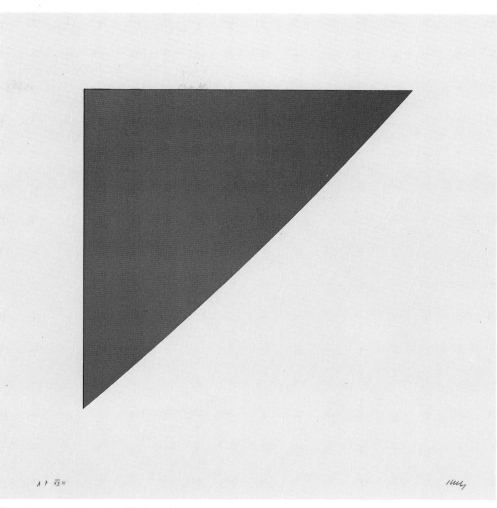

Green Curve with Radius of 20′, 1974 (cat. no. 101)

99–103

FIRST CURVE SERIES 1973–74

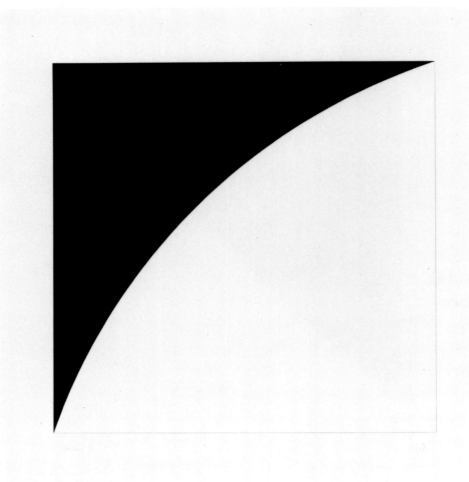

White Curve I (Black Curve I) 1973

Lithograph with pencil on Special Arjomari paper

Sheet: 34 x 34 (86.4 x 86.4)

Image: 26 x 26 (66.0 x 66.0)

Signed in pencil, lower right: *Kelly*; numbered in pencil, lower left. Blind stamp, lower right: logo of Gemini G.E.L., ©. Inscribed in pencil on verso: *EK72–572*. Stamped on verso: *Gemini G.E.L. Los Angeles, Calif.*

Edition: 49

Proofs: 9 AP, TP, 5 CTP (with colored-pencil lines), RTP, PPII, 3 GEL, C

Collaboration and supervision: Kenneth Tyler. Proofing, processing, and edition printing: Serge Lozingot.

Published by Gemini G.E.L., Los Angeles (Gemini 462)

2 runs from 1 plate and pencil

1 black; aluminum photo plate, from hand-cut negative
2 lines; graphite pencil, hand-drawn by artist

Comments: *White Curve I* is related to the right-angled circle-section paintings of 1972, which include *White Curve II* (EK#486), *White Curve III* (EK#496), and *White Curve V* (EK#497). The right-angle circle section was executed as a weathering steel sculpture, *Curve II*, 1973 (EK#S507; Sims and Pulitzer 1982, no. 55). In the print oeuvre, *White Curve I* is related to *Black Curve I* (cat. no. 100) and to the cover the artist designed for Eugene C. Goossen's *Ellsworth Kelly* (New York: Museum of Modern Art, 1973; App. If). The original published title of this print, *Black Curve I*, was an error. Kelly's curved shapes are always sections of circles and are thus convex, not concave. A similar titling mistake was made for cat. no. 100.

99

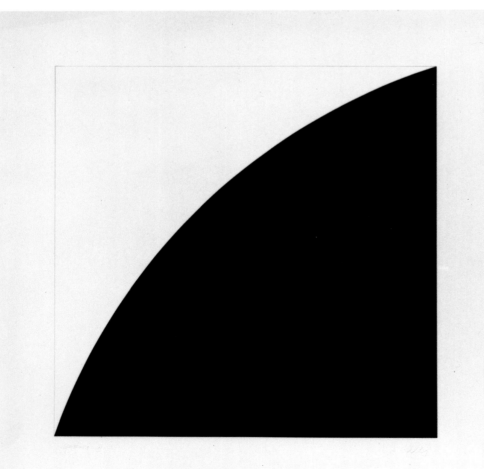

Black Curve I (White Curve I) 1973

Lithograph with pencil on Special Arjomari paper

Sheet: 34 x 34 (86.4 x 86.4)

Image: 26 x 26 (66.0 x 66.0)

Signed in pencil, lower right: *Kelly*; numbered in pencil, lower left. Blind stamp, lower right: logo of Gemini G.E.L., ©. Inscribed in pencil on verso: *EK72–573*. Stamped on verso: *Gemini G.E.L. Los Angeles, Calif.*

Edition: 49

Proofs: 9 AP, TP, 5 CTP (with colored-pencil lines), RTP, PPII, 3 GEL, C

Collaboration and supervision: Kenneth Tyler. Proofing, processing, and edition printing: Serge Lozingot.

Published by Gemini G.E.L., Los Angeles (Gemini 463)

2 runs from 1 plate and pencil

1 black; aluminum photo plate, from hand-cut negative
2 lines; graphite pencil, hand-drawn by artist

Comments: *Black Curve I* is related to the right-angled circle-section paintings of 1972, which include *Black Curve III* (EK#485). The right-angle circle section was also executed as a weathering steel sculpture in *Curve II*, 1973 (EK#S507; Sims and Pulitzer 1982, no. 55). In the print oeuvre, *Black Curve I* is related to *White Curve I* (cat. no. 99) and to the cover the artist designed for Eugene C. Goossen's *Ellsworth Kelly* (New York: Museum of Modern Art, 1973; App. If). The original published title of this print, *White Curve I*, was an error. Kelly's curved shapes are always sections of circles and are thus convex, not concave. A similar titling mistake was made for cat. no. 99.

100

Green Curve with Radius of 20′ 1974

Lithograph with embossing on Special Arjomari paper

Sheet: 36¾ x 36 (93.3 x 91.4)

Image: 24 x 24 (61.0 x 61.0)

Signed in pencil, lower right: *Kelly*; numbered in pencil, lower left. Blind stamp, lower right: logo of Gemini G.E.L., ©. Inscribed in pencil on verso: *EK74–653*. Stamped on verso: *Gemini G.E.L. Los Angeles, Calif.*

Edition: 100

Proofs: 25 AP, 3 TP, RTP, PPII, 3 GEL, C

Collaboration and supervision: Ron McPherson. Proofing and processing: Serge Lozingot, Ron McPherson. Edition printing: lithography: Charles Ritt; embossing: Ron McPherson.

Published by the Committee to Endow a Chair in Honor of Meyer Schapiro at Columbia University, New York (Gemini 527)

2 runs from 1 plate and 1 die
1 green; aluminum photo plate, from hand-cut negative
2 embossing (square outline of image area); sheet hand-burnished over plastic die

Literature: "Prints and Portfolios," *Print Collector's Newsletter* 1974b, 125; Konheim 1978, no. 52c, 62–63; Davies 1980, n.p.

Comments: *Green Curve with Radius of 20′* is one of twelve prints in the portfolio *For Meyer Schapiro*, published in 1974 to raise funds to endow a chair in honor of Professor Meyer Schapiro at Columbia University. The portfolio also included the work of Stanley William Hayter, Jasper Johns, Alexander Liberman, Roy Lichtenstein, André Masson, Robert Motherwell, Claes Oldenburg, Robert Rauschenberg, Saul Steinberg, Frank Stella, and Andy Warhol. Although this lithograph is related to the artist's inscribed circle-section paintings of 1972, there is no direct relationship between it and any one of the paintings. In the print oeuvre, *Green Curve with Radius of 20′* is related to *Black Curve I* and *White Curve I* (cat. nos. 99, 100), from the First Curve Series. It is also related to cat. nos. 106 and 109, from the Second Curve Series, and to cat. no. 147, from the Colored Paper Images series.

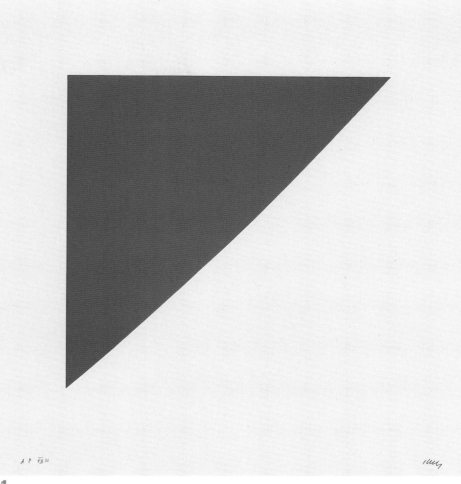

101

Large Black Curve 1974

Screenprint with embossing on Arches 88 paper

Sheet: 24⅛ x 84⅛ (61.3 x 213.7)

Image: 12⅝ x 72 (32.5 x 182.9)

Signed in pencil, lower right: *Kelly*; numbered in pencil, lower right. Blind stamp, lower right: logo of Gemini G.E.L., ©. Inscribed in pencil on verso: *EK74–5085*. Stamped on verso: *Gemini G.E.L. Los Angeles, Calif.*

Edition: 30

Proofs: 10 AP, 2 TP, 2 CTP, RTP, PPII, 3 GEL, C; screen and die used for cat. no. 103

Collaboration and supervision: Ron McPherson. Proofing and processing: Jeff Wasserman. Edition printing: Jeff Wasserman, Gary Reams. Embossing: Ron McPherson.

Published by Gemini G.E.L., Los Angeles (Gemini 535)

2 runs from 1 screen and 1 die
1 black; screen, from hand-cut stencil, same as cat. no. 103/1
2 embossing (rectangular image area); sheet hand-burnished over plastic die, same as cat. no. 103/2

Literature: "Prints and Portfolios," *Print Collector's Newsletter* 1975a, 44; Field, Melot, et al. 1981, 214; Fine 1984, 130

Comments: *Large Black Curve* and *Large Gray Curve* (cat. no. 103) are related in the ratios of their rectangular dimensions and circle sections to the 1973 paintings *Gray Curve I* (EK#499) and *Gray Curve II* (EK#500). The shape of the prints and paintings was realized in 1986 as an untitled stainless-steel sculpture (EK#S730).

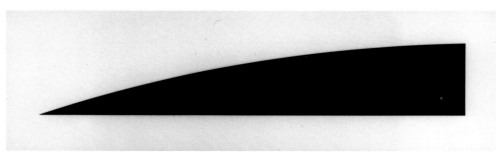

102

103

Large Gray Curve 1974

Screenprint with embossing on Arches 88 paper

Sheet: 24⅛ x 84⅛ (61.3 x 213.7)

Image: 12⅝ x 72 (32.1 x 182.9)

Signed in pencil, lower right: *Kelly*; numbered in pencil, lower right. Blind stamp, lower right: logo of Gemini G.E.L., ©. Inscribed in pencil on verso: *EK74–5087*. Stamped on verso: *Gemini G.E.L. Los Angeles, Calif.*

Edition: 30

Proofs: 10 AP, 4 TP, RTP, PPII, 3 GEL, C (documented with cat. no. 102); screen and die used for cat. no. 102

Collaboration and supervision: Ron McPherson. Proofing and processing: Jeff Wasserman. Edition printing: Jeff Wasserman, Robert Knisel. Embossing: Ron McPherson.

Published by Gemini G.E.L., Los Angeles (Gemini 536)

2 runs from 1 screen and 1 die
1 gray; screen, from hand-cut stencil, same as cat. no. 102/1
2 embossing (rectangular image area); sheet hand-burnished over plastic die, same as cat. no. 102/2

Literature: Fine 1984, no. 48, 130, 132

Comments: *Large Gray Curve* is a color variant of *Large Black Curve* (cat. no. 102).

Eleven lithographs and one screenprint make up the Second Curve Series. The inscribed circle sections of *Red Curve* (cat. no. 106) and *Black Variation I* (cat. no. 109) continue the motif that Kelly explored in the First Curve Series. *Two Yellows* (cat. no. 108) states the curve-sectioned rectangle that will be the basis for the black, white, and gray variations of the Third Curve Series (cat. nos. 116–39). The remaining nine prints in the Second Curve Series give the sequence its distinctive shapes: the squared ovoid and the slope-cornered square. These forms either float independently on the sheet or are inscribed with an embossed or debossed line, an element that had been utilized in the First Curve Series. In four of these prints, the ground established for a shape by the embossed line is printed in gray, the result of a "toned plate." This is an aluminum plate whose surface is not drawn upon with tusche but evenly abraded in a ball-graining machine. It is rubbed evenly with ink, hand wiped, and printed on a lithography press. The process approximates the effect of aquatint, although the use of the word "intaglio" in the original published series title and documentation is misleading, inasmuch as true intaglio plates and an etching press were not used.

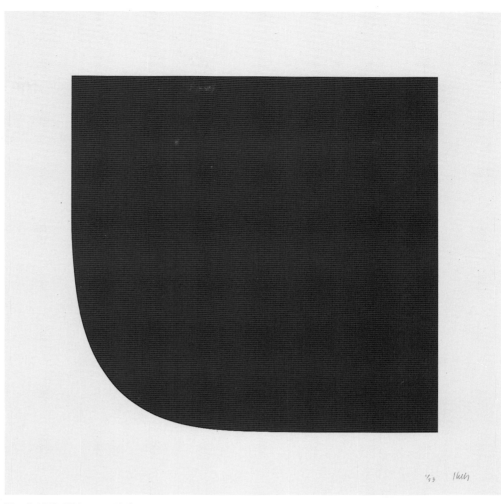

Blue I, 1973–75 (cat. no. 104)

104–15
SECOND CURVE SERIES
(Intaglio/Lithograph Series) 1973–75

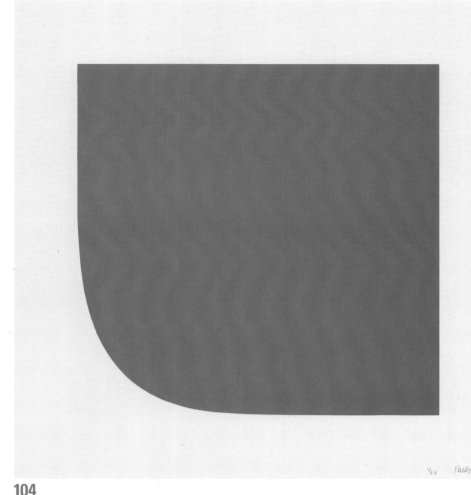

104

Blue I 1973–75

Lithograph with embossing on 300-gram Rives BFK paper

Sheet: 39¾ x 39 (101.0 x 99.1)

Image: 29 x 29 (73.7 x 73.7)

Signed in pencil, lower right: *Kelly*; numbered in pencil, lower right. Blind stamp, lower right: logo of Gemini G.E.L., ©. Inscribed in pencil on verso: *EK73–642*. Stamped on verso: *Gemini G.E.L. Los Angeles, Calif.*

Edition: 23

Proofs: 11 AP, RTP, PPII, 3 GEL, C; same plate used for cat. nos. 105, 113, 114; same die used for cat. no. 105

Collaboration and supervision: Ron McPherson. Proofing and processing: Ron McPherson, Jim Webb. Edition printing: Jim Webb, Barbara Thomason. Embossing: Edward Henderson.

Published by Gemini G.E.L., Los Angeles (Gemini 584)

2 runs from 1 plate and 1 die
1 blue-green; aluminum photo plate, from hand-cut negative, same as cat. nos. 105/1, 113/1, 114
2 embossing (square outline of image area); sheet hand-burnished over plastic die, same as cat. no. 105/2

Comments: *Blue I* is related to the painting *Blue Curve*, 1969 (EK#444). It is a color variation of three other prints in the Second Curve Series: cat. nos. 105, 113, and 114.

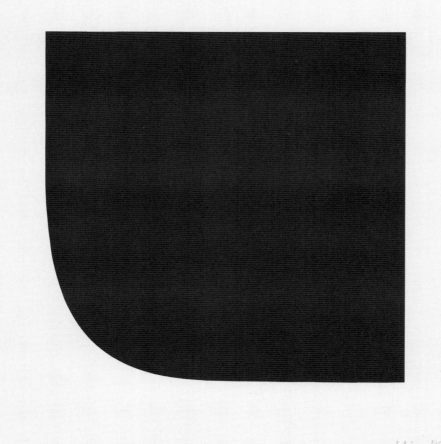

105

Blue II 1973–75

Lithograph with embossing on 300-gram Rives BFK paper

Sheet: 39¾ x 39 (101.0 x 99.1)

Image: 29 x 29 (73.7 x 73.7)

Signed in pencil, lower right: *Kelly*; numbered in pencil, lower right. Blind stamp, lower right: logo of Gemini G.E.L., ©. Inscribed in pencil on verso: *EK73–643*. Stamped on verso: *Gemini G.E.L. Los Angeles, Calif.*

Edition: 23

Proofs: 11 AP, RTP, PPII, 3 GEL, C (documented with cat. no. 104); same plate used for cat. nos. 104, 113, 114; same die used for cat. no. 104

Collaboration and supervision: Ron McPherson. Proofing and processing: Jim Webb, Barbara Thomason. Edition printing: Barbara Thomason, Jim Webb. Embossing: Edward Henderson.

Published by Gemini G.E.L., Los Angeles (Gemini 585)

2 runs from 1 plate and 1 die
1 blue; aluminum photo plate, from hand-cut negative, same as cat. nos. 104/1, 113/1, 114
2 embossing (square outline of image area); sheet hand-burnished over plastic die, same as cat. no. 104/2

Comments: *Blue II* is related to the painting *Blue Curve*, 1969 (EK#444). It is a color variation of three other prints in the Second Curve Series: cat. nos. 104, 113, and 114.

Red Curve (Radius of 8′) 1973–75

Lithograph with embossing on 300-gram Rives BFK paper

Sheet: 43 x 34 (109.2 x 86.3)

Image: 32¼ x 24 (81.9 x 61.0)

Signed in pencil, lower right: *Kelly*; numbered in pencil, lower right. Blind stamp, lower right: logo of Gemini G.E.L., ©. Inscribed in pencil on verso: *EK73–644*. Stamped on verso: *Gemini G.E.L. Los Angeles, Calif.*

Edition: 50

Proofs: 11 AP, RTP, PPII, SP, 3 GEL, C; same plate used for cat. no. 109

Collaboration and supervision: Ron McPherson. Proofing and processing: Jim Webb, Edward Henderson, Serge Lozingot, Ron McPherson. Edition printing: Edward Henderson, John Roberts, Charles Ritt, Jim Webb, Serge Lozingot. Embossing: Edward Henderson.

Published by Gemini G.E.L., Los Angeles (Gemini 586)

2 runs from 1 plate and 1 die
1 red; aluminum photo plate, from hand-cut negative, same as cat. no. 109/1
2 embossing (rectangular outline of image area); sheet hand-burnished over plastic die

Literature: "Prints and Portfolios," *Print Collector's Newsletter* 1975b, 73

Comments: *Red Curve* was the basis for the painting *Red Curve VII*, 1982 (EK#646). It is an embossed color variation of the debossed *Black Variation I* (cat. no. 109). The motif of the circle section inscribed with a drawn or embossed line was the basis for the First Curve Series (cat. nos. 99–103). The format of a rectangle bisected at opposite corners by a curved line later appears in cat. no. 147, from the Colored Paper Images series.

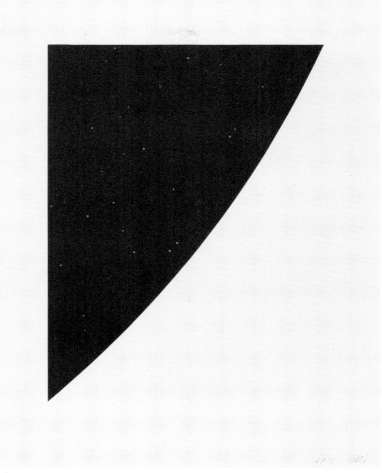

106

Yellow 1973–75

Lithograph on 300-gram Rives BFK paper

Sheet: 38⅝ x 38 (98.1 x 96.5)

Signed in pencil, lower right: *Kelly*; numbered in pencil, lower right. Blind stamp, lower right: logo of Gemini G.E.L., ©. Inscribed in pencil on verso: *EK73–645*. Stamped on verso: *Gemini G.E.L. Los Angeles, Calif.*

Edition: 48

Proofs: 11 AP, RTP, PPII, 3 GEL, C

Collaboration and supervision: Ron McPherson. Proofing and processing: Ron McPherson, Charles Ritt. Edition printing: Charles Ritt, Barbara Thomason.

Published by Gemini G.E.L., Los Angeles (Gemini 587)

1 run from 1 plate
1 yellow; aluminum photo plate, from hand-cut negative, same as cat. nos. 110, 111

Literature: Fine 1984, no. 49, 132–34

Comments: *Yellow* repeats the color shape of the painting *Yellow White*, 1966 (EK#364), which was derived from the collage *Study for "Yellow White,"* 1963 (EK#63.11; Waldman 1971, pl. 131). The lithograph also repeats the shape of the weathering steel sculpture *Stele II*, 1973 (EK#S509; Sims and Pulitzer 1982, no. 57). Within the Second Curve Series, *Yellow* is a color variation of cat. nos. 110 and 112. Its flattened ovoid form recurs in cat. nos. 111 and 115 but is there inscribed within a debossed square outline.

107

108

Two Yellows 1973–75

Lithograph on 300-gram Rives BFK paper

Sheet: 36⁷⁄₁₆ x 33¹⁄₁₆ (92.6 x 84.0)

Image: 26 x 23¼ (66.0 x 59.1)

Signed in pencil, lower right: *Kelly*; numbered in pencil, lower right. Blind stamp, lower right: logo of Gemini G.E.L., ©. Inscribed in pencil on verso: *EK73–646*. Stamped on verso: *Gemini G.E.L. Los Angeles, Calif.*

Edition: 44

Proofs: 11 AP, RTP, PPII, 3 GEL, C

Collaboration and supervision: Ron McPherson. Proofing and processing: Ron McPherson. Edition printing: Robin Geiger, assisted by Charles Ritt, Jim Webb.

Published by Gemini G.E.L., Los Angeles (Gemini 588)

2 runs from 2 plates
1 yellow (lower); aluminum photo plate, from hand-cut negative
2 chrome yellow; aluminum photo plate, from hand-cut negative

Comments: *Two Yellows* is related in its composition to a series of paintings, executed by the artist during the early 1970s, in which a single-panel rectangular canvas is bisected by a curved line. In the print oeuvre, this lithograph, with its vertical rectangle bisected by a convex line, is a color variation of cat. nos. 116, 117, 122, 123, 128, 129, 134, and 137, from the Third Curve Series.

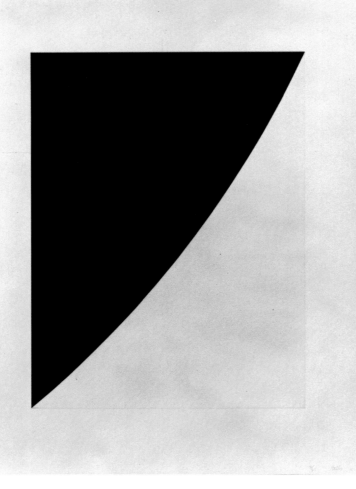

109

Black Variation I 1973–75

Lithograph with intaglio and debossing on 300-gram Rives BFK paper

Sheet: 42 x 34 (106.7 x 86.4)

Image: 32¼ x 24 (81.9 x 61.0)

Signed in pencil, lower right: *Kelly*; numbered in pencil, lower right. Blind stamp, lower right: logo of Gemini G.E.L., ©. Inscribed in pencil on verso: *EK74–646*. Stamped on verso: *Gemini G.E.L. Los Angeles, Calif.*

Edition: 25

Proofs: 11 AP, RTP, PPII, 3 GEL, C (documented with cat. no. 106); plate 1 used for cat. no. 106

Collaboration and supervision: Ron McPherson. Proofing and processing: Ron McPherson, Charles Ritt. Edition printing: Charles Ritt, Barbara Thomason. Debossing: Edward Henderson.

Published by Gemini G.E.L., Los Angeles (Gemini 589)

3 runs from 2 plates and 1 die
1 black; aluminum photo plate from hand-cut negative, same as cat. no. 106/1
2 light gray tone; ball-grained aluminum plate, wiped
3 debossing (rectangular outline of image area); sheet hand-burnished over plastic die

Literature: "Prints and Portfolios," *Print Collector's Newsletter* 1975b, 73

Comments: *Black Variation I* repeats the composition and color of the painting *Black Curve VII*, 1976 (EK#533). Within the Second Curve Series, it is a debossed color variation of *Red Curve (Radius 8')*, cat. no. 106. The motif of the circle section inscribed by a drawn or embossed line was the basis for the First Curve Series (cat. nos. 99–103).

Black Variation II 1973–75

Lithograph on 300-gram Rives BFK paper

Sheet: 38⅝ x 38 (98.1 x 96.5)

Signed in pencil, lower right: *Kelly*; numbered in pencil, lower right. Blind stamp, lower right: logo of Gemini G.E.L., ©. Inscribed in pencil on verso: *EK74–677*. Stamped on verso: *Gemini G.E.L. Los Angeles, Calif.*

Edition: 24

Proofs: 11 AP, RTP, PPII, 3 GEL, C (documented with cat. no. 107); same plate used for cat. nos. 107, 111

Collaboration and supervision: Ron McPherson. Proofing and processing: Edward Henderson, Barbara Thomason, Charles Ritt, Jim Webb. Edition printing: Charles Ritt, Jim Webb.

Published by Gemini G.E.L., Los Angeles (Gemini 590)

1 run from 1 plate
1 black; aluminum photo plate, from hand-cut negative, same as cat. nos. 107, 111

Literature: Fine 1984, 132

Comments: *Black Variations II, III, IV,* and *Gray Variation* (cat. nos. 110–12, 115) repeat the shape of the lithograph *Yellow* (cat. no. 107), which was derived from the painting *Yellow White*, 1963 (EK#364). In *Black Variation III* and *Gray Variation* the shape is overprinted with a gray-toned plate and inscribed within a debossed square outline. The flattened ovoid of the prints and painting was also realized as a weathering steel sculpture, *Stele II*, 1973 (EK#S509; Sims and Pulitzer 1982, no. 57).

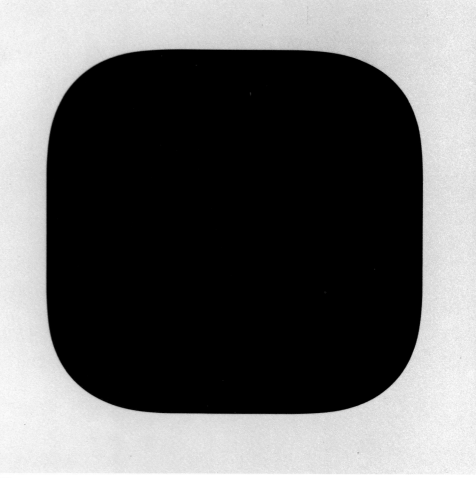

110

Black Variation III 1973–75

Lithograph with intaglio and debossing on 300-gram Rives BFK paper

Sheet: 39¾ x 39 (101.0 x 99.1)

Image: 29 x 29 (73.7 x 73.7)

Signed in pencil, lower right: *Kelly*; numbered in pencil, lower right. Blind stamp, lower right: logo of Gemini G.E.L., ©. Inscribed in pencil on verso: *EK74–678*. Stamped on verso: *Gemini G.E.L. Los Angeles, Calif.*

Edition: 25

Proofs: 11 AP, RTP, PPII, 3 GEL, C (documented with cat. no. 107); plate 1 used for cat. nos. 107, 110; plate 2 used for cat. no. 115

Collaboration and supervision: Ron McPherson. Proofing and processing: Ron McPherson, Anthony Zepeda, Charles Ritt. Edition printing: Dan Freeman, Anthony Zepeda. Debossing: Dan Freeman.

Published by Gemini G.E.L., Los Angeles (Gemini 591)

3 runs from 2 plates and 1 die
1 black; aluminum photo plate, from hand-cut negative, same as cat. nos. 107, 110
2 light-gray tone (over 1, square image area); aluminum ball-grained plate, wiped, same as cat. no. 115/1
3 debossing (square outline of image area); sheet hand-burnished over plastic die

Literature: Fine 1984, 132

Comments: *Black Variations II, III, IV, and Gray Variation* (cat. nos. 110–12, 115) repeat the shape of the lithograph *Yellow* (cat. no. 107), which was derived from the painting *Yellow White*, 1963 (EK#364). In *Black Variation III* and *Gray Variation* the shape is overprinted with a gray-toned plate and inscribed within a debossed square outline. The flattened ovoid of the prints and painting was also realized as a weathering steel sculpture, *Stele II*, 1973 (EK#S509; Sims and Pulitzer 1982, no. 57).

111

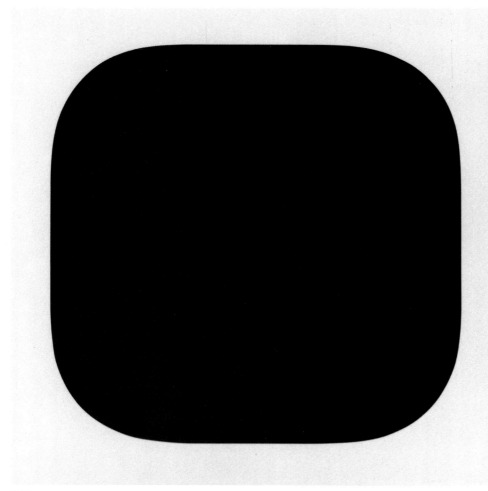

Black Variation IV 1973–75

Screenprint on 300-gram Rives BFK paper

Sheet: 45¾ x 45 (116.2 x 114.3)

Signed in pencil, lower right: *Kelly*; numbered in pencil, lower right. Blind stamp, lower right: logo of Gemini G.E.L., ©. Inscribed in pencil on verso: *EK75–5123*. Stamped on verso: *Gemini G.E.L. Los Angeles, Calif.*

Edition: 25

Proofs: 11 AP, RTP, PPII, 3 GEL, C

Collaboration and supervision: Jeff Wasserman, Ron McPherson. Proofing and processing: Jeff Wasserman, Robert Knisel. Edition printing: Jeff Wasserman, Robert Knisel.

Published by Gemini G.E.L., Los Angeles (Gemini 592)

1 run from 1 screen

1 black; screen, from hand-cut stencil

Comments: *Black Variations II, III, IV*, and *Gray Variation* (cat. nos. 110–12, 115) repeat the shape of the lithograph *Yellow* (cat. no. 107), which was derived from the painting *Yellow White*, 1963 (EK#364). In *Black Variation III* and *Gray Variation* the shape is overprinted with a gray-toned plate and inscribed within a debossed square outline. The flattened ovoid of the prints and painting was also realized as a weathering steel sculpture, *Stele II*, 1973 (EK#S509; Sims and Pulitzer 1982, no. 57). Although related in its shape to other lithographs in the Second Curve Series, *Black Variation IV* differs in its larger scale and screenprint medium.

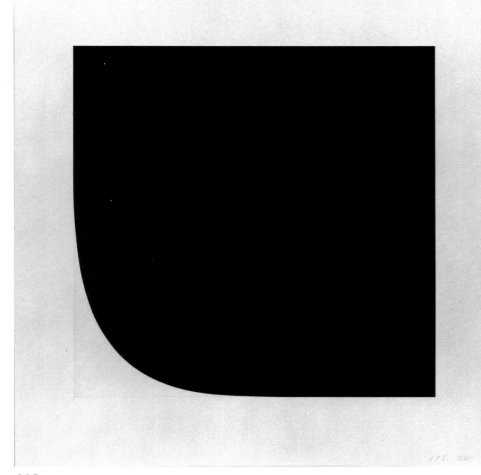

Black Variation V 1973–75

Lithograph with intaglio and debossing on 300-gram Rives BFK paper

Sheet: 39½ x 38½ (100.3 x 97.8)

Image: 29 x 29 (73.7 x 73.7)

Signed in pencil, lower right: *Kelly*; numbered in pencil, lower right. Blind stamp, lower right: logo of Gemini G.E.L., ©. Inscribed in pencil on verso: *EK74–679*. Stamped on verso: *Gemini G.E.L. Los Angeles, Calif.*

Edition: 21

Proofs: 11 AP, RTP, PPII, 3 GEL, C (documented with cat. no. 104); plate 1 used for cat. nos. 104, 105, 114

Collaboration and supervision: Ron McPherson. Proofing and processing: Barbara Thomason, Jim Webb. Edition printing: Barbara Thomason, Jim Webb. Debossing: Barbara Thomason.

Published by Gemini G.E.L., Los Angeles (Gemini 593)

3 runs from 2 plates and 1 die

1 black; aluminum photo plate, from hand-cut negative, same as cat. nos. 104/1, 105/1, 114
2 light-gray tone (over 1, square image area); aluminum ball-grained plate, wiped
3 debossing (square outline of image area); sheet hand-burnished over plastic die

Comments: *Black Variation V* is related to the painting *Blue Curve*, 1969 (EK#444). In the print oeuvre, its shape is a color variation of *Blue I* and *Blue II* (cat. nos. 104, 105). Although repeating the colors and shape of *Black Variation VI* (cat. no. 114), it differs in the addition of an overprinted toned plate and a debossed square line within which the black form is inscribed.

Black Variation VI 1973–75

Lithograph on 300-gram Rives BFK paper

Sheet: 39¼ x 38½ (99.7 x 97.8)

Signed in pencil, lower right: *Kelly*; numbered in pencil, lower right. Blind stamp, lower right: logo of Gemini G.E.L., ©. Inscribed in pencil on verso: *EK74–680*. Stamped on verso: *Gemini G.E.L. Los Angeles, Calif.*

Edition: 25

Proofs: 11 AP, RTP, PPII, 3 GEL, C (documented with cat. no. 104); same plate used for cat. nos. 104, 105, 113

Collaboration and supervision: Ron McPherson. Proofing and processing: Jim Webb, Charles Ritt. Edition printing: Jim Webb, Charles Ritt.

Published by Gemini G.E.L., Los Angeles (Gemini 594)

1 run from 1 plate
1 black; aluminum photo plate, from hand-cut negative, same as cat. nos. 104/1, 105/1, 113/1

Comments: *Black Variation VI* is related to the painting *Blue Curve*, 1969 (EK#444). In the print oeuvre, its shape is a color variation of *Blue I* and *Blue II* (cat. nos. 104, 105). Although repeating the colors and shape of *Black Variation V* (cat. no. 113), it differs in the absence of an overprinted toned plate and a debossed square line within which the black form is inscribed.

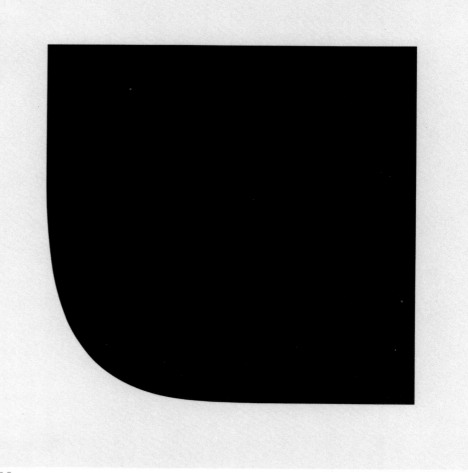

114

Gray Variation 1973–75

Lithograph with debossing on 300-gram Rives BFK paper

Sheet: 39½ x 39 (100.3 x 99.1)

Image: 29 x 29 (73.7 x 73.7)

Signed in pencil, lower right: *Kelly*; numbered in pencil, lower right. Blind stamp, lower right: logo of Gemini G.E.L., ©. Inscribed in pencil on verso: *EK75–651*. Stamped on verso: *Gemini G.E.L. Los Angeles, Calif.*

Edition: 27

Proofs: 11 AP, RTP, PPII, 3 GEL, C (documented with cat. no. 107); same plate used for cat. no. 111

Collaboration and supervision: Ron McPherson. Proofing and processing: Dan Freeman, Ron McPherson, Anthony Zepeda. Edition printing: Robert Bigelow, Serge Lozingot, Barbara Thomason. Debossing: Robert Bigelow, Barbara Thomason.

Published by Gemini G.E.L., Los Angeles (Gemini 595)

2 runs from 1 plate and 1 die
1 light-gray tone (square image area); aluminum ball-grained plate, wiped, same as cat. no. 111/2
2 debossing (outline of ovoid shape); sheet hand-burnished over plastic die

Comments: *Black Variations II, III, IV,* and *Gray Variation* (cat. nos, 110–12, 115) repeat the shape of the lithograph *Yellow* (cat. no. 107), which was derived from the painting *Yellow White*, 1963 (EK#364). In *Black Variation III* and *Gray Variation* the shape is overprinted with a gray-toned plate and inscribed within a debossed square outline. The flattened ovoid of the prints and painting was also realized as a weathering steel sculpture, *Stele II*, 1973 (EK#S509; Sims and Pulitzer 1982, no. 57). Although related in its shape to other prints in the Second Curve Series, *Gray Variation*, like *Black Variation III*, differs in the addition of an overprinted toned plate that inscribes the flattened ovoid, which is delineated by a debossed line.

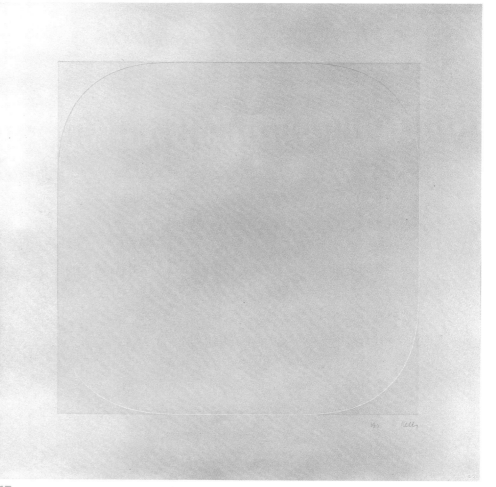

115

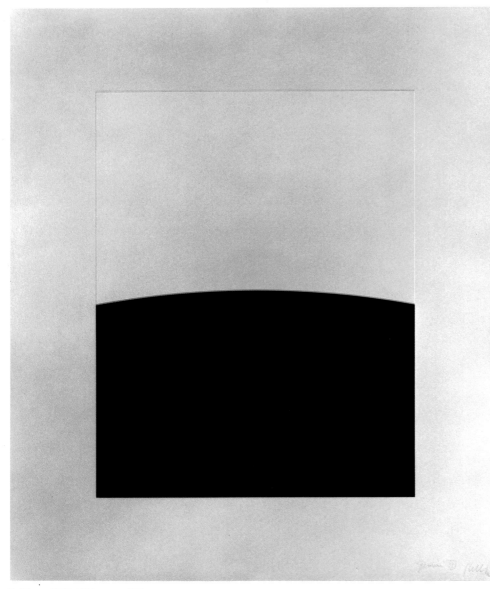

Poitiers, 1973–76 (cat. no. 117)

The Third Curve Series, the last in a sequence of three series devoted to and reflective of Kelly's renewed interest, during the 1970s, in curvilinear forms, is related to a set of paintings that Kelly executed during the early part of that decade. The basic configuration is a rectangle that is evenly divided by a curved line, a format that had earlier appeared in the lithograph *Two Yellows* (cat. no. 108), from the Second Curve Series. Of the two possible vertical rectangles, one with a concave curve, the other with a convex, Kelly preferred the former. The Third Curve Series is an exploration of this configuration in a set of variations that play upon vertical and horizontal orientations of the sheet, embossed and debossed shape, and various combinations of black, white, and gray. Of the myriad possibilities, Kelly selected twenty-four for editioning. As he had in the earlier First and Second Curve Series, he again relied on plastic dies for hand embossing and debossing and on ball-grained aluminum plates for gray-toned flats. In some cases documentation is not available for the identity of the embosser.

The names of the prints designate Romanesque sites in France and Spain that Kelly has visited. They are appropriate references for prints whose curved shapes evoke the characteristic Roman arch of eleventh- and twelfth-century Western architecture.

Literature: *Ellsworth Kelly: Third Curve Series*, 1976; "Prints and Photographs," *Print Collector's Newsletter* 1976, 54; Castleman 1985, 105

116–39
THIRD CURVE SERIES 1973–76

Conques 1973–76

Lithograph with embossing on 300-gram Rives BFK paper

Sheet: 41 x 34 (104.1 x 86.4)

Image: 29 x 22 (73.7 x 55.9)

Signed in pencil, lower right: *Kelly*; numbered in pencil, lower right. Blind stamp, lower right: logo of Gemini G.E.L., ©. Inscribed in pencil on verso: *EK73–652*. Stamped on verso: *Gemini G.E.L. Los Angeles, Calif.*

Edition: 16

Proofs: 9 AP, RTP, PPII, SP, 3 GEL, C; plate used for cat. nos. 118, 119, 122, 124, 125, 128, 130, 131

Collaboration and supervision: Ron McPherson. Proofing, processing, and edition printing: Dan Freeman, Barbara Thomason. Embossing: Serge Lozingot.

Published by Gemini G.E.L., Los Angeles (Gemini 672)

2 runs from 1 plate and 1 die

1 black; aluminum photo plate, from hand-cut negative, same as cat. nos. 118/1, 119/1, 122/1, 124/1, 125/1, 128/1, 130/1, 131/1
2 embossing (outline of unprinted image area); sheet hand-burnished over plastic die

Comments: *Conques* repeats the composition and colors of the painting *White Curve VIII*, 1976 (EK#545), and is a color variation of cat. no. 108, from the Second Curve Series.

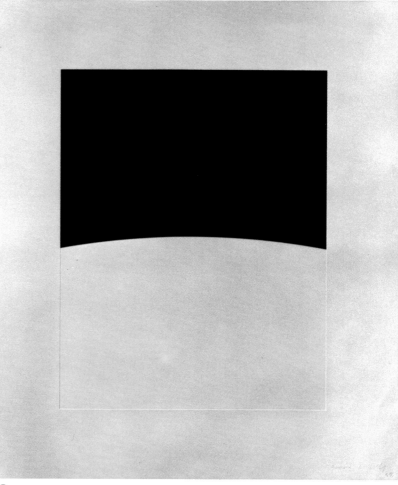

116

Poitiers 1973–76

Lithograph with embossing on 300-gram Rives BFK paper

Sheet: 41 x 34 (104.1 x 86.4)

Image: 29 x 22 (73.7 x 55.9)

Signed in pencil, lower right: *Kelly*; numbered in pencil, lower right. Blind stamp, lower right: logo of Gemini G.E.L., ©. Inscribed in pencil on verso: *EK73–653*. Stamped on verso: *Gemini G.E.L. Los Angeles, Calif.*

Edition: 16

Proofs: 9 AP, RTP, PPII, 3 GEL, C; plate used for cat. nos. 120, 121, 123, 126, 127, 129, 132, 133

Collaboration and supervision: Ron McPherson. Proofing, processing, and edition printing: Edward Henderson, Anthony Zepeda. Embossing: Serge Lozingot.

Published by Gemini G.E.L., Los Angeles (Gemini 673)

2 runs from 1 plate and 1 die

1 black; aluminum photo plate, from hand-cut negative, same as cat. nos. 120/1, 121/1, 123/1, 126/1, 127/1, 129/1, 132/1, 133/1
2 embossing (outline of unprinted image area); sheet hand-burnished over plastic die

Comments: *Poitiers* repeats the composition and colors of the painting *Black Curve I*, 1970 (EK#425), which was derived from the pencil-and-ink drawing *Study for "Black Curve I"* (EK#69.25), and is a color variation of cat. no. 108, from the Second Curve Series. With this painting, Kelly reintroduced curvilinear form into his art, although without the biomorphic suggestiveness or distinct figure–ground relationships of earlier work from the later 1950s and early 1960s.

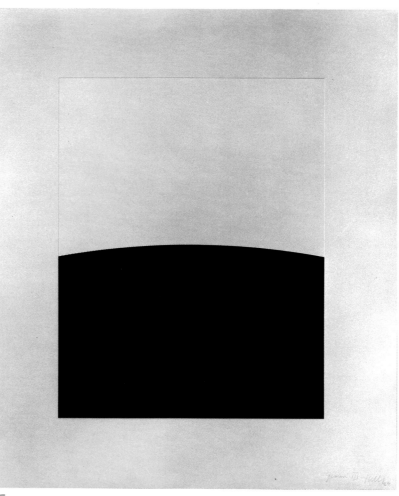

117

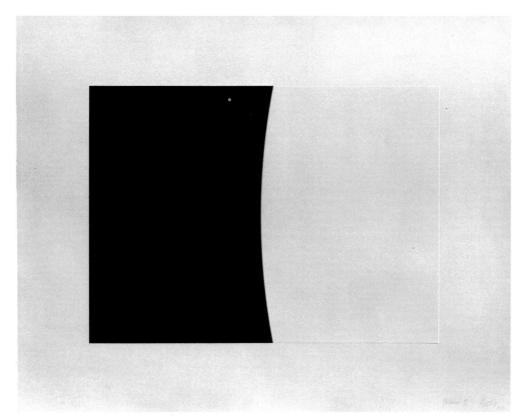

Serrabone 1973–76

Lithograph with embossing on 300-gram Rives BFK paper

Sheet: 34 x 41 (86.4 x 104.1)

Image: 22 x 29 (55.9 x 73.7)

Signed in pencil, lower right: *Kelly*; numbered in pencil, lower right. Blind stamp, lower right: logo of Gemini G.E.L., ©. Inscribed in pencil on verso: *EK73–654*. Stamped on verso: *Gemini G.E.L. Los Angeles, Calif.*

Edition: 16

Proofs: 9 AP, RTP, PPII, 3 GEL, C (documented with cat. no 116); plate used for cat. nos. 116, 119, 122, 124, 125, 128, 130, 131

Collaboration and supervision: Ron McPherson. Proofing and processing: Dan Freeman, Anthony Zepeda. Edition printing: Dan Freeman, Anthony Zepeda, Edward Henderson, Barbara Thomason. Embossing: Serge Lozingot.

Published by Gemini G.E.L., Los Angeles (Gemini 674)

2 runs from 1 plate and 1 die
1 black; aluminum photo plate, from hand-cut negative, same as cat. nos. 116/1, 119/1, 122/1, 124/1, 125/1, 128/1, 130/1, 131/1
2 embossing (outline of unprinted image area); sheet hand-burnished over plastic die

118

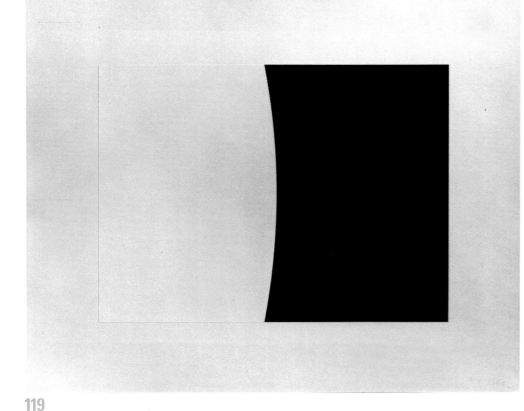

Corneilla 1973–76

Lithograph with embossing on 300-gram Rives BFK paper

Sheet: 34 x 41 (86.4 x 104.1)

Image: 22 x 29 (55.9 x 73.7)

Signed in pencil, lower right: *Kelly*; numbered in pencil, lower right. Blind stamp, lower right: logo of Gemini G.E.L., ©. Inscribed in pencil on verso: *EK73–655*. Stamped on verso: *Gemini G.E.L. Los Angeles, Calif.*

Edition: 16

Proofs: 9 AP, RTP, PPII, 3 GEL, C (documented with cat. no. 116); plate used for cat. nos. 116, 118, 122, 124, 125, 128, 130, 131

Collaboration and supervision: Ron McPherson. Proofing, processing, and edition printing: Anthony Zepeda, Dan Freeman. Embossing: Edward Henderson.

Published by Gemini G.E.L., Los Angeles (Gemini 675)

2 runs from 1 plate and 1 die
1 black; aluminum photo plate, from hand-cut negative, same as cat. nos. 116/1, 118/1, 122/1, 124/1, 125/1, 128/1, 130/1, 131/1
2 embossing (outline of unprinted image area); sheet hand-burnished over plastic die

119

Talmont 1973–76

Lithograph with embossing on 300-gram Rives BFK paper

Sheet: 34 x 41 (86.4 x 104.1)

Image: 22 x 29 (55.9 x 73.7)

Signed in pencil, lower right: *Kelly*; numbered in pencil, lower right. Blind stamp, lower right: logo of Gemini G.E.L., ©. Inscribed in pencil on verso: *EK73–656*. Stamped on verso: *Gemini G.E.L. Los Angeles, Calif.*

Edition: 16

Proofs: 9 AP, RTP, PPII, 3 GEL, C (documented with cat. no. 117); plate used for cat. nos. 117, 121, 123, 126, 127, 129, 132, 133

Collaboration and supervision: Ron McPherson. Proofing, processing, and edition printing: Charles Ritt, Robert Bigelow. Embossing: Serge Lozingot.

Published by Gemini G.E.L., Los Angeles (Gemini 676)

2 runs from 1 plate and 1 die
1 black; aluminum photo plate, from hand-cut negative, same as cat. nos. 117/1, 121/1, 123/1, 126/1, 127/1, 129/1, 132/1, 133/1
2 embossing (outline of unprinted image area); sheet hand-burnished over plastic die

Comments: *Talmont* repeats the composition and colors of the painting *Black Curve IV*, 1972 (EK#587).

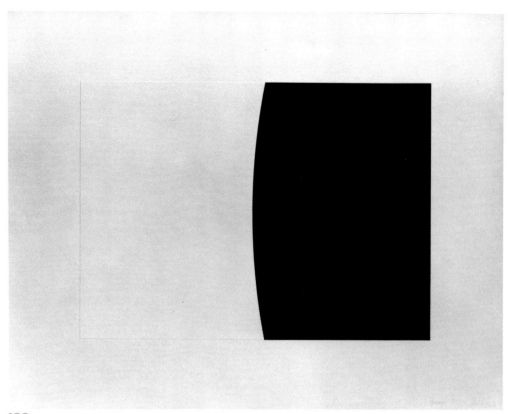

120

Chauvigny 1973–76

Lithograph with embossing on 300-gram Rives BFK paper

Sheet: 34 x 41 (86.4 x 104.1)

Image: 22 x 29 (55.9 x 73.7)

Signed in pencil, lower right: *Kelly*; numbered in pencil, lower right. Blind stamp, lower right: logo of Gemini G.E.L., ©. Inscribed in pencil on verso: *EK73–657*. Stamped on verso: *Gemini G.E.L. Los Angeles, Calif.*

Edition: 16

Proofs: 9 AP, RTP, PPII, 3 GEL, C (documented with cat. no. 117); plate used for cat. nos. 117, 120, 123, 126, 127, 129, 132, 133

Collaboration and supervision: Ron McPherson. Proofing, processing, and edition printing: Robert Bigelow, Charles Ritt. Embossing: Serge Lozingot.

Published by Gemini G.E.L., Los Angeles (Gemini 677)

2 runs from 1 plate and 1 die
1 black; aluminum photo plate, from hand-cut negative, same as cat. nos. 117/1, 120/1, 123/1, 126/1, 127/1, 129/1, 132/1, 133/1
2 embossing (outline of unprinted image area); sheet hand-burnished over plastic die

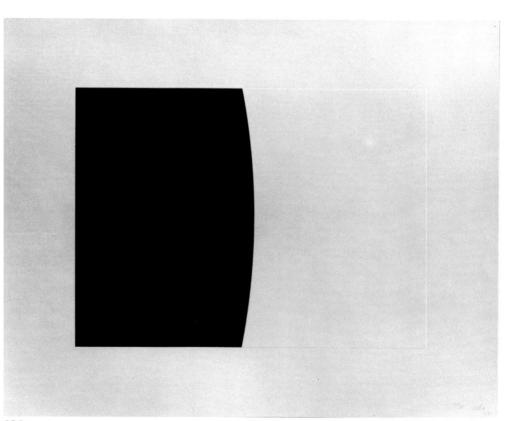

121

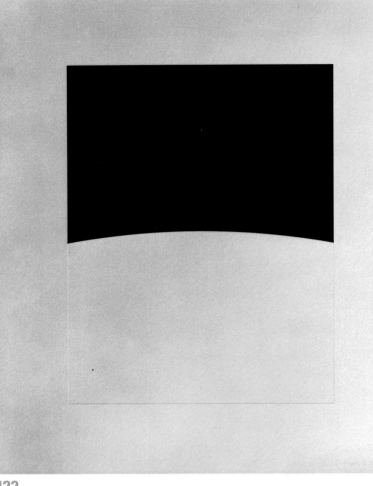

Thoronet 1973–76

Lithograph with debossing on 300-gram Rives BFK paper

Sheet: 41 x 34 (104.1 x 86.4)

Image: 29 x 22 (73.7 x 55.9)

Signed in pencil, lower right: *Kelly*; numbered in pencil, lower right. Blind stamp, lower right: logo of Gemini G.E.L., ©. Inscribed in pencil on verso: *EK73–658*. Stamped on verso: *Gemini G.E.L. Los Angeles, Calif.*

Edition: 16

Proofs: 9 AP, RTP, PPII, SP, 3 GEL, C (documented with cat. no. 116); plate used for cat. nos. 116, 118, 119, 124, 125, 128, 130, 131

Collaboration and supervision: Ron McPherson. Proofing, processing, and edition printing: Robert Bigelow, Barbara Thomason.

Published by Gemini G.E.L., Los Angeles (Gemini 678)

2 runs from 1 plate and 1 die
1 black; aluminum photo plate, from hand-cut negative, same as cat. nos. 116/1, 118/1, 119/1, 124/1, 125/1, 128/1, 130/1, 131/1
2 debossing (outline of unprinted image area); sheet hand-burnished over plastic die

Comments: *Thoronet* repeats the composition and colors of the painting *White Curve VIII*, 1976 (EK#545). It is a color variation of cat. no. 108, from the Second Curve Series.

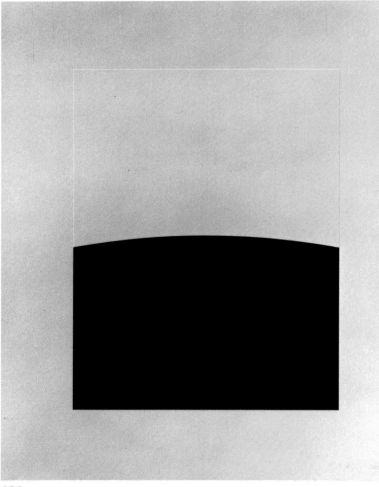

Caen 1973–76

Lithograph with debossing on 300-gram Rives BFK paper

Sheet: 41 x 34 (104.1 x 86.4)

Image: 29 x 22 (73.7 x 55.9)

Signed in pencil, lower right: *Kelly*; numbered in pencil, lower right. Blind stamp, lower right: logo of Gemini G.E.L., ©. Inscribed in pencil on verso: *EK73–659*. Stamped on verso: *Gemini G.E.L. Los Angeles, Calif.*

Edition: 16

Proofs: 9 AP, RTP, PPII, 3 GEL, C (documented with cat. no. 117); plate used for cat. nos. 117, 120, 121, 126, 127, 129, 132, 133

Collaboration and supervision: Ron McPherson. Proofing, processing, and edition printing: Charles Ritt, Robert Bigelow.

Published by Gemini G.E.L., Los Angeles (Gemini 679)

2 runs from 1 plate and 1 die
1 black; aluminum photo plate, from hand-cut negative, same as cat. nos. 117/1, 120/1, 121/1, 126/1, 127/1, 129/1, 132/1, 133/1
2 debossing (outline of unprinted image area); sheet hand-burnished over plastic die

Comments: *Caen* repeats the composition and colors of the painting *Black Curve I*, 1970 (EK#425), which was derived from the pencil-and-ink drawing *Study for "Black Curve I"* (EK#69.25), and is a color variation of cat. no. 108, from the Second Curve Series. With this painting, Kelly reintroduced curvilinear form into his art, although without the biomorphic suggestiveness or distinct figure–ground relationships of earlier work from the later 1950s and early 1960s.

Fontenay 1973–76

Lithograph with debossing on 300-gram Rives BFK paper

Sheet: 34 x 41 (86.4 x 104.1)

Image: 22 x 29 (55.9 x 73.7)

Signed in pencil, lower right: *Kelly*; numbered in pencil, lower left. Blind stamp, lower right: logo of Gemini G.E.L., ©. Inscribed in pencil on verso: *EK73–660*. Stamped on verso: *Gemini G.E.L. Los Angeles, Calif.*

Edition: 16

Proofs: 9 AP, RTP, PPII, 3 GEL, C (documented with cat. no. 116); plate used for cat. nos. 116, 118, 119, 122, 125, 128, 130, 131

Collaboration and supervision: Ron McPherson. Proofing, processing, and edition printing: Robert Bigelow, Charles Ritt.

Published by Gemini G.E.L., Los Angeles (Gemini 680)

2 runs from 1 plate and 1 die
1 black; aluminum photo plate, from hand-cut negative, same as cat. nos. 116/1, 118/1, 119/1, 122/1, 125/1, 128/1, 130/1, 131/1
2 debossing (outline of unprinted image area); sheet hand-burnished over plastic die

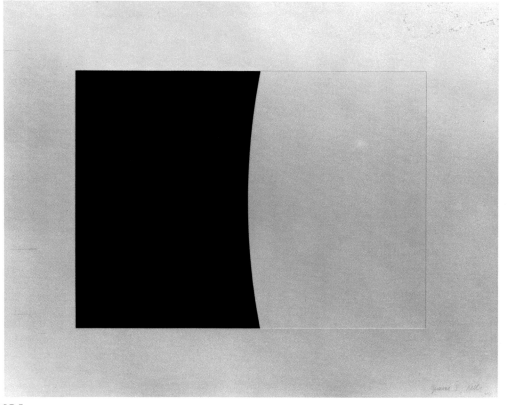

124

Angers 1973–76

Lithograph with debossing on 300-gram Rives BFK paper

Sheet: 34 x 41 (86.4 x 104.1)

Image: 22 x 29 (55.9 x 73.7)

Signed in pencil, lower right: *Kelly*; numbered in pencil, lower left. Blind stamp, lower right: logo of Gemini G.E.L., ©. Inscribed in pencil on verso: *EK73–661*. Stamped on verso: *Gemini G.E.L. Los Angeles, Calif.*

Edition: 16

Proofs: 9 AP, RTP, PPII, 3 GEL, C (documented with cat. no. 116); plate used for cat. nos. 116, 118, 119, 122, 124, 128, 130, 131

Collaboration and supervision: Ron McPherson. Proofing, processing, and edition printing: Charles Ritt, Robert Bigelow.

Published by Gemini G.E.L., Los Angeles (Gemini 681)

2 runs from 1 plate and 1 die
1 black; aluminum photo plate, from hand-cut negative, same as cat. nos. 116/1, 118/1, 119/1, 122/1, 124/1, 128/1, 130/1, 131/1
2 debossing (outline of unprinted image area); sheet hand-burnished over plastic die

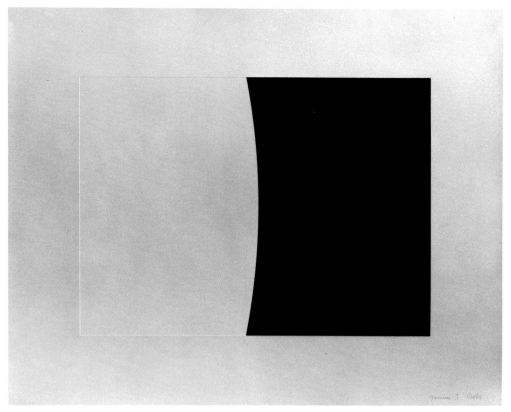

125

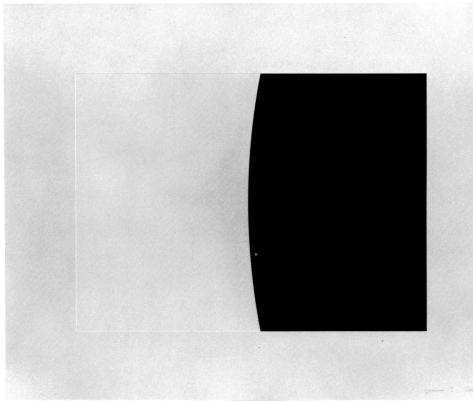

126

Tournus 1973–76

Lithograph with debossing on 300-gram Rives BFK paper

Sheet: 34 x 41 (86.4 x 104.1)

Image: 22 x 29 (55.9 x 73.7)

Signed in pencil, lower right: *Kelly*; numbered in pencil, lower left. Blind stamp, lower right: logo of Gemini G.E.L., ©. Inscribed in pencil on verso: *EK73–661*. Stamped on verso: *Gemini G.E.L. Los Angeles, Calif.*

Edition: 16

Proofs: 9 AP, RTP, PPII, 3 GEL, C (documented with cat. no. 117); plate used for cat. nos. 117, 120, 121, 123, 127, 129, 132, 133

Collaboration and supervision: Ron McPherson. Proofing, processing, and edition printing: Barbara Thomason, Charles Ritt.

Published by Gemini G.E.L., Los Angeles (Gemini 682)

2 runs from 1 plate and 1 die
1 black; aluminum photo plate, from hand-cut negative, same as cat. nos. 117/1, 120/1, 121/1, 123/1, 127/1, 129/1, 132/1, 133/1
2 debossing (outline of unprinted image area); sheet hand-burnished over plastic die

Comments: *Tournus* repeats the composition and colors of the painting *Black Curve IV*, 1972 (EK #587).

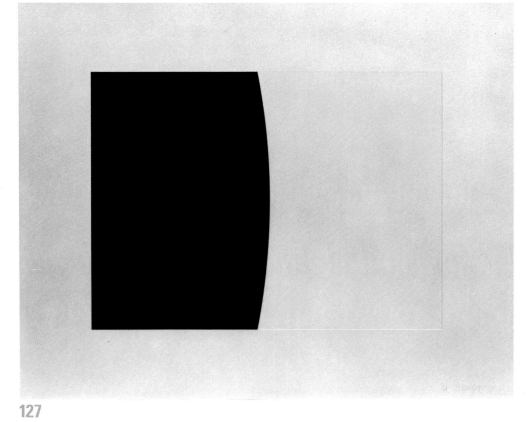

127

Canigou 1973–76

Lithograph with debossing on 300-gram Rives BFK paper

Sheet: 34 x 41 (86.4 x 104.1)

Image: 22 x 29 (55.9 x 73.7)

Signed in pencil, lower right: *Kelly*; numbered in pencil, lower left. Blind stamp, lower right: logo of Gemini G.E.L., ©. Inscribed in pencil on verso: *EK73–663*. Stamped on verso: *Gemini G.E.L. Los Angeles, Calif.*

Edition: 16

Proofs: 9 AP, RTP, PPII, 3 GEL, C (documented with cat. no. 117); plate used for cat. nos. 117, 120, 121, 123, 126, 129, 132, 133

Collaboration and supervision: Ron McPherson. Proofing and processing: Charles Ritt, Barbara Thomason. Edition printing: Charles Ritt, Barbara Thomason, Robert Bigelow.

Published by Gemini G.E.L., Los Angeles (Gemini 683)

2 runs from 1 plate and 1 die
1 black; aluminum photo plate, from hand-cut negative, same as cat. nos. 117/1, 120/1, 121/1, 123/1, 126/1, 129/1, 132/1, 133/1
2 debossing (outline of unprinted image area); sheet hand-burnished over plastic die

Tavant 1973–76

Lithograph with debossing on 300-gram Rives BFK paper

Sheet: 41 x 34 (104.1 x 86.4)

Image: 29 x 22 (73.7 x 55.9)

Signed in pencil, lower right: *Kelly*; numbered in pencil, lower left. Blind stamp, lower right: logo of Gemini G.E.L., ©. Inscribed in pencil on verso: *EK73–664*. Stamped on verso: *Gemini G.E.L. Los Angeles, Calif.*

Edition: 16

Proofs: 9 AP, RTP, PPII, 3 GEL, C (documented with cat. no. 116); plate 1 used for cat. nos. 116, 118, 119, 122, 124, 125, 130, 131

Collaboration and supervision: Ron McPherson. Proofing and processing: Robert Bigelow, Charles Ritt. Edition printing: Robert Bigelow, Charles Ritt, Serge Lozingot.

Published by Gemini G.E.L., Los Angeles (Gemini 684)

3 runs from 2 plates and 1 die
1 black; aluminum photo plate, from hand-cut negative, same as cat. nos. 116/1, 118/1, 119/1, 122/1, 124/1, 125/1, 130/1, 131/1
2 light-gray tone; ball-grained aluminum plate, wiped
3 debossing (outline of 2); sheet hand-burnished over plastic die

Comments: *Tavant* is a color variation of cat. no. 108, from the Second Curve Series.

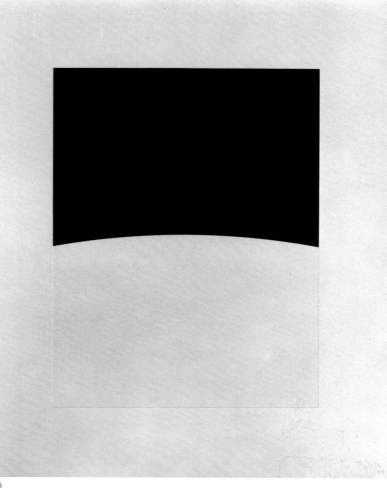

128

Cluny 1973–76

Lithograph with debossing on 300-gram Rives BFK paper

Sheet: 41 x 34 (104.1 x 86.4)

Image: 29 x 22 (73.7 x 55.9)

Signed in pencil, lower right: *Kelly*; numbered in pencil, lower right. Blind stamp, lower right: logo of Gemini G.E.L., ©. Inscribed in pencil on verso: *EK73–665*. Stamped on verso: *Gemini G.E.L. Los Angeles, Calif.*

Edition: 16

Proofs: 9 AP, RTP, PPII, 3 GEL, C (documented with cat. no. 117); plate 1 used for cat. nos. 117, 120, 121, 123, 126, 127, 132, 133

Collaboration and supervision: Ron McPherson. Proofing and processing: Charles Ritt, Robert Bigelow. Edition printing: Charles Ritt, Robert Bigelow, Jim Webb. Debossing: Edward Henderson.

Published by Gemini G.E.L., Los Angeles (Gemini 685)

3 runs from 2 plates and 1 die
1 black; aluminum photo plate, from hand-cut negative, same as cat. nos. 117/1, 120/1, 121/1, 123/1, 126/1, 127/1, 132/1, 133/1
2 light-gray tone; ball-grained aluminum plate, wiped
3 debossing (outline of 2); sheet hand-burnished over plastic die

Comments: *Cluny* is a color variation of cat. no. 108, from the Second Curve Series.

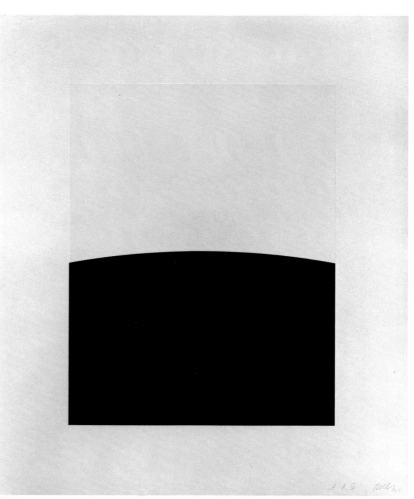

129

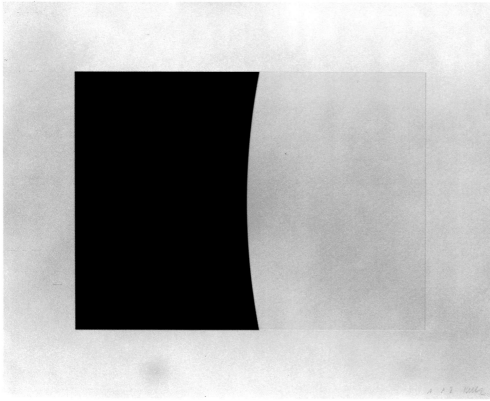

130

Germigny 1973–76

Lithograph with debossing on 300-gram Rives BFK paper

Sheet: 34 x 41 (86.4 x 104.1)

Image: 22 x 29 (55.9 x 73.7)

Signed in pencil, lower right: *Kelly*; numbered in pencil, lower left. Blind stamp, lower right: logo of Gemini G.E.L., ©. Inscribed in pencil on verso: *EK73–666*. Stamped on verso: *Gemini G.E.L. Los Angeles, Calif.*

Edition: 16

Proofs: 9 AP, RTP, PPII, 3 GEL, C (documented with cat. no. 116); plate 1 used for cat. nos. 116, 118, 119, 122, 124, 125, 128, 131

Collaboration and supervision: Ron McPherson. Proofing and processing: Robert Bigelow, Charles Ritt. Edition printing: Robert Bigelow, Charles Ritt, Anthony Zepeda, Barbara Thomason. Debossing: Barbara Thomason.

Published by Gemini G.E.L., Los Angeles (Gemini 686)

3 runs from 2 plates and 1 die
1. black; aluminum photo plate, from hand-cut negative, same as cat. nos. 116/1, 118/1, 119/1, 122/1, 124/1, 125/1, 128/1, 131/1
2. light-gray tone; ball-grained aluminum plate, wiped
3. debossing (outline of 2); sheet hand-burnished over plastic die

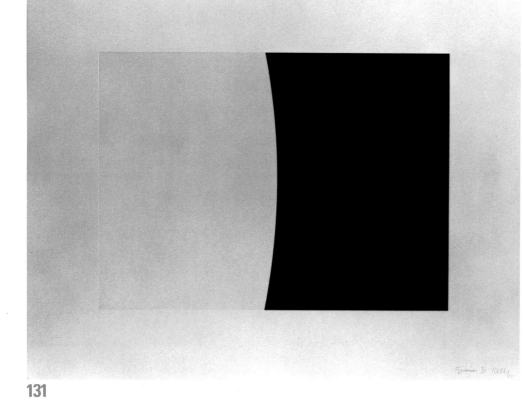

131

Senanque 1973–76

Lithograph with debossing on 300-gram Rives BFK paper

Sheet: 34 x 41 (86.4 x 104.1)

Image: 22 x 29 (55.9 x 73.7)

Signed in pencil, lower right: *Kelly*; numbered in pencil, lower right. Blind stamp, lower right: logo of Gemini G.E.L., ©. Inscribed in pencil on verso: *EK73–667*. Stamped on verso: *Gemini G.E.L. Los Angeles, Calif.*

Edition: 16

Proofs: 9 AP, RTP, PPII, 3 GEL, C (documented with cat. no. 116); plate 1 used for cat. nos. 116, 118, 119, 122, 124, 125, 128, 130

Collaboration and supervision: Ron McPherson. Proofing and processing: Jim Webb, Barbara Thomason. Edition printing: Jim Webb, Barbara Thomason, Ed Henderson. Debossing: Dan Freeman.

Published by Gemini G.E.L., Los Angeles (Gemini 687)

3 runs from 2 plates and 1 die
1. black; aluminum photo plate, from hand-cut negative, same as cat. nos. 116/1, 118/1, 119/1, 122/1, 124/1, 125/1, 128/1, 130/1
2. light-gray tone; ball-grained aluminum plate, wiped
3. debossing (outline of 2); sheet hand-burnished over plastic die

Saint-Savin 1973–76

Lithograph with debossing on 300-gram Rives BFK paper

Sheet: 34 x 41 (86.4 x 104.1)

Image: 22 x 29 (55.9 x 73.7)

Signed in pencil, lower right: *Kelly*; numbered in pencil, lower right. Blind stamp, lower right: logo of Gemini G.E.L., ©. Inscribed in pencil on verso: *EK73–668*. Stamped on verso: *Gemini G.E.L. Los Angeles, Calif.*

Edition: 16

Proofs: 9 AP, RTP, PPII, 3 GEL, C (documented with cat. no. 117); plate 1 used for cat. nos. 117, 120, 121, 123, 126, 127, 129, 133

Collaboration and supervision: Ron McPherson. Proofing and processing: Dan Freeman, Anthony Zepeda. Edition printing: Dan Freeman, Anthony Zepeda, Barbara Thomason, Jim Webb.

Published by Gemini G.E.L., Los Angeles (Gemini 688)

3 runs from 2 plates and 1 die
1 black; aluminum photo plate, from hand-cut negative, same as cat. nos. 117/1, 120/1, 121/1, 123/1, 126/1, 127/1, 129/1, 133/1
2 light-gray tone; ball-grained aluminum plate, wiped
3 debossing (outline of 2); sheet hand-burnished over plastic die

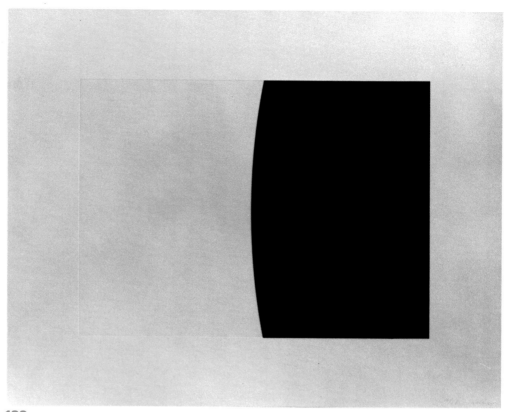

132

Cuxa 1973–76

Lithograph with embossing on 300-gram Rives BFK paper

Sheet: 34 x 41 (86.4 x 104.1)

Image: 22 x 29 (55.9 x 73.7)

Signed in pencil, lower right: *Kelly*; numbered in pencil, lower right. Blind stamp, lower right: logo of Gemini G.E.L., ©. Inscribed in pencil on verso: *EK73–669*. Stamped on verso: *Gemini G.E.L. Los Angeles, Calif.*

Edition: 16

Proofs: 9 AP, RTP, PPII, 3 GEL, C (documented with cat. no. 117); plate 1 used for cat. nos. 117, 120, 121, 123, 126, 127, 129, 132

Collaboration and supervision: Ron McPherson. Proofing and processing: Serge Lozingot. Edition printing: Serge Lozingot, Charles Ritt, Anthony Zepeda.

Published by Gemini G.E.L., Los Angeles (Gemini 689)

3 runs from 2 plates and 1 die
1 black; aluminum photo plate, from hand-cut negative, same as cat. nos. 117/1, 120/1, 121/1, 123/1, 126/1, 127/1, 129/1, 132/1
2 light-gray tone; ball-grained aluminum plate, wiped
3 debossing (outline of 2); sheet hand-burnished over plastic die

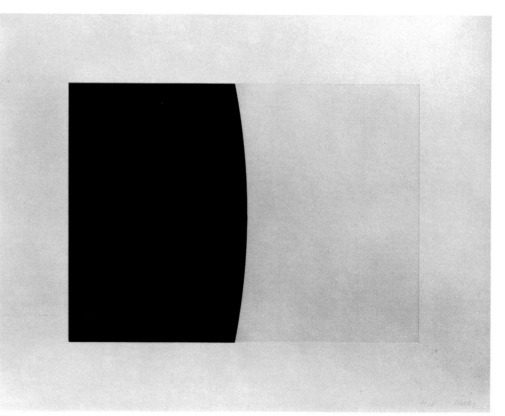

133

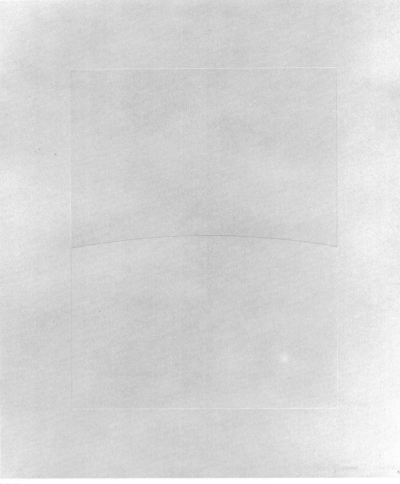

134

Moissac 1973–76

Lithograph with debossing and embossing on 300-gram Rives BFK paper

Sheet: 41 x 34 (104.1 x 86.4)

Image: 29 x 22 (73.7 x 55.9)

Signed in pencil, lower right: *Kelly*; numbered in pencil, lower right. Blind stamp, lower right: logo of Gemini G.E.L., ©. Inscribed in pencil on verso: *EK73–670.* Stamped on verso: *Gemini G.E.L. Los Angeles, Calif.*

Edition: 16

Proofs: 9 AP, RTP, PPII, 3 GEL, C

Collaboration and supervision: Ron McPherson. Proofing and processing: Barbara Thomason. Edition printing, debossing, and embossing: Barbara Thomason.

Published by Gemini G.E.L., Los Angeles (Gemini 690)

3 runs from 1 plate and 2 dies

1. light-gray tone; ball-grained aluminum plate, wiped, same as cat. nos. 138/1, 139/1
2. debossing (outline of 1); sheet hand-burnished over plastic die
3. embossing (unprinted image area); sheet hand-burnished over plastic die

Comments: *Moissac* is a color variation of cat. no. 108, from the Second Curve Series.

135

Montmorillon 1973–76

Lithograph with debossing and embossing on 300-gram Rives BFK paper

Sheet: 34 x 41 (86.4 x 104.1)

Image: 22 x 29 (55.9 x 73.7)

Signed in pencil, lower right: *Kelly*; numbered in pencil, lower right. Blind stamp, lower right: logo of Gemini G.E.L., ©. Inscribed in pencil on verso: *EK73–691.* Stamped on verso: *Gemini G.E.L. Los Angeles, Calif.*

Edition: 16

Proofs: 9 AP, RTP, PPII, 3 GEL, C

Collaboration and supervision: Ron McPherson. Proofing and processing: Jim Webb. Edition printing: Jim Webb, Serge Lozingot, Barbara Thomason. Debossing and embossing: Dan Freeman.

Published by Gemini G.E.L., Los Angeles (Gemini 691)

3 runs from 1 plate and 2 dies

1. light-gray tone; ball-grained aluminum plate, wiped, same as cat. nos. 136/1, 137/1
2. debossing (outline of 1); sheet hand-burnished over plastic die
3. embossing (unprinted image area); sheet hand-burnished over plastic die

Vic 1973–76

Lithograph with debossing and embossing on 300-gram Rives
BFK paper

Sheet: 34 x 41 (86.4 x 104.1)

Image: 22 x 29 (55.9 x 73.7)

Signed in pencil, lower right: *Kelly*; numbered in pencil, lower
right. Blind stamp, lower right: logo of Gemini G.E.L., ©.
Inscribed in pencil on verso: *EK73–672*. Stamped on verso:
Gemini G.E.L. Los Angeles, Calif.

Edition: 16

Proofs: 9 AP, RTP, PPII, 3 GEL, C (documented with cat. no. 135)

Collaboration and supervision: Ron McPherson. Proofing and
processing: Dan Freeman. Edition printing: Dan Freeman, Jim
Webb. Debossing and embossing: Dan Freeman.

Published by Gemini G.E.L., Los Angeles (Gemini 692)

3 runs from 1 plate and 2 dies
1 light-gray tone; ball-grained aluminum plate, wiped, same
 as cat. nos. 135/1, 137/1
2 debossing (outline of 1); sheet hand-burnished over plastic
 die
3 embossing (unprinted image area); sheet hand-burnished
 over plastic die

136

Brioude 1973–76

Lithograph with debossing and embossing on 300-gram Rives
BFK paper

Sheet: 41 x 34 (104.1 x 86.4)

Image: 29 x 22 (73.7 x 55.9)

Signed in pencil, lower right: *Kelly*; numbered in pencil, lower
right. Blind stamp, lower right: logo of Gemini G.E.L., ©.
Inscribed in pencil on verso: *EK73–673*. Stamped on verso:
Gemini G.E.L. Los Angeles, Calif.

Edition: 16

Proofs: 9 AP, RTP, PPII, 3 GEL, C (documented with cat. no. 135)

Collaboration and supervision: Ron McPherson. Proofing,
processing, edition printing, debossing, and embossing: Dan
Freeman.

Published by Gemini G.E.L., Los Angeles (Gemini 673)

3 runs from 1 plate and 2 dies
1 light-gray tone; ball-grained aluminum plate, wiped, same
 as cat. nos. 135/1, 136/1
2 debossing (outline of 1); sheet hand-burnished over plastic
 die
3 embossing (unprinted image area); sheet hand-burnished
 over plastic die

Comments: *Brioude* is a color variation of cat. no. 108, from
the Second Curve Series.

137

138

Fontevrault 1973–76

Lithograph with debossing and embossing on 300-gram Rives BFK paper

Sheet: 34 x 41 (86.4 x 104.1)

Image: 22 x 29 (55.9 x 73.7)

Signed in pencil, lower right: *Kelly*; numbered in pencil, lower right. Blind stamp, lower right: logo of Gemini G.E.L., ©. Inscribed in pencil on verso: *EK73–674*. Stamped on verso: *Gemini G.E.L. Los Angeles, Calif.*

Edition: 16

Proofs: 9 AP, RTP, PPII, 3 GEL, C (documented with cat. no. 134)

Collaboration and supervision: Ron McPherson. Proofing, processing, edition printing, debossing, and embossing: Barbara Thomason.

Published by Gemini G.E.L., Los Angeles (Gemini 694)

3 runs from 1 plate and 2 dies
1 light gray tone; ball-grained aluminum plate, wiped, same as cat. nos. 134/1, 139/1
2 debossing (outline of 1); sheet hand-burnished over plastic die
3 embossing (unprinted image area); sheet hand-burnished over plastic die

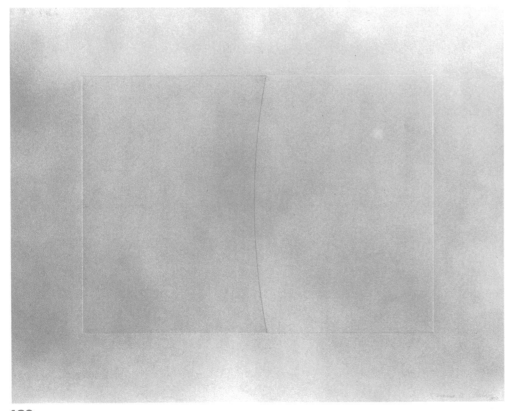

139

Souillac 1973–76

Lithograph with debossing and embossing on 300-gram Rives BFK paper

Sheet: 34 x 41 (86.4 x 104.1)

Image: 22 x 29 (55.9 x 73.7)

Signed in pencil, lower right: *Kelly*; numbered in pencil, lower right. Blind stamp, lower right: logo of Gemini G.E.L., ©. Inscribed in pencil on verso: *EK73–675*. Stamped on verso: *Gemini G.E.L. Los Angeles, Calif.*

Edition: 16

Proofs: 9 AP, RTP, PPII, 3 GEL, C (documented with cat. no. 134)

Collaboration and supervision: Ron McPherson. Proofing, · processing, edition printing, debossing, and embossing: Barbara Thomason.

Published by Gemini G.E.L., Los Angeles (Gemini 695)

3 runs from 1 plate and 2 dies
1 light gray tone; ball-grained aluminum plate, wiped, same as cat. nos. 134/1, 138/1
2 debossing (outline of 1); sheet hand-burnished over plastic die
3 embossing (unprinted image area); sheet hand-burnished over plastic die

Colors on a Grid, Screenprint 1976

1976

Screenprint and offset lithograph on 350-gram Arches 88 paper

Sheet: 48⅛ x 48¼ (122.0 x 122.6)

Image: 40⅛ x 40 (101.9 x 101.6)

Signed in pencil, lower right: *Kelly*; numbered in pencil, lower left. Blind stamp, lower right: logo of Tyler Graphics Ltd. Inscribed in pencil on verso: *EK76–220*

Edition: 46

Proofs: 10 AP, RTP, PPII, A, C

Collaboration and supervision: Kenneth Tyler. Screen preparation and proofing: Kim Halliday. Plate preparation and proofing: John Hutcheson. Edition printing: Kim Halliday, John Hutcheson.

Published by Tyler Graphics Ltd., Bedford, New York (294:EK1)

16 runs from 2 plates and 5 screens
 1 gray (left-half grid); aluminum photo plate, from photographically prepared film
 2 gray (right-half grid); aluminum photo plate, from photographically prepared film
 3 yellow; screen, from hand-cut stencil
 4 pink; screen, same as 3
 5 dark green; screen, from hand-cut stencil
 6 light orange; screen, same as 5
 7 violet; screen, same as 5
 8 dark orange; screen, same as 5
 9 light green; screen, same as 5
 10 purple; screen, from hand-cut stencil
 11 light blue; screen, same as 10
 12 medium blue; screen, same as 10
 13 dark blue; screen, from hand-cut stencil
 14 red; screen, same as 13
 15 brown; screen, same as 13
 16 black; screen, from hand-cut stencil

Comments: This screenprint, the first work by Kelly published by Tyler Graphics Ltd., repeats the composition and colors of the painting *Colors for a Large Wall*, 1951 (EK#46; Coplans 1973, pl. 18).

140

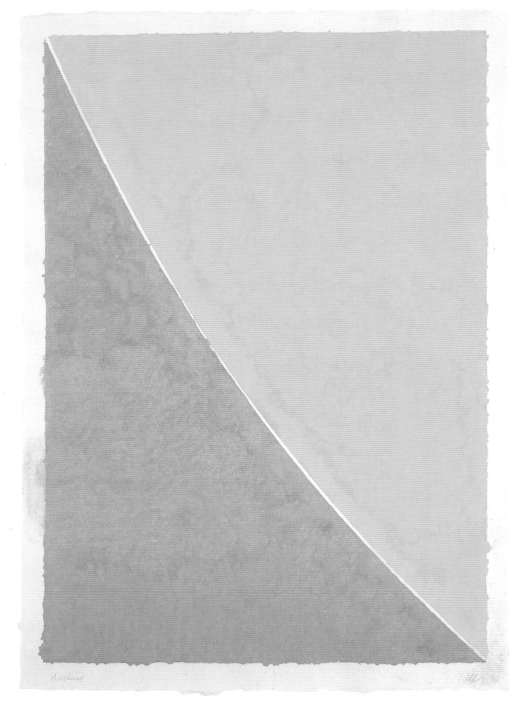

Colored Paper Image VII, 1976 (cat. no. 147)

141–63
COLORED PAPER IMAGES 1976–77

Kelly made the twenty-three paper pieces that constitute this series in collaboration with John and Kathleen Koller of the HMP Paper Mill in Woodstock, Connecticut, and Kenneth Tyler, of Tyler Graphics Ltd., who supervised and published the project.

To make each image, colored cotton pulp was spooned into molds positioned on wet sheets of unpigmented handmade paper made from the same material. Kelly created the molds for his curvilinear and rectilinear shapes with flexible metal rulers, masking tape, and Lucite. These guides for the containing and distribution of the colored pulp were the equivalent of the traditional printmaking matrix —the plate, block, or screen—from which multiple images are produced. Tyler researched the pigmentation for coloring the cotton pulp. From a basic palette, which he created with acrylic gouaches, Kelly mixed nearly fifty colors for the series. In several instances different colored pulps were overlaid on the base sheet. After the molds were removed, the wet sheets were placed in a vertical press between heavy felt blankets and the colored pulp was pressed into the white base sheet.

The fusing of the colored pulp with the white base sheet caused color to bleed out of the shapes, a process that resulted in slight variations from impression to impression within a given edition. Kelly's willingness to experiment with bleeding color and the textural surface qualities of handmade paper was a radical departure from his established preoccupation (which he maintained in paintings) with immaculate shape, bounded color, and anonymous surface. This move, however, was in keeping with his long-standing fascination with the processes of chance and was stimulated by a developing interest in random surface effects, as was apparent in his weathering steel and wood sculptures.

In 1986 Kelly assigned new titles to the first twenty-one paper pieces. They had each originally been published in 1976 with the series name and a roman numeral. The artist's decision to rename each piece followed his practice of indicating color and shape in the titles of his works. In 1977 the last two paperworks were published separately with color titles. They are here joined to the series, understood by the artist as constituting a single body of work.

Literature: *Ellsworth Kelly: Colored Paper Images* 1976; Flint 1977, 11; Frackman 1977, 31; Goldman 1977a, 26, 31, 35; Goldman 1977b, 50–51, 54; Halbreich 1977, introduction, n.p.; "New Editions," *Art News* 1977, 110; "Prints and Photographs," *Print Collector's Newsletter* 1977, 181; Schiller 1977, 6, 12, 14; Skoggard 1977, 62–63; Farmer 1978, 11, 41; Harvey 1979, 12; Field, Melot, et al. 1981, 232; Gilmour and Willsford 1982, 49–50; Armstrong 1984, 15; Castleman 1985, 105–6; Gilmour 1985, 8; Newland 1985, n.p.; Gilmour 1986, 89, 93

Colored Paper Image I (White Curve with Black I) 1976

Colored and pressed paper pulp

Sheet: 46½ x 32½ (118.1 x 82.6)

Signed in pencil, lower right: *Kelly*; numbered in pencil, lower left. Blind stamps, lower right: *EK*, logo of Tyler Graphics Ltd. Inscribed in pencil on verso: *EK76–254*

Edition: 20

Proofs: 10 AP, TP, RTP, PPII, SP, A, C (all molds and colored pulp destroyed)

Collaboration and supervision: Kenneth Tyler. Experimental trial proof and RTP paper coloring: Ellsworth Kelly, assisted by Kenneth Tyler, John Koller. Paper coloring: John Koller, Kathleen Koller. Fabricated at HMP Paper Mill, Woodstock, Connecticut.

Published by Tyler Graphics Ltd., Bedford, New York (295:EK2)

Base sheet: White cotton pulp

Image: Pressed gray-black and white cotton pulp

Comments: *Colored Paper Image I* is related to the painting *White Curve VII*, 1976 (EK#535).

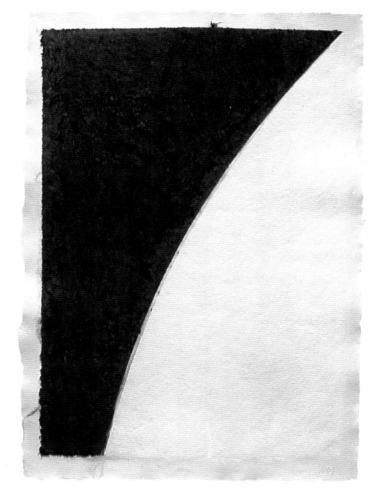

141

Colored Paper Image II (Dark Green Curves) 1976

Colored and pressed paper pulp

Sheet: 46½ x 32½ (118.1 x 82.6)

Signed in pencil, lower right: *Kelly*; numbered in pencil, lower left. Blind stamps, lower right: *EK*, logo of Tyler Graphics Ltd. Inscribed in pencil on verso: *EK76–255*

Edition: 17

Proofs: 8 AP, TP, 2 CTP, RTP, PPII, A, C (all molds and colored pulp destroyed)

Collaboration and supervision: Kenneth Tyler. Experimental trial proof and RTP paper coloring: Ellsworth Kelly, assisted by Kenneth Tyler, John Koller. Paper coloring: John Koller, Kathleen Koller. Fabricated at HMP Paper Mill, Woodstock, Connecticut.

Published by Tyler Graphics Ltd., Bedford, New York (296:EK3)

Base sheet: White cotton pulp

Image: Pressed dark green cotton pulp

Comments: *Colored Paper Image II* was derived from a collage entitled *Green Curves*, 1951 (EK#51.55; Waldman 1971, pl. 54). The collage was a preliminary study for an image Kelly planned to include in a book entitled *Line, Form, Color*. The book, which was never published, was the artist's own survey of his basic formal vocabulary. *Colored Paper Image II* is also related to the lithograph *Blue and Orange* from the Suite of Twenty-Seven Color Lithographs that was published in 1965 (cat. no. 8).

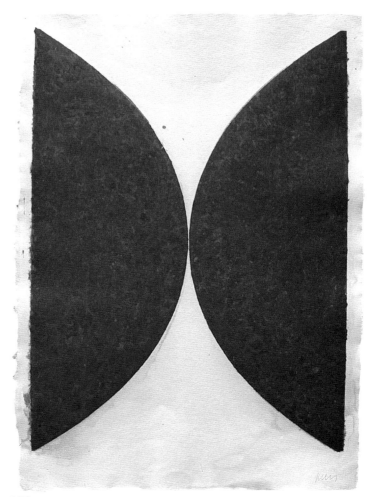

142

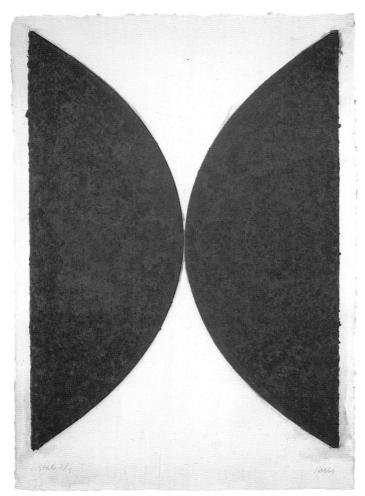

Colored Paper Image II, State (Green Curves) 1976

Colored and pressed paper pulp

Sheet: 46½ x 32½ (118.1 x 82.6)

Signed in pencil, lower right: *Kelly*; numbered in pencil, lower left. Blind stamps, lower right: *EK*, logo of Tyler Graphics Ltd. Inscribed in pencil on verso: *EK76–255A*

Edition: 9

Proofs: TP, RTP, PPII, C (all molds and colored pulp destroyed)

Collaboration and supervision: Kenneth Tyler. Experimental trial proof and RTP paper coloring: Ellsworth Kelly, assisted by Kenneth Tyler, John Koller. Paper coloring: John Koller, Kathleen Koller. Fabricated at HMP Paper Mill, Woodstock, Connecticut.

Published by Tyler Graphics Ltd., Bedford, New York (297:EK4)

Base sheet: White cotton pulp

Image: Pressed green cotton pulp

Comments: See cat. no. 142

142a

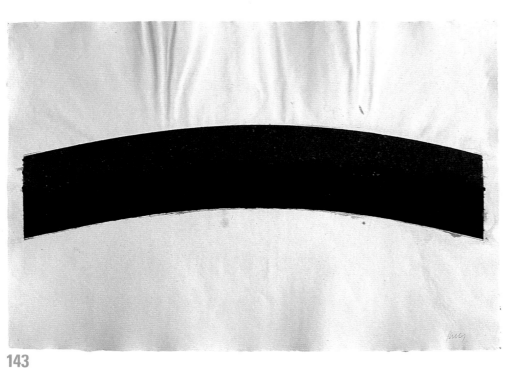

143

Colored Paper Image III (Blue Black Curves) 1976

Colored and pressed paper pulp

Sheet: 32½ x 46½ (82.6 x 118.1)

Signed in pencil, lower right: *Kelly*; numbered in pencil, lower left. Blind stamps, lower right: *EK*, logo of Tyler Graphics Ltd. Inscribed in pencil on verso: *EK76–256*

Edition: 21

Proofs: 8 AP, TP, 5 CTP, RTP, PPII, A, C (all molds and colored pulp destroyed)

Collaboration and supervision: Kenneth Tyler. Experimental trial proof and RTP paper coloring: Ellsworth Kelly, assisted by Kenneth Tyler, John Koller. Paper coloring: John Koller, Kathleen Koller. Fabricated at HMP Paper Mill, Woodstock, Connecticut.

Published by Tyler Graphics Ltd., Bedford, New York (298:EK5)

Base sheet: White cotton pulp

Image: Pressed black and blue cotton pulp

Literature: Skoggard 1977, 62–63; Sims and Pulitzer 1982, 129, 133; Glaubinger 1986, 6–7

Comments: The image in *Colored Paper Image III* is related to the horizontal bow motif of the metal sculptures *Curve XIII*, 1974 (EK#S528; Sims and Pulitzer 1982, no. 84), and *Curve XVI*, 1978 (EK#S571; Sims and Pulitzer 1982, no. 85).

Colored Paper Image IV (Red Curve)

1976

Colored and pressed paper pulp

Sheet: 46½ x 32½ (118.1 x 82.6)

Signed in pencil, lower right: *Kelly*; numbered in pencil, lower left. Blind stamps, lower right: *EK*, logo of Tyler Graphics Ltd. Inscribed in pencil on verso: *EK76–257*

Edition: 20

Proofs: 9 AP, 2 TP, RTP, PPII, A, C (all molds and colored pulp destroyed)

Collaboration and supervision: Kenneth Tyler. Experimental trial proof and RTP paper coloring: Ellsworth Kelly, assisted by Kenneth Tyler, John Koller. Paper coloring: John Koller, Kathleen Koller. Fabricated at HMP Paper Mill, Woodstock, Connecticut.

Published by Tyler Graphics Ltd., Bedford, New York (299:EK6)

Base sheet: White cotton pulp

Image: Pressed red cotton pulp

Comments: *Colored Paper Image IV* is related to the single-ellipse figure– ground paintings of the early 1960s.

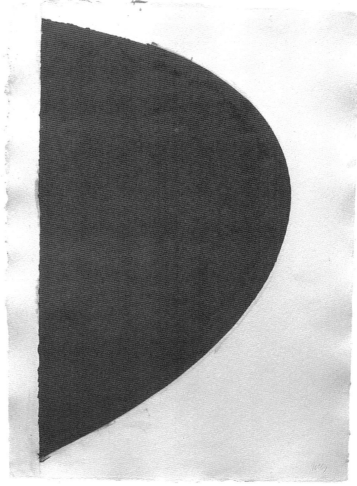

144

Colored Paper Image V (Blue Curves)

1976

Colored and pressed paper pulp

Sheet: 46½ x 32½ (118.1 x 82.6)

Signed in pencil, lower right: *Kelly*; numbered in pencil, lower left. Blind stamps, lower right: *EK*, logo of Tyler Graphics Ltd. Inscribed in pencil on verso: *EK76–258*

Edition: 19

Proofs: 7 AP, TP, 2 CTP, RTP, PPII, A, C (all molds and colored pulp destroyed)

Collaboration and supervision: Kenneth Tyler. Experimental trial proof and RTP paper coloring: Ellsworth Kelly, assisted by Kenneth Tyler, John Koller. Paper coloring: John Koller, Kathleen Koller. Fabricated at HMP Paper Mill, Woodstock, Connecticut.

Published by Tyler Graphics Ltd., Bedford, New York (300:EK7)

Base sheet: White cotton pulp

Image: Pressed blue cotton pulp

Comments: The opposing curved shapes of *Colored Paper Image V* are related to the bow motif as it was developed in the artist's 1973–78 Curve series of metal sculptures. *Colored Paper Image V* is also a curvilinear variation of the X configuration that appeared in the drawings, collages, paintings, and sculpture of the later 1950s.

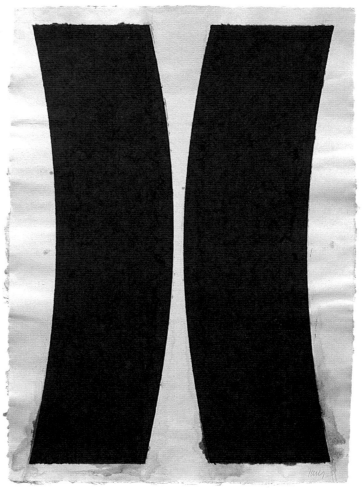

145

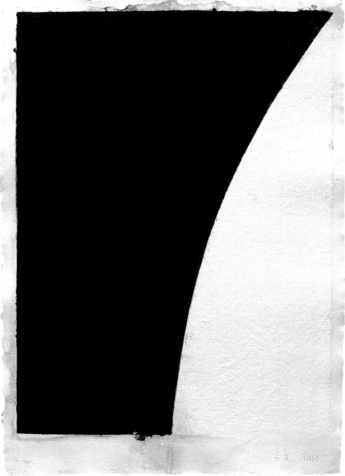

146

Colored Paper Image VI (White Curve with Black II) 1976

Colored and pressed paper pulp

Sheet: 46½ x 32½ (118.1 x 82.6)

Signed in pencil, lower right: *Kelly*; numbered in pencil, lower left. Blind stamps, lower right: *EK*, logo of Tyler Graphics Ltd. Inscribed in pencil on verso: *EK76–259*

Edition: 23

Proofs: 8 AP, TP, 4 CTP, RTP, PPII, A, C (all molds and colored pulp destroyed)

Collaboration and supervision: Kenneth Tyler. Experimental trial proof and RTP paper coloring: Ellsworth Kelly, assisted by Kenneth Tyler, John Koller. Paper coloring: John Koller, Kathleen Koller. Fabricated at HMP Paper Mill, Woodstock, Connecticut.

Published by Tyler Graphics Ltd., Bedford, New York (301:EK8)

Base sheet: White cotton pulp

Image: Pressed green-black and white cotton pulp

Comments: *Colored Paper Image VI* is related to the painting *White Curve VII*, 1976 (EK#535).

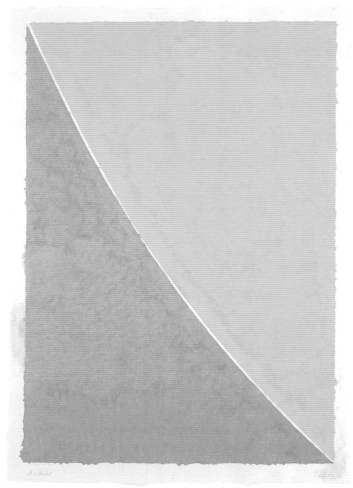

147

Colored Paper Image VII (Yellow Curve with Gray) 1976

Colored and pressed paper pulp

Sheet: 46½ x 32½ (118.1 x 82.6)

Signed in pencil, lower right: *Kelly*; numbered in pencil, lower left. Blind stamps, lower right: *EK*, logo of Tyler Graphics Ltd. Inscribed in pencil on verso: *EK76–260*

Edition: 20

Proofs: 8 AP, TP, RTP, PPII, A, C (all molds and colored pulp destroyed)

Collaboration and supervision: Kenneth Tyler. Experimental trial proof and RTP paper coloring: Ellsworth Kelly, assisted by Kenneth Tyler, John Koller. Paper coloring: John Koller, Kathleen Koller. Fabricated at HMP Paper Mill, Woodstock, Connecticut.

Published by Tyler Graphics Ltd., Bedford, New York (302:EK9)

Base sheet: White cotton pulp

Image: Pressed yellow and gray cotton pulp

Literature: Driesbach et al. 1985

Comments: The rectangle bisected at opposite corners by a curved line is a configuration that Kelly developed in his paintings and sculptures of the early 1970s. Varying in proportions and color in the lithographs, it dominates the First Curve Series (cat. nos. 99–103) and appears in two prints in the Second Curve Series (cat. nos. 106, 109). The format is suggested in *Colored Paper Image XIV*.

Colored Paper Image VIII (Gray Curve with Blue) 1976

Colored and pressed paper pulp

Sheet: 46½ x 32½ (118.1 x 82.6)

Signed in pencil, lower right: *Kelly*; numbered in pencil, lower left. Blind stamps, lower right: *EK*, logo of Tyler Graphics Ltd. Inscribed in pencil on verso: *EK76–261*

Edition: 20

Proofs: 7 AP, TP, RTP, PPII, A, C (all molds and colored pulp destroyed)

Collaboration and supervision: Kenneth Tyler. Experimental trial proof and RTP paper coloring: Ellsworth Kelly, assisted by Kenneth Tyler, John Koller. Paper coloring: John Koller, Kathleen Koller. Fabricated at HMP Paper Mill, Woodstock, Connecticut.

Published by Tyler Graphics Ltd., Bedford, New York (303:EK10)

Base sheet: White cotton pulp

Image: Pressed gray, blue-green, and yellow cotton pulp

Comments: *Colored Paper Image VIII* is related to the bisected-rectangle format of the Third Curve Series (cat. nos. 116–39).

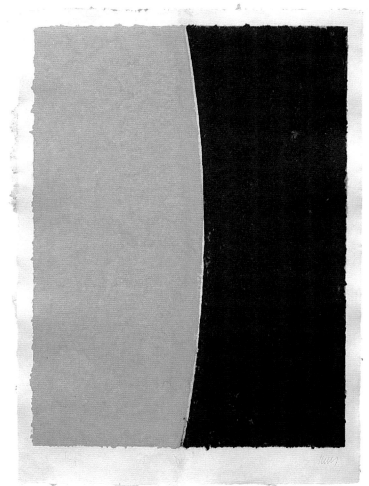

148

Colored Paper Image IX (Four Grays with Black I) 1976

Colored and pressed paper pulp

Sheet: 46½ x 32½ (118.1 x 82.6)

Signed in pencil, lower right: *Kelly*; numbered in pencil, lower left. Blind stamps, lower right: *EK*, logo of Tyler Graphics Ltd. Inscribed in pencil on verso: *EK76–262*

Edition: 18

Proofs: 8 AP, TP, RTP, PPII, A, C (all molds and colored pulp destroyed)

Collaboration and supervision: Kenneth Tyler. Experimental trial proof and RTP paper coloring: Ellsworth Kelly, assisted by Kenneth Tyler, John Koller. Paper coloring: John Koller, Kathleen Koller. Fabricated at HMP Paper Mill, Woodstock, Connecticut.

Published by Tyler Graphics Ltd., Bedford, New York (304:EK11)

Base sheet: White cotton pulp

Image: Pressed light gray, medium gray, dark gray, gray-black, and black cotton pulp

Comments: *Colored Paper Image IX* and *Colored Paper Image IX, State* (cat. no. 149a) are related to the joined-panel painting *Red Orange White Green Blue*, 1968 (EK#386; Coplans 1973, pl. 177). Kelly did not execute any gray-scale panel paintings. These two paperworks are also related to cat. nos. 153, 159, and 161.

149

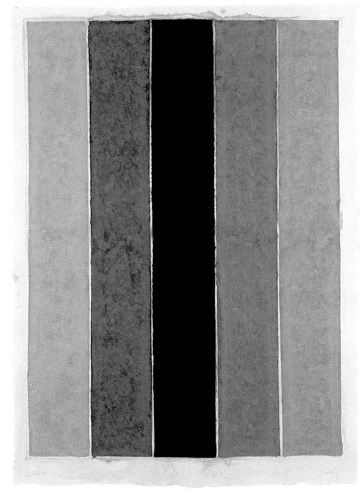

149a

Colored Paper Image IX, State (Four Grays with Black II) 1976

Colored and pressed paper pulp

Sheet: 46½ x 32½ (118.1 x 82.6)

Signed in pencil, lower right: *Kelly*; numbered in pencil, lower left. Blind stamps, lower right: *EK*, logo of Tyler Graphics Ltd. Inscribed in pencil on verso: *EK76–262A*

Edition: 10

Proofs: RTP, C (all molds and colored pulp destroyed)

Collaboration and supervision: Kenneth Tyler. Experimental trial proof and RTP paper coloring: Ellsworth Kelly, assisted by Kenneth Tyler, John Koller. Paper coloring: John Koller, Kathleen Koller. Fabricated at HMP Paper Mill, Woodstock, Connecticut.

Published by Tyler Graphics Ltd., Bedford, New York (305:EK12)

Base sheet: White cotton pulp

Image: Pressed light gray, medium gray, dark gray, and gray-black cotton pulp

Comments: See cat. no. 149

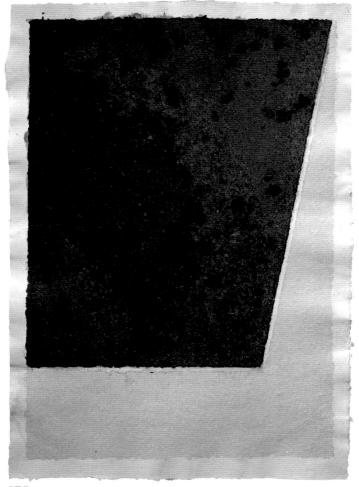

150

Colored Paper Image X (Blue with Gray) 1976

Colored and pressed paper pulp

Sheet: 46½ x 32½ (118.1 x 82.6)

Signed in pencil, lower right: *Kelly*; numbered in pencil, lower left. Blind stamps, lower right: *EK*, logo of Tyler Graphics Ltd. Inscribed in pencil on verso: *EK76–263*

Edition: 20

Proofs: 7 AP, TP, RTP, PPII, A, C (all molds and colored pulp destroyed)

Collaboration and supervision: Kenneth Tyler. Experimental trial proof and RTP paper coloring: Ellsworth Kelly, assisted by Kenneth Tyler, John Koller. Paper coloring: John Koller, Kathleen Koller. Fabricated at HMP Paper Mill, Woodstock, Connecticut.

Published by Tyler Graphics Ltd., Bedford, New York (306:EK13)

Base sheet: White cotton pulp

Image: Pressed light blue, medium blue, dark blue cotton pulp

Literature: Dückers 1981, no. 538

Comments: *Colored Paper Image X* is a proportional variation of the Concorde motif, which was first stated in the painting *Concorde I*, 1955 (EK#84), and in the wood sculpture Concorde Relief, 1958 (EK#S158; Sims and Pulitzer 1982, no. 28). The paperwork, in turn, was the basis for further development of the variation in the wood sculpture *Concorde Relief II*, 1978 (EK#S585; Sims and Pulitzer 1982, no. 104), and in the aquatints *Concorde IV* and *Concorde V* from the Concorde Series (1982; cat. nos. 194–200a).

Colored Paper Image XI (Gray Curves with Brown) 1976

Colored and pressed paper pulp

Sheet: 46½ x 32½ (118.1 x 82.6)

Signed in pencil, lower right: *Kelly*; numbered in pencil, lower left. Blind stamps, lower right: *EK*, logo of Tyler Graphics Ltd. Inscribed in pencil on verso: *EK76–264*

Edition: 18

Proofs: 7 AP, TP, RTP, PPII, A, C (all molds and colored pulp destroyed)

Collaboration and supervision: Kenneth Tyler. Experimental trial proof and RTP paper coloring: Ellsworth Kelly, assisted by Kenneth Tyler, John Koller. Paper coloring: John Koller, Kathleen Koller. Fabricated at HMP Paper Mill, Woodstock, Connecticut.

Published by Tyler Graphics Ltd., Bedford, New York (307:EK14)

Base sheet: White cotton pulp

Image: Pressed brown and gray cotton pulp

Comments: *Colored Paper Image XI* is related to the paintings *Rebound*, 1959 (EK#213; Coplans 1973, pl. 25), and *Blue White*, 1962 (EK#283).

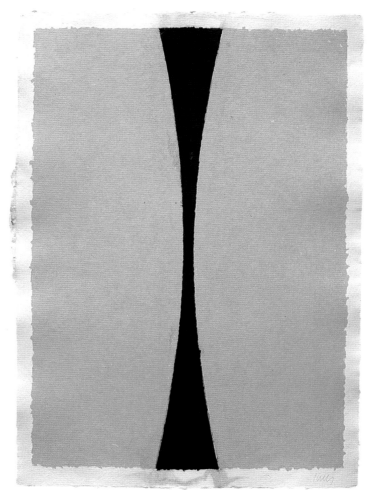

151

Colored Paper Image XII (Blue Curve with Brown and Gray) 1976

Colored and pressed paper pulp

Sheet: 46½ x 32½ (118.1 x 82.6)

Signed in pencil, lower right: *Kelly*; numbered in pencil, lower left. Blind stamps, lower right: *EK*, logo of Tyler Graphics Ltd. Inscribed in pencil on verso: *EK76–265*

Edition: 20

Proofs: 8 AP, TP, RTP, PPII, A, C (all molds and colored pulp destroyed)

Collaboration and supervision: Kenneth Tyler. Experimental trial proof and RTP paper coloring: Ellsworth Kelly, assisted by Kenneth Tyler, John Koller. Paper coloring: John Koller, Kathleen Koller. Fabricated at HMP Paper Mill, Woodstock, Connecticut.

Published by Tyler Graphics Ltd., Bedford, New York (308:EK15)

Base sheet: White cotton pulp

Image: Pressed gray, blue, and brown cotton pulp

Literature: Flint 1977, no. 22, 11; Schiller 1977, 6

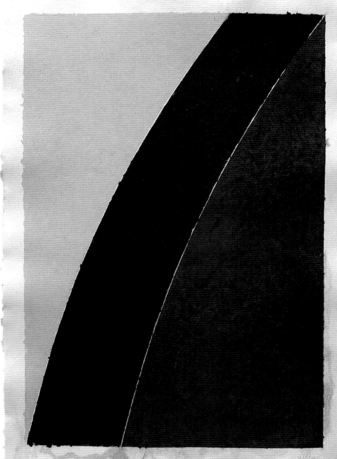

152

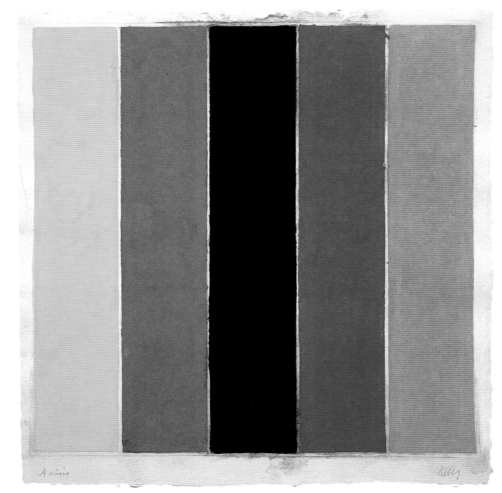

Colored Paper Image XIII (Yellow/Green/Black/Blue/Orange) 1976

Colored and pressed paper pulp

Sheet: 32¼ x 31¼ (81.9 x 79.4)

Signed in pencil, lower right: *Kelly*; numbered in pencil, lower left. Blind stamps, lower right: *EK*, logo of Tyler Graphics Ltd. Inscribed in pencil on verso: *EK76–306*

Edition: 23

Proofs: 9 AP, TP, RTP, PPII, SP, A, C (all molds and colored pulp destroyed)

Collaboration and supervision: Kenneth Tyler. Experimental trial proof and RTP paper coloring: Ellsworth Kelly, assisted by Kenneth Tyler, John Koller. Paper coloring: John Koller, Kathleen Koller. Fabricated at HMP Paper Mill, Woodstock, Connecticut.

Published by Tyler Graphics Ltd., Bedford, New York (309:EK16)

Base sheet: White cotton pulp

Image: Pressed orange, yellow, blue, green, and black cotton pulp

Comments: The joined vertical stripes of *Colored Paper Image XIII* are a color variation of cat. nos. 159 and 161. These three paperworks are related in their proportions to the painting *Red Orange White Green Blue*, 1968 (EK #386; Coplans 1973, pl. 177).

153

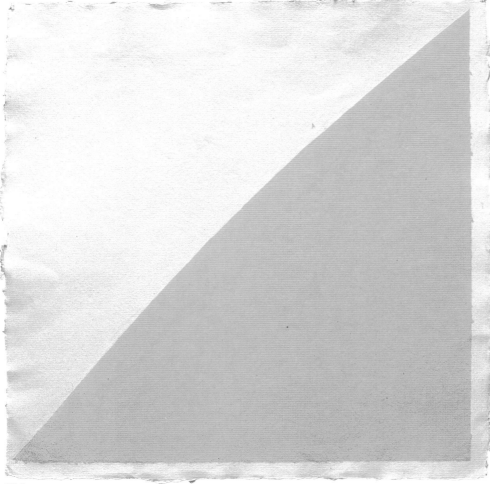

Colored Paper Image XIV (Yellow Curve) 1976

Colored and pressed paper pulp

Sheet: 32¼ x 31¼ (81.9 x 79.4)

Signed in pencil, lower right: *Kelly*; numbered in pencil, lower left. Blind stamps, lower right: *EK*, logo of Tyler Graphics Ltd. Inscribed in pencil on verso: *EK76–310*

Edition: 24

Proofs: 8 AP, TP, RTP, PPII, A, C (all molds and colored pulp destroyed)

Collaboration and supervision: Kenneth Tyler. Experimental trial proof and RTP paper coloring: Ellsworth Kelly, assisted by Kenneth Tyler, John Koller. Paper coloring: John Koller, Kathleen Koller. Fabricated at HMP Paper Mill, Woodstock, Connecticut.

Published by Tyler Graphics Ltd., Bedford, New York (310:EK17)

Base sheet: White cotton pulp

Image: Pressed yellow cotton pulp

Comments: *Colored Paper Image XIV* repeats the composition and color of the painting *Yellow Curve II*, 1972 (EK #484). The rectangle bisected at opposite corners by a curved line is a configuration that Kelly developed in his paintings and sculptures of the early 1970s. Varying in proportions and colors in the lithographs, it dominates the First Curve Series (cat. nos. 99–103) and appears in two prints in the Second Curve Series (cat. nos. 106, 109). The format appears once again in *Colored Paper Image VII*. In *Colored Paper Image XIV* Kelly varies this motif by floating the curved form on the sheet.

154

Colored Paper Image XV (Dark Gray and Blue) 1976

Colored and pressed paper pulp

Sheet: 32¼ x 31¼ (81.9 x 79.4)

Signed in pencil, lower right: *Kelly*; numbered in pencil, lower left. Blind stamps, lower right: *EK*, logo of Tyler Graphics Ltd. Inscribed in pencil on verso: *EK76–311*

Edition: 23

Proofs: 8 AP, 2 TP, RTP, PPII, A, C (all molds and colored pulp destroyed)

Collaboration and supervision: Kenneth Tyler. Experimental trial proof and RTP paper coloring: Ellsworth Kelly, assisted by Kenneth Tyler, John Koller. Paper coloring: John Koller, Kathleen Koller. Fabricated at HMP Paper Mill, Woodstock, Connecticut.

Published by Tyler Graphics Ltd., Bedford, New York (311:EK18)

Base sheet: White cotton pulp

Image: Pressed gray-black and blue cotton pulp

Comments: *Colored Paper Image XV* is a color variation of the paintings *Black White*, 1968 (EK#396; Coplans 1973, pl. 191), and *Two Grays III*, 1975–77 (EK#513), and of the aquatint *Diagonal with Black* (cat. no. 195) from the Concorde Series.

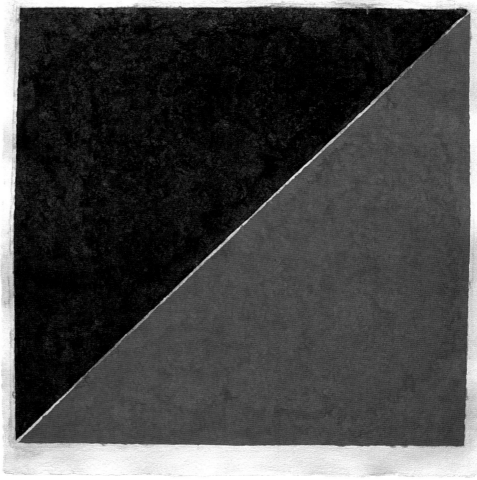

155

Colored Paper Image XVI (Blue/Yellow/Red) 1976

Colored and pressed paper pulp

Sheet: 32¼ x 31¼ (81.9 x 79.4)

Signed in pencil, lower right: *Kelly*; numbered in pencil, lower left. Blind stamps, lower right; *EK*, logo of Tyler Graphics Ltd. Inscribed in pencil on verso: *EK76–312*

Edition: 24

Proofs: 8 AP, 2 TP, RTP, PPII, A, C (all molds and colored pulp destroyed)

Collaboration and supervision: Kenneth Tyler. Experimental trial proof and RTP paper coloring: Ellsworth Kelly, assisted by Kenneth Tyler, John Koller. Paper coloring: John Koller, Kathleen Koller. Fabricated at HMP Paper Mill, Woodstock, Connecticut.

Published by Tyler Graphics Ltd., Bedford, New York (312:EK19)

Base sheet: White cotton pulp

Image: Pressed blue, yellow, and red cotton pulp

Literature: Skoggard 1977, 62–63

Comments: The paperwork *Colored Paper Image XVI* repeats the composition and colors of two earlier paintings in small and large versions: *Blue Yellow Red*, 1971 (EK#451), and *Blue Yellow Red*, 1972 (EK#470). It is also related in color and design to the screenprint *Blue/Yellow/Red* (cat. no. 91). *Colored Paper Image XVII* is a color variation. Kelly derived these later paintings and prints from a series of collages done in Paris in 1953 and from the painting *Train Landscape*, 1952–53 (EK#61).

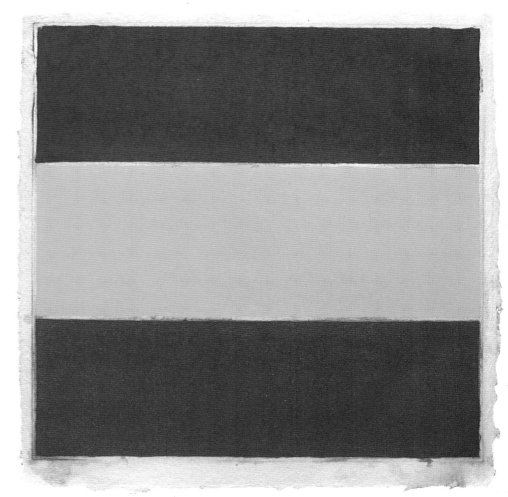

157

Colored Paper Image XVII (Blue/ Black/Brown) 1976

Colored and pressed paper pulp

Sheet: 32¼ x 31¼ (81.9 x 79.4)

Signed in pencil, lower right: *Kelly*; numbered in pencil, lower left. Blind stamps, lower right: *EK*, logo of Tyler Graphics Ltd. Inscribed in pencil on verso: *EK76–254*

Edition: 20

Proofs: 10 AP, TP, RTP, PPII, SP, A, C (all molds and colored pulp destroyed)

Collaboration and supervision: Kenneth Tyler. Experimental trial proof and RTP paper coloring: Ellsworth Kelly, assisted by Kenneth Tyler, John Koller. Paper coloring: John Koller, Kathleen Koller. Fabricated at HMP Paper Mill, Woodstock, Connecticut.

Published by Tyler Graphics Ltd., Bedford, New York (295:EK2)

Base sheet: White cotton pulp

Image: Pressed gray-black and white cotton pulp

Comments: See cat. no. 156

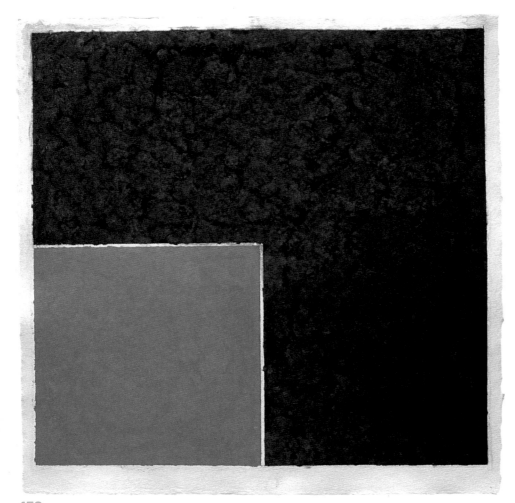

158

Colored Paper Image XVIII (Green Square with Dark Gray) 1976

Colored and pressed paper pulp

Sheet: 32¼ x 31¼ (81.9 x 79.4)

Signed in pencil, lower right: *Kelly*; numbered in pencil, lower left. Blind stamps, lower right: *EK*, logo of Tyler Graphics Ltd. Inscribed in pencil on verso: *EK76–307*

Edition: 22

Proofs: 8 AP, TP, RTP, PPII, A, C (all molds and colored pulp destroyed)

Collaboration and supervision: Kenneth Tyler. Experimental trial proof and RTP paper coloring: Ellsworth Kelly, assisted by Kenneth Tyler, John Koller. Paper coloring: John Koller, Kathleen Koller. Fabricated at HMP Paper Mill, Woodstock, Connecticut.

Published by Tyler Graphics Ltd., Bedford, New York (314:EK21)

Base sheet: White cotton pulp

Image: Pressed green and gray-black cotton pulp

Literature: Farmer 1978, 41

Comments: *Colored Paper Image XVIII* is a color variation of the painting *White Square with Black*, 1970 (EK#434; Coplans 1973, pl. 217), and the aquatint *Square with Black* (cat. no. 194) from the Concorde Series, 1981–82.

Colored Paper Image XIX (Brown/ Blue/Black/Green/Violet) 1976

Colored and pressed paper pulp

Sheet: 32¼ x 31¼ (81.9 x 79.4)

Signed in pencil, lower right: *Kelly*; numbered in pencil, lower left. Blind stamps, lower right: *EK*, logo of Tyler Graphics Ltd. Inscribed in pencil on verso: *EK76–305*

Edition: 17

Proofs: 7 AP, TP, RTP, PPII, A, C (all molds and colored pulp destroyed)

Collaboration and supervision: Kenneth Tyler. Experimental trial proof and RTP paper coloring: Ellsworth Kelly, assisted by Kenneth Tyler, John Koller. Paper coloring: John Koller, Kathleen Koller. Fabricated at HMP Paper Mill, Woodstock, Connecticut.

Published by Tyler Graphics Ltd., Bedford, New York (315:EK22)

Base sheet: White cotton pulp

Image: Pressed brown, blue, black, green, and violet cotton pulp

Comments: The joined vertical stripes of *Colored Paper Image XIX* are a color variation of cat. nos. 153 and 161. These three paperworks are related in their proportions to the painting *Red Orange White Green Blue*, 1968 (EK#386; Coplans 1973, pl. 177).

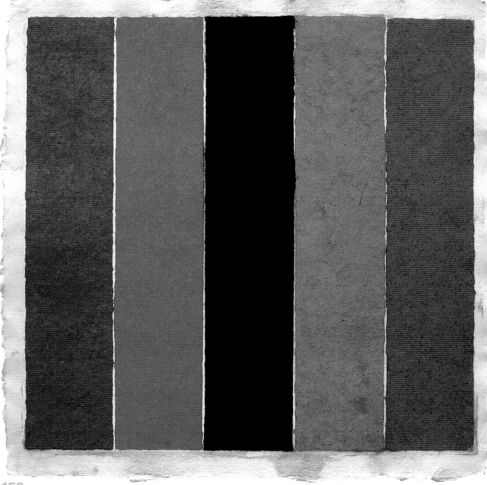

159

Colored Paper Image XX (Brown Square with Blue) 1976

Colored and pressed paper pulp

Sheet: 32¼ x 31¼ (81.9 x 79.4)

Signed in pencil, lower right: *Kelly*; numbered in pencil, lower left. Blind stamps, lower right: *EK*, logo of Tyler Graphics Ltd. Inscribed in pencil on verso: *EK76–308*

Edition: 22

Proofs: 8 AP, 2 TP, RTP, PPII, A, C (all molds and colored pulp destroyed)

Collaboration and supervision: Kenneth Tyler. Experimental trial proof and RTP paper coloring: Ellsworth Kelly, assisted by Kenneth Tyler, John Koller. Paper coloring: John Koller, Kathleen Koller. Fabricated at HMP Paper Mill, Woodstock, Connecticut.

Published by Tyler Graphics Ltd., Bedford, New York (316:EK23)

Base sheet: White cotton pulp

Image: Pressed blue and brown cotton pulp

Comments: *Colored Paper Image XX* is related to the collage *Study for "Painting in Two Panels,"* 1967 (EK#67.05).

160

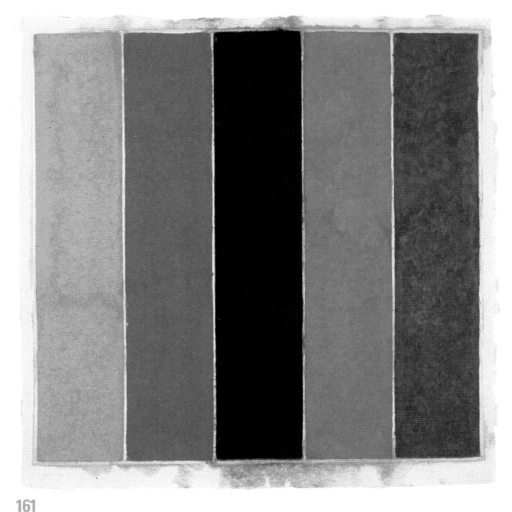

161

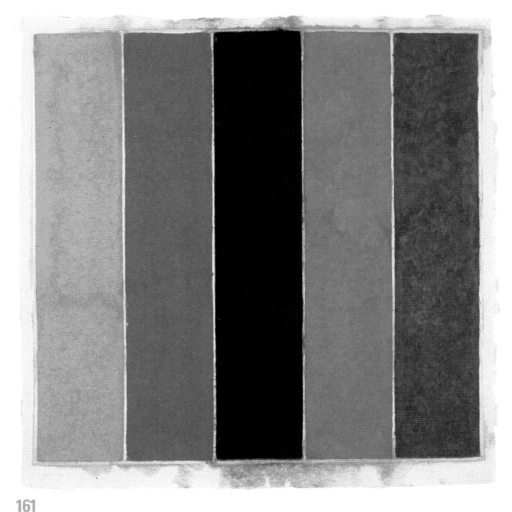

162

Colored Paper Image XXI (Orange/Blue/Black/Green/Brown) 1976–77

Colored and pressed paper pulp

Sheet: 32¼ x 31¼ (81.9 x 79.4)

Signed in pencil, lower right: *Kelly*; numbered in pencil, lower left. Blind stamps, lower right: *EK*, logo of Tyler Graphics Ltd. Inscribed in pencil on verso: *EK76–226*

Edition: 10

Proofs: 7 AP, TP, RTP, PPII, A, C (all molds and colored pulp destroyed)

Collaboration and supervision: Kenneth Tyler. Experimental trial proof and RTP paper coloring: Ellsworth Kelly, assisted by Kenneth Tyler, John Koller. Paper coloring: John Koller, Kathleen Koller. Fabricated at HMP Paper Mill, Woodstock, Connecticut.

Published by Tyler Graphics Ltd., Bedford, New York (317:EK24)

Base sheet: White cotton pulp

Image: Pressed orange, blue, black, green, and brown cotton pulp

Comments: The joined vertical stripes of *Colored Paper Image XXI* are a color variation of cat. nos. 153 and 159. These three paperworks are related in their proportions to the painting *Red Orange White Green Blue*, 1968 (EK#386; Coplans 1973, pl. 177).

Blue/Green/Yellow/Orange/Red (Colored Paper Image XXII) 1976–77

Colored and pressed paper pulp

Sheet: 13½ x 46 (34.3 x 116.8)

Signed in pencil, lower right: *Kelly*; numbered in pencil, lower left. Blind stamps, lower right: *EK*, logo of Tyler Graphics Ltd. Inscribed in pencil on verso: *EK75–225*

Edition: 14

Proofs: 8 AP, 3 TP, 2 CTP, WP, RTP, PPII, A, C (all molds and colored pulp destroyed)

Collaboration and supervision: Kenneth Tyler. Experimental trial proof and RTP paper coloring: Ellsworth Kelly, assisted by Kenneth Tyler, John Koller. Paper coloring: John Koller, Kathleen Koller. Fabricated at HMP Paper Mill, Woodstock, Connecticut.

Published by Tyler Graphics Ltd., Bedford, New York (318:EK25)

Base sheet: White cotton pulp

Image: Pressed blue, green, yellow, orange, and red cotton pulp

Comments: *Blue/Green/Yellow/Orange/Red* repeats the composition and colors of two paintings, both entitled *Blue Green Yellow Orange Red*, 1968 (EK#359, EK#360), the first a smaller version of the other. The paintings and this paperwork were derived from a series of ink-and-pencil studies from 1955 (EK#55.115A, 115B, 115C).

Nine Colors (Colored Paper Image XXIII) 1976–77

Colored and pressed paper pulp

Sheet: 30 x 30 (76.2 x 76.2)

Signed in pencil, lower right: *Kelly*; numbered in pencil, lower left. Blind stamps, lower right: *EK*, logo of Tyler Graphics Ltd. Inscribed in pencil on verso: *EK75–224*

Edition: 20

Proofs: 10 AP, TP, RTP, PPII, SP, A, C (all molds and colored pulp destroyed)

Collaboration and supervision: Kenneth Tyler. Experimental trial proof and RTP paper coloring: Ellsworth Kelly, assisted by Kenneth Tyler, John Koller. Paper coloring: John Koller, Kathleen Koller. Fabricated at HMP Paper Mill, Woodstock, Connecticut.

Published by Tyler Graphics Ltd., Bedford, New York (319:EK26)

Base sheet: White cotton pulp

Image: Pressed green, yellow, dark blue, royal blue, black, red, orange, light green, and purple cotton pulp

Comments: The paperwork *Nine Colors* is based on the collage *Nine Colors on White*, 1953 (EK#53.58; Waldman 1971, pl. 75). It also repeats the composition and colors of the screenprint and lithograph *Nine Squares* (cat. no. 164).

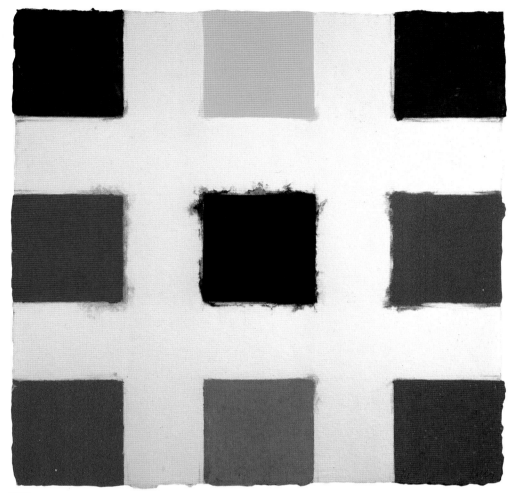

163

Nine Squares 1976–77

Screenprint and offset lithograph on Rives BFK paper

Sheet: 40½ x 40½ (102.9 x 102.9)

Image: 40 x 40 (101.6 x 101.6)

Signed in pencil, lower right: *Kelly*; numbered in pencil, lower right. Blind stamp, lower right: logo of Tyler Graphics Ltd. Inscribed in pencil on verso: *EK76–223*

Edition: 44

Proofs: 12 AP, 4 CTP, RTP, PPII, A, C

Collaboration and supervision: Kenneth Tyler. Screen preparation, proofing, and edition printing: Kim Halliday. Lithography plate preparation, proofing, and edition printing: John Hutcheson.

Published by Tyler Graphics Ltd., Bedford, New York (320:EK27)

11 runs from 2 plates and 3 screens
1. gray (left-half grid); aluminum photo plate, from photographically prepared film
2. gray (right-half grid); aluminum photo plate, from photographically prepared film
3. yellow; screen, from hand-cut stencil
4. light green; same screen as 3
5. black; screen, from hand-cut stencil
6. red; same screen as 5
7. blue; same screen as 5
8. orange; same screen as 5
9. green; screen, from hand-cut stencil
10. purple; same screen as 9
11. dark blue; same screen as 9

Comments: The screenprint *Nine Squares* is based on the collage *Nine Colors on White*, 1953 (EK#53.58; Waldman 1971, pl. 75). It also repeats the composition and colors of the paperwork *Nine Colors* (cat. no. 163) from the Colored Paper Images series.

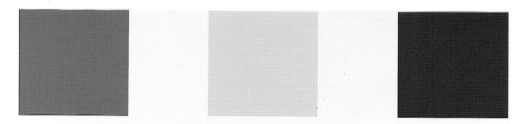

164

Leaf XI, 1978 (cat. no. 176)

165–76
TWELVE LEAVES 1978

Twelve Leaves is related to two other botanical series of lithographic drawings that Kelly made at Gemini G.E.L.: Leaves, published in 1974 (cat. nos. 93–96); and the Series of Plant and Flower Lithographs of 1985 (cat. nos. 207–13). Twelve Leaves begins with a spider plant, cropped so that only its umbrellalike spray of leaves is visible; this is followed by eleven variations on a calla-lily leaf, each print adopting a slightly different point of view, from above or below. The calla-lily sequence, which Kelly drew from a bouquet that a friend brought into the Gemini workshop, is related to a series in the artist's drawing oeuvre where a single plant, such as a cornstalk or a water lily, is explored in numerous permutations. Kelly executed the calla-lily drawings directly on transfer paper without any preliminary sketches. Each sheet was kept for processing and editioning; none, remarkably, was rejected or redrawn.

The Twelve Leaves series was in part published to raise funds for Change, Inc., Robert Rauschenberg's organization for the arts. For this purpose a special proof was pulled for each print, which was inscribed *Change Inc.*

Literature: *Ellsworth Kelly: Twelve Leaves* 1978; "New Editions," *Art News*, 1978, 106; "Prints and Photographs," *Print Collector's Newsletter* 1979a, 193

Leaves 1978

Transfer lithograph on 350-gram Arches 88 paper

Sheet: 30 x 42 (76.2 x 106.7)

Signed in pencil, lower right: *Kelly*; inscribed in pencil, lower right: *Leaves*; numbered in pencil, lower right. Blind stamp, lower right: logo of Gemini G.E.L.,©. Inscribed in pencil on verso: *EK78–862*. Stamped on verso: © *Gemini G.E.L. 1978*

Edition: 30

Proofs: 9 AP, RTP, PPII, 2 SP, Change, Inc., 3 GEL, C

Collaboration and supervision: Serge Lozingot, Mark Stock. Proofing and processing: Mark Stock. Edition printing: Edward Henderson.

Published by Gemini G.E.L., Los Angeles (Gemini 802)

1 run from 1 plate
1 black; aluminum plate, from lithographic-crayon drawing on transfer paper

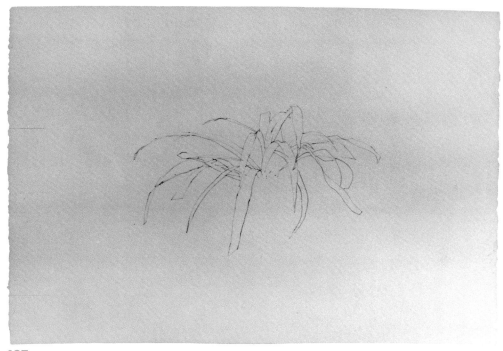

165

Leaf I 1978

Transfer lithograph on 350-gram Arches 88 paper

Sheet: 30 x 42 (76.2 x 106.7)

Signed in pencil, lower right: *Kelly*; inscribed in pencil, lower right: *Leaf I*; numbered in pencil, lower right. Blind stamp, lower right: logo of Gemini G.E.L., ©. Inscribed in pencil on verso: *EK78–863*. Stamped on verso: © *Gemini G.E.L. 1978*

Edition: 20

Proofs: 9 AP, RTP, PPII, 2 SP, Change, Inc., 3 GEL, C

Collaboration and supervision: Serge Lozingot, Mark Stock. Proofing and processing: Serge Lozingot, Mark Stock, Edward Henderson. Edition printing: Mark Stock.

Published by Gemini G.E.L., Los Angeles (Gemini 803)

1 run from 1 plate
1 black; aluminum plate, from lithographic-crayon drawing on transfer paper

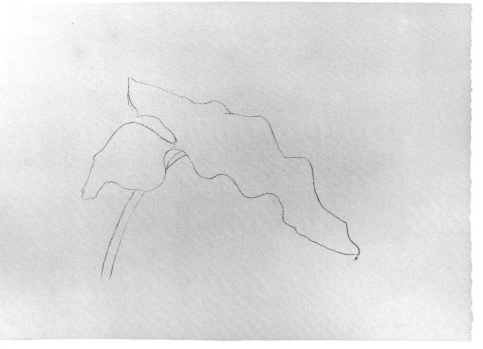

166

167

Leaf II 1978

Transfer lithograph on 350-gram Arches 88 paper

Sheet: 30 x 42 (76.2 x 106.7)

Signed in pencil, lower right: *Kelly*; inscribed in pencil, lower right: *Leaf II*; numbered in pencil, lower right. Blind stamp, lower right: logo of Gemini G.E.L., ©. Inscribed in pencil on verso: *EK78–864*. Stamped on verso: © *Gemini G.E.L. 1978*

Edition: 20

Proofs: 9 AP, RTP, PPII, 2 SP, Change, Inc., 3 GEL, C

Collaboration and supervision: Serge Lozingot, Mark Stock. Proofing and processing: Serge Lozingot, Mark Stock, Edward Henderson. Edition printing: Edward Henderson.

Published by Gemini G.E.L., Los Angeles (Gemini 804)

1 run from 1 plate

1 black; aluminum plate, from lithographic-crayon drawing on transfer paper

168

Leaf III 1978

Transfer lithograph on 350-gram Arches 88 paper

Sheet: 30 x 42 (76.2 x 106.7)

Signed in pencil, lower right: *Kelly*; inscribed in pencil, lower right: *Leaf III*; numbered in pencil, lower right. Blind stamp, lower right: logo of Gemini G.E.L., ©. Inscribed in pencil on verso: *EK78–865*. Stamped on verso: © *Gemini G.E.L. 1978*

Edition: 20

Proofs: 9 AP, RTP, PPII, SP, Change, Inc., 3 GEL, C

Collaboration and supervision: Serge Lozingot, Mark Stock. Proofing and processing: Serge Lozingot, Mark Stock, Edward Henderson. Edition printing: Serge Lozingot.

Published by Gemini G.E.L., Los Angeles (Gemini 805)

1 run from 1 plate

1 black; aluminum plate, from lithographic-crayon drawing on transfer paper

Leaf IV 1978

Transfer lithograph on 350-gram Arches 88 paper

Sheet: 30 x 42 (76.2 x 106.7)

Signed in pencil, lower right: *Kelly*; inscribed in pencil, lower right: *Leaf IV*; numbered in pencil, lower right. Blind stamp, lower right: logo of Gemini G.E.L., ©. Inscribed in pencil on verso: *EK78–866*. Stamped on verso: © *Gemini G.E.L. 1978*

Edition: 20

Proofs: 9 AP, RTP, PPII, 2 SP, Change, Inc., 3 GEL, C

Collaboration and supervision: Serge Lozingot, Mark Stock. Proofing and processing: Serge Lozingot, Mark Stock, Edward Henderson. Edition printing: Edward Henderson.

Published by Gemini G.E.L., Los Angeles (Gemini 806)

1 run from 1 plate
1 black; aluminum plate, from lithographic-crayon drawing on transfer paper

Literature: Fine 1984, no. 51, 136–37

169

Leaf V 1978

Transfer lithograph on 350-gram Arches 88 paper

Sheet: 30 x 42 (76.2 x 106.7)

Signed in pencil, lower right: *Kelly*; inscribed in pencil, lower right: *Leaf V*; numbered in pencil, lower right. Blind stamp, lower right: logo of Gemini G.E.L., ©. Inscribed in pencil on verso: *EK78–867*. Stamped on verso: © *Gemini G.E.L. 1978*

Edition: 20

Proofs: 9 AP, RTP, PPII, 2 SP, Change, Inc., 3 GEL, C

Collaboration and supervision: Serge Lozingot, Mark Stock. Proofing and processing: Serge Lozingot, Mark Stock, Edward Henderson. Edition printing: Mark Stock.

Published by Gemini G.E.L., Los Angeles (Gemini 807)

1 run from 1 plate
1 black; aluminum plate, from lithographic-crayon drawing on transfer paper

170

171

Leaf VI 1978

Transfer lithograph on 350-gram Arches 88 paper

Sheet: 30 x 42 (76.2 x 106.7)

Signed in pencil, lower right: *Kelly*; inscribed in pencil, lower right: *Leaf VI*; numbered in pencil, lower right. Blind stamp, lower right: logo of Gemini G.E.L., ©. Inscribed in pencil on verso: *EK78–868*. Stamped on verso: © *Gemini G.E.L. 1978*

Edition: 20

Proofs: 9 AP, RTP, PPII, SP, Change, Inc., 3 GEL, C

Collaboration and supervision: Serge Lozingot, Mark Stock. Proofing and processing: Serge Lozingot, Mark Stock, Edward Henderson. Edition printing: Serge Lozingot.

Published by Gemini G.E.L., Los Angeles (Gemini 808)

1 run from 1 plate
1 black; aluminum plate, from lithographic-crayon drawing on transfer paper

172

Leaf VII 1978

Transfer lithograph on 350-gram Arches 88 paper

Sheet: 30 x 42 (76.2 x 106.7)

Signed in pencil, lower right: *Kelly*; inscribed in pencil, lower right: *Leaf VII*; numbered in pencil, lower right. Blind stamp, lower right: logo of Gemini G.E.L., ©. Inscribed in pencil on verso: *EK78–869*. Stamped on verso: © *Gemini G.E.L. 1978*

Edition: 20

Proofs: 9 AP, RTP, PPII, SP, Change, Inc., 3 GEL, C

Collaboration and supervision: Serge Lozingot, Mark Stock. Proofing and processing: Serge Lozingot, Mark Stock, Edward Henderson. Edition printing: Edward Henderson.

Published by Gemini G.E.L., Los Angeles (Gemini 809)

1 run from 1 plate
1 black; aluminum plate, from lithographic-crayon drawing on transfer paper

Leaf VIII 1978

Transfer lithograph on 350-gram Arches 88 paper

Sheet: 30 x 42 (76.2 x 106.7)

Signed in pencil, lower right: *Kelly*; inscribed in pencil, lower right: *Leaf VIII*; numbered in pencil, lower right. Blind stamp, lower right: logo of Gemini G.E.L., ©. Inscribed in pencil on verso: *EK78–870*. Stamped on verso: © *Gemini G.E.L. 1978*

Edition: 20

Proofs: 9 AP, RTP, PPII, SP, Change, Inc., 3 GEL, C

Collaboration and supervision: Serge Lozingot, Mark Stock. Proofing and processing: Serge Lozingot, Mark Stock, Edward Henderson. Edition printing: Edward Henderson.

Published by Gemini G.E.L., Los Angeles (Gemini 810)

1 run from 1 plate
1 black; aluminum plate, from lithographic-crayon drawing on transfer paper

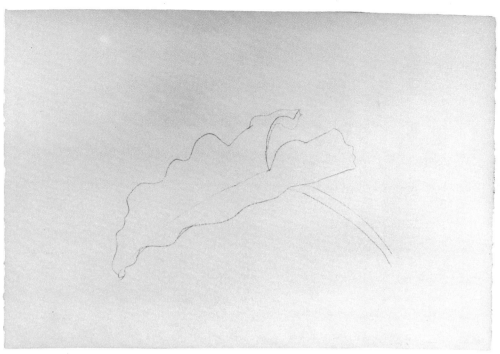

173

Leaf IX 1978

Transfer lithograph on 350-gram Arches 88 paper

Sheet: 30 x 42 (76.2 x 106.7)

Signed in pencil, lower right: *Kelly*; inscribed in pencil, lower right: *Leaf IX*; numbered in pencil, lower right. Blind stamp, lower right: logo of Gemini G.E.L., ©. Inscribed in pencil on verso: *EK78–871*. Stamped on verso: © *Gemini G.E.L. 1978*

Edition: 20

Proofs: 9 AP, RTP, PPII, SP, Change, Inc., 3 GEL, C

Collaboration and supervision: Serge Lozingot, Mark Stock. Proofing and processing: Serge Lozingot, Mark Stock, Edward Henderson. Edition printing: Serge Lozingot.

Published by Gemini G.E.L., Los Angeles (Gemini 811)

1 run from 1 plate
1 black; aluminum plate, from lithographic-crayon drawing on transfer paper

174

175

Leaf X 1978

Transfer lithograph on 350-gram Arches 88 paper

Sheet: 30 x 42 (76.2 x 106.7)

Signed in pencil, lower right: *Kelly*; inscribed in pencil, lower right: *Leaf X*; numbered in pencil, lower right. Blind stamp, lower right: logo of Gemini G.E.L., ©. Inscribed in pencil on verso: *EK78–872*. Stamped on verso: © *Gemini G.E.L. 1978*

Edition: 20

Proofs: 9 AP, RTP, PPII, SP, Change, Inc., 3 GEL, C

Collaboration and supervision: Serge Lozingot, Mark Stock. Proofing and processing: Serge Lozingot, Mark Stock, Edward Henderson. Edition printing: Edward Henderson.

Published by Gemini G.E.L., Los Angeles (Gemini 812)

1 run from 1 plate
1 black; aluminum plate, from lithographic-crayon drawing on transfer paper

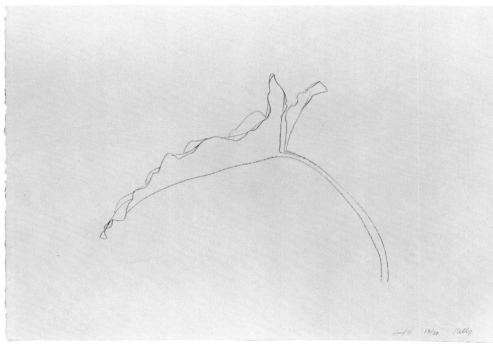

176

Leaf XI 1978

Transfer lithograph on 350-gram Arches 88 paper

Sheet: 30 x 42 (76.2 x 106.7)

Signed in pencil, lower right: *Kelly*; inscribed in pencil, lower right: *Leaf XI*; numbered in pencil, lower right. Blind stamp, lower right: logo of Gemini G.E.L., ©. Inscribed in pencil on verso: *EK78–873*. Stamped on verso: © *Gemini G.E.L. 1978*

Edition: 20

Proofs: 9 AP, RTP, PPII, SP, Change, Inc., 3 GEL, C

Collaboration and supervision: Serge Lozingot, Mark Stock. Proofing and processing: Serge Lozingot, Mark Stock, Edward Henderson. Edition printing: Mark Stock.

Published by Gemini G.E.L., Los Angeles (Gemini 813)

1 run from 1 plate
1 black; aluminum plate, from lithographic-crayon drawing on transfer paper

Wall 1976–79

Etching and aquatint on 300-gram Arches Cover paper

Sheet: 31½ x 28 (80.0 x 71.1)

Image: 16⅛ x 14⅛ (41 x 35.9)

Signed in pencil, lower right, under image: *Kelly*; numbered in pencil, lower left, under image. Blind stamp, lower right: logo of Tyler Graphics Ltd. Inscribed in pencil on verso: *EK76–255.*

Edition: 50

Proofs: 16 AP, 2 TP (Dutch Etching paper), RTP, PPII, O (Rives BFK paper with trimmed margins, signed in pencil by artist, lower right: *OK Kelly*), A, C

Collaboration and supervision: Kenneth Tyler. Processing: Betty Fiske. Proofing and edition printing: Rodney Konopaki.

Published by Tyler Graphics Ltd., Bedford, New York (322:EK29)

1 run from 1 plate

1 black; copper plate

Literature: "Prints and Photographs," *Print Collector's Newsletter* 1979c, 93; Goldman 1980, 85; Field and Rosenfeld 1982, 6; Ackley, Krens, and Menaker 1984, 26; Goldman 1985, 13

Comments: The etching *Wall* repeats the composition and colors of the paintings *Wall Study*, 1955 (EK#85; Coplans 1973, pl. 101), and *Wall*, 1958 (EK#172), which in turn were derived from a number of preliminary drawings and collages that include *Preliminary Study for "Wall,"* 1955 (EK#55.191; Waldman 1971, pl. 88). The motif of the canted rectangle within a rectangle was further developed in three other paintings between 1958 and 1959. Other related material includes a preliminary collage with pencil drawing, also entitled *Wall* (EK#76.20), done in preparation for the etching.

177

Woodland Plant 1979

Transfer lithograph on 300-gram Arches Cover paper

Sheet: 31⅝ x 47½ (80.3 x 120.7)

Signed in pencil, lower left: *Kelly*; numbered in pencil, lower left. Blind stamp, lower right: logo of Tyler Graphics Ltd. Inscribed in pencil on verso: *EK79–429*

Edition: 100

Proofs: 15 AP, RTP, PPII, 6 SP, A, C

Collaboration and supervision: Kenneth Tyler. Proofing, processing, and edition printing: Kenneth Tyler.

Published by Tyler Graphics Ltd., Bedford, New York (323:EK30)

1 run from 1 plate

1 black; aluminum plate, from lithographic-crayon drawing on transfer paper

Literature: "Prints and Photographs," *Print Collector's Newsletter* 1979b, 55; Davies 1980, n.p.

Comments: Kelly created this lithograph on the occasion of an exhibition of his work that was organized by the Metropolitan Museum of Art in New York in 1979 and entitled "Ellsworth Kelly: Recent Paintings and Sculptures." *Woodland Plant* is based on a finished pencil drawing entitled *Wild Sarsaparilla* (EK#P12.79). It is a subtle variation of the lithograph *Sarsaparilla* (cat. no. 189).

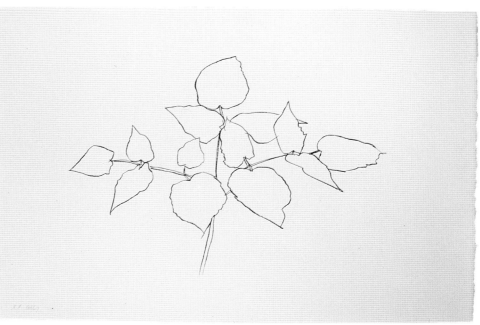

178

179

Saint Martin Landscape *1976–79*

Lithograph and screenprint with collage on 350-gram Arches 88 paper and white Rives Satine paper

Sheet: 26⅞ x 33½ (68.3 x 85.1)

Image: 15⅜ x 22 (39.0 x 55.9)

Signed in pencil, lower right, under image: *Kelly*; numbered in pencil, lower left, under image. Blind stamp, lower right: logo of Tyler Graphics Ltd. Inscribed in pencil on verso: *EK75–220*

Edition: 39

Proofs: 12 AP, 8 CTP, RTP, PPII, A

Collaboration and supervision: Kenneth Tyler. Proofing and processing: John Hutcheson, Kim Halliday, Kenneth Tyler. Lithography: John Hutcheson. Screenprinting: Kim Halliday, Kenneth Tyler. Preparation and adhering of collage element: Kim Halliday, Kenneth Tyler, Rodney Konopaki.

Published by Tyler Graphics Ltd., Bedford, New York (324:EK31)

Base sheet (350-gram Arches 88 paper):
8 runs from 2 screens and 6 plates
1 light blue; screen, from hand-cut stencil
2 transparent turquoise green; screen, from hand-cut stencil
3 process magenta; aluminum photo plate
4 process yellow; aluminum photo plate
5 cyan blue; aluminum photo plate
6 blue; aluminum photo plate
7 blue-black; aluminum photo plate
8 transparent light yellow; aluminum photo plate, from hand-cut masking film

Collaged element (Rives Satine paper; torn and adhered to base sheet):
6 runs from 5 plates and 1 screen
1 yellow; aluminum photo plate
2 transparent yellow; aluminum photo plate
3 process magenta; aluminum photo plate
4 blue; aluminum photo plate
5 transparent orange; screen, from hand-cut stencil
6 blue-black; aluminum photo plate

Comments: Since the 1950s Kelly has intermittently made "postcard collages" that consist of postcards, often picked up on his travels, to which he adheres cut-out figurative or abstract elements. *Saint Martin Landscape* was the only print published in a projected series of lithograph-screenprints that was based on a selection of Kelly's postcard collages. It was derived from a postcard collage (EK#74.36) that Kelly had made while vacationing in Saint Martin, in the West Indies, in 1974. In preparation for the print, Kelly made a preliminary collage-and-ink study of the postcard collage: *Study for Print*, 1976 (EK#76.42). *Saint Martin Landscape* was also realized in three state versions prior to the edition. Printed with the same plates, screens, and inks as the editioned print but on single sheets of paper without a collage element, the state versions represent the artist's experimentation with a darker range of colors. Kelly made trial proofs for several other postcard collage prints which were not, however, developed for editioning. These include a trial proof based on the 1974 postcard collage *Nose/Sailboat* (EK#74.32), a witty juxtaposition of Marilyn Monroe's nose with the prow of a ship. *Dark Gray and White* (cat. no. 180) contains a shape taken from another projected postcard collage print.

Saint Martin Landscape, IA 1976–79

Lithograph and screenprint on 350-gram Arches 88 paper

Sheet: 26⅞ x 33½ (68.3 x 85.1)

Image: 15⅜ x 22 (39.0 x 55.9)

Signed in pencil, lower right, under image: *Kelly*; numbered in pencil, lower left, under image. Blind stamp, lower right: logo of Tyler Graphics Ltd. Inscribed in pencil on verso: *EK75–220A*

Edition: 9

Proofs: A

Collaboration and supervision: Kenneth Tyler. Proofing and processing: John Hutcheson, Kim Halliday, Kenneth Tyler. Lithography: John Hutcheson. Screenprinting: Kim Halliday, Kenneth Tyler.

Published by Tyler Graphics Ltd., Bedford, New York (325:EK32)

14 runs from 3 screens and 11 photo plates
1 light blue; screen, from hand-cut stencil
2 transparent turquoise green; screen, from hand-cut stencil
3 process magenta; aluminum photo plate
4 process yellow; aluminum photo plate
5 cyan blue; aluminum photo plate
6 blue; aluminum photo plate
7 blue-black; aluminum photo plate
8 transparent light yellow; aluminum photo plate, from hand-cut masking film
9 yellow; aluminum photo plate
10 transparent yellow; aluminum photo plate
11 process magenta; aluminum photo plate
12 blue; aluminum photo plate
13 transparent orange; screen, from hand-cut stencil
14 blue-black; aluminum photo plate

179a

Saint Martin Landscape, IB 1976–79

Lithograph and screenprint on 350-gram Arches 88 paper

Sheet: 26⅞ x 33½ (68.3 x 85.1)

Image: 15⅜ x 22 (39.0 x 55.9)

Signed in pencil, lower right, under image: *Kelly*; numbered in pencil, lower left, under image. Blind stamp, lower right: logo of Tyler Graphics Ltd. Inscribed in pencil on verso: *EK75–220B*

Edition: 9

Proofs: None

Collaboration and supervision: Kenneth Tyler. Proofing and processing: John Hutcheson, Kim Halliday, Kenneth Tyler. Lithography: John Hutcheson. Screenprinting: Kim Halliday, Kenneth Tyler.

Published by Tyler Graphics Ltd., Bedford, New York (326:EK33)

14 runs from 3 screens and 11 photo plates
1 light blue; screen, from hand-cut stencil
2 transparent turquoise green; screen, from hand-cut stencil
3 process magenta; aluminum photo plate
4 process yellow; aluminum photo plate
5 cyan blue; aluminum photo plate
6 blue; aluminum photo plate
7 blue-black; aluminum photo plate
8 transparent light yellow; aluminum photo plate, from hand-cut masking film
9 yellow; aluminum photo plate
10 transparent yellow; aluminum photo plate
11 process magenta; aluminum photo plate
12 blue; aluminum photo plate
13 transparent orange; screen, from hand-cut stencil
14 blue-black; aluminum photo plate

179b

179c

Saint Martin Landscape, IC 1976–79

Lithograph and screenprint on 350-gram Arches 88 paper

Sheet: 26⅞ x 33½ (68.3 x 85.1)

Image: 15⅜ x 22 (39.0 x 55.9)

Signed in pencil, lower right, under image: *Kelly*; numbered in pencil, lower left, under image. Blind stamp, lower right: logo of Tyler Graphics Ltd. Inscribed in pencil on verso: *EK75–220C*

Edition: 1

Proofs: None

Collaboration and supervision: Kenneth Tyler. Proofing and processing: John Hutcheson, Kim Halliday, Kenneth Tyler. Lithography: John Hutcheson. Screenprinting: Kim Halliday, Kenneth Tyler.

Published by Tyler Graphics Ltd., Bedford, New York (327:EK34)

14 runs from 3 screens and 11 photo plates
1 light blue; screen, from hand-cut stencil
2 transparent turquoise green; screen, from hand-cut stencil
3 process magenta; aluminum photo plate
4 process yellow; aluminum photo plate
5 cyan blue; aluminum photo plate
6 blue; aluminum photo plate
7 blue-black; aluminum photo plate
8 transparent light yellow; aluminum photo plate, from hand-cut masking film
9 yellow; aluminum photo plate
10 transparent yellow; aluminum photo plate
11 process magenta; aluminum photo plate
12 blue; aluminum photo plate
13 transparent orange; screen, from hand-cut stencil
14 blue-black; aluminum photo plate

180

Dark Gray and White 1977–79

Screenprint and collage on Rives Newsprint paper and Duchene handmade paper

Sheet: 30 x 42 (76.2 x 106.7)

Signed in pencil, lower right: *Kelly*; numbered in pencil, lower right. Blind stamp, lower right: logo of Tyler Graphics Ltd. Inscribed in pencil on verso: *EK77–313*

Edition: 41

Proofs: 10 AP, RTP, PPII, A, C

Collaboration and supervision: Kenneth Tyler. Proofing, processing, edition printing, preparation, and adhering of collage element: Kim Halliday, assisted by Kenneth Tyler.

Published by Tyler Graphics Ltd., Bedford, New York (328:EK35)

2 runs from 1 screen and 1 collage element
1 black; photo screen, from photographically prepared film
2 unprinted white; Duchene handmade paper, torn and adhered to base sheet

Comments: The screenprinted black shape repeats in shape and color the collage element for a projected postcard collage print based upon *Philipsburg*, a postcard collage of 1974 (EK#74.05).

The abutted rectangle and triangle first appear in Kelly's work in the painted-aluminum sculpture *Black White*, 1968 (EK # S415; Sims and Pulitzer 1982, no. 48), and in the painting *White Blue*, 1968 (EK #395; Coplans 1973, pl. 204). Between 1973 and 1978 Kelly developed this composition in a number of black, white, and gray variations in the paintings and in a series of five untitled weathering steel and wood wall sculptures (Sims and Pulitzer 1982, nos. 93–97). While he was in California in 1978, overseeing the fabrication of the wall sculptures, Kelly began work on the related Series of Seven Lithographs.

State editions of the series, with open line drawings of each configuration, were made first. The line that Kelly drew directly on the aluminum plates is nuanced and spontaneous as it scores angles and corners. To get the deliberate yet sketchlike line he wanted, Kelly used a Spectracolor pencil directly on the plate. This, unlike the softer lithographic crayon, would not crumble under the pressures needed to effect the desired quality of line. For the standard edition, photo plates of the blocked-in shapes were printed in black ink over and within the drawn lines of the configurations.

The titles of the prints name places in France (Bordrouant, on Belle Ile; Bandol, near Toulouse in Provence), Switzerland (Amden and Braunwald), and the Caribbean (Grand Case and Marigot, on Saint Martin), of which Kelly holds fond memories of pleasant times with friends.

Literature: "Prints and Photographs," *Print Collector's Newsletter* 1980, 102; Sims and Pulitzer 1982, nos. 93–97, 138; Fine 1984, 134

Bandol, 1978–80 (cat. no. 187)

181–87a
SERIES OF SEVEN LITHOGRAPHS
1978–80

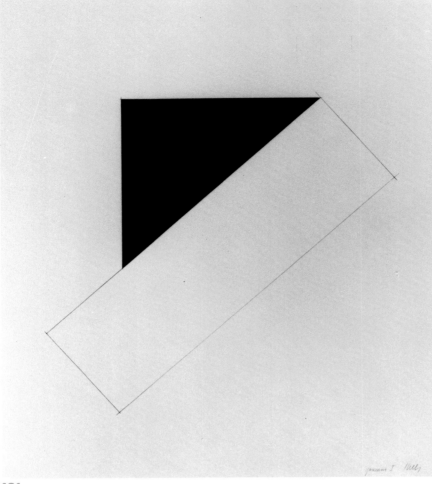

181

Jacmel 1978–80

Lithograph on Rives BFK paper

Sheet: 34½ x 30 (87.6 x 76.2)

Signed in pencil, lower right: *Kelly*; numbered in pencil, lower right. Blind stamp, lower left: logo of Gemini G.E.L., *©*. Inscribed in pencil on verso: *EK78–874*. Stamped on verso: *© Gemini G.E.L. Los Angeles*

Edition: 25

Proofs: 9 AP, RTP, PPII, SP, 3 GEL, C

Collaboration and supervision: Serge Lozingot, Mark Stock. Proofing and processing: Serge Lozingot, Mark Stock, Edward Henderson. Edition printing: Anthony Zepeda.

Published by Gemini G.E.L., Los Angeles (Gemini 855)

2 runs from 2 plates
1 black (line); aluminum plate, drawn with Spectracolor pencil, same as cat. no. 181a
2 black; aluminum photo plate, from hand-cut negative

Comments: *Jacmel* repeats the forms and colors of the painting *Black Triangle with White*, 1976 (EK#532).

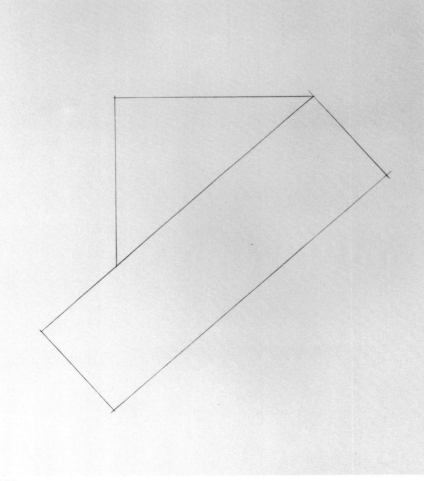

181a

Jacmel (State) 1978–80

Lithograph on Rives BFK paper

Sheet: 34½ x 30 (87.6 x 76.2)

Signed in pencil, lower right: *Kelly*; numbered in pencil, lower right. Blind stamp, lower left: logo of Gemini G.E.L., *©*. Inscribed in pencil on verso: *EK78–874A*. Stamped on verso: *© Gemini G.E.L. Los Angeles*

Edition: 10

Proofs: RTP, PPII, C (documented with cat. no. 181); plate reserved for cat. no. 181

Collaboration and supervision: Serge Lozingot, Mark Stock. Proofing and processing: Mark Stock, Edward Henderson. Edition printing: Anthony Zepeda.

Published by Gemini G.E.L., Los Angeles (Gemini 862)

1 run from 1 plate
1 black (line); aluminum plate, drawn with Spectracolor pencil, same as cat. no. 181

Comments: See cat. no. 181

Grand Case 1978–80

Lithograph on Rives BFK paper

Sheet: 30 x 34½ (76.2 x 87.6)

Signed in pencil, lower right: *Kelly*; numbered in pencil, lower right. Blind stamp, lower left: logo of Gemini G.E.L., ©. Inscribed in pencil on verso: *EK78–875*. Stamped on verso: © *Gemini G.E.L. Los Angeles*

Edition: 25

Proofs: 9 AP, RTP, PPII, SP, 3 GEL, C

Collaboration and supervision: Serge Lozingot, Mark Stock. Proofing and processing: Serge Lozingot, Mark Stock, Edward Henderson. Edition printing: Anthony Zepeda, Edward Henderson, Serge Lozingot.

Published by Gemini G.E.L., Los Angeles (Gemini 856)

2 runs from 2 plates
1 black (line); aluminum plate, drawn with Spectracolor pencil; same as cat. no. 182a
2 black; aluminum photo plate, from hand-cut negative

Literature: Fine 1984, no. 50, 134–35

Comments: *Grand Case* repeats the composition and colors of the painting *Dark Gray with White Triangle II*, 1977 (EK#550; Baker 1979, pl. 17).

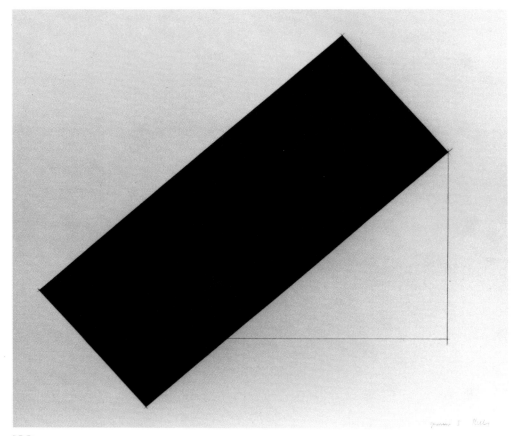

182

Grand Case (State) 1978–80

Lithograph on Rives BFK paper

Sheet: 30 x 34½ (76.2 x 87.6)

Signed in pencil, lower right: *Kelly*; numbered in pencil, lower right. Blind stamp, lower left: logo of Gemini G.E.L., ©. Inscribed in pencil on verso: *EK78–875A*. Stamped on verso: © *Gemini G.E.L. Los Angeles*

Edition: 10

Proofs: RTP, PPII, C (documented with cat. no. 182); plate reserved for cat. no. 182

Collaboration and supervision: Serge Lozingot, Mark Stock. Proofing and processing: Serge Lozingot, Mark Stock, Edward Henderson. Edition printing: Edward Henderson.

Published by Gemini G.E.L., Los Angeles (Gemini 864)

1 run from 1 plate
1 black (line); aluminum plate, drawn with Spectracolor pencil, same as cat. no. 182

Comments: See cat. no. 182

182a

183

Marigot 1978–80

Lithograph on Rives BFK paper

Sheet: 30 x 34½ (76.2 x 87.6)

Signed in pencil, lower right: *Kelly*; numbered in pencil, lower right. Blind stamp, lower left: logo of Gemini G.E.L., ©. Inscribed in pencil on verso: *EK78–876*. Stamped on verso: © *Gemini G.E.L. Los Angeles*

Edition: 25

Proofs: 9 AP, RTP, PPII, SP, 3 GEL, C

Collaboration and supervision: Serge Lozingot, Mark Stock. Proofing and processing: Serge Lozingot, Mark Stock, Edward Henderson. Edition printing: Mark Stock, Anthony Zepeda.

Published by Gemini G.E.L., Los Angeles (Gemini 857)

2 runs from 2 plates
1 black (line); aluminum plate, drawn with Spectracolor pencil, same as cat. no. 183a
2 black; aluminum photo plate, from hand-cut negative

Comments: *Marigot* is related to a series of 1973 paintings, of which the most immediate source was *Black with White Triangle* (EK#501). It also repeats the shapes of the wood sculpture *Untitled*, 1978 (EK#S584; Sims and Pulitzer 1982, no. 96), and, in inverted form, those of the weathering steel sculpture *Untitled*, 1978 (EK#S573; Sims and Pulitzer 1982, no. 93).

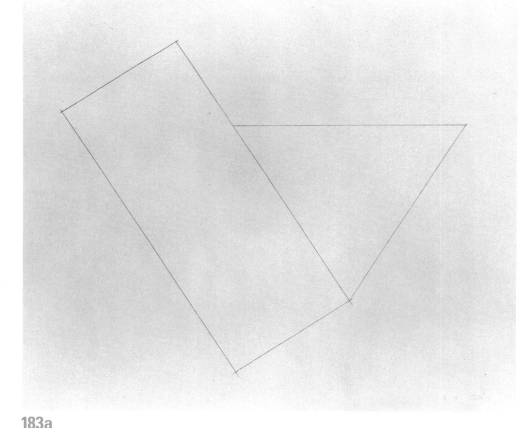

183a

Marigot (State) 1978–80

Lithograph on Rives BFK paper

Sheet: 30 x 34½ (76.2 x 87.6)

Signed in pencil, lower right: *Kelly*; numbered in pencil, lower right. Blind stamp, lower left: logo of Gemini G.E.L., ©. Inscribed in pencil on verso: *EK78–876A*. Stamped on verso: © *Gemini G.E.L. Los Angeles*

Edition: 10

Proofs: RTP, PPII, C (documented with cat. no. 183); plate reserved for cat. no. 183

Collaboration and supervision: Serge Lozingot, Mark Stock. Proofing and processing: Serge Lozingot, Mark Stock, Edward Henderson. Edition printing: Edward Henderson.

Published by Gemini G.E.L., Los Angeles (Gemini 863)

1 run from 1 plate
1 black (line); aluminum plate, drawn with Spectracolor pencil, same as cat. no. 183

Comments: See cat. no. 183

Amden 1978–80

Lithograph on Rives BFK paper

Sheet: 30 x 34½ (76.2 x 87.6)

Signed in pencil, lower right: *Kelly*; numbered in pencil, lower right. Blind stamp, lower left: logo of Gemini G.E.L., ©. Inscribed in pencil on verso: *EK78–877*. Stamped on verso: © *Gemini G.E.L. Los Angeles*

Edition: 25

Proofs: 9 AP, RTP, PPII, SP, 3 GEL, C

Collaboration and supervision: Serge Lozingot, Mark Stock. Proofing and processing: Serge Lozingot, Mark Stock, Edward Henderson. Edition printing: Edward Henderson.

Published by Gemini G.E.L., Los Angeles (Gemini 858)

2 runs from 2 plates
1 black (line); aluminum plate, drawn with Spectracolor pencil, same as cat. no. 184a
2 black; aluminum photo plate, from hand-cut negative

Comments: *Amden* has no precedent in a painting but repeats the configuration of the weathering steel wall sculptures *Untitled*, 1978 (EK#S575; Sims and Pulitzer 1982, no. 95), and *Untitled*, 1978 (EK#S588; Sims and Pulitzer 1982, no. 97).

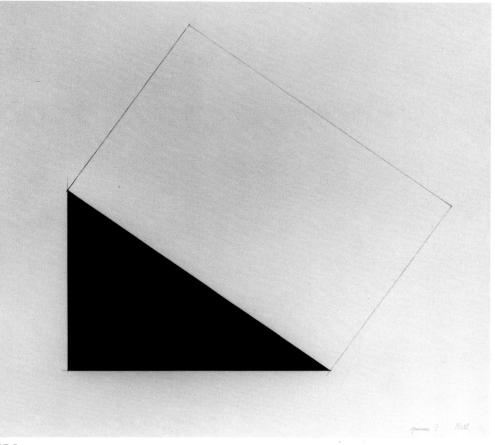

184

Amden (State) 1978–80

Lithograph on Rives BFK paper

Sheet: 30 x 34½ (76.2 x 87.6)

Signed in pencil, lower right: *Kelly*; numbered in pencil, lower right. Blind stamp, lower left: logo of Gemini G.E.L., ©. Inscribed in pencil on verso: *EK78–877A*. Stamped on verso: © *Gemini G.E.L. Los Angeles*

Edition: 10

Proofs: RTP, PPII, C (documented with cat. no. 184); plate reserved for cat. no. 184

Collaboration and supervision: Serge Lozingot, Mark Stock. Proofing and processing: Serge Lozingot, Mark Stock, Edward Henderson. Edition printing: Edward Henderson.

Published by Gemini G.E.L., Los Angeles (Gemini 865)

1 run from 1 plate
1 black (line); aluminum plate, drawn with Spectracolor pencil, same as cat. no. 184

Comments: See cat. no. 184

184a

185

Braunwald 1978–80

Lithograph on Rives BFK paper

Sheet: 30 x 34½ (76.2 x 87.6)

Signed in pencil, lower right: *Kelly*; numbered in pencil, lower right. Blind stamp, lower left: logo of Gemini G.E.L., ©. Inscribed in pencil on verso: *EK78–878*. Stamped on verso: © *Gemini G.E.L. Los Angeles*

Edition: 25

Proofs: 9 AP, RTP, PPII, SP, 3 GEL, C

Collaboration and supervision: Serge Lozingot, Mark Stock. Proofing and processing: Serge Lozingot, Mark Stock, Edward Henderson. Edition printing: Mark Stock.

Published by Gemini G.E.L., Los Angeles (Gemini 859)

2 runs from 2 plates
1 black (line); aluminum plate, drawn with Spectracolor pencil, same as cat. no. 185a
2 black; aluminum photo plate, from hand-cut negative

Comments: *Braunwald* repeats the composition and colors of the painting *Dark Gray with White Triangle III*, 1978 (EK#581), and the shapes of the weathering steel wall sculpture *Untitled*, 1978 (EK#S574; Sims and Pulitzer 1982, no. 94).

185a

Braunwald (State) 1978–80

Lithograph on Rives BFK paper

Sheet: 30 x 34½ (76.2 x 87.6)

Signed in pencil, lower right: *Kelly*; numbered in pencil, lower right. Blind stamp, lower left: logo of Gemini G.E.L., ©. Inscribed in pencil on verso: *EK78–878A*. Stamped on verso: © *Gemini G.E.L. Los Angeles*

Edition: 10

Proofs: RTP, PPII, C (documented with cat. no. 185); plate reserved for cat. no. 185

Collaboration and supervision: Serge Lozingot, Mark Stock. Proofing and processing: Serge Lozingot, Mark Stock, Edward Henderson. Edition printing: Edward Henderson.

Published by Gemini G.E.L., Los Angeles (Gemini 866)

1 run from 1 plate
1 black (line); aluminum plate, drawn with Spectracolor pencil, same as cat. no. 185

Comments: See cat. no. 185

Bordrouant 1978–80

Lithograph on Rives BFK paper

Sheet: 30 x 34½ (76.2 x 87.6)

Signed in pencil, lower right: *Kelly*; numbered in pencil, lower right. Blind stamp, lower left: logo of Gemini G.E.L., ©. Inscribed in pencil on verso: *EK78–879*. Stamped on verso: © *Gemini G.E.L. Los Angeles*

Edition: 25

Proofs: 9 AP, RTP, PPII, SP, 3 GEL, C

Collaboration and supervision: Serge Lozingot, Mark Stock. Proofing and processing: Serge Lozingot, Mark Stock, Edward Henderson. Edition printing: Edward Henderson, Serge Lozingot.

Published by Gemini G.E.L., Los Angeles (Gemini 860)

2 runs from 2 plates
1 black (line); aluminum plate, drawn with Spectracolor pencil, same as cat. no. 186a
2 black; aluminum photo plate, from hand-cut negative

Comments: *Bordrouant* repeats the colors and shapes of the painting *White Triangle with Black*, 1976 (EK#549).

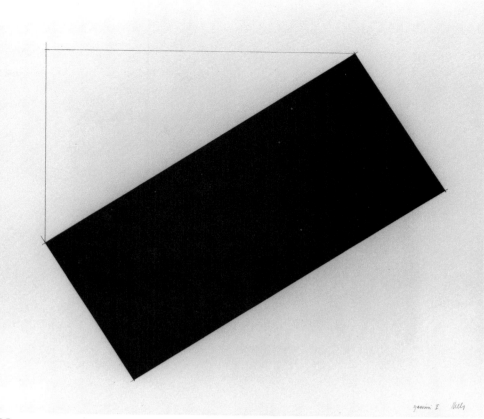

186

Bordrouant (State) 1978–80

Lithograph on Rives BFK paper

Sheet: 30 x 34½ (76.2 x 87.6)

Signed in pencil, lower right: *Kelly*; numbered in pencil, lower right. Blind stamp, lower left: logo of Gemini G.E.L., ©. Inscribed in pencil on verso: *EK78–879A*. Stamped on verso: © *Gemini G.E.L. Los Angeles*

Edition: 10

Proofs: RTP, PPII, C (documented with cat. no. 186); plate reserved for cat. no. 186

Collaboration and supervision: Serge Lozingot, Mark Stock. Proofing and processing: Serge Lozingot, Mark Stock, Edward Henderson. Edition printing: Edward Henderson.

Published by Gemini G.E.L., Los Angeles (Gemini 867)

1 run from 1 plate
1 black (line); aluminum plate, drawn with Spectracolor pencil, same as cat. no. 186

Comments: See cat. no. 186

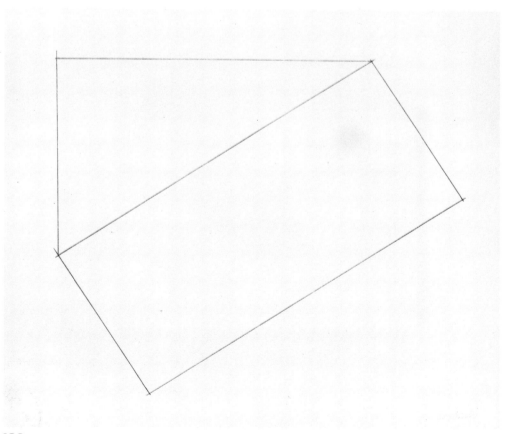

186a

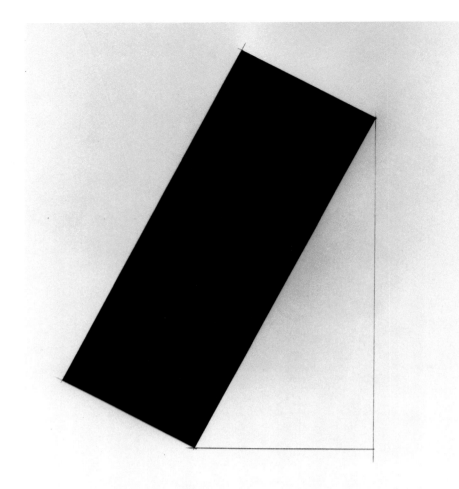

187

Bandol 1978–80

Lithograph on Rives BFK paper

Sheet: 34½ x 30 (87.6 x 76.2)

Signed in pencil, lower right: *Kelly*; numbered in pencil, lower right. Blind stamp, lower right: logo of Gemini G.E.L., ©. Inscribed in pencil on verso: *EK78–880*. Stamped on verso: © *Gemini G.E.L. Los Angeles*

Edition: 25

Proofs: 9 AP, RTP, PPII, SP, 3 GEL, C

Collaboration and supervision: Serge Lozingot, Mark Stock. Proofing and processing: Serge Lozingot, Mark Stock, Edward Henderson. Edition printing: Serge Lozingot, Anthony Zepeda.

Published by Gemini G.E.L., Los Angeles (Gemini 861)

2 runs from 2 plates
1 black (line); aluminum plate, drawn with Spectracolor pencil, same as cat. no. 187a
2 black; aluminum photo plate, from hand-cut negative

Comments: *Bandol* repeats the composition of the painting *Dark Gray with White Triangle I*, 1977 (EK#549; Baker 1979, pl. 18).

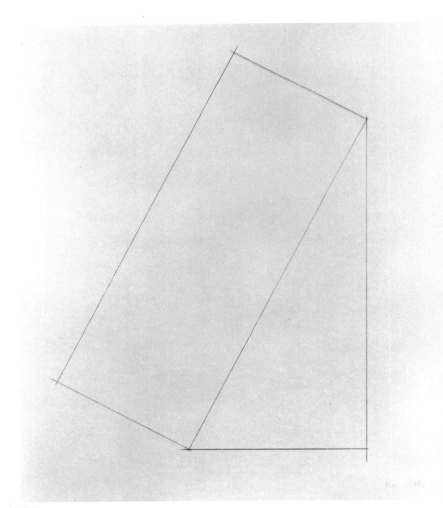

187a

Bandol (State) 1978–80

Lithograph on Rives BFK paper

Sheet: 34½ x 30 (87.6 x 76.2)

Signed in pencil, lower right: *Kelly*; numbered in pencil, lower right. Blind stamp, lower right: logo of Gemini G.E.L., ©. Inscribed in pencil on verso: *EK78–880A*. Stamped on verso: © *Gemini G.E.L. Los Angeles*

Edition: 10

Proofs: RTP, PPII, C (documented with cat. no. 187); plate reserved for cat. no. 187

Collaboration and supervision: Serge Lozingot, Mark Stock. Proofing and processing: Serge Lozingot, Mark Stock, Edward Henderson. Edition printing: Edward Henderson.

Published by Gemini G.E.L., Los Angeles (Gemini 868)

1 run from 1 plate
1 black (line); aluminum plate, drawn with Spectracolor pencil, same as cat. no. 187

Comments: See cat. no. 187

Daffodil 1979–80

Transfer lithograph on 300-gram Arches Cover paper

Sheet: 39¼ x 28¼ (99.7 x 71.8)

Signed in pencil, lower right: *Kelly*; numbered in pencil, lower left. Blind stamp, lower right: logo of Tyler Graphics Ltd. Inscribed in pencil on verso: *EK79–431*

Edition: 50

Proofs: 12 AP, RTP, PPII, A, C

Collaboration, supervision, proofing, and processing: Kenneth Tyler. Edition printing: Lee Funderburg.

Published by Tyler Graphics Ltd., Bedford, New York (329:EK36)

1 run from 1 plate
1 black; aluminum plate, from lithographic-crayon drawing on transfer paper

Literature: "Prints and Photographs," *Print Collector's Newsletter* 1980, 102

Comments: *Daffodil* was derived from a finished pencil drawing (EK#P11.78).

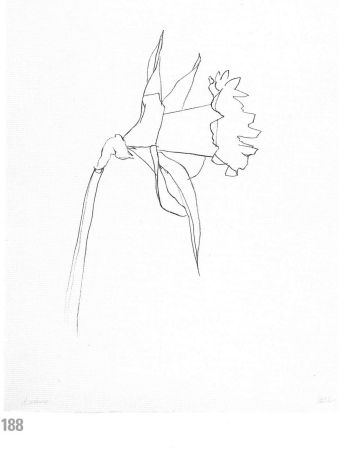

188

Sarsaparilla 1979–80

Transfer lithograph on 300-gram Arches Cover paper

Sheet: 31¾ x 47¾ (80.6 x 121.3)

Signed in pencil, lower right: *Kelly*; numbered in pencil, lower left. Blind stamp, lower right: logo of Tyler Graphics Ltd. Inscribed in pencil on verso: *EK79–430*

Edition: 50

Proofs: 12 AP, RTP, PPII, A, C

Collaboration, supervision, proofing, processing, and edition printing: Kenneth Tyler.

Published by Tyler Graphics Ltd., Bedford, New York (330:EK37)

1 run from 1 stone
1 black; stone, from lithographic-crayon drawing on transfer paper

Literature: "Prints and Photographs," *Print Collector's Newsletter* 1980, 102

Comments: *Sarsaparilla* is a variation of *Woodland Plant* (cat. no. 178). Though based upon the drawing for *Woodland Plant*, it differs in the thinner, more delicate quality of line, in the contours of stem and leaves, and in its printing from a lithographic stone, not an aluminum plate. *Sarsaparilla* and *Woodland Plant* were based on a finished pencil drawing (EK#P12.79).

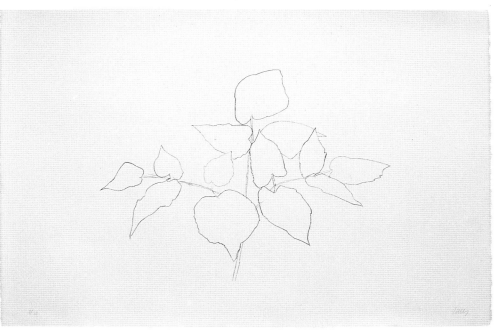

189

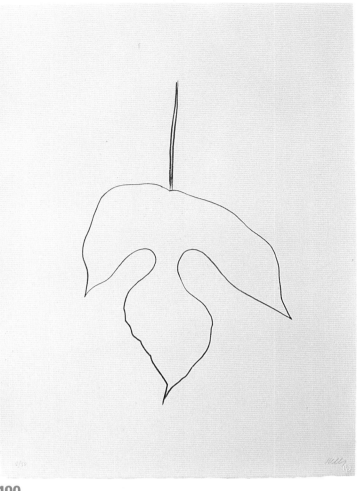

190

Mulberry Leaf 1979–80

Transfer lithograph on 300-gram Arches Cover paper

Sheet: 36½ x 26⅝ (92.7 x 67.6)

Signed in pencil, lower right: *Kelly*; numbered in pencil, lower left. Blind stamp, lower right: logo of Tyler Graphics Ltd. Inscribed in pencil on verso: *EK79–430*

Edition: 50

Proofs: 14 AP, RTP, PPII, A, C

Collaboration, supervision, proofing, and processing: Kenneth Tyler. Edition printing: Lee Funderburg.

Published by Tyler Graphics Ltd., Bedford, New York (331:EK38)

1 run from 1 plate
1 black; aluminum plate, from lithographic-crayon drawing on transfer paper

Literature: "Prints and Photographs," *Print Collector's Newsletter* 1980, 102

Comments: *Mulberry Leaf* was based upon a finished pencil drawing (EK#P3.75) that Kelly made in 1975.

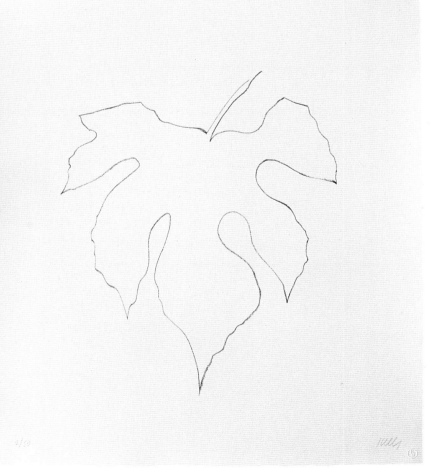

Wild Grape Leaf 1979–80

Transfer lithograph on 300-gram Arches Cover paper

Sheet: 27½ x 24¾ (69.9 x 62.9)

Signed in pencil, lower right: *Kelly*; numbered in pencil, lower left. Blind stamp, lower right: logo of Tyler Graphics Ltd. Inscribed in pencil on verso: *EK79–433*

Edition: 50

Proofs: 13 AP, TP (white HMP handmade paper, 24 x 20½ [61.0 x 52.0]), RTP, PPII, A, C

Collaboration, supervision, proofing, and processing: Kenneth Tyler. Edition printing: Lee Funderburg.

Published by Tyler Graphics Ltd., Bedford, New York (332:EK39)

1 run from 1 stone
1 black; stone, from lithographic-crayon drawing on transfer paper

Literature: "Prints and Photographs," *Print Collector's Newsletter* 1980, 102

Comments: *Wild Grape Leaf* is based on a finished pencil drawing (EK#P1.76) that Kelly made at HMP Paper Mill, Woodstock, Connecticut, in 1976 while he was working on the Colored Paper Images series. The print is also related to the series of wine labels that the artist designed for Douglas Cramer in the early 1980s (App. III.g1).

191

Saint Martin Tropical Plant 1981–82

Transfer lithograph on Arches Cover paper

Sheet: 26 x 34 (66.0 x 86.4)

Signed in pencil, lower right: *Kelly*; numbered in pencil, lower right. Blind stamp, lower right: logo of Gemini G.E.L., ©. Inscribed in pencil on verso: *EK81–1027*. Stamped on verso: © *Gemini G.E.L. Los Angeles*

Edition: 50

Proofs: 11 AP, 8 PAP (Participant Artist Proof), 7 TP (I–III on Arches Buff paper, 24 x 32 [61.0 x 81.0]; IV on Arches Cover paper, 26 x 34 [66.0 x 86.4]; V on Arches 88 paper, 24 x 32 [61.0 x 81.0]; VI, VII on Arches Cover paper, 24 x 32 [61.0 x 81.0]), RTP, PPII, 3 SP, 3 GEL, NGA, C (Arches 88 paper)

Collaboration and supervision: Serge Lozingot. Proofing and processing: Yasutoshi Ishibashi, Anthony Zepeda. Edition printing: Yasutoshi Ishibashi, Joseph Corso, Krystine Graziano.

Published by Gemini G.E.L., Los Angeles (Gemini 957)

1 run from 1 plate
1 black; aluminum plate, from lithographic-crayon drawing on transfer paper

Literature: "News of the Print World," *Print Collector's Newsletter* 1982, 177; Fine 1984, 136–37

Comments: This lithograph is from the portfolio *Eight Lithographs to Benefit the Foundation for Contemporary Performance Arts, Inc.*, which also includes the work of Sam Francis, Philip Guston, David Hockney, Jasper Johns, Bruce Nauman, Robert Rauschenberg, and Richard Serra. Each contributing artist received a complete portfolio with each print inscribed *P.A.P.* (Participant Artist Proof). *Saint Martin Tropical Plant* was derived from a finished ink drawing (EK#P18.81).

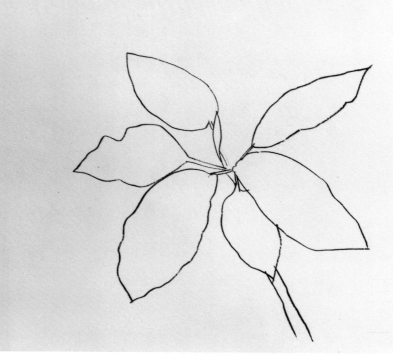

192

"18 Colors (Cincinnati)" 1979–82

Lithograph on Arches Cover paper

Sheet: 16 x 90½ (40.6 x 229.8)

Signed in pencil, lower right: *Kelly*; numbered in pencil, lower right. Blind stamp, lower right: logo of Gemini G.E.L., ©. Inscribed in pencil on verso: *EK79–881*. Stamped on verso: © *Gemini G.E.L. Los Angeles*

Edition: 57

Proofs: 15 AP, RTP, PPII, SP, 3 GEL, NGA, C (Arches 88 paper)

Collaboration and supervision: Serge Lozingot. Proofing and processing: Serge Lozingot, Christine Fox, Joseph Corso. Edition printing: Serge Lozingot, Krystine Graziano.

Published by Gemini G.E.L., Los Angeles (Gemini 978)

9 runs from 9 plates
1 brown, lemon yellow; aluminum photo plate, from hand-cut negative
2 black, dark green; aluminum photo plate, from hand-cut negative
3 blue-violet, red; aluminum photo plate, from hand-cut negative
4 yellow-orange, medium blue; aluminum photo plate, from hand-cut negative
5 medium green, dark red-violet; aluminum photo plate, from hand-cut negative
6 yellow, black; aluminum photo plate, from hand-cut negative
7 light blue, yellow-green; aluminum photo plate, from hand-cut negative
8 orange, dark blue; aluminum photo plate, from hand-cut negative
9 red-orange, light red-violet; aluminum photo plate, from hand-cut negative

Literature: Ratcliff 1982, n.p.; Fine 1984, no. 52, 138–39

193

Comments: Kelly took two years to produce *"18 Colors (Cincinnati)."* The protracted collaboration period reflects the time that he and the printers needed to solve certain technical and aesthetic problems—most particularly those of color. Although the choice of basic colors was determined by the monumental, multiple-canvas painting upon which the lithograph was based, Kelly recalibrated the precise value and degree of saturation of all the colors in relation to each other as a result of their greater proximity, reduction in size, and smaller-scaled confinement on the sheet of white paper. This he did and then provided cutout gouache samples for Serge Lozingot, the *chromiste* for the project, who matched them in difficult mixings of inks. Color proofing was extensive; Kelly considered first proofs at his home studio in Spencertown, but he was not satisfied with them. When he returned to Gemini a year later, he initiated a reproofing, which led directly to editioning. In his work at Gemini, *"18 Colors (Cincinnati),"* marked an expansive return of color after eight years of concentration on black and white.

The print was based on the 1978 painting *Color Panels for a Large Wall* (EK#589), a work composed of eighteen monochrome canvases, each 48 × 68½ inches, that were installed on a 136-foot wall at the Central Trust Company in Cincinnati. Kelly derived the painting indirectly from a small 1951 collage *Eight Color Pairs* (EK#51.123), which he reworked in two collages during 1978 (EK#78.02, EK#78.02A). The ninety-inch horizontal length of the lithograph, the greatest in the print oeuvre, was necessitated by the composition of the painting, an accommodation that Kelly also made in four of the screenprints (cat. nos. 73, 90, 102, and 103) to produce, with *"18 Colors (Cincinnati),"* a distinctive group of oblong prints that average seven feet in length.

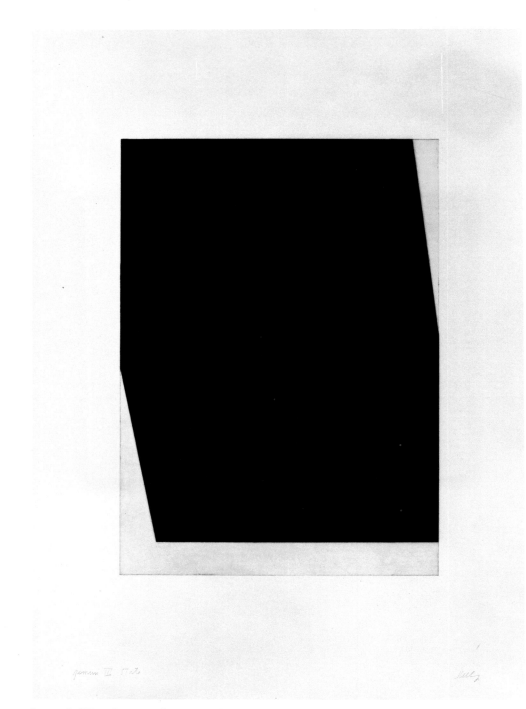

Concorde I (State), 1981–82 (cat. no. 196a)

194–200a
THE CONCORDE SERIES 1981–82

The original Concorde shape, after which the series is named, dates in Kelly's painting to *Concorde I*, 1955 (EK#84; Coplans 1973, pl. 100), and in his sculpture to the wood *Concorde Relief*, 1958 (EK#S158; Sims and Pulitzer 1982, no. 28). Turned on its side, it provided the shape for the chrome-plated sculpture *Mirrored Concorde*, 1970–71 (EK#S439; Sims and Pulitzer 1982, no. 53), a multiple that Kelly made with Gemini G.E.L. The Concorde shape was the basis in this series of etchings/aquatints for *Concorde I* and *Concorde II*. Later variants of the form led to *Concorde III–V*. These prints are related to a group of collages and pencil studies (EK#81.37–40) that Kelly made in preparation for this project.

Kelly chose the name for the original Concorde form because he thought of it as a harmonious form, which he has also compared to a shade pulled down to close out the light (Sims and Pulitzer 1982, 68). The first two prints in the series are unrelated to the Concorde shape; they are based on paintings from 1968 and 1970.

With a drypoint needle, Kelly drew the interior design of each Concorde shape directly on a copper plate whose rectangular edges marked, with a faintly printed line, the outline of the image. The areas of the plate that were not to print in color were masked out with stop-out varnish, and two or more aquatint grounds were applied to the exposed area and etched to achieve a dense, rich black when inked and printed. Foul biting occurred when acid ate through the stop-out that was applied to the white areas and through the aquatint ground. The resulting irregular marks in the copper plates were burnished by hand to mute the effects of the foul biting. Still, the black and white areas appear pitted with cuts and smudges; the toning and burnishing of the plates did not efface all marks. This process appealed to Kelly, and he cultivated its effects. The Concorde Series prints reveal, as had the Colored Paper Images in 1976, the artist's new interest in surfaces that are not immaculate—a borrowing, it would appear, from his sculpture, in which the textural variations of weathering steel and wood are visible.

For the standard edition, the white areas were wiped clean when the plates were inked; for the state prints, the white areas were more lightly wiped, leaving a light plate tone.

Literature: *Ellsworth Kelly at Gemini: 1979–1982* 1982; Ratcliff 1982, n.p.; Sims and Pulitzer 1982, nos. 28 and 117, 68, 166; Fine 1984, no. 53, 140–41

Square with Black 1981–82

Etching and aquatint on Arches Cover paper

Sheet: 30⅜ x 27½ (77.2 x 69.9)

Image: 12 x 12 (30.5 x 30.5)

Signed in pencil, lower right: *Kelly*; numbered in pencil, lower left. Blind stamp, lower right: logo of Gemini G.E.L., ©. Inscribed in pencil on verso: *EK81–3059*. Stamped on verso: © *Gemini G.E.L. Los Angeles*

Edition: 18

Proofs: 9 AP, RTP, PPII, 3 SP, 3 GEL, NGA, C (Somerset Satine paper)

Collaboration and supervision: Doris Simmelink. Proofing and processing: Anthony Zepeda, Jacob Samuels, Doris Simmelink. Edition printing: Doris Simmelink.

Published by Gemini G.E.L., Los Angeles (Gemini 993)

1 run from 1 plate
1 black; copper plate, same as cat. no. 194a

Comments: *Square with Black* repeats the forms and colors of *White Square with Black*, 1970 (EK#434; Coplans 1973, pl. 217). It is related to the paperwork *Colored Paper Image XVIII* (cat. no. 158).

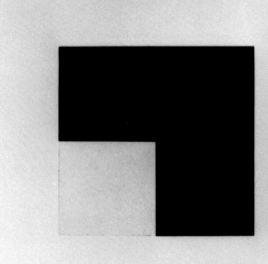

194

Square with Black (State) 1981–82

Etching and aquatint with plate tone on Arches Cover paper

Sheet: 30⅜ x 27½ (77.2 x 69.9)

Image: 12 x 12 (30.5 x 30.5)

Signed in pencil, lower right: *Kelly*; numbered in pencil, lower left. Blind stamp, lower right: logo of Gemini G.E.L., ©. Inscribed in pencil on verso: *EK81–3059A*. Stamped on verso: © *Gemini G.E.L. Los Angeles*

Edition: 18

Proofs: 9 AP, RTP, PPII, 3 SP, 3 GEL, NGA, C (documented with cat. no. 194); plate reserved for cat. no. 194

Collaboration and supervision: Doris Simmelink. Proofing and processing: Anthony Zepeda, Jacob Samuels, Doris Simmelink. Edition printing: Doris Simmelink.

Published by Gemini G.E.L., Los Angeles (Gemini 1000)

1 run from 1 plate
1 black; copper plate, wiped for toned area; same as cat. no. 194

Comments: See cat. no. 194.

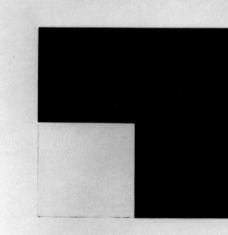

194a

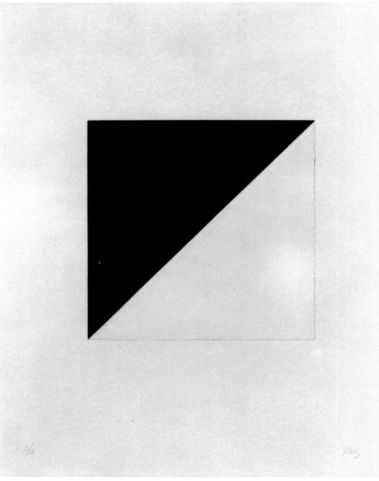

195

Diagonal with Black 1981–82

Etching and aquatint on Arches Cover paper

Sheet: 34⅛ x 29⅛ (86.7 x 74.0)

Image: 15¾ x 15¾ (40.0 x 40.0)

Signed in pencil, lower right: *Kelly*; numbered in pencil, lower left. Blind stamp, lower right: logo of Gemini G.E.L., ©. Inscribed in pencil on verso: *EK81–3060*. Stamped on verso: *© Gemini G.E.L. Los Angeles*

Edition: 18

Proofs: 9 AP, RTP, PPII, 3 SP, 3 GEL, NGA, C (Somerset Satine paper)

Collaboration and supervision: Doris Simmelink. Proofing and processing: Anthony Zepeda, Jacob Samuels, Doris Simmelink. Edition printing: Sarah Todd.

Published by Gemini G.E.L., Los Angeles (Gemini 994)

1 run from 1 plate

1 black; copper plate, same as cat. no. 195a

Comments: *Diagonal with Black* repeats the forms and colors of the painting *Black White*, 1968 (EK#396; Coplans 1973, pl. 191). It is a color variation of the painting *Two Grays III*, 1975–77 (EK#513), and of the paperwork *Colored Paper Image XV* (cat. no. 155).

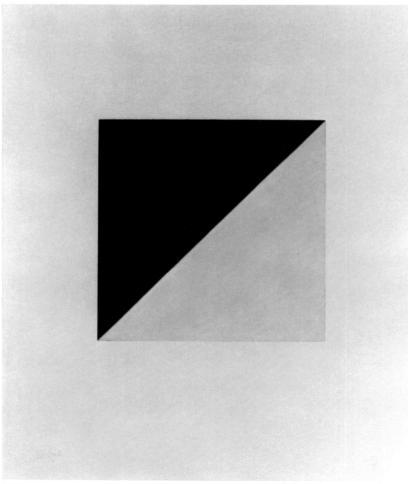

195a

Diagonal with Black (State) 1981–82

Etching and aquatint with plate tone on Arches Cover paper

Sheet: 34⅛ x 29⅛ (86.7 x 74.0)

Image: 15¾ x 15¾ (40.0 x 40.0)

Signed in pencil, lower right: *Kelly*; numbered in pencil, lower left. Blind stamp, lower right: logo of Gemini G.E.L., ©. Inscribed in pencil on verso: *EK81–3060A*. Stamped on verso: *© Gemini G.E.L. Los Angeles*

Edition: 18

Proofs: 9 AP, RTP, PPII, 3 SP, 3 GEL, NGA, C (documented with cat. no. 195); plate reserved for cat. no. 195

Collaboration and supervision: Doris Simmelink. Proofing and processing: Anthony Zepeda, Jacob Samuels, Doris Simmelink. Edition printing: Sarah Todd.

Published by Gemini G.E.L., Los Angeles (Gemini 1001)

1 run from 1 plate

1 black; copper plate, wiped for toned area; same as cat. no. 195

Comments: See cat. no. 195

Concorde I 1981–82

Etching and aquatint on Arches Cover paper

Sheet: 41½ x 29½ (105.4 x 74.9)

Image: 27 x 19 (68.6 x 48.3)

Signed in pencil, lower right: *Kelly*; numbered in pencil, lower left. Blind stamp, lower right: logo of Gemini G.E.L., ©. Inscribed in pencil on verso: *EK81–3063*. Stamped on verso: © *Gemini G.E.L. Los Angeles*

Edition: 18

Proofs: 9 AP, RTP, PPII, SP, 3 GEL, NGA, C (Somerset Satine paper)

Collaboration and supervision: Doris Simmelink. Proofing and processing: Anthony Zepeda, Jacob Samuels, Doris Simmelink. Edition printing: Patrick Foye.

Published by Gemini G.E.L., Los Angeles (Gemini 995)

1 run from 1 plate

1 black; copper plate, same as cat. no. 196a

Comments: The Concorde shape, used for the aquatints *Concorde I* and *Concorde II* and their related state editions, is a rectangle diagonally sliced at its upper right and lower left corners. It first appears in Kelly's paintings and sculpture of the 1950s.

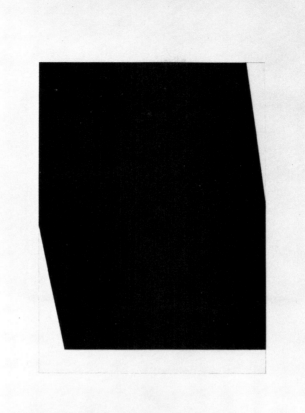

196

Concorde I (State) 1981–82

Etching and aquatint with plate tone on Arches Cover paper

Sheet: 41½ x 29½ (105.4 x 74.9)

Image: 27 x 19 (68.6 x 48.3)

Signed in pencil, lower right: *Kelly*; numbered in pencil, lower left. Blind stamp, lower right: logo of Gemini G.E.L., ©. Inscribed in pencil on verso: *EK81–3063A*. Stamped on verso: © *Gemini G.E.L. Los Angeles*

Edition: 18

Proofs: 9 AP, RTP, PPII, 3 SP, 3 GEL, NGA, C (documented with cat. no. 196); plate reserved for cat. no. 196

Collaboration and supervision: Doris Simmelink. Proofing and processing: Anthony Zepeda, Jacob Samuels, Doris Simmelink. Edition printing: Patrick Foye.

Published by Gemini G.E.L., Los Angeles (Gemini 1002)

1 run from 1 plate

1 black; copper plate, wiped for toned area; same as cat. no. 196

Literature: Fine 1984, 132

Comments: See cat. no. 196

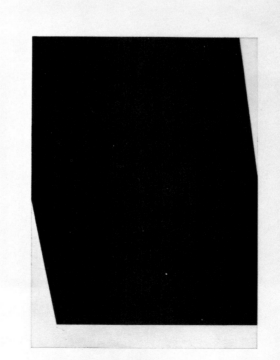

196a

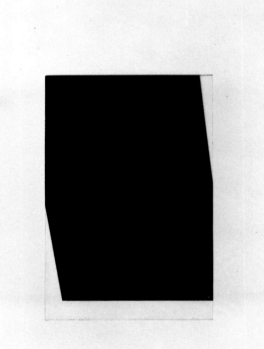

197

Concorde II 1981–82

Etching and aquatint on Arches Cover paper

Sheet: 32¾ x 25⅛ (83.2 x 63.8)

Image: 16¾ x 12³⁄₁₆ (42.5 x 31.0)

Signed in pencil, lower right: *Kelly*; numbered in pencil, lower left. Blind stamp, lower right: logo of Gemini G.E.L., ©. Inscribed in pencil on verso: *EK81–3058*. Stamped on verso: © *Gemini G.E.L. Los Angeles*

Edition: 18

Proofs: 9 AP, RTP, PPII, 3 SP, 3 GEL, NGA, C (Somerset Satine paper)

Collaboration and supervision: Doris Simmelink. Proofing and processing: Anthony Zepeda, Jacob Samuels, Doris Simmelink. Edition printing: Sarah Todd.

Published by Gemini G.E.L., Los Angeles (Gemini 996)

1 run from 1 plate

1 black; copper plate, same as cat. no. 197a

Comments: See cat. no. 196

Concorde II (State) 1981–82

Etching and aquatint with plate tone on Arches Cover paper

Sheet: 32¾ x 25⅛ (83.2 x 63.8)

Image: 16¾ x 12³⁄₁₆ (42.5 x 31.0)

Signed in pencil, lower right: *Kelly*; numbered in pencil, lower left. Blind stamp, lower right: logo of Gemini G.E.L., ©. Inscribed in pencil on verso: *EK81–3058A*. Stamped on verso: © *Gemini G.E.L. Los Angeles*

Edition: 18

Proofs: 9 AP, RTP, PPII, 3 SP, 3 GEL, NGA, C (documented with cat. no. 197); plate reserved for cat. no. 197

Collaboration and supervision: Doris Simmelink. Proofing and processing: Anthony Zepeda, Jacob Samuels, Doris Simmelink. Edition printing: Sarah Todd.

Published by Gemini G.E.L., Los Angeles (Gemini 1003)

1 run from 1 plate

1 black; copper plate, wiped for toned area; same as cat. no. 197

Comments: See cat. no. 196

197a

Concorde III 1981–82

Etching and aquatint on Arches Cover paper

Sheet: 41½ x 29½ (105.4 x 74.9)

Image: 26 x 19 (66.0 x 48.3)

Signed in pencil, lower right: *Kelly*; numbered in pencil, lower left. Blind stamp, lower right: logo of Gemini G.E.L., ©. Inscribed in pencil on verso: *EK81–3064*. Stamped on verso: © *Gemini G.E.L. Los Angeles*

Edition: 18

Proofs: 9 AP, RTP, PPII, SP, 3 GEL, NGA, C (Somerset Satine paper)

Collaboration and supervision: Doris Simmelink. Proofing and processing: Anthony Zepeda, Jacob Samuels, Doris Simmelink. Edition printing: Ken Farley.

Published by Gemini G.E.L., Los Angeles (Gemini 997)

1 run from 1 plate

1 black; copper plate, same as cat. no. 198a

Literature: Sims and Pulitzer 1982, no. 117, 166

Comments: Kelly created a variant form of the original Concorde shape by isolating its lower half and adjusting the proportions for the wood sculpture *Concorde Relief III*, 1982 (EK#S628; Sims and Pulitzer 1982, no. 105), and for the aquatint *Concorde III* and its state edition.

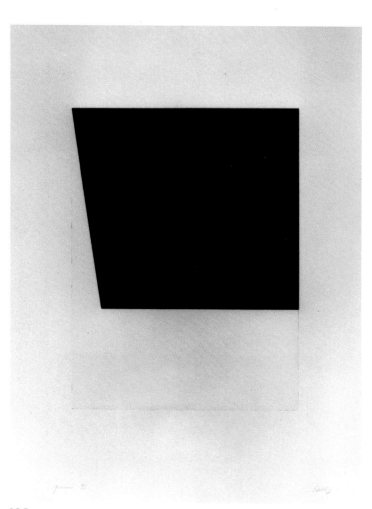

198

Concorde III (State) 1981–82

Etching and aquatint with plate tone on Arches Cover paper

Sheet: 41½ x 29½ (105.4 x 74.9)

Image: 26 x 19 (66.0 x 48.3)

Signed in pencil, lower right: *Kelly*; numbered in pencil, lower left. Blind stamp, lower right: logo of Gemini G.E.L., ©. Inscribed in pencil on verso: *EK81–3064A*. Stamped on verso: © *Gemini G.E.L. Los Angeles*

Edition: 18

Proofs: 9 AP, RTP, PPII, SP, 3 GEL, NGA, C (documented with cat. no. 198); plate reserved for cat. no. 198

Collaboration and supervision: Doris Simmelink. Proofing and processing: Anthony Zepeda, Jacob Samuels, Doris Simmelink. Edition printing: Doris Simmelink.

Published by Gemini G.E.L., Los Angeles (Gemini 1004)

1 run from 1 plate

1 black; copper plate, wiped for toned area; same as cat. no. 198

Comments: See cat. no. 198

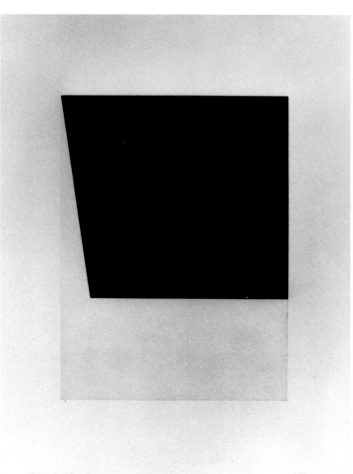

198a

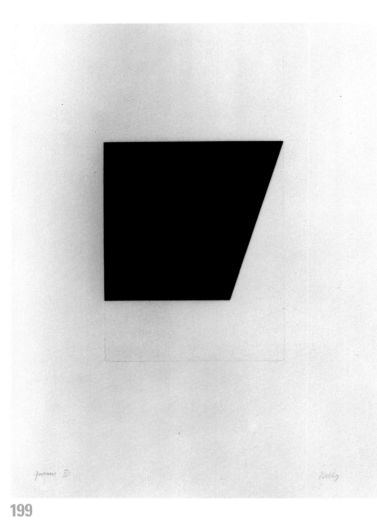

199

Concorde IV 1981–82

Etching and aquatint on Arches Cover paper

Sheet: 34½ x 25⅞ (87.6 x 65.7)

Image: 16 x 12½ (40.6 x 31.8)

Signed in pencil, lower right: *Kelly*; numbered in pencil, lower left. Blind stamp, lower right: logo of Gemini G.E.L., ©. Inscribed in pencil on verso: *EK81–3061*. Stamped on verso: *© Gemini G.E.L. Los Angeles*

Edition: 18

Proofs: 9 AP, RTP, PPII, 3 SP, 3 GEL, NGA, C (Somerset Satine paper)

Collaboration and supervision: Doris Simmelink. Proofing and processing: Anthony Zepeda, Jacob Samuels, Doris Simmelink. Edition printing: Doris Simmelink.

Published by Gemini G.E.L., Los Angeles (Gemini 998)

1 run from 1 plate

1 black; copper plate, same as cat. no. 199a

Comments: In 1976 Kelly created a variant form of the original Concorde shape by isolating its lower half, flipping it over, and adjusting the proportions. The result was the paperwork *Colored Paper Image X* (cat. no. 150). It was the basis for the wood sculpture *Concorde Relief II*, 1978 (EK#S585; Sims and Pulitzer 1982, no. 104), the weathering steel sculpture *Concorde Angle*, 1982 (EK#S654; Sims and Pulitzer 1982, no. 117), and the aquatints *Concorde IV* and *Concorde V* (cat. no. 200).

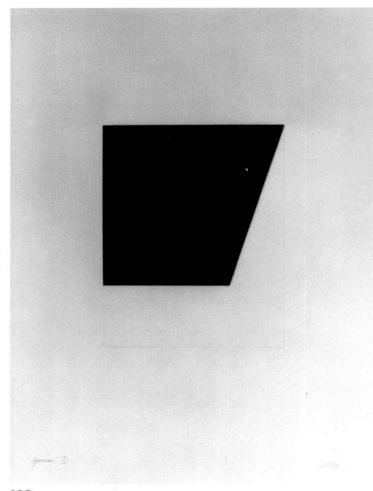

199a

Concorde IV (State) 1981–82

Etching and aquatint with plate tone on Arches Cover paper

Sheet: 34½ x 25⅞ (87.6 x 65.7)

Image: 16 x 12½ (40.6 x 31.8)

Signed in pencil, lower right: *Kelly*; numbered in pencil, lower left. Blind stamp, lower right: logo of Gemini G.E.L., ©. Inscribed in pencil on verso: *EK81–3061A*. Stamped on verso: *© Gemini G.E.L. Los Angeles*

Edition: 18

Proofs: 9 AP, RTP, PPII, 3 SP, 3 GEL, NGA, C (documented with cat. no. 199); plate reserved for cat. no. 199

Collaboration and supervision: Doris Simmelink. Proofing and processing: Anthony Zepeda, Jacob Samuels, Doris Simmelink. Edition printing: Doris Simmelink.

Published by Gemini G.E.L., Los Angeles (Gemini 1005)

1 run from 1 plate

1 black; copper plate, wiped for toned area; same as cat. no. 199

Comments: See cat. no. 199

Concorde V 1981–82

Etching and aquatint on Arches Cover paper

Sheet: 26½ x 21¼ (67.3 x 54.0)

Image: 10¼ x 8⁵⁄₁₆ (26.0 x 21.1)

Signed in pencil, lower right: *Kelly*; numbered in pencil, lower left. Blind stamp, lower right: logo of Gemini G.E.L., © Inscribed in pencil on verso: *EK81–3062*. Stamped on verso: © *Gemini G.E.L. Los Angeles*

Edition: 18

Proofs: 9 AP, RTP, PPII, 3 SP, 3 GEL, NGA, C (Somerset Satine paper)

Collaboration and supervision: Doris Simmelink. Proofing and processing: Anthony Zepeda, Jacob Samuels, Doris Simmelink. Edition printing: Patrick Foye.

Published by Gemini G.E.L., Los Angeles (Gemini 999)

1 run from 1 plate
1 black; copper plate, same as cat. no. 200a

Comments: See cat. no. 199

200

Concorde V (State) 1981–82

Etching and aquatint with plate tone on Arches Cover paper

Sheet: 26½ x 21¼ (67.3 x 54.0)

Image: 10¼ x 8⁵⁄₁₆ (26.0 x 21.1)

Signed in pencil, lower right: *Kelly*; numbered in pencil, lower left. Blind stamp, lower right: logo of Gemini G.E.L., ©. Inscribed in pencil on verso: *EK81–3062A*. Stamped on verso: © *Gemini G.E.L. Los Angeles*

Edition: 18

Proofs: 9 AP, RTP, PPII, 3 SP, 3 GEL, NGA, C (documented with cat. no. 200); plate reserved for cat. no. 200

Collaboration and supervision: Doris Simmelink. Proofing and processing: Anthony Zepeda, Jacob Samuels, Doris Simmelink. Edition printing: Patrick Foye.

Published by Gemini G.E.L., Los Angeles (Gemini 1006)

1 run from 1 plate
1 black; copper plate, wiped for toned area; same as cat. no. 200

Comments: See cat no. 199

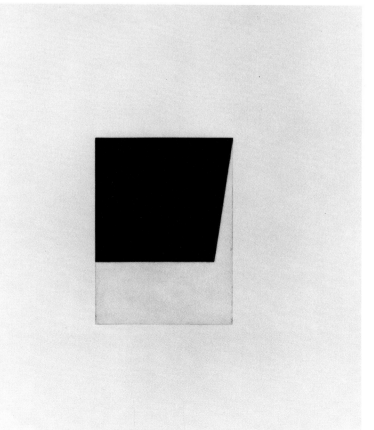

200a

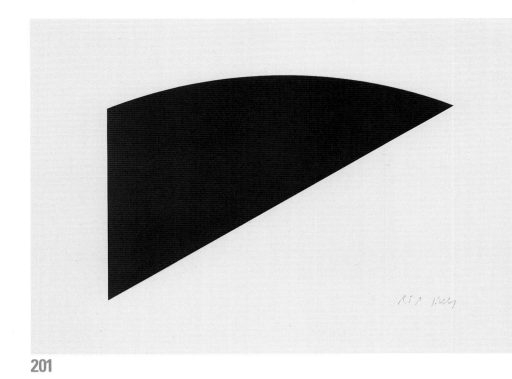

201

Untitled 1983

Lithograph on Arches 88 paper

Sheet: 29 x 41 (73.7 x 104.1)

Signed in pencil, lower right: *Kelly*; numbered in pencil, lower right. Blind stamp, lower right: logo of Gemini G.E.L., ©. Inscribed in pencil on verso: *EK83–1029*. Stamped on verso: © *Gemini G.E.L. Los Angeles*

Edition: 250

Proofs: 43 AP, RTP, PPII, 3 GEL, NGA, C

Collaboration and supervision: James Reid. Proofing and processing: Serge Lozingot, James Reid. Edition printing: James Reid, Krystine Graziano.

Published by the Museum of Contemporary Art, Los Angeles (Gemini 1149)

1 run from 1 plate

1 blue; aluminum photo plate, from hand-cut negative

Comments: This is one of eight lithographs in the portfolio *Eight by Eight to Celebrate the Temporary Contemporary*, which also includes the work of Richard Diebenkorn, Sam Francis, David Hockney, Robert Rauschenberg, Niki de Saint-Phalle, Jean Tinguely, and Andy Warhol. Joseph Kosuth designed the portfolio box and the frontispiece.

Untitled repeats the form but varies the color of the painting *Blue-Violet Curve I*, 1983 (EK#639). It is derived from a pencil study (EK#83.2). The shape is related to the diagonal circle-section relief sculptures and paintings of 1983.

SAINT MARTIN SERIES 1983–84

Kelly sketched out the original four shapes for the Saint Martin Series on a sheet of hotel stationery in Los Angeles (see p. 25, fig. 32). He refined them in further small and large working drawings at his home studio in Spencertown (EK#83.47–50, EK#84.60–63). Not based on specific paintings, but generally related to the curve paintings of the early 1980s, these forms were from the outset envisioned by Kelly as prints. His reasons for this resided in his desire to explore texture patterns, rather than flat color, as grounds for the shapes. This interest had never been developed in the paintings but already had a history in the weathering steel and wood sculptures and in the prints. In the Colored Paper Images of 1976–77 (cat. nos. 141–63) Kelly discarded immaculate surface and precise contour in favor of tactile handmade paper and bleeding color; in *Wall* (cat. no. 177) and the Concorde Series (cat. nos. 194–200a), etching/aquatints of 1976–79 and 1981–82 respectively, he used sketchy edges, pitted surfaces, and the random effects of foul biting. In the Saint Martin Series, he addressed and elaborated upon these concerns within the realm of lithography.

During the first working session at Gemini, Kelly established a variety of texture patterns on a series of lithographic plates that were treated with an unusual variety of tools and agents, such as tusche and salt washes, large brushes, and tarpaulin rags. In seeking anonymous textures and random effects as well as painterly surfaces, he had the printers improvise designs on the plates themselves, under his supervision. After these initial, chance gestures, Kelly then worked the plates directly. During this process, several treated plates were laid out in a back room on the floor. Kelly accidentally stepped back on one (which was to be the basis for *Orient Beach*) and marked it with his footprint. He liked the

effect as it played with other textures on the plate, and left it in. Of six plates that were treated, Kelly decided on four that best suited his interests. These plates were originally to have been printed in color and collectively superimposed on a single sheet to create one texture panel for his four predetermined shapes. Later, upon receipt in Spencertown of full-panel proofs in black and white and in blue, Kelly abandoned color and the amalgamated texture panels and decided to assign each of the four patterns to a different shape and to develop the series in black and white.

At Spencertown, Kelly resolved other variables: which texture pattern would be selected for which shape, the orientation of the texture pattern within the shape, and the positioning of the shape on the sheet of paper. This he did by cutting out paper negatives, like stencils, for each shape and placing them over black-and-white proofs of the texture patterns. The possibilities with the four paper templates and the four printed panels were myriad. The paper negatives could be repositioned in any number of ways.

During the second working session at Gemini, Kelly generated two new developments: the evolution of state editions and the initiation of a sculpture series of multiples. In starting to think about the most satisfying orientation of the shape to the sheet, Kelly had a white paper negative for each of the four shapes pinned to fifty-by-fifty-eight-inch sheets of white paper. After a few days the paper negatives began to sag and separate from the flat sheets to create relieflike effects. Kelly liked the look of the pieces and began to make a series of all-white, painted-aluminum relief sculptures, the Metal Wall Reliefs (Gemini 1199–1202), based on the shapes of the Saint Martin Series.

State prints for each of the standard editions evolved out of Kelly's search for the right adjustment of the texture grounds within each shape. The final solution entailed placing the paper negative in position on the plate, tracing the line of the shape, and then chemically deleting the surrounding negative areas from each plate, thus permanently destroying texture areas not to be used. The term "deleted" in the documentation refers to this. Kelly and the printers worked out two systems of collaging that would obviate the need for any deleting until

the preferred orientation had been chosen. In one case a paper negative of the shape, serving as a window mat, was adhered to a base sheet that had been printed with the black-and-white texture. In the other, a given shape was cut out of a printed black-and-white texture panel and collaged to a white base sheet. These led, respectively, to a State I and State II of each print. Kelly liked several different sections of *Orient Beach*, and four state editions evolved, with States III and IV maintaining the texture orientation of the standard edition and States I and II altering it—a process that can be tracked by the movement of the artist's footprint from the upper-right-hand corner to the lower-right-hand edge.

Kelly wished three of the four printed panels —*Cupecoy*, *Baie Rouge*, and *Orient Beach*—to exist as they were without deletions and to have unsigned proofs for himself. At a later point, having hung them together in varying sequences and in different horizontal and vertical orientations, he decided to edition them together to form a triptych (cat. no. 206).

Saint Martin is an island in the West Indies where Kelly has frequently vacationed since the winter of 1971. The individual titles in the print series refer to various locations on the island.

Literature: Knight 1985, opp. 8

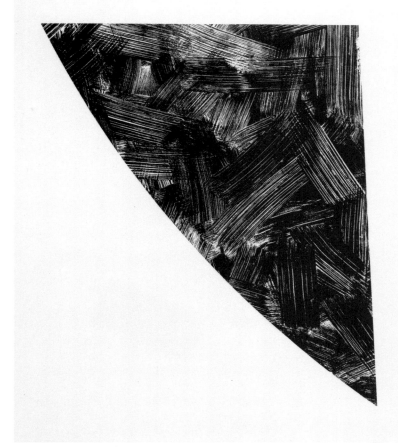

202, 202a, 202b

202
Cupecoy 1983–84

Lithograph on Arches 88 paper

Sheet: 58 x 50 (147.3 x 127.0)

Signed in pencil, lower left: *Kelly*; numbered in pencil, lower left. Blind stamp, lower left: logo of Gemini G.E.L., ©. Inscribed in pencil on verso: *EK84–1095*. Stamped on verso: © *Gemini G.E.L. Los Angeles*

Edition: 25

Proofs: 9 AP, TP, RTP, PPII, 3 GEL, NGA, C

Collaboration and supervision: James Reid, Alan Holoubek (with the participation of Gemini curators Bill Padien, Mari Andrews). Proofing and processing: James Reid, Chris Sukimoto, Serge Lozingot, Anthony Zepeda, Alan Holoubek. Edition printing: James Reid, Alan Holoubek, Serge Lozingot.

Published by Gemini G.E.L., Los Angeles (Gemini 1158)

1 run from 1 plate
1 black (crosshatched brushstrokes with tusche wash); aluminum plate, same as cat. no. 206B, deleted

Literature: "Prints and Photographs," *Print Collector's Newsletter* 1984, 177

202a
Cupecoy, State I 1983–84

Lithograph and collage on Arches 88 paper

Sheet: 58 x 50 (147.3 x 127.0)

Signed in pencil, lower left: *Kelly*; numbered and inscribed in pencil, lower left: *State I*. Blind stamp, lower left: logo of Gemini G.E.L., ©. Inscribed in pencil on verso: *EK84–1095A*. Stamped on verso: © *Gemini G.E.L. Los Angeles*

Edition: 2

Proofs: None

Collaboration and supervision: James Reid, Alan Holoubek (with the participation of Gemini curators Bill Padien, Mari Andrews). Proofing and processing: James Reid, Chris Sukimoto, Serge Lozingot, Anthony Zepeda, Alan Holoubek. Edition printing: James Reid, Alan Holoubek, Serge Lozingot.

Published by Gemini G.E.L., Los Angeles (Gemini 1286)

Base sheet:
1 run from 1 plate
1 black (crosshatched brushstrokes with tusche wash); aluminum plate, same as cat. no. 206B

Collage element:
Unprinted full sheet with shape cut out; adhered to base sheet

202b
Cupecoy, State II 1983–84

Lithograph and collage on Arches 88 paper

Sheet: 58 x 50 (147.3 x 127.0)

Signed in pencil, lower left: *Kelly*; numbered and inscribed in pencil, lower left: *State II*. Blind stamp, lower left: logo of Gemini G.E.L., ©. Inscribed in pencil on verso: *EK84–1095B*. Stamped on verso: © *Gemini G.E.L. Los Angeles*

Edition: 2

Proofs: None

Collaboration and supervision: James Reid, Alan Holoubek (with the participation of Gemini curators Bill Padien, Mari Andrews). Proofing and processing: James Reid, Chris Sukimoto, Serge Lozingot, Anthony Zepeda, Alan Holoubek. Edition printing: James Reid, Alan Holoubek, Serge Lozingot.

Published by Gemini G.E.L., Los Angeles (Gemini 1287)

Collage sheet:
1 run from 1 plate
1 black (crosshatched brushstrokes with tusche wash); aluminum plate, same as cat. no. 206

Base sheet (unprinted):
Collage shape cut out from printed sheet and adhered to base sheet

203
Cul de Sac 1983–84

Lithograph on Arches 88 paper

Sheet: 42½ x 56½ (108.0 x 143.5)

Signed in pencil, lower right: *Kelly*; numbered in pencil, lower right. Blind stamp, lower right: logo of Gemini G.E.L., ©. Inscribed in pencil on verso: *EK84–1096*. Stamped on verso: © *Gemini G.E.L. Los Angeles*

Edition: 25

Proofs: 11 AP, TP, RTP, PPII, 2 SP, 3 GEL, NGA, C

Collaboration and supervision: James Reid, Alan Holoubek (with the participation of Gemini curators Bill Padien, Mari Andrews). Proofing and processing: Serge Lozingot, Krystine Graziano (with Bill Padien, Mari Andrews). Edition printing: Serge Lozingot, Anthony Zepeda, James Reid.

Published by Gemini G.E.L., Los Angeles (Gemini 1159)

1 run from 1 plate
1 black (blotted-cloth texture); aluminum plate

Literature: "Prints and Photographs," *Print Collector's Newsletter* 1984, 177

Comments: The texture pattern for *Cul de Sac* was derived from a full plate that was deleted to form the printed shape. The full plate for *Cul de Sac* was never printed in a separate edition, unlike the plates from which were extracted the shapes of the other three single prints in this series, and which were also printed in their entirety to create the three full panels of the *Saint Martin Triptych* (cat. no. 206).

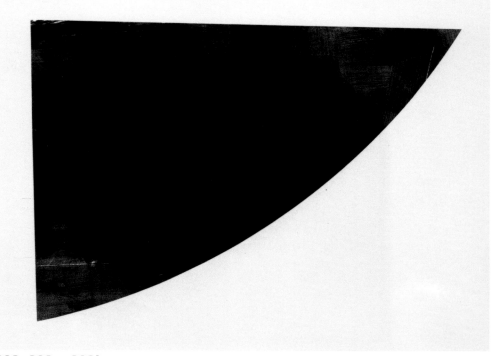

203, 203a, 203b

203a
Cul de Sac, State I 1983–84

Lithograph and collage on Arches 88 paper

Sheet: 42½ x 56½ (108.0 x 143.5)

Signed in pencil, lower right: *Kelly*; numbered and inscribed in pencil, lower right: *State I*. Blind stamp, lower right: logo of Gemini G.E.L., ©. Inscribed in pencil on verso: *EK84–1096A*. Stamped on verso: © *Gemini G.E.L. Los Angeles*

Edition: 2

Proofs: None

Collaboration and supervision: James Reid, Alan Holoubek (with the participation of Gemini curators Bill Padien, Mari Andrews). Proofing and processing: Serge Lozingot, Krystine Graziano (with Bill Padien, Mari Andrews). Edition printing: Serge Lozingot, Anthony Zepeda, James Reid.

Published by Gemini G.E.L., Los Angeles (Gemini 1288)

Base sheet:
1 run from 1 plate
1 black (blotted-cloth texture); aluminum plate

Collage element:
Unprinted full sheet with shape cut out; adhered to base sheet

203b
Cul de Sac, State II 1983–84

Lithograph and collage on Arches 88 paper

Sheet: 42½ x 56½ (108.0 x 143.5)

Signed in pencil, lower right: *Kelly*; numbered and inscribed in pencil, lower right: *State II*. Blind stamp, lower right: logo of Gemini G.E.L., ©. Inscribed in pencil on verso: *EK84–1096B*. Stamped on verso: © *Gemini G.E.L. Los Angeles*

Edition: 2

Proofs: None

Collaboration and supervision: James Reid, Alan Holoubek (with the participation of Gemini curators Bill Padien, Mari Andrews). Proofing and processing: Serge Lozingot, Krystine Graziano (with Bill Padien, Mari Andrews). Edition printing: Serge Lozingot, Anthony Zepeda, James Reid.

Published by Gemini G.E.L., Los Angeles (Gemini 1289)

Collage sheet:
1 run from 1 plate
1 black (blotted-cloth texture); aluminum plate

Base sheet (unprinted):
Collage shape cut out from printed sheet and adhered to base sheet

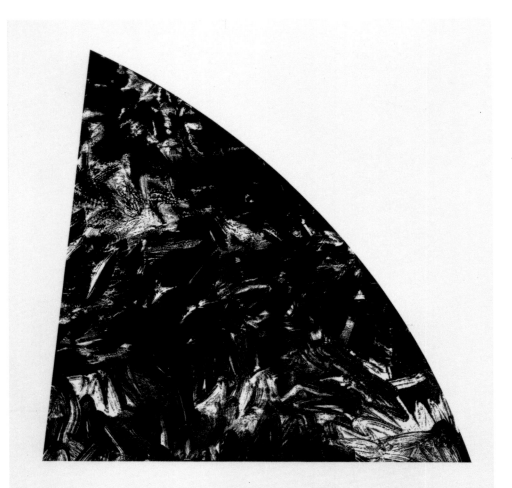

204, 204a, 204b

204
Baie Rouge 1983–84

Lithograph on Arches 88 paper

Sheet: 51 x 52 (129.5 x 132.1)

Signed in pencil, lower right: *Kelly*; numbered in pencil, lower right. Blind stamp, lower right: logo of Gemini G.E.L., ©. Inscribed in pencil on verso: *EK84–1097*. Stamped on verso: © *Gemini G.E.L. Los Angeles*

Edition: 25

Proofs: 9 AP, TP, RTP, PPII, SP, 3 GEL, NGA, C

Collaboration and supervision: James Reid, Alan Holoubek (with the participation of Gemini curators Bill Padien and Mari Andrews). Proofing and processing: James Reid, Chris Sukimoto, Serge Lozingot, Anthony Zepeda. Edition printing: James Reid, Alan Holoubek.

Published by Gemini G.E.L., Los Angeles (Gemini 1160)

1 run from 1 plate
1 black (brushstrokes with tusche wash); aluminum plate, same as cat. no. 206A, deleted

Literature: "Prints and Photographs," *Print Collector's Newsletter* 1984, 177

204a
Baie Rouge, State I 1983–84

Lithograph on Arches 88 paper

Sheet: 51 x 52 (129.5 x 132.1)

Signed in pencil, lower right: *Kelly*; numbered and inscribed in pencil, lower left: *State I*. Blind stamp, lower right: logo of Gemini G.E.L., ©. Inscribed in pencil on verso: *EK84–1097A*. Stamped on verso: © *Gemini G.E.L. Los Angeles*

Edition: 2

Proofs: None

Collaboration and supervision: James Reid, Alan Holoubek (with the participation of Gemini curators Bill Padien and Mari Andrews). Proofing and processing: James Reid, Chris Sukimoto, Serge Lozingot, Anthony Zepeda (with Bill Padien, Mari Andrews). Edition printing: James Reid, Alan Holoubek.

Published by Gemini G.E.L., Los Angeles (Gemini 1290)

Base sheet:
1 run from 1 plate
1 black (brushstrokes with tusche wash); plate, same as cat. no. 206A

Collage element:
Unprinted full sheet with shape cut out; adhered to base sheet

204b
Baie Rouge, State II 1983–84

Lithograph on Arches 88 paper

Sheet: 51 x 52 (129.5 x 132.1)

Signed in pencil, lower right: *Kelly*; numbered and inscribed in pencil, lower right: *State II*. Blind stamp, lower right: logo of Gemini G.E.L., ©. Inscribed in pencil on verso: *EK84–1097B*. Stamped on verso: © *Gemini G.E.L. Los Angeles*

Edition: 2

Proofs: None

Collaboration and supervision: James Reid, Alan Holoubek (with the participation of Gemini curators Bill Padien and Mari Andrews). Proofing and processing: James Reid, Chris Sukimoto, Serge Lozingot, Anthony Zepeda (with Bill Padien, Mari Andrews). Edition printing: James Reid, Alan Holoubek.

Published by Gemini G.E.L., Los Angeles (Gemini 1291)

Collage sheet:
1 run from 1 plate
1 black (brushstrokes with tusche wash); plate, same as cat. no. 206A

Base sheet (unprinted):
Collage shape cut out from printed sheet and adhered to base sheet

205
Orient Beach · 1983–84

Lithograph on Arches 88 paper

Sheet: 48 x 50 (121.9 x 127.0)

Signed in pencil, lower left: *Kelly*; numbered in pencil, lower left. Blind stamp, lower left: logo of Gemini G.E.L., ©. Inscribed in pencil on verso: *EK84–1098*. Stamped on verso: © *Gemini G.E.L. Los Angeles*

Edition: 16

Proofs: 9 AP, TP, RTP, PPII, 3 GEL, NGA, C

Collaboration and supervision: James Reid, Alan Holoubek (with the participation of Gemini curators Bill Padien and Mari Andrews). Proofing and processing: James Reid, Chris Sukimoto, Alan Holoubek. Edition printing: James Reid, Alan Holoubek.

Published by Gemini G.E.L., Los Angeles (Gemini 1161)

1 run from 1 plate

1 black (tusche wash and flat); aluminum plate, same as cat. no. 206C, deleted

Literature: "Prints and Photographs," *Print Collector's Newsletter* 1984, 177

205c
Orient Beach, State III · 1983–84

Lithograph on Arches 88 paper

Sheet: 48 x 50 (121.9 x 127.0)

Signed in pencil, lower left: *Kelly*; numbered and inscribed in pencil, lower left: *State III*. Blind stamp, lower left: logo of Gemini G.E.L., ©. Inscribed in pencil on verso: *EK84–1098C*. Stamped on verso: © *Gemini G.E.L. Los Angeles*

Edition: 2

Proofs: None

Collaboration and supervision: James Reid, Alan Holoubek (with the participation of Gemini curators Bill Padien and Mari Andrews). Proofing and processing: James Reid, Chris Sukimoto, Alan Holoubek. Edition printing: James Reid, Alan Holoubek.

Published by Gemini G.E.L., Los Angeles (Gemini 1293)

Base sheet:
1 run from 1 plate
1 black (tusche wash and flat); aluminum plate, same as cat. no. 206C

Collage element:
Unprinted full sheet with shape cut out; adhered to base sheet

205d
Orient Beach, State IV · 1983–84

Lithograph on Arches 88 paper

Sheet: 48 x 50 (121.9 x 127.0)

Signed in pencil, lower left: *Kelly*; numbered and inscribed in pencil, lower left: *State IV*. Blind stamp, lower left: logo of Gemini G.E.L., ©. Inscribed in pencil on verso: *EK84–1098D*. Stamped on verso: © *Gemini G.E.L. Los Angeles*

Edition: 2

Proofs: None

Collaboration and supervision: James Reid, Alan Holoubek (with the participation of Gemini curators Bill Padien and Mari Andrews). Proofing and processing: James Reid, Chris Sukimoto, Alan Holoubek. Edition printing: James Reid, Alan Holoubek.

Published by Gemini G.E.L., Los Angeles (Gemini 1294)

Collage sheet:
1 run from 1 plate
1 black (tusche wash and flat); plate, same as cat. no. 206C

Base sheet (unprinted):
Collage shape cut out from printed sheet and adhered to base sheet

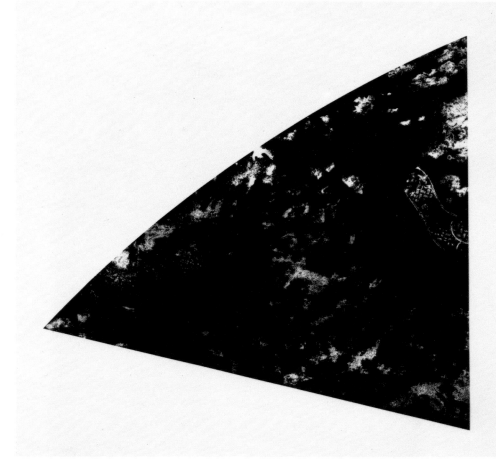

205, 205c, 205d

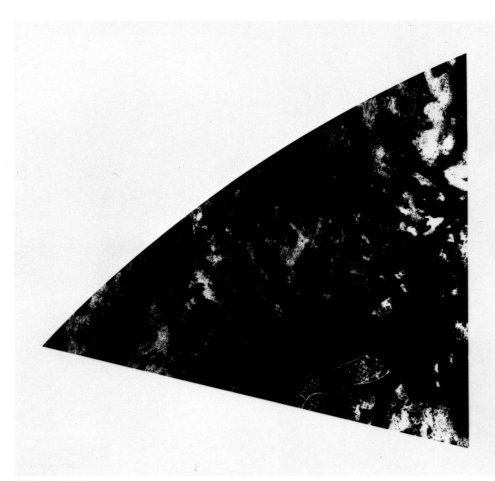

205a, 205b

205a
Orient Beach, State I 1983–84

Lithograph on Arches 88 paper

Sheet: 48 x 50 (121.9 x 127.0)

Signed in pencil, lower left: *Kelly*; numbered and inscribed in pencil, lower left: *State I*. Blind stamp, lower left: logo of Gemini G.E.L., ©. Inscribed in pencil on verso: *EK84–1098A*. Stamped on verso: © *Gemini G.E.L. Los Angeles*

Edition: 10

Proofs: None

Collaboration and supervision: James Reid, Alan Holoubek (with the participation of Gemini curators Bill Padien and Mari Andrews). Proofing and processing: James Reid, Chris Sukimoto, Alan Holoubek. Edition printing: James Reid, Alan Holoubek.

Published by Gemini G.E.L., Los Angeles (Gemini 1162)

Base sheet:
1 run from 1 plate
1 black (tusche wash and flat); plate, same as cat. no. 206C

Collage element:
Unprinted full sheet with shape cut out; adhered to base sheet

205b
Orient Beach, State II 1983–84

Lithograph on Arches 88 paper

Sheet: 48 x 50 (121.9 x 127.0)

Signed in pencil, lower left: *Kelly*; numbered and inscribed in pencil, lower left: *State II*. Blind stamp, lower left: logo of Gemini G.E.L., ©. Inscribed in pencil on verso: *EK84–1098B*. Stamped on verso: © *Gemini G.E.L. Los Angeles*

Edition: 2

Proofs: None

Collaboration and supervision: James Reid, Alan Holoubek (with the participation of Gemini curators Bill Padien and Mari Andrews). Proofing and processing: James Reid, Chris Sukimoto, Alan Holoubek. Edition printing: James Reid, Alan Holoubek.

Published by Gemini G.E.L., Los Angeles (Gemini 1292)

Collage element:
1 run from 1 plate
1 black (tusche wash and flat); plate, same as cat. no. 206C

Base sheet (unprinted):
Collage shape cut out from printed sheet and adhered to base sheet

Saint Martin Triptych 1984

A LEFT PANEL

Lithograph on Arches 88 paper

Sheet: 58 x 52 (147.3 x 132.1)

Signed in pencil, lower right *A/EK*. Blind stamp, lower right: logo of Gemini G.E.L., ©. Inscribed in pencil on verso: *EK84–1099*. Stamped on verso: © *Gemini G.E.L. Los Angeles*

Edition: 6

Proofs: C (documented with cat. no. 204); plate reserved and deleted for *Baie Rouge* (cat. nos. 204–204b)

1 run from 1 plate

1 black (brushstroke wash; salt added to tusche for speckling and bubbling); aluminum plate, same as cat. nos. 204–204b

B MIDDLE PANEL

Lithograph on Arches 88 paper

Sheet: 56 x 52 (142.2 x 132.1)

Signed in pencil, lower right: *B/EK*. Blind stamp, lower right: logo of Gemini G.E.L., ©. Inscribed in pencil on verso: *EK84–1099*. Stamped on verso: © *Gemini G.E.L. Los Angeles*

Edition: 6

Proofs: C (documented with cat. no. 202); plate reserved and deleted for *Cupecoy* (cat. nos. 202–202b)

1 run from 1 plate

1 black (direct drawing, crosshatched); aluminum plate, same as cat. nos. 202–202b

C RIGHT PANEL

Lithograph on Arches 88 paper

Sheet: 56 x 52 (142.2 x 132.1)

Signed in pencil, lower right: *C/Kelly*; numbered in pencil, lower right. Blind stamp, lower right: logo of Gemini G.E.L., ©. Inscribed in pencil on verso: *EK84–1099*. Stamped on verso: © *Gemini G.E.L. Los Angeles*

Edition: 6

Proofs: C (documented with cat. no. 205; plate reserved and deleted for *Orient Beach* (cat. nos. 205–205d)

1 run from 1 plate

1 black (wash and flat); aluminum plate, same as cat. nos. 205–205d

Collaboration and supervision: James Reid, Alan Holoubek (with the participation of Gemini curators Bill Padien and Mari Andrews). Proofing and processing: James Reid, Alan Holoubek, Chris Sukimoto. Edition printing: James Reid, Alan Holoubek.

Published by Gemini G.E.L, Los Angeles (Gemini 1163)

206

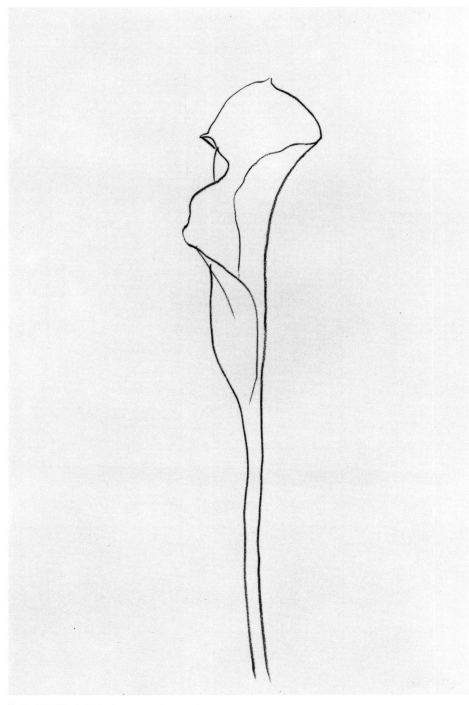

Calla Lily III, 1983–85 (cat. no. 211)

The seven lithographs in this third botanical series done at Gemini G.E.L. were derived from transfer-paper drawings that Kelly made of plants and flowers in the workshop studio. Although the philodendron and dracena appear here for the first time in the artist's graphic oeuvre, the calla lily, which is represented in the set by three prints, was the subject of eleven variations in the Twelve Leaves series of 1978 (cat. nos. 165–76). Begun in the summer of 1983, the Series of Plant and Flower Lithographs was completed in the spring of 1984, at the same time that Kelly was working on the Saint Martin Series (cat. nos. 202–6).

As he had done on several earlier occasions, Kelly worked directly on transfer paper. He did not base the lithographic drawings on a set of preliminary studies. For the two dracenas, he worked on the same commercial decal paper that he had used for all previous plant lithographs done at Gemini. In consultation with Gemini curator Bill Padien, Kelly found a different kind of transfer paper for the remaining lithographs that would give him a quality of drawing similar to the thicker, crayoned line of the earlier Maeght Suite of Plant Lithographs (cat. nos. 32–59), which he had always liked. In contrast to the lighter, more delicate line of the dracena drawings, the calla lilies and the philodendrons carry a full, rich line. The printers also experimented with both stone and metal-plate elements for an enhancement of line that Kelly sought. Although the sensitivity of stone can create the subtle effects of drawing, the printers achieved a comparable denseness of line with aluminum plates—a result, in part, of their experimentation with various chemical processes.

Literature: Knight 1985, 5–7

207–13

SERIES OF PLANT AND FLOWER LITHOGRAPHS 1983–85

Philodendron I 1983–85

Transfer lithograph on Rives BFK paper

Sheet: 25 x 36 (63.5 x 91.4)

Signed in pencil, lower right: *Kelly*; numbered in pencil, lower right. Blind stamp, lower right: logo of Gemini G.E.L., ©. Inscribed in pencil on verso: *EK83–1088*. Stamped on verso: © *Gemini G.E.L. Los Angeles*

Edition: 30

Proofs: 9 AP, RTP, PPII, 3 SP, 3 GEL, NGA, C

Collaboration and supervision: Alan Holoubek, James Reid. Proofing and processing: Anthony Zepeda, Alan Holoubek, James Reid. Edition printing: Alan Holoubek, James Reid.

Published by Gemini G.E.L., Los Angeles (Gemini 1203)

1 run from 1 stone
1 black; stone, from lithographic-crayon drawing on transfer paper

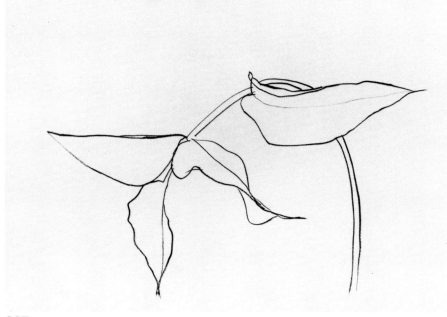

207

Philodendron II 1983–85

Transfer lithograph on Rives BFK paper

Sheet: 25 x 36 (63.5 x 91.4)

Signed in pencil, lower right: *Kelly*; numbered in pencil, lower right. Blind stamp, lower right: logo of Gemini G.E.L., ©. Inscribed in pencil on verso: *EK83–1089*. Stamped on verso: © *Gemini G.E.L. Los Angeles*

Edition: 30

Proofs: 9 AP, RTP, PPII, 2 SP, 3 GEL, NGA, C

Collaboration and supervision: Alan Holoubek, James Reid. Proofing and processing: Anthony Zepeda, Alan Holoubek, James Reid. Edition printing: Anthony Zepeda, Serge Lozingot.

Published by Gemini G.E.L., Los Angeles (Gemini 1204)

1 run from 1 plate
1 black; aluminum plate, from lithographic-crayon drawing on transfer paper

Literature: Knight 1985, 5, 7

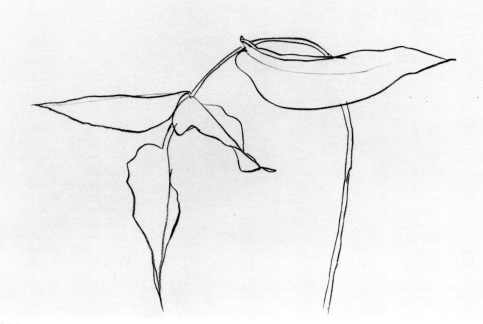

208

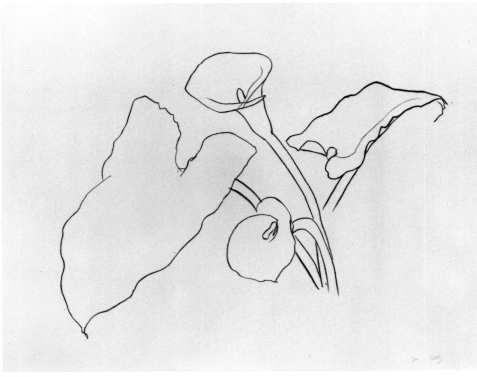

209

Calla Lily I 1983–85

Transfer lithograph on Rives BFK paper

Sheet: 30¼ x 39 (76.8 x 99.1)

Signed in pencil, lower right: *Kelly*; numbered in pencil, lower right. Blind stamp, lower right: logo of Gemini G.E.L., ©. Inscribed in pencil on verso: *EK83–1092*. Stamped on verso: © *Gemini G.E.L. Los Angeles*

Edition: 30

Proofs: 9 AP, RTP, PPII, 2 SP, 3 GEL, NGA, C

Collaboration and supervision: Alan Holoubek, James Reid. Proofing and processing: Anthony Zepeda, Alan Holoubek, James Reid. Edition printing: James Reid, Alan Holoubek.

Published by Gemini G.E.L., Los Angeles (Gemini 1207)

1 run from 1 plate
1 black; aluminum plate from lithographic-crayon drawing on transfer paper

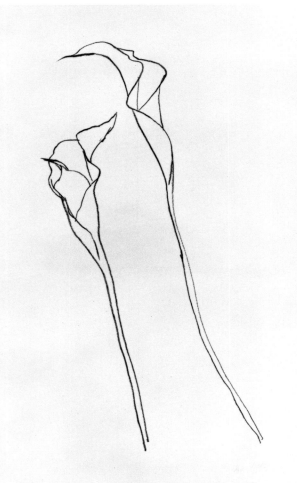

Calla Lily II 1983–85

Transfer lithograph on Rives BFK paper

Sheet: 36 x 25 (91.4 x 63.5)

Signed in pencil, lower right: *Kelly*; numbered in pencil, lower right. Blind stamp, lower right: logo of Gemini G.E.L., ©. Inscribed in pencil on verso: *EK83–1090*. Stamped on verso: © *Gemini G.E.L. Los Angeles*

Edition: 30

Proofs: 9 AP, RTP, PPII, 3 SP, 3 GEL, NGA, C

Collaboration and supervision: Alan Holoubek, James Reid. Proofing and processing: Anthony Zepeda, Alan Holoubek, James Reid. Edition printing: Serge Lozingot, Anthony Zepeda.

Published by Gemini G.E.L., Los Angeles (Gemini 1205)

1 run from 1 plate
1 black; aluminum plate, from lithographic-crayon drawing on transfer paper

210

Calla Lily III 1983–85

Transfer lithograph on Rives BFK paper

Sheet: 36 x 25 (91.4 x 63.5)

Signed in pencil, lower right: *Kelly*; numbered in pencil, lower right. Blind stamp, lower right: logo of Gemini G.E.L., ©
Inscribed in pencil on verso: *EK83–1091*. Stamped on verso: © *Gemini G.E.L. Los Angeles*

Edition: 30

Proofs: 9 AP, RTP, PPII, 2 SP, 3 GEL, NGA, C

Collaboration and supervision: Alan Holoubek, James Reid.
Proofing and processing: Anthony Zepeda, Alan Holoubek, James Reid. Edition printing: Alan Holoubek, James Reid.

Published by Gemini G.E.L., Los Angeles (Gemini 1206)

1 run from 1 stone
1 black; stone, from lithographic-crayon drawing on transfer paper

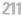

211

Dracena I 1983–85

Transfer lithograph on Rives BFK paper

Sheet: 43 x 31½ (109.2 x 80.0)

Signed in pencil, lower right: *Kelly*; numbered in pencil, lower right. Blind stamp, lower right: logo of Gemini G.E.L., ©.
Inscribed in pencil on verso: *EK83–1094*. Stamped on verso: © *Gemini G.E.L. Los Angeles*

Edition: 30

Proofs: 9 AP, RTP, PPII, 3 GEL, NGA, C

Collaboration and supervision: Alan Holoubek, James Reid.
Proofing and processing: Serge Lozingot, James Reid, Anthony Zepeda. Edition printing: Anthony Zepeda, Serge Lozingot.

Published by Gemini G.E.L., Los Angeles (Gemini 1209)

1 run from 1 plate
1 black; aluminum plate, from lithographic-crayon drawing on transfer paper

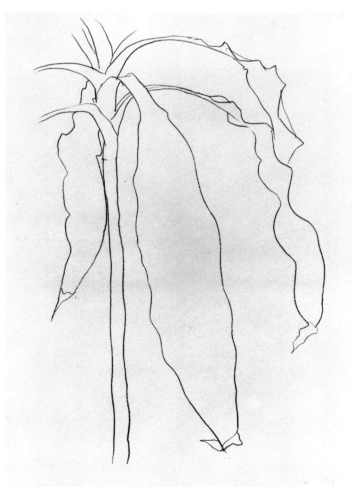

212

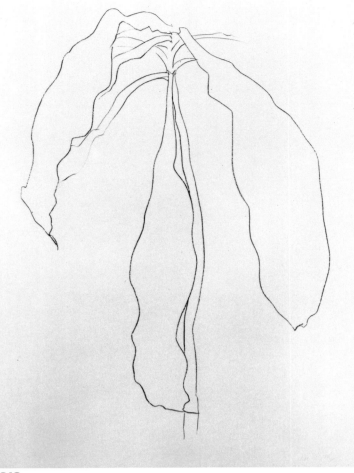

213

Dracena II 1983–85

Transfer lithograph on Rives BFK paper

Sheet: 43 x 31½ (109.2 x 80.0)

Signed in pencil, lower right: *Kelly*; numbered in pencil, lower right. Blind stamp, lower right: logo of Gemini G.E.L., *©*. Inscribed in pencil on verso: *EK83–1093*. Stamped on verso: *© Gemini G.E.L. Los Angeles*

Edition: 30

Proofs: 9 AP, RTP, PPII, 4 SP, 3 GEL, NGA, C

Collaboration and supervision: Alan Holoubek, James Reid. Proofing and processing: Serge Lozingot, James Reid, Anthony Zepeda. Edition printing: James Reid, Alan Holoubek.

Published by Gemini G.E.L., Los Angeles (Gemini 1208)

1 run from 1 plate
1 black; aluminum plate, from lithographic-crayon drawing on transfer paper

APPENDIX: RELATED PRINTMAKING ACTIVITY

Ellsworth Kelly's involvement with multiple images has extended beyond the making of autographic, editioned prints. He has collaborated on several graphic-design projects; his first, in 1938, was the creation of linocut designs for the cover of his junior-high-school magazine, *Chirp*.

Kelly's subsequent activities in areas related to printmaking have included graphic work for the contemporary art journal *Derrière le miroir*, exhibition catalogues, posters, the design of invitations for exhibitions of his work, and designs for wine labels. They are chronicled in the following three sections: Graphic Work for Books and Exhibition Catalogues; Posters; Miscellaneous.

DERRIÈRE LE MIROIR

In 1951, while living and working in Paris, Kelly met Aimé Maeght and his wife, Marguerite, owners of the Galerie Maeght, Paris, and the Imprimerie Maeght, Levallois-Perret. Maeght had opened his gallery devoted to contemporary work in 1945, hoping to encourage interest in modern art. He had studied lithography and drawing at the Académie des Beaux-Arts in Nîmes and held a degree in technical printing; after the war he founded a lithography workshop. Maeght's ambition in establishing his printshop was to make available to a broader audience less expensive printed imagery by the artists of his time, many of whom were represented by his Paris gallery. "It was natural that a growing and ever more exacting public, after seeing exhibitions of modern art, wanted to prolong the too brief emotions and to relive the fugitive pleasure it aroused," wrote Georges Limbour in the tenth-anniversary issue of Maeght's periodical, *Derrière le miroir*.

Aimé's son Adrien left his father's employ in 1955 to establish a gallery devoted to graphic art, the Galerie Adrien Maeght, and in 1964 opened his own print workshop in Paris, the Imprimerie Arte.

In the postwar years, Aimé Maeght embarked on a series of publishing ventures: the Editions Pierre à Feu, collections of poetry and prose by contemporary authors illustrated with original prints, and, in 1946, the journal *Derrière le miroir*, devoted exclusively to current art and published six times a year. Individual issues of *Derrière le miroir* served as exhibition catalogues for Maeght shows and discussed the work of artists represented by the Paris gallery. Texts were commissioned from Samuel Beckett, Jean-Paul Sartre, Tennessee Williams, and René Char, among others. Some of these, such as Sartre's essay on Alberto Giacometti, have since become classics. The journal also served as a forum for the distribution of original graphic work by Maeght artists.

Throughout its thirty-five-year history, *Derrière le miroir* offered original graphics by such acclaimed contemporary artists as Georges Braque, Joan Miró, Alberto Giacometti, Marc Chagall, Henri Matisse, Wassily Kandinsky, and Ellsworth Kelly. Some installments were issued in limited, deluxe editions, which were signed and numbered on the cover, in addition to a regular edition, produced as the current issue of the periodical. Although the graphic work in *Derrière le miroir* was part of a complete package of image and text, occasionally individual sheets have been removed and sold.

Ia

Derrière le miroir, no. 110

October–November 1958

Kelly's first collaboration on *Derrière le miroir* began in the fall of 1958, when he submitted collages for six lithographs to be included in the October–November issue. Published in conjunction with his first one-man show at the Galerie Maeght, Paris, the issue included an essay by Eugene C. Goossen on the artist's paintings. Kelly also designed the six black "spot" illustrations interspersed in the text. In preparing the issue for publication, the editors had found the typeset text somewhat short for the sixteen-page spread. Kelly, who was in Paris at the time, created a series of black-paper collages to be incorporated with the essay, to extend the layout.

This installment of *Derrière le miroir* effectively represents Kelly's first color printmaking activity and reflects a return to color in the artist's paintings of late 1958 and 1959, after a period of predominantly black-and-white work. The imagery Kelly provided for the issue relates to the geometric and organic figure–ground paintings of 1954–58.

The lithographs in this issue were produced from photo plates derived from Kelly's original collages; they were printed on smooth-wove paper at the Imprimerie Maeght, Levallois-Perret. Published by Maeght Editeur, Paris, in the Editions Pierre à Feu, the issue is unsigned and unnumbered.

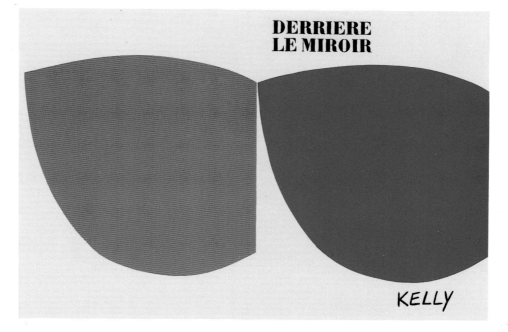

Untitled (back cover)

One-color lithograph, printed in red from photo plates on smooth-wove paper

Image: 15 x 11⅛ (38.0 x 28.3)

Sheet, with *Untitled*, front cover: 15 x 22¼ (38.0 x 56.5)

Comments: The lithograph was derived from a collage of 1958, EK#58.101.

Untitled (front cover)

One-color lithograph from photo plates, printed in blue on smooth-wove paper

Image: 15 x 11⅛ (38.0 x 28.3)

Sheet, with *Untitled*, back cover: 15 × 22¼ (38.0 × 56.5)

Comments: The lithograph was derived from a collage of 1958, EK#58.51.

Untitled (page 4)

One-color lithograph from photo plate, printed in yellow on smooth-wove paper

Image: 15 x 11 (38.0 x 28.0)

Sheet, with *Untitled*, page 13: 15 x 22¼ (38.0 x 56.5)

Comments: This lithograph is based on the painting *City Island*, 1958 (EK#167), and derived from a collage prepared specifically for this issue (EK#58.50).

Untitled (pages 6, 7)

Three-color lithograph from photo plates, printed in black, blue, and green on smooth-wove paper

15 x 22¼ (38.0 x 56.5)

Comments: This image was later echoed in the painting *Green Blue Black*, 1963 (EK#306), and is derived from an ink drawing and two collages of 1958, (EK#58.45–47).

Untitled (pages 10, 11)

One-color lithograph from photo plate, printed in black on smooth-wove paper

15 x 22¼ (38.0 x 56.5)

Comments: This print is based on the painting *Cowboy*, 1958 (EK#145; Goossen 1973, 86), and derived from two collages and an ink drawing of 1958 (EK#58.42–44).

Untitled (page 13)

One-color lithograph from photo plate, printed in red on smooth-wove paper

Image: 15 x 11 (38.0 x 28)

Sheet, with *Untitled*, page 4: 15 x 22¼ (38.0 x 56.5)

Comments: The print is related to the painting *Red White*, 1962 (EK#290), and to a collage of 1958 (EK#58.28). A series of related drawings is reproduced in Sims and Pulitzer 1982, 73, fig. 37. The image is also related to a poster Kelly designed for his first painting exhibition at the Galerie Maeght (App. IIb).

Ib

Derrière le miroir, no. 149

November 1964

In the fall of 1964 Kelly created a series of collages, related to his ovoid figure–ground paintings of the early 1960s, which formed the basis for five lithographic sheets for the November issue of *Derrière le miroir*. Kelly also designed the vignettes interspersed in the text. These were derived from ink-wash drawings produced in New York before his trip to Paris in October.

The November 1964 installment of *Derrière le miroir*, with an essay by Dale McConathy, coincided with Kelly's second one-man show at the Galerie Maeght, Paris. It was printed in two versions: a boxed limited edition of 150 on Rives wove paper, and an unsigned, unnumbered edition on smooth-wove paper, both produced from photo plates taken from Kelly's original designs. The unsigned edition was distributed as the current issue of the periodical. The deluxe version included a separate sleeve, on which the issue was signed and numbered, and a yellow box cover designed by the artist.

Printed by Imprimerie Maeght, Levallois-Perret; published by Maeght Editeur, Paris.

Untitled (front and back covers)

Three-color lithograph from photo plates, printed in blue, red-orange, and green

15 x 22¼ (38.0 x 56.5)

Comments: The single image, folded for a front and back cover, was derived from two collages produced in 1964 specifically for this project: EK#64.10 and EK#64.11.

Untitled (page 4)

One-color lithograph from photo plate, printed in black

Image: 15 x 11 (38.0 x 28.0)

Sheet, with *Untitled*, page 13: 15 x 22¼ (38.0 x 56.5)

Untitled (page 6)

Two-color lithograph from photo plates, printed in orange and green

Image: 15 x 11 (38.0 x 28.0)

Sheet, with *Untitled*, page 11: 15 x 22¼ (38.0 x 56.5)

Comments: This print was later echoed in the painting *Orange Green*, 1966 (EK#352).

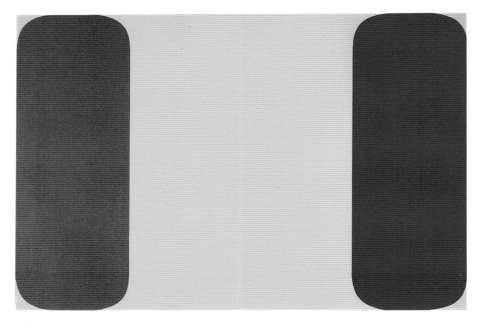

Untitled (pages 8, 9)

Three-color lithograph from photo plates, printed in red, yellow, and blue

15 x 22¼ (38.0 x 56.5)

Comments: This image is related to the painting *Red Blue Yellow*, 1963 (EK#302).

Untitled (page 11)

Two-color lithograph from photo plates, printed in red and blue

Image: 15 x 11 (38.0 x 28.0)

Sheet, with *Untitled*, page 6: 15 x 22¼ (38 x 56.5)

Comments: This print is related to the painting *Blue Red*, 1965 (EK#333).

Untitled (page 13)

One-color lithograph from photo plate, printed in black
Image: 15 x 11 (38.0 x 28.0)
Sheet, with *Untitled*, page 4: 15 x 22¼ (38 x 56.5)

Lotus, 1982; Derrière le miroir: Hommage à Aimé et Marguerite Maeght, No. 250 August 1982

Kelly produced the drawing for *Lotus* in Spencertown, New York, and sent the transfer-paper study to Paris for proofing. It was included in the final memorial issue of *Derrière le miroir* with prints by Eduardo Chillida, Takis, Pierre Alechinsky, Joan Miró, Marc Chagall, Shusaku Arakawa, and Saul Steinberg, to name only a few of the twenty-four artists who provided original graphic work for this issue. The August 1982 installment of *Derrière le miroir* was published in two versions: a deluxe edition of 150 on Arches paper, with an unspecified number *hors commerce*, and a second version on smooth-wove paper for the regular issue of the publication.

Lotus 1982

One-color transfer lithograph, printed in black
15 x 11 (38.0 x 28.0)

Printed by Imprimerie Moderne du Lion, Paris; published by Maeght Editeur, Paris
 The deluxe edition is stamped on the inside cover with the number and the edition; individual prints are unsigned and unnumbered. *Lotus* was based on the ink drawing *Lotus* (EK#P74.65).

lc

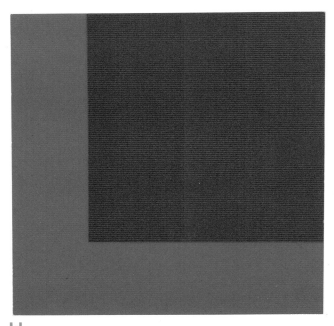

Id

Untitled 1966
for the exhibition catalogue
Vormen van de Kleur / New Shapes of Color

Two-color screenprint, printed in red and blue on smooth-wove card stock

10½ x 10½ (26.7 x 26.7)

Edition: 2,200

Printed on verso: *Tentoonstelling Vormen van de Kleur, New Shapes of Color / Stedelijk Museum, Amsterdam, 19 november 1966 t/m 15 januari 1967 / Reeks van 4 zeefdrukken bij de katalogus, oplage 2200 exemplaren / 1. Bonies* [effaced] *Ellsworth Kelly*

Printed by Stadsdrukkerij van Amsterdam; published by the Stedelijk Museum, Amsterdam, for the exhibition catalogue *Vormen van de Kleur / New Shapes of Color*, 20 November 1966–15 January 1967

Comments: The catalogue included four screenprints, by Kelly, Bonies, Georg-Karl Pfahler, and William Turnbull, all printed in variations of blue and red. E. de Wilde wrote in the preface to the catalogue: "It was through the spontaneous cooperation of Kelly, Pfahler, Turnbull and Bonies, whose silkscreens for the catalogue were especially designed for this exhibition, that we were able to enhance the value of this catalogue." Kelly's imagery was invented specifically for this project as well. *Untitled* is a color variation of the 1967 painting *Green White* (EK#381).

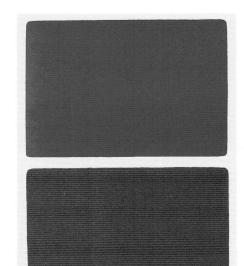

Ie

Untitled 1966
for the exhibition catalogue
Gravures Maeght Editeur

In 1966 the Redfern Gallery, London, invited Kelly to participate in an exhibition honoring Aimé Maeght as a print publisher. In conjunction with the exhibition the gallery published a limited-edition catalogue, *Gravures Maeght Editeur*, with an essay by John Russell; the catalogue included original graphic work by selected artists from the Imprimerie Maeght. In the fall of 1966 Kelly sent his collage to the Maeght workshop in Paris for proofing. Along with color lithographs by Joan Miró, Alexander Calder, Raoul Ubac, Pierre Tal-Coat, Eduardo Chillida, Saul Steinberg, and Marc Chagall, edition printing was completed by 22 November 1966. The corresponding exhibition was held at the Redfern Gallery, London, from 29 November 1966 to 7 January 1967.

Two-color lithograph from photo plates, printed in blue and red on Chiffon de Mandeure paper

10 x 7 (25.4 x 18.0)

Edition: 500

Printed by Atelier Arte; published by Maeght Editeur and the Redfern Gallery, London

Comments: The imagery was invented specifically for this project.

ELLSWORTH KELLY

If

Untitled 1972
cover for Eugene C. Goossen, *Ellsworth Kelly*

In 1972 Kelly provided a collage for the cover of Eugene C. Goossen's monograph, *Ellsworth Kelly*, the catalogue of the artist's first major retrospective at the Museum of Modern Art, New York. The image is related to *Black Curve I* (cat. no. 100) in the First Curve Series. It is dated 1972, and the monograph was published the following year.

One-color offset lithograph from photo plate, printed in black

11¼ x 9¼ (28.7 x 23.5)

Edition size unknown

Printed by Eastern Press, New Haven, Connecticut; published by the Museum of Modern Art, New York

II POSTERS

Throughout his career, Kelly has participated in the design of posters announcing exhibitions of his work or to benefit nonprofit organizations. The works in the following section include posters for which Kelly participated in the design and/or production.

Kelly peintures & reliefs, Galerie Arnaud 1951

Two-color linoleum cut, printed in black and yellow

21⅝ x 17½ (55.0 x 44.5)

Edition size unknown

In block: *KELLY/PEINTURES & RELIEFS/DU 26 AVRIL AU 9 MAI 1951/GALERIE ARNAUD/34, RUE DU FOUR PARIS (6e) LIT 40–26. Presentation du Francois DI DIO Impr. LA BELLE EDITIONS 5, du Sequier. PARIS (6e)*

Printed by François DiDio, La Belle Editions, Paris; published by the artist on the occasion of Kelly's first one-man exhibition in Paris, at the Galerie Arnaud, *Kelly Peintures & reliefs*, 26 April–9 May 1951

Comments: The poster's imagery was developed specifically for this project and for an exhibition invitation.

Ellsworth Kelly Galerie Maeght 1958

Two-color lithograph from photo plates, printed in black and red-orange

25½ x 19½ (65.0 x 49.5)

Edition size unknown

In plate: *ELLSWORTH KELLY/GALERIE MAEGHT/Arte Paris*

Printed by Imprimerie Arte, Paris; published by Maeght Editeur, Paris, on the occasion of Kelly's first one-man exhibition at the Galerie Maeght, Paris, 24 October– 30 November 1958

An unidentified number were signed by the artist

Comments: The image is related to the painting *West Side*, 1957 (EK#124), and derived from two collages of 1958 (EK#58.100 and EK#58.48).

Kelly Galerie Maeght 1964

Two-color lithograph from photo plates, printed in red-orange and green

26 x 20 (66.0 x 50.7)

Edition size unknown

In plate: *GALERIE MAEGHT/KELLY/MAEGHT EDITEUR IMPRIMEUR*

Printed and published by Maeght Editeur, Paris, on the occasion of the artist's second one-man exhibition at the Galerie Maeght, Paris, 20 November–31 December 1964

Comments: The imagery is related to the painting *Green Red*, 1964 (EK#331).

Kelly Lithographies Galerie Adrien Maeght 1965

Two-color lithograph from photo plates, printed in blue and yellow

26¼ x 20 (66.5 x 50.7)

Edition size unknown

In plate: *KELLY/lithographies/GALERIE ADRIEN MAEGHT/ IMPRIMERIE ARTE PARIS*

Printed by Imprimerie Arte, Paris; published by Galerie Adrien Maeght, Paris, on the occasion of the first exhibition of Kelly's prints, *Kelly: 27 lithographies*, June 1965

Comments: The poster's imagery is derived from the print *Blue with Yellow* (cat. no. 31).

IIa

IIb

IIc

IId

lle

Vivian Beaumont Theater, Lincoln Center 1965

Four-color offset lithograph from photo plates, printed in blue, yellow, red, and green

Deluxe edition:

41¾ x 26 (106.0 x 66.0)

Edition: 100

Signed and numbered

Commercial edition:

45½ x 30 (115.5 x 76.2)

Edition size unknown

In plate: *Commissioned by Lincoln Center for The Performing Arts List Art Poster Program of the AFA. VIVIAN BEAUMONT THEATER/ LINCOLN CENTER 1965*

Printed by the Pratt Graphic Art Center, New York; published by the Albert A. List Foundation Commission to raise money for the Vivian Beaumont Theater, New York

Comments: Along with Frank Stella and other contemporary artists, Ellsworth Kelly participated in the List Art Poster Program, in which artists provided graphic work for posters whose sale benefited programs and events at the Lincoln Center, New York. This poster was issued to raise funds for the Vivian Beaumont Theater of the Lincoln Center. Its imagery was invented specifically for this project.

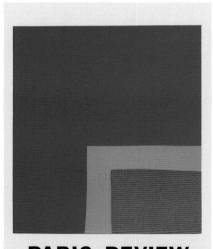

llf

The Paris Review 1968

In 1965 *The Paris Review* initiated a program to raise money for the periodical by issuing posters by acclaimed contemporary artists. By 1969 over thirty-four artists had participated in the program, including Jim Dine, Helen Frankenthaler, Roy Lichtenstein, Robert Motherwell, Claes Oldenburg, James Rosenquist, Robert Rauschenberg, Andy Warhol, and Ellsworth Kelly.

Three-color screenprint in blue, green, and red

40 x 26 (101.6 x 66.0)

Edition: 150

Signed, lower right: *Kelly*; numbered, lower left

Printed by Chiron Press, New York; published by *The Paris Review*

Comments: The imagery was invented specifically for this project.

llg

The Art of the Real: USA 1948–1968 The Museum of Modern Art 1968

Three-color offset lithograph, printed in blue, yellow, and red

53¼ x 23¼ (135.2 x 59.0)

Edition size unknown

Signed in plate, upper right: *Kelly*; in plate, twice: *THE ART OF THE REAL: USA 1948–1968 THE MUSEUM OF MODERN ART, NEW YORK JULY 3–SEPT. 8, 1968*

Printed by Colorcraft, New York; published by the Museum of Modern Art, New York, on the occasion of the exhibition *The Art of the Real: USA 1948–1968*, 3 July–8 September 1968

Comments: The imagery is based on the painting *Blue Yellow Red*, 1968 (EK#406)

L'Art vivant aux Etats-Unis, Fondation Maeght 1970

Two-color lithograph from photo plates, printed in red and blue

28½ x 19¾ (72.5 x 50.3)

Edition size unknown

In plate: *FONDATION/MAEGHT/06 Saint-Paul/l'art/vivant/ aux/Etats-Unis/18 juillet–30 septembre 1970/Maeght Editeur —Imprimerie Arte*

Printed by Imprimerie Arte; published by Maeght Editeur on the occasion of an exhibition at the Fondation Maeght, Saint-Paul de Vence, 18 July–30 September 1970

Comments: The poster's imagery was invented specifically for this project.

Ellsworth Kelly Galerie Denise René Hans Mayer Düsseldorf 1972

Two-color offset lithograph from photo plates, printed in yellow and red-orange

33 x 23½ (83.8 x 59.6)

Edition size unknown

In plate: *vom 1.Juli bis 31.Juli 1972/Ellsworth Kelly/Galerie/ Denise René Hans Mayer/4000 Düsseldorf/Grabbeplatz 2*

Published by Galerie Denise René and Hans Mayer, Düsseldorf, on the occasion of a one-man exhibition, 1–31 July 1972

Comments: The imagery is based on the painting *Red Yellow* 1970 (EK#450).

Ellsworth Kelly Albright-Knox Art Gallery 1972

Two-color offset lithograph from photo plates, printed in blue and yellow

33½ x 24 (85.0 x 61.0)

Edition size unknown

In plate: *ELLSWORTH KELLY/Albright-Knox Art Gallery July 11–Aug. 27, 1972/POSTER COPYRIGHT 1972 ELLSWORTH KELLY*

Published by the Albright-Knox Art Gallery, on the occasion of the exhibition *The Chatham Series: Paintings by Ellsworth Kelly*, 11 July–27 August 1972

Comments: The poster's image is based on the painting *Blue Yellow (Chatham XI, 1971)*, 1971 (EK#462).

Ellsworth Kelly Recent Paintings and Sculptures Metropolitan Museum of Art 1979

Two-color offset lithograph from photo plates, printed in gray and black

38¾ x 24½ (98.4 x 62.2)

Edition size unknown

In plate: *©The Metropolitan Museum of Art/ELLSWORTH KELLY/Recent Paintings and Sculptures/THE METROPOLITAN MUSEUM OF ART, NEW YORK/April 26 to June 24, 1979*

Published by the Metropolitan Museum of Art, on the occasion of the exhibition *Ellsworth Kelly Recent Paintings and Sculptures*, 26 April–24 June 1979

Comments: The imagery is based on the painting *Diagonal with Curve III*, 1978 (EK#564).

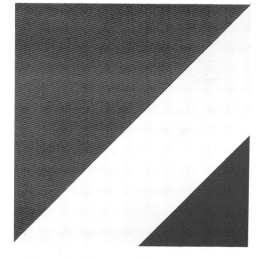

Fondation Maeght
06 Saint-Paul

l'art vivant aux Etats-Unis
18 juillet - 30 septembre 1970

IIh

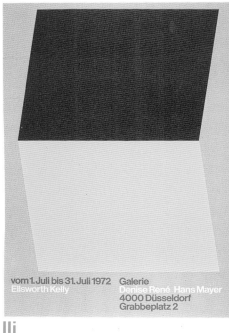

vom 1.Juli bis 31.Juli 1972
Ellsworth Kelly

Galerie
Denise René Hans Mayer
4000 Düsseldorf
Grabbeplatz 2

IIi

ELLSWORTH KELLY
Albright-Knox Art Gallery · July 11 - Aug. 27, 1972

IIj

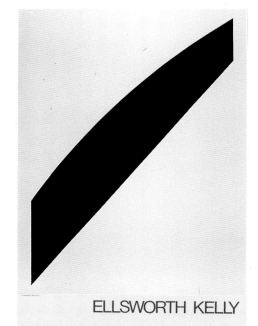

ELLSWORTH KELLY

Recent Paintings and Sculptures
THE METROPOLITAN MUSEUM OF ART, NEW YORK
April 26 to June 24, 1979

IIk

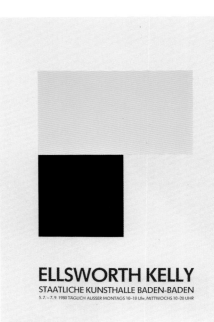

Ellsworth Kelly Staatliche Kunsthalle Baden-Baden 1980

Two-color offset lithograph from photo plates, printed in black and yellow

33 x 23¼ (83.7 x 59.0)

Edition size unknown

In plate: *ELLSWORTH KELLY/STAATLICHE KUNSTHALLE BADEN-BADEN/5.7.–7.9.1980 TAGLICH AUSSER MONTAGS 10–18 Uhr, MITTWOCHS 10–20 UHR*

Published by the Staatliche Kunsthalle, Baden-Baden, on the occasion of the exhibition *Ellsworth Kelly Painting and Sculpture 1966–1979*, 5 July–7 September 1980

Comments: The imagery is based on the painting *Yellow Black (Chatham XII, 1971)*, 1971 (EK#463).

IIl

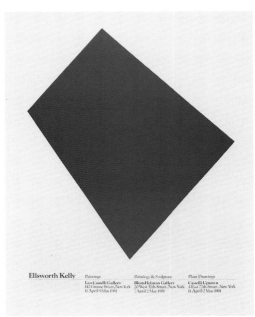

Ellsworth Kelly Paintings/Paintings and Sculpture/Plant Drawings 1981

One-color offset lithograph from photo plate, printed in blue

36 x 27¾ (91.4 x 70.5)

Edition size unknown

In plate: *Ellsworth Kelly Paintings Paintings & Sculpture Plant Drawings/Leo Castelli Gallery/142 Greene Street, New York/11 April–9 May 1981/BlumHelman Gallery/20 West 57th Street, New York/7 April–2 May 1981/Castelli Uptown/4 East 77th Street, New York/11 April–2 May 1981; Copyright © Ellsworth Kelly, 1980 Photo: Bevan Davies Design Richard Haynes*

Published by Castelli Uptown, New York

Comments: The poster reproduces the painting *Blue Panel*, 1980 (EK#608).

IIm

Ellsworth Kelly: Sculpture Whitney Museum of American Art 1982

One-color offset lithograph from photo plate, printed in red

43¼ x 36 (109.8 x 91.4)

Edition size unknown

In plate: *ELLSWORTH KELLY: SCULPTURE/WHITNEY MUSEUM OF AMERICAN ART DECEMBER 17, 1982–FEBRUARY 27, 1983/THIS EXHIBITION IS SUPPORTED BY GRANTS FROM INTERNATIONAL TELEPHONE AND TELEGRAPH AND THE NATIONAL ENDOWMENT FOR THE ARTS/©1982 WHITNEY MUSEUM OF AMERICAN ART*

Published by the Whitney Museum of American Art, on the occasion of the exhibition *Ellsworth Kelly: Sculpture*, 17 December 1982–27 February 1983

Comments: The poster's imagery is related to the sculpture *Curve XXXIII*, 1982 (EK#S674; Sims and Pulitzer 1982, 181, no. 135).

IIn

Ellsworth Kelly Paintings 1951–1956

1956

One-color offset lithograph from photo plate, printed in black

15¾ x 9 (40.0 x 22.9)

Edition size unknown

In plate: *Ellsworth Kelly, paintings 1951–1956/Preview May 21, 4 to 7 thru June 8/Betty Parsons Gallery 15 E 57 N. Y.*

Printed for the Betty Parsons Gallery on the occasion of Kelly's first one-man show at the Betty Parsons Gallery, New York, 21 May–8 June 1956

Comments: The image reproduced is based on the painting *South Ferry*, 1956 (EK#88; Sims and Pulitzer 1982, 73, fig. 38).

Ellsworth Kelly Betty Parsons Gallery

1957

One-color offset lithograph from photo plate, printed in blue

15½ x 14 (39.3 x 35.5)

Edition size unknown

In plate: *ELLSWORTH KELLY/Betty Parsons Gallery 15 E. 57 N.Y. Sept. 23–Oct. 12, 1957*

Printed for the Betty Parsons Gallery, New York, on the occasion of a one-man exhibition, 23 September–12 October 1957

Comments: The imagery is based on the painting *Palm*, 1957 (EK#116). An ink and collage study for this announcement is reproduced in Sims and Pulitzer 1982, 69, fig. 35.

Exposition des peintures de Ellsworth Kelly, Galerie Maeght 1958

Three-color lithograph from photo plates, printed in blue, red, and black on smooth card stock

Edition size unknown

3½ x 7¼ (8.9 x 18.5), closed

Front: Printed in blue and black

Back: Printed in red and black

In plate: *GALERIE MAEGHT 13, RUE DE TEHERAN, PARIS-8e/VOUS ETES PRIE D'HONORER DE/VOTRE PRESENCE LE VERNISSAGE/DE L'EXPOSITION DES PEINTURES DE/ELLSWORTH/KELLY/LE VENDREDI 24 OCTOBRE 1958, A 17 HEURES*

Printed for the Galerie Maeght, Paris, on the occasion of Kelly's first exhibition there in 1958

Ellsworth Kelly Painting and Sculpture Betty Parsons Gallery 1959

One-color offset lithograph from photo plate, printed in black

15½ x 10¾ (39.4 x 27.3)

Edition size unknown

In plate: *ELLSWORTH KELLY/PAINTING AND SCULPTURE BETTY PARSONS GALLERY 15 EAST 57TH STREET, NEW YORK OCT. 19–NOV. 7, 1959*

Printed for Betty Parsons Gallery, New York, on the occasion of a one-man exhibition, 19 October–7 November 1959

Comments: The imagery reproduced is based on the painting *Running White*, 1959 (EK#230).

Ellsworth Kelly, paintings 1951-1956
Preview May 21, 4 to 7. thru June 8
Betty Parsons Gallery 15 E 57 N.Y.

IIIa

ELLSWORTH KELLY
Betty Parsons Gallery 15 E. 57 N.Y. Sept. 23–Oct. 12, 1957

IIIb

IIIc

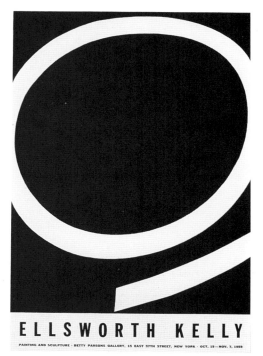

ELLSWORTH KELLY
PAINTING AND SCULPTURE · BETTY PARSONS GALLERY, 15 EAST 57TH STREET, NEW YORK · OCT. 19–NOV. 7, 1959

IIId

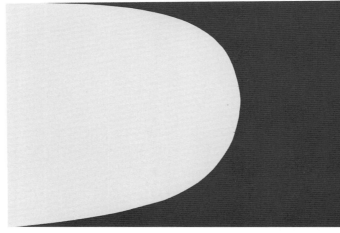

IIIe

Paintings by Ellsworth Kelly 1962

One-color offset lithograph from photo plate, printed in blue

4⅛ x 5¾ (10.5 x 14.7), closed

Edition size unknown

In plate: *Arthur Tooth and Sons Ltd., 31 Burton Street, London W1/Paintings by Ellsworth Kelly/May 29, 1962–June 23, 1962*

Printed for Arthur Tooth and Sons, Ltd., on the occasion of Kelly's first one-man exhibition in London

Comments: The imagery was invented specifically for this project.

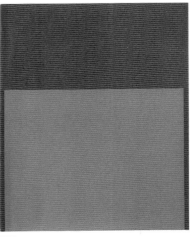

IIIf

Oeuvres récentes de Ellsworth Kelly
1964

Three-color lithograph from photo plates, printed in blue, green, and red on smooth card stock

5¾ x 4¾ (14.7 x 12.0), closed

Edition size unknown

Front: Printed in green and red

Back: Printed in blue and red

In plate: *Vous êtes prié d'honorer/de votre présence le vernissage/des oeuvres récentes de/Ellsworth/KELLY/Prix Carnegie 1964/qui aura lieu le vendredi /20 novembre 1964 à 17 heures/GALERIE MAEGHT/13 rue de Téhéran Paris 8ᵉ*

Printed for Galerie Maeght on the occasion of a one-man exhibition, 20 November–31 December 1964. The front of the invitation was based on the painting *Green Red*, 1964 (EK#331). The back was based on the painting *Blue Red*, 1964 (EK#330).

Wine Labels

In the early 1980s Douglas Cramer, a Hollywood producer and art collector, invited Kelly to design a series of wine labels for his privately bottled vintage wine, produced in the Santa Ynez Valley under the name of Douglas Vineyards. For the two drawings Kelly appropriately chose Cabernet Sauvignon and Chardonnay grape leaves. The drawings were made specifically for this project. Drawn in the tradition of Kelly's plant lithographs and drawings, the Cabernet Sauvignon and Chardonnay grape-leaf designs are related in the print oeuvre to *Grape Leaves I–III* (cat. nos. 94–96) and to *Wild Grape Leaf* (cat. no. 191). Kelly also made pencil drawings for Cramer, yet to be reproduced for wine labels, of a *Johannesburg Riesling* leaf (EK#P3.82) and a *Sauvignon Blanc* leaf (EK#P5.82).

g1. Cabernet Sauvignon, 1981, 1982, 1983

Commercial offset lithograph, printed in black and red-orange on Simpson Estate paper

4¾ x 3⅞ (12.0 x 10.0)

Editions: 3,300 (1981), printed April 1983
3,300 (1982), printed February 1984
2,500 (1983), printed May 1985

Printed by the Blake Printery, San Luis Obispo, California

Comments: For the 1982 and 1983 labels a thin line border was added and the gray underprinting beneath the leaf and lettering of the 1981 label was omitted. The label reproduces the 1982 pencil drawing *Cabernet Sauvignon* (EK#P2.82).

g2. Chardonnay, 1982, 1983, 1984

Commercial offset lithograph, printed in black and chartreuse on Simpson Estate paper

4¾ x 3⅞ (12.0 x 10.0)

Editions: 3,300 (1982), printed April 1983
4,500 (1983), printed February 1984
3,500 (1984), printed May 1985

Printed by the Blake Printery, San Luis Obispo, California

Comments: For the 1983 and 1984 labels a thin line border was added and the gray underprinting beneath the leaf and lettering of the 1982 label was omitted. The label reproduces the 1982 pencil drawing *Chardonnay* (EK#P4.82).

IIIg

CHRONOLOGY

For additional biographical information, see works listed in the Bibliography under "Monographs," especially Goossen 1973, Rose and Kelly 1979, and Sims and Pulitzer 1982. An asterisk following an exhibition citation indicates the publication of a catalogue.

1923

May 31 Born in Newburgh, New York, to Allan Howe Kelly and Florence Githens Kelly. Family soon moves to Pittsburgh, Pennsylvania.

1929

Kelly and his family move to Oradell, New Jersey.

1935

At Oradell Elementary School, produces first sculptures and watercolors through the special encouragement of manual-training and sixth-grade teachers Mr. and Mrs. Edward Opsut.

1937–38

At Oradell Junior High School, produces linoleum-cut designs for the covers of four issues of the school magazine *Chirp*. Kelly's first prints include images of Thanksgiving, Abraham Lincoln and George Washington, a daffodil, and the school's cupola.

1941–42

Art student at the Pratt Institute, Brooklyn, New York. Studies with Maitland Graves.

1943

January Drafted into army; requests assignment to the 603rd Engineers Camouflage Battalion, composed mainly of artists from New York and Philadelphia; primary job is preparing silkscreen posters.

1944

May Army unit leaves for Europe; tours of duty in England, France, and Germany; sketches landscape and architecture.

1945

Summer 603rd Battalion shipped back to United States; receives discharge.

1946–47

Student, School of the Museum of Fine Arts, Boston. Studies drawing with Ture Bengtz and painting with Karl Zerbe.

1948

October Returns to France; trip to Colmar to see Grünewald's Isenheim Altarpiece; enrolls at an atelier affiliated with the Ecole des Beaux-Arts in Paris and makes extensive visits to museums there; meets Jack Youngerman.

1949

Residence in Paris, at the Hôtel de Bourgogne, rue Saint-Louis-en-l'Ile.

Spring Travels to Romanesque sites at Tavant, Saint-Savin, and Poitiers; visits Mont-Saint-Michel and Chartres: "My line of influence has been the 'structure' of the things I liked: French Romanesque architecture, Byzantine, Egyptian, and Oriental art" (Rose and Kelly 1979, 32).

Summer Does first automatic drawings; visits Alice B. Toklas and sees Gertrude Stein's art collection; spends several weeks drawing at Belle-Ile-en-Mer; visits Bordruant, Belle-Ile, on the Brittany coast, with Ralph Colburn.

October Returns to Ecole des Beaux-Arts atelier; remains until the end of the year.

Fall First print, *Untitled* (cat. no. 1), done on printing presses of the Ecole des Beaux-Arts; completed and published by the artist.

1950

Winter Meets Jean Arp, who invites Kelly to his studio in Meudon; visits studios of Constantin Brancusi and the De Stijl artist George Vantongerloo; meets Francis Picabia. "I admired and felt the anonymous structure of the work of Brancusi, Vantongerloo, Arp, and [Sophie] Taeuber-Arp, whose studios I visited. Their work reinforced my own ideas for the creation of a pre-Renaissance, European-type art: its anonymous stonework, the object quality of the artifacts, the fact that the work was more important than the artist's personality" (Rose and Kelly 1979, 32); produces first shaped panel, *Window V* (EK#S10; Sims and Pulitzer 1982, no. 7).

Spring Work first shown in Europe, at *Premier Salon des Jeunes Peintres*, Galerie des Beaux-Arts, Paris; makes first collages.

Summer Spends summer at Villa La Combe, near Meschers.

Fall Teaches art to children at American School of Paris.

1951

Leaves his job at the American School of Paris.

26 April–9 May First one-man exhibition of paintings at the Galerie Arnaud, Paris: *Kelly peintures & reliefs*; poster for exhibition designed and published by the artist (App. IIa).

Summer At Villa La Combe, near Meschers.

October Paintings included in *Tendance*, group exhibition at Galerie Maeght, Paris; meets the Swiss textile manufacturer and collector Gustav Zumsteg, who invites Kelly to submit fabric designs. Kelly makes a trip to Zurich to work on the project.

Winter Moves to Sanary, on the Riviera; visits Bandol, near Toulon in Provence, and Le Corbusier's apartment house, Habitation, still under construction; makes first multiple solid panel paintings, *Colors for a Large Wall* (EK#46).

1952

May Leaves Sanary for Torcy, a town on the river Marne, east of Paris.

September Visits Claude Monet's house at Giverny.

1953

Summer Meets Alexander Calder.

July Visits Braunwald, Switzerland.

October Visits Amden, Switzerland.

Christmas Trip to Holland, where he sees Solomon Slijpor's Mondrian collection: "Contrary to what has been said about me, Mondrian and Matisse did not interest me when I was in Paris. Mondrians could not be seen in Paris and when I did see them in Holland in 1953, I thought their structure too rigid and intellectual" (Rose and Kelly 1979, 34).

1954

July Returns to the United States and sets up studio on Broad Street in lower Manhattan, New York.

1956

Receives commission to design sculptural screens for Transportation Building, Penn Center, Philadelphia; begins paintings with biomorphic shapes.

21 May–8 June After joining Betty Parsons Gallery, has first one-man exhibition in the United States there, for which Kelly designs an invitation (App. IIIa); moves to loft at 3–5 Coenties Slip, where he remains for seven years. His neighbors include Fred Mitchell, Jack Youngerman, Edgar Negret, Robert Indiana, Agnes Martin, Lenore Tawney, Larry Poons, and James Rosenquist.

1957

27 February–14 April Invited to participate in *Young America 1957*, group exhibition at the Whitney Museum of American Art, New York. First museum purchase: *Atlantic*, 1956, Whitney Museum.

23 September–12 October Exhibition at Betty Parsons Gallery, New York, for which Kelly designs an invitation (App. IIIb).

1958

September–October In New York, completes collages for October–November issue of Maeght publication, *Derrière le miroir* (App. Ia), catalogue of first one-man exhibition at the Galerie Maeght, Paris.

24 October–30 November First one-man exhibition at the Galerie Maeght, Paris; designs poster (App. IIb) and invitation (App. IIIc) for the exhibition.

5 December–8 February 1959 Participated in *The 1958 Pittsburgh International Exhibition of Contemporary Painting and Sculpture*, Carnegie Institute, Pittsburgh.*

1959

Produces first painted aluminum sculptures.

19 October–7 November One-man exhibition at Betty Parsons Gallery, New York, for which Kelly designs invitation (App. IIId).

16 December–14 February 1960 Paintings included in *Sixteen Americans* exhibition, Museum of Modern Art, New York.*

1961

27 October–7 January 1962 Receives Fourth Painting Prize, *The 1961 Pittsburgh International Exhibition of Contemporary Painting and Sculpture*, Carnegie Institute, Pittsburgh.*

1962

29 May–23 June *Paintings by Ellsworth Kelly*, first London exhibition, at Arthur Tooth and Sons Ltd.; Kelly designs invitation for the exhibition (App. IIIe).

1963

Moves to an apartment at the Hotel des Artistes, New York.

29 October–23 November *Kelly: Painting and Sculpture*, traveling exhibition organized by Betty Parsons Gallery, last show with Betty Parsons.

11 December–26 January 1964 *Painting, Sculpture and Drawings by Ellsworth Kelly*, first one-man museum exhibition in the United States, Gallery of Modern Art, Washington, D.C.*

1964

Winter Works on collage for *Red/Blue* (cat. no. 2).

March Visits Tatyana Grosman at Universal Limited Art Editions, on Long Island, to discuss the possibility of collaboration on a print project.

23 April–7 June Paintings selected for inclusion in *Post-Painterly Abstraction*, traveling exhibition organized by Clement Greenberg; opens Los Angeles County Museum of Art.*

September–October In New York, works on collages for November issue of *Derrière le miroir* (App. Ib), catalogue of one-man show at Galerie Maeght, Paris.

29 October Sails for Paris on *La France*; travels with Dale McConathy and David McCorkle.

30 October–10 January 1965 Awarded Painting Prize, *The 1964 Pittsburgh International Exhibition of Contemporary Painting and Sculpture*, Carnegie Institute, Pittsburgh.*

20 November–31 December *Oeuvres récentes de Ellsworth Kelly*, one-man painting exhibition at Galerie Maeght, Paris, for which Kelly designs a poster (App. IIc) and an invitation (App. IIIf).

Mid-November Begins Suite of Twenty-Seven Color Lithographs (cat. nos. 4–30) with Marcel Durassier at Imprimerie Maeght, in Levallois-Perret, a suburb northwest of Paris.

Late November Draws *David* (cat. no. 3).

December *David* completed, published by the artist. Second and third weeks: works on Suite of Twenty-Seven Color Lithographs (cat. nos. 4–30); begins Suite of Plant Lithographs (cat. nos. 32–59) in Paris; before Christmas, does drawings for the Cyclamen prints (cat. nos. 36–40) at an *orangerie* outside of Paris; spends Christmas holidays at the Maeght residence at Saint-Paul-de-Vence; after Christmas, completes studies for *Leaves*, *Grapefruit*, *Tangerine*, and *Lemon* (cat. nos. 32–35) and Camellia prints (cat. nos. 41–43) at Saint-Paul-de-Vence; completes sketches and transfer-paper drawings for the first twelve prints in the Suite of Plant Lithographs (cat. nos. 32–43) before returning to New York in January.

December 15 *Red/Blue* (cat. no. 2), in the portfolio *Ten Works x Ten Painters*, published by Wadsworth Atheneum, Hartford, Connecticut.

1965

January Returns to Paris; at Levallois-Perret, proofs Suite of Twenty-Seven Color Lithographs and first twelve prints of the Suite of Plant Lithographs (cat. nos. 32–43), from transfer drawings made in Paris and the south of France in December; returns to New York.

Winter Suite of Twenty-Seven Color Lithographs (cat. nos. 4–30) and first twelve prints in the Suite of Plant Lithographs (cat. nos. 32–43) signed and published by Maeght Editeur. Joins Sidney Janis Gallery, New York; designs poster for Vivian Beaumont Theater, Lincoln Center (App. IIe), published by the Albert A. List Foundation Commission.

9 March–5 April Suite of Twenty-Seven Color Lithographs (cat. nos. 4–30) included in *An Exhibition of Recent Lithography Executed in France by the Artist Ellsworth Kelly*, shown at the Ferus Gallery, Los Angeles.

May Makes collage for *Blue with Yellow* (cat. no. 31) and the poster announcing the forthcoming exhibition of the Suite of Twenty-Seven Color Lithographs at the Galerie Maeght, Paris (App. IId). Travels to Paris; spends summer in France, Italy, and Switzerland; visits Romanesque sites.

June *Blue with Yellow* (cat. no. 31) published by Maeght Editeur, Paris, to coincide with exhibition *Ellsworth Kelly Lithographs* at the Galerie Adrien Maeght; exhibition includes Suite of Twenty-Seven Color Lithographs (cat. nos. 4–30) and first twelve prints in the Series of Plant Lithographs (cat. nos. 32–43); Kelly designs poster for the exhibition (App. IId), published by Galerie Adrien Maeght.

29 June–7 July Travels in northern France, Brittany, Belle-Ile; original study and transfer drawing for *Seaweed* (cat. no. 53) drawn in Brittany.

July–late August Travels to southern France: the Cévinnes, La Salle, near Nîmes (Maeght farm Le Grand Bois), Juan-les-Pins, Saint-Paul-de-Vence. Takes transfer paper on travels to continue plant drawings; does original studies and transfer drawings for pear and string bean prints (cat. nos. 45–50) and *Melon Leaf*, *Fig Branch*, and *Locust* (cat. nos. 44, 51, 52) at Le Grand Bois.

August 22 Returns to New York with sketches and transfer-paper drawings for Plant Lithographs, to rework and continue drawings for the series.

18 October–19 November Selected prints from the Suite of Twenty-Seven Color Lithographs (cat. nos. 4–30) exhibited at Knoll International Gallery, Düsseldorf, *Ellsworth Kelly, Neue Lithographien*.

22 November–5 January 1966 A selection of early prints included in *Ellsworth Kelly, Neue Lithographien* exhibition at Galerie Ricke, Kassel, West Germany.

1966

Spring Resumes work on Series of Plant Lithographs in New York; reworks transfer drawings made in France during summer 1965; prepares transfer drawings of *Catalpa Leaf*, *Oranges*, *Magnolia*, and *Lemon Branch* (cat. nos. 54–57).

May 30 Leaves for Europe; takes transfer drawings for Suite of Plant Lithographs to Maeght for proofing.

June In Italy for Thirty-third Venice Biennale, in which his paintings are represented; returns to Paris; drawings for *Ailanthus Leaves* prints (cat. nos. 58, 59) done in Paris; remaining prints from the Suite of Plant Lithographs (cat. nos. 44–59) printed and signed at Imprimerie Arte, rue de Guerre, Paris, published by Maeght Editeur.

June 20 Returns to New York.

Fall Kelly designs collage for the print *Untitled* (App. Ie), included in the exhibition catalogue *Gravures Maeght Editeur*, with text by John Russell.

November Henry Persche becomes Kelly's assistant.

1–22 November *Black with White* (cat. no. 9), *Dark Blue with Red* (cat. no. 10), *Orange with Blue* (cat. no. 12), and *Orange with Green* (cat. no. 13) included in *The Responsive Eye*, traveling exhibition organized by the Museum of Modern Art, New York, opens Syracuse University, Syracuse, New York.*

20 November–15 January 1967 Provides design for *Untitled* screenprint (App. Id), included in the exhibition catalogue *Vormen van de Kleur/New Shapes of Color*, Amsterdam, Stedelijk Museum.*

29 November–7 January 1967 *Orange with Green* (cat. no. 13), *Blue over Green* (cat. no. 26), and *Kelly Galerie Maeght* poster (App. IIc) included in *Gravures Maeght Editeur* exhibition, the Redfern Gallery, London;* Kelly print, *Untitled* (App. Ie), published in the exhibition catalogue.

1967

Collaboration with Irwin Hollander on *Black Form* (cat. no. 60), for the portfolio *9*, published by Hollander Workshop, New York.

6 November–16 December *Cyclamen V* (cat. no. 40) and artist's proofs for *Blue and Orange* (cat. no. 8), *Green with Red* (cat. no. 11), and *Yellow over Yellow* (cat. no. 25), from the Suite of Twenty-Seven Color Lithographs, included in *Transatlantic Graphics 1960/67*, Camden Arts Centre, London.

7 November–December First twelve prints in Series of Plant Lithographs (cat. nos. 32–43) included in *A Suite of Twelve Lithographs by Ellsworth Kelly* exhibition at the Irving Blum Memorial Gallery, Los Angeles.

1968

Designs poster for *The Paris Review* (App. IIf), published by *The Paris Review*, New York; Kenneth Tyler, Stanley Grinstein, and Sidney Felsen write to Kelly, inviting him to make prints at Gemini G.E.L., Los Angeles.

14 January–11 February *Red over Yellow* (cat. no. 19) included in *Graphics '68: Recent American Prints*, University of Kentucky Art Gallery, Lexington, Kentucky.*

12 March–12 May Suite of Twenty-Seven Color Lithographs (cat. nos. 4–30) included in *Suites: Recent Prints*, Jewish Museum, New York.

3 July–8 September Designs poster (App. IIg) for exhibition *The Art of the Real: USA 1948–1968* at the Museum of Modern Art, New York, which includes selection of Kelly's paintings.*

13 October–17 November *Green* (cat. no. 7) included in *American Prints Today*, Munson-Williams-Proctor Institute Museum of Art, Utica, New York.

1969

May *Black* (cat. no. 4) and *Red-Orange* (cat. no. 6) included in *American Contemporary Prints: One*, traveling exhibition, organized by the American Museum in Britain, Calverton Manor, Bath.*

17 November–21 December *Orange with Blue* (cat. no. 12), *Yellow with Dark Blue* (cat. no. 15), *Melon Leaf* (cat. no. 44), and *Oranges* (cat. no. 55) included in *Graphics '69: Lithographs*, University of Kentucky Art Gallery, Lexington, Kentucky.*

1970

Begins *Blue/Yellow/Red* (cat. no. 91) for deluxe edition of John Coplans's monograph *Ellsworth Kelly*; does drawing for *Black Curve* (cat. no. 80).

January Begins first print project with Gemini G.E.L., Series of Ten Lithographs (cat. nos. 61–70); conceives projects for *Blue/White/Red* (cat. no. 74), *Blue/Red-Orange/Green* (cat. no. 75), *Black Green II* (cat. no. 77), *Green/Black* (cat. no. 78), *Black/Brown* (cat. no. 79), *Green/White* (cat. no. 81), *Blue/Red-Orange* (cat. no. 82), and *Black/Yellow* (cat. no. 83).

February Plate preparation and right-to-print proof for *Blue/White/Red* (cat. no. 74) completed at Gemini G.E.L.

March Moves to and renovates an old farmhouse in Spencertown, New York; rents as a studio an old theater in the nearby village of Chatham, New York.

May Plate preparation and right-to-print proof for *Green/Black* (cat. no. 78) completed at Gemini G.E.L.

June Begins *Red-Orange over Black* (cat. no. 71) at Gemini G.E.L.

18 July–30 September Exhibition *L'Art vivant aux Etats-Unis* at Fondation Maeght, Saint-Paul-de-Vence; Kelly designs the poster (App. IIh), published by Maeght Editeur.

August Plate preparation and right-to-print proof for *Blue/Red-Orange* (cat. no. 82) completed at Gemini G.E.L.; Series of Ten Lithographs (cat. nos. 61–70) and *Red-Orange over Black* (cat. no. 71) completed and signed at Gemini G.E.L.

September *Blue/White/Red* (cat. no. 74) and *Green/Black* (cat. no. 78) completed at Gemini G.E.L.

December Begins *Four Panels* (cat. no. 72) and *Blue, Yellow and Red Squares* (cat. no. 73) at Gemini G.E.L.

1971

Blue/Green/Black/Red (cat. no. 76) published by Paul Bianchini, New York, for deluxe edition of Diane Waldman's monograph, *Ellsworth Kelly: Drawings, Collages, Prints*.

Winter First of frequent trips to the island of Saint Martin in the Caribbean.

January At Gemini G.E.L., begins first embossed screenprints: *Two Whites and Black* (cat. no. 85), *Two Blacks and White* (cat. no. 86), and *White and Black* (cat. no. 87).

January Series of Ten Lithographs (cat. nos. 61–70) included in *Ellsworth Kelly: Performing Lithographs*, Fendrick Gallery, Washington, D.C.

6 February–7 March *Orange over Green* (cat. no. 27) included in *A New Consciousness: The Ciba-Geigy Collection*, Hudson River Museum, Yonkers, New York.*

March *Four Panels* (cat. no. 72) and *Blue, Yellow and Red Squares* (cat. no. 73) completed and published at Gemini G.E.L.

April Begins *Black Curve* (cat. no. 80) at Gemini G.E.L.

May Plate preparation and right-to-print proof for *Black/Green II* (cat. no. 77) completed at Gemini G.E.L.

5 May–6 July *Blue/Yellow/Red* (cat. no. 61), *Black/White/Black* (cat. no. 63), *Orange/Green* (cat. no. 64), *Blue/Green* (cat. no. 65), *Yellow/Red-Orange* (cat. no. 66), *Blue/Black* (cat. no. 67), *Yellow/Black* (cat. no. 69), *Yellow/Orange* (cat. no. 70), and *Four Panels* (cat. no. 72) included in *Technics and Creativity: Gemini G.E.L.*, Museum of Modern Art, New York.*

June *Blue/Red-Orange* (cat. no. 82) completed at Gemini G.E.L.

July Plate preparation and right-to-print proof for *Black/Brown* (cat. no. 79) completed at Gemini G.E.L.

August At Gemini G.E.L., *Black/Green II* (cat. no. 77) completed; plate preparation and right-to-print proof for first embossed lithograph, *Green/White* (cat. no. 81) completed.

28 August–28 November Five prints, including *Dark Blue and Red* (cat. no. 18), from the Suite of Twenty-Seven Color Lithographs, and *Black Form* (cat. no. 60) included in *Graphik der Welt: Internazionale Druckgraphik der letzten 25 Jahre*, Kunsthalle, Nürnberg.*

September Plate preparation and right-to-print proofs for *Blue/Red-Orange/Green* (cat. no. 75) and *Black/Yellow* (cat. no. 83) completed at Gemini G.E.L.

October *Black/Brown*, *Green/White*, and *Black/Yellow* (cat. nos. 79, 81, 83) completed at Gemini G.E.L.

8 October–21 November *Red-Orange/Yellow/Blue* (cat. no. 62), *Black/White/Black* (cat. no. 63), *Blue/Black* (cat. no. 67), *Black/Green* (cat. no. 68), *Yellow/Black* (cat. no. 69), *Blue/White/Red* (cat. no. 74), and *Blue/Red-Orange/Green* (cat. no. 75) included in *Experiment in Grafiek: Gemini G.E.L.*, Stedelijk van Abbemuseum, Eindhoven, Netherlands.*

November *Black Curve* (cat. no. 80) completed at Gemini G.E.L.

December *Blue/Red-Orange/Green* (cat. no. 75) completed and published at Gemini G.E.L.

1972

January Begins *Blue with Black II* (cat. no. 98); plate preparation and right-to-print proofs for *Two Whites and Black*, *Two Blacks and White*, and *White and Black* (cat. nos. 85–87) completed at Gemini G.E.L.

3 March–12 April The Suite of Twenty-Seven Color Lithographs (cat. nos. 4–30) included in *Ellsworth Kelly: Lithographies en couleur de 1964*, Galerie Ziegler, Geneva.

13 April–21 May *Camellia III* (cat. no. 43) included in *Detroit Collects Prints and Drawings*, Detroit Institute of Arts.*

June At Gemini G.E.L. *Two Blacks and White* and *White and Black* (cat. nos. 86 and 87) completed; begins *Blue with Black I* (cat. no. 97).

July *Two Whites and Black* (cat. no. 85) and *Blue with Black I* (cat. no. 97) completed at Gemini G.E.L.

1–31 July One-man exhibition at the Galerie Denise René and Hans Mayer, Düsseldorf; Kelly designs poster for exhibition (App. IIi).

11 July–27 August *The Chatham Series: Paintings by Ellsworth Kelly* exhibition at the Albright-Knox Art Gallery, Buffalo, New York, for which Kelly designs a poster (App. IIj).

October–November *Untitled* (cat. no. 84), in the portfolio *Prints for Phoenix House*, completed, signed, and published at Brooke Alexander Inc., New York.

22 November–4 February 1973 *Black/White/Black* (cat. no. 63) included in the *Eighteenth National Print Exhibition*, Brooklyn Museum, New York.*

1973

Produces first weathering steel sculptures.

Untitled (cat. no. 92) in the portfolio *Works by Artists in the New York Collection for Stockholm* published by Experiments in Art and Technology, New York; *Red/Blue* (cat. no. 2) included in *Blattkünste Internazionale Druckgraphik seit 1945*, Kaiser Wilhelm Museum, Krefeld.*

18 March–15 April Selected prints included in *Ellsworth Kelly: Drawings and Prints*, Margo Leavin Gallery, Los Angeles.

April At Gemini G.E.L., begins *Black and White Pyramid* (cat. no. 88), *White Bar with Black* (cat. no. 89), *Spectrum* (cat. no. 90), and first two prints in the First Curve Series —*White Curve I* (cat. no. 99) and *Black Curve I* (cat. no. 100); also begins Second Curve Series (cat. nos. 104–15) and Third Curve Series (cat. nos. 116–39).

5 April–6 May *Leaves* (cat. no. 32) included in *Selection III: Contemporary Graphics from the Museum's Collection*, Museum of Art, Rhode Island School of Design, Providence.*

7–28 April After joining the Leo Castelli Gallery, New York, has first one-man exhibition there: *Ellsworth Kelly: Curve Series*.

19 April–6 May *Yellow* (cat. no. 5) included in *Modern Art in Prints*, traveling exhibition organized by the International Council of the Museum of Modern Art, New York; opens at Art Gallery of Western Australia, Perth.*

May At Gemini G.E.L., *Black and White Pyramid* (cat. no. 88), *White Bar with Black* (cat. no. 89), *Spectrum* (cat. no. 90), *White Curve I* (cat. no. 99), and *Black Curve I* (cat. no. 100) completed and signed.

June Begins Leaves series (cat. nos. 93–96) at Gemini G.E.L.; *Peach Branch* (cat. no. 93) completed.

July *Grape Leaves I* (cat. no. 94) completed at Gemini G.E.L.

12 September–4 November Retrospective exhibition at Museum of Modern Art, New York, *Ellsworth Kelly Retrospective*, travels to Pasadena Art Museum, California; Walker Art Center, Minneapolis; and Detroit Institute of Arts.*

Fall *Blue/Yellow/Red* (cat. no. 91) published by Harry N. Abrams, Inc., New York, to accompany the deluxe edition of John Coplans's book, *Ellsworth Kelly*.

October *Grape Leaves III* (cat. no. 96) completed at Gemini G.E.L.

November *Grape Leaves II* (cat. no. 95) completed at Gemini G.E.L.

1974

January At Gemini G.E.L. *Blue with Black II* (cat. no. 98) completed; begins *Green Curve with Radius of 20'* (cat. no. 101), *Large Black Curve* (cat. no. 102), and *Large Gray Curve* (cat. no. 103).

March *Green Curve with Radius of 20'* (cat. no. 101) completed and signed at Gemini G.E.L.

April Leaves series (cat. nos. 93–96) and *Blue with Black I* and *II* (cat. nos. 97, 98) published by Gemini G.E.L.; *Large Black Curve* and *Large Gray Curve* (cat. nos. 102, 103) completed, signed, and published at Gemini G.E.L.

August At Gemini G.E.L. signs *Green Curve with Radius of 20'* (cat. no. 101).

17 August–29 September *Green/Black* (cat. no. 78), *Black/Brown* (cat. no. 79), *Green/White* (cat. no. 81), *Blue/Red-Orange* (cat. no. 82), *Black/Yellow* (cat. no. 83), *Two Blacks and White* (cat. no. 86), *Spectrum* (cat. no. 90), *Blue with*

Black I (cat. no. 97), *Large Black Curve* (cat. no. 102), and *Large Gray Curve* (cat. no. 103) included in *Johns, Kelly, Lichtenstein, Motherwell, Nauman, Rauschenberg, Serra, Stella: Prints from Gemini G.E.L.*, Walker Art Center, Minneapolis.*

Fall *Green Curve with Radius of 20'* (cat. no. 101) published by the Committee to Endow a Chair in Honor of Meyer Schapiro at Columbia University, New York, in the portfolio *For Meyer Schapiro*.

1–6 October *Green Curve with Radius of 20'* (cat. no. 101) exhibited as part of portfolio *For Meyer Schapiro*, Metropolitan Museum of Art, New York.

4–29 October *Blue/Green* (cat. no. 65), *Blue, Yellow and Red Squares* (cat. no. 73), and *White Curve I* (cat. no. 99) included in *National Invitational: Prints II*, Anchorage Historical and Fine Arts Museum, Alaska.*

1975

February Second Curve Series (cat. nos. 104–15) completed, signed, and published at Gemini G.E.L.

September–October First one-man exhibition at the BlumHelman Gallery, New York.

30 September–23 November *Green Curve with Radius of 20'* (cat. no. 101) included in *For Meyer Schapiro* exhibition at Los Angeles County Museum of Art.

October All but one print—*Cluny* (cat. no. 129)—in the Third Curve Series completed and signed at Gemini G.E.L.

December *Cluny* (cat. no. 129) completed and signed at Gemini G.E.L.

1976

7 January–18 February *Red/Blue* (cat. no. 2) included in *Twentieth Century Master Prints*, traveling exhibition organized by the Walker Art Center, Minneapolis; opens Flint Institute of Arts, Michigan.

February Third Curve Series (cat. nos. 116–39) published by Gemini G.E.L.

March First collaboration with Tyler Graphics Ltd., Bedford, New York: begins *Colors on a Grid, Screenprint 1976* (cat. no. 140), *Nine Squares* (cat. no. 164), first collage print, *Saint Martin Landscape* (cat. no. 179), and first etching, *Wall* (cat. no. 177).

April Begins Colored Paper Images series (cat. nos. 141–63) with Tyler Graphics Ltd., at HMP Paper Mill, Woodstock, Connecticut.

September *Colors on a Grid, Screenprint 1976* (cat. no. 140) completed and published by Tyler Graphics Ltd.

November First twenty prints and two state prints in the Colored Paper Images series (cat. nos. 141–60) completed, signed, and published at Tyler Graphics Ltd.

20 November–30 January 1977 *Red-Orange/Yellow/Blue* (cat. no. 62) and *Yellow/Black* (cat. no. 69) selected for the Twentieth National Print Exhibition, included in *Thirty Years of American Printmaking, Including the Twentieth National Print Exhibition*, Brooklyn Museum, New York.*

1977

January At Tyler Graphics Ltd., completes and signs *Nine Squares* (cat. no. 164); begins *Dark Gray and White* (cat. no. 180).

7–29 January Selected prints from the Colored Paper Images series, including *Colored Paper Images III, XI*, and *XVII* (cat. nos. 143, 151, and 157), exhibited at Castelli Graphics, New York.

15 January–27 February Twenty-three prints from the Colored Paper Images series (cat. nos. 141–63) and *Nine Squares* (cat. no. 164) included in *Art off the Picture Press*, traveling exhibition organized by the Emily Lowe Gallery, Hofstra University, Hempstead, New York; opens Katonah Gallery, Katonah, New York.*

February *Colored Paper Image XXI* (cat. no. 161) and *Nine Colors* (cat. no. 163) completed with Tyler Graphics at HMP Paper Mill, Woodstock, Connecticut.

5–20 March Selected prints from the Colored Paper Images series (cat. nos. 141–63) included in *Ellsworth Kelly: Colored Paper Images*, Margo Leavin Gallery, Los Angeles.

April *Blue/Green/Yellow/Orange/Red* (cat. no. 162) and *Nine Squares* (cat. no. 164) published by Tyler Graphics Ltd.

May *Nine Colors* (cat. no. 163) published by Tyler Graphics Ltd.

4 June–15 August Nine prints (cat. nos. 61–69) from the Series of Ten Lithographs included in *Modern American Master Prints from the Collection of Kimiko and John Powers*, Denver Art Museum.

2 September–5 October *Colored Paper Images VII, IX, XI, XIII, XVI,* and *XIX* (cat. nos. 147, 149, 151, 153, 156, and 159) and *Blue/Green/Yellow/Orange/Red* (cat. no. 162) included in *Paper Forms: Hand-Made Paper Projects*, Hayden Gallery, Massachusetts Institute of Technology, Cambridge.*

10 September–4 December *Colored Paper Image XIX* (cat. no. 159) included in *Prints of the Seventies*, Museum of Fine Arts, Boston.*

November *Colored Paper Images III, VI, XIV,* and *XXI* (cat. nos. 143, 146, 154, and 161) included in *Selected Prints from the Collection of Kenneth E. Tyler, Tyler Graphics Ltd.*, Bedford Historical Society, Bedford, New York.

2 December–20 February 1978 *Colored Paper Image XII* (cat. no. 152) included in *New Ways with Paper*, National Collection of Fine Arts, Smithsonian Institution, Washington, D.C.*

8–21 December *Colored Paper Image IV* (cat. no. 144) included in *Artists Salute Skowhegan*, Kennedy Galleries, New York.*

1978

20 February–15 March *Colored Paper Images X* and *XXI* (cat. nos. 150 and 161) and *Blue/Green/Yellow/Orange/Red* (cat. no. 162) included in *Prints from the Tyler Graphics Workshop*, Ohio State University, Columbus, Ohio.

March Begins Twelve Leaves series (cat. nos. 165–76) and Series of Seven Lithographs (cat. nos. 181–87a) at Gemini G.E.L.

10 March–7 July *Colored Paper Image XII* (cat. no. 152) included in *Paper*, Dayton Art Institute, Ohio.

May At Gemini G.E.L., Twelve Leaves series (cat. nos. 165–76) completed and signed; all but two prints in the Series of Seven Lithographs—*Bandol* (cat. no. 187) and *Bandol (State)* (cat. no. 187a)—completed and signed.

June Twelve Leaves series (cat. nos. 165–76) published by Gemini G.E.L.

June–August *Colored Paper Image XII* (cat. no. 152) included in *Before Your Very Eyes: Color*, Danbury Public Library, Connecticut.

16 September–3 December *Spectrum* (cat. no. 90) included in *Prints of the High Museum: Image and Process*, High Museum of Art, Atlanta.*

17 September–22 October *Red-Orange over Black* (cat. no 71) and *Green Curve with Radius of 20'* (cat. no. 101) included in *Prints from the Guggenheim Museum Collection*, traveling exhibition circulated by the American Federation of Arts; opens Midland Art Center, Midland, Michigan.*

23 September–22 October *Colored Paper Image XVIII* (cat. no. 158) included in *Paper as Medium*, traveling exhibition organized by the Smithsonian Institution Traveling Exhibition Service; opens at Idaho State University, Pocatello, Idaho.*

1 December–30 January 1979 *Colored Paper Images II, III, IV, VI, VIII, XI, XIII, XVI, XVII,* and *XIX* (cat. nos. 142–44, 146, 148, 151, 153, 156, 157, and 159) included in *Paperworks by Ellsworth Kelly*, Museum of Modern Art, New York.

1979

January Begins *Woodland Plant* (cat. no. 178), *Daffodil, Sarsaparilla, Mulberry Leaf,* and *Wild Grape Leaf* (cat. nos. 188–91) at Tyler Graphics Ltd.; drawings for the series done in Spencertown, New York.

March *Woodland Plant* (cat. no. 178) completed and signed at Tyler Graphics Ltd.; *Colors for a Large Wall* (EK#589) installed at the Central Trust Company, Cincinnati.

26 April–24 June One-man exhibition, *Ellsworth Kelly: Recent Paintings and Sculpture*, Metropolitan Museum of Art, New York; Kelly designs poster for the exhibition (App. IIk).*

May *Wall* (cat. no. 177), *Woodland Plant* (cat. no. 178), *Saint Martin Landscape* (cat. no. 179), and *Dark Gray and White* (cat. no. 180) published by Tyler Graphics Ltd.; begins "*18 Colors (Cincinnati)*" (cat. no. 193) at Gemini G.E.L.

July–October *Colored Paper Images I* and *IV* (cat. nos. 141 and 144) included in *25 Años Despues*, at the Museo de Arte Moderno, Bogota, Colombia.

10 September–6 October *Seven Artists at Tyler Graphics Ltd.*, traveling exhibition organized by the Trisolini Gallery, Ohio University, Athens, includes *Colored Paper Images I, II,* and *IX* (cat. nos. 141, 142, and 149).*

October *Bandol* and *Bandol (State)* (cat. nos. 187, 187a) completed and signed at Gemini G.E.L.

4 October–November *Ellsworth Kelly, Lithographien* exhibition at Galerie Maeght, Zurich.

October 1979–1980 *Colored Paper Image VI* (cat. no. 146) included in *Print Publishing in America*, traveling exhibition organized by the USIA International Communications Agency; exhibition travels in Alexandria, Egypt, Tel Aviv, Paris, and Belgrade.

18 November–27 January 1980 *Red/Blue* (cat. no. 2) from the portfolio *Ten Works x Ten Painters* included in *Portfolios: In and Out of the 1960s*, Joe and Emily Lowe Art Gallery, Syracuse University.*

13 December–3 February 1980 Retrospective exhibition, *Ellsworth Kelly: Painting and Sculpture 1963–1979*, opens at the Stedelijk Museum, Amsterdam.*

1980

January Series of Seven Lithographs (cat. nos. 181–87a) published by Gemini G.E.L.

27 January–9 August *Prints from the Walker Art Center's Permanent Collection*, traveling exhibition organized by the Walker Art Center, includes *Green/White* (cat. no. 81); opens Conkling Gallery, Mankato State College, Mankato, Minnesota.

14 February–1 April *Germigny* (cat. no. 130) and *Senanque* (cat. no. 131) included in *Printed Art: A View of Two Decades*, Museum of Modern Art, New York.*

29 March–4 May *Sculpture on the Wall: Relief Sculpture of the Seventies*, exhibition held at University Gallery, University of Massachusetts at Amherst, includes *Green Curve with Radius of 20'* (cat. no. 101) and *Woodland Plant* (cat. no. 178).*

April *Daffodil, Sarsaparilla, Mulberry Leaf,* and *Wild Grape Leaf* (cat. nos. 188–91) completed, signed, and published at Tyler Graphics Ltd.

12 April–3 May *Leaf I, IV, VI,* and *XI* (cat. nos. 166, 169, 171, 176), *Dark Gray and White* (cat. no. 180), *Jacmel* (cat. no. 181), *Grand Case* (cat. no. 182), *Marigot* (cat. no 183), *Amden* (cat. no. 184), *Braunwald* (cat. no. 185), *Bordrouant* (cat. no. 186), *Bandol* (cat. no. 187), *Daffodil* (cat. no. 188), *Sarsaparilla* (cat. no. 189), and *Mulberry Leaf* (cat. no. 190) included in *Ellsworth Kelly Prints 1978–1980*, Castelli Graphics gallery, New York.

5 July–7 September *Ellsworth Kelly Painting and Sculpture 1966–1979*, traveling exhibition organized by the Stedelijk Museum, Amsterdam, shown at the Staatliche Kunsthalle, Baden-Baden; Kelly designs poster for the exhibition (App. IІl).

7 December–18 January 1981 *Artist and Printer: Six American Print Studios*, traveling exhibition organized by and opening at Walker Art Center, Minneapolis, includes *Blue/Green/Yellow/Orange/Red* (cat. no. 162), *Wall* (cat. no. 177), *Jacmel* (cat. no. 181), *Bandol* (cat. no. 187), and *Daffodil* (cat. no. 188).*

1981

22 March–19 July *Colored Paper Images V, VII, IX, X, XIV,* and *XX* (cat. nos. 145, 147, 149, 150, 154 and 160) included in *Contemporary American Prints and Drawings 1940–1980*, traveling exhibition organized by the National Gallery of Art, Washington, D.C.

6–30 April *Large Black Curve* (cat. no. 102) and *Large Gray Curve* (cat. no. 103) included in *American Avant-Garde Art 1940–80*, College of Saint Benedict, Saint Joseph, Minnesota.

April–May *Ellsworth Kelly Paintings* exhibition at Leo Castelli Gallery, New York (11 April–9 May), *Ellsworth Kelly Paintings and Sculpture*, BlumHelman Gallery, New York (7 April–2 May), and *Ellsworth Kelly Plant Drawings*, Castelli Uptown (11 April–2 May); Kelly designs a poster for the exhibitions (App. IІm).

June Begins first aquatint prints, the Concorde Series (cat. nos. 194–200a), and editions Painted Wall Sculptures at Gemini G.E.L.

3 June–3 July *Large Gray Curve* (cat. no. 103) included in exhibition *Great Prints*, Thomas Segal Gallery, Boston.

9 June–9 August *Colors on a Grid, Screenprint 1976* (cat. no. 140) and three unique paper pieces related to the Colored Paper Images series included in *1981 Invitational Exhibition*, Berkshire Museum, Pittsfield, Massachusetts.*

17 June–16 August Eighteen prints from the Colored Paper Images series (cat. nos. 142, 144–49, 150–52, 154–61) and an artist's proof of *Blue/Black* (cat. no. 67) included in *Druckgraphik: Wandlungen eines Mediums seit 1945*, Staatliche Museen Preussischer Kulturbesitz, Kupferstichkabinett, Nationalgalerie, Berlin.*

November "*18 Colors (Cincinnati)*" (cat. no. 193) completed and signed at Gemini G.E.L.

1982

January *Saint Martin Tropical Plant* (cat. no. 192) published by the Foundation for Contemporary Performance Arts, Inc., New York, in the portfolio *Eight Lithographs to Benefit the Foundation for Contemporary Performance Arts, Inc.*

15 January–13 February *Saint Martin Tropical Plant* (cat. no. 192) included in *Eight Lithographs*, Margo Leavin Gallery, Los Angeles.

22 January–21 March *Colored Paper Image IV* (cat. no. 144) included in *Post-1945 American Art*, Museum of Fine Arts, Houston.

February "*18 Colors (Cincinnati)*" (cat. no. 193) published by Gemini G.E.L.

5 February–21 March *Cyclamen III* (cat. no. 38) and *Blue/Yellow/Red* (cat. no. 61) included in *American Prints 1960–1980*, Milwaukee Art Museum.*

9–28 March *Colored Paper Images II, IV, VI, VII, IX, XII, XV, XVII, XVIII,* and *XX* (cat. nos. 142, 144, 146, 147, 149, 152, 155, 157, 158, and 160) and selected lithographs included in *Ellsworth Kelly: Lithographs and Colored Paper Images*, University of Lethbridge Art Gallery, Lethbridge, Alberta, Canada.

April The Concorde Series (cat. nos. 194–200a) completed and signed at Gemini G.E.L.

15 April–23 May *Colored Paper Image XVIII* (cat. no. 158) and *Leaf VII* (cat. no. 172) included in *Drawings, Watercolors and Prints by Contemporary Masters*, Root Art Center, Hamilton College, Clinton, New York.

May Painted Wall Sculptures published by Gemini G.E.L.

18 May–31 August *Wall* (cat. no. 177) included in *Prints by Contemporary Sculptors*, Yale University Art Gallery, New Haven, Connecticut.*

20 May–19 June Eight prints from the Concorde Series (cat. nos. 194, 194a, 195, 196, 197, 198, 199, and 200) and "*18 Colors (Cincinnati)*" (cat. no. 193) included in *Ellsworth Kelly: The Concorde Series (Recent Aquatints)*, at the Margo Leavin Gallery, Los Angeles.

June The Concorde Series (cat. nos. 194–200a) published by Gemini G.E.L.

August *Lotus* (App. Ic) published in deluxe edition of *Derrière le miroir*, No. 250, *Hommage à Aimé et Marguerite Maeght*.

12 October–30 June 1983 Twenty prints from the Colored Paper Images series (cat. nos. 141–60) and *Blue/Green/Yellow/Orange/Red* (cat. no. 162) included in *Paperwork*, Australian National Gallery, Canberra.*

17 December–27 February 1983 *Ellsworth Kelly: Sculpture* exhibition, Whitney Museum of American Art, New York;* Kelly designs poster for the exhibition (App. IIn).

1983

February Plate preparation and right-to-print proof for *Untitled* (cat. no. 201) completed at Gemini G.E.L.

22 May–11 September *Dark Gray and White* (cat. no. 180) included in *Changes* exhibition, Aldrich Museum of Contemporary Art, Ridgefield, Connecticut.

July *Untitled* (cat. no. 201) completed at Gemini G.E.L.; begins Series of Plant and Flower Lithographs (cat. nos. 207–13) at Gemini G.E.L.

October *Untitled* (cat. no. 201) signed.

Untitled (cat. no. 201) published by Museum of Contemporary Art, Los Angeles, in the portfolio *Eight by Eight to Celebrate the Temporary Contemporary.*

Begins drawings for Saint Martin Series (cat. nos. 202–206).

1984

January Begins Saint Martin Series (cat. nos. 202–206) at Gemini G.E.L.

February *Colored Paper Image XIX* (cat. no. 159) included in *Prints from Tyler Graphics* at the Carlson Gallery, University of Bridgeport, Connecticut.

March–April Transfer drawings for Series of Plant and Flower Lithographs (cat. nos. 207–13) completed in Spencertown, New York.

April *Cupecoy* (cat. no. 202), *Baie Rouge* (cat. no. 204), *Orient Beach* (cat. no. 205), and Series of Plant and Flower Lithographs (cat. nos. 207–13) completed at Gemini G.E.L.

24 April–19 May *Green* (cat. no. 7) included in *Icons of the Sixties*, Brooke Alexander Inc., New York.

May Saint Martin Series (cat. nos. 202–206) and *Calla Lily II* (cat. no. 210) signed at Gemini G.E.L.

5 May–16 July *Wall* (cat. no. 177) included in *The Modern Art of the Print: Selections from the Collection of Lois and Michael Torf*, Williams College Museum of Art, Williamstown, Massachusetts.*

June *Calla Lily I–III* (cat. nos. 209–11) and *Dracena I* (cat. no. 212) signed at Gemini G.E.L.; Saint Martin Series (cat. nos. 202–206) published by Gemini G.E.L.

29 August–25 November *Wall* (cat. no 177) included in *Recent Acquisitions 1974–1984*, Whitney Museum of American Art, New York.*

23 September–17 March 1985 *Colors on a Grid, Screenprint 1976* (cat. no. 140) and *Colored Paper Images I, IV, V, VII, and XI* (cat. nos. 141, 144, 145, 147, and 151) included in *Selections from Tyler Graphics*, Walker Art Center, Minneapolis, Minnesota.*

10 November–1 December Exhibition at Castelli Uptown gallery, *Ellsworth Kelly: New Editions*, includes *Yellow* (cat. no. 5), *Spectrum* (cat. no. 90), *White Curve I* (cat. no. 99), *Black Variation I* (cat. no. 109), and six prints from the Saint Martin Series (cat. nos. 202, 203, 204, 205, 205a, and 206).

18 November–24 February 1985 *Blue/Red-Orange/Green* (cat. no. 75), *Large Gray Curve* (cat. no. 103), *Yellow* (cat. no. 107), *Leaf IV* (cat. no. 169), *Grand Case* (cat. no. 182), *"18 Colors (Cincinnati)"* (cat. no. 193), and *Concorde I (State)* (cat. no. 196a) included in *Gemini G.E.L.: Art and Collaboration*, traveling exhibition organized by and opening at the National Gallery of Art, Washington, D.C.*

1985

14 January–10 March *Camellia II* (cat. no. 42), *Locust* (cat. no. 52), and *Wall* (cat. no. 177) included in *Twentieth-Century American Printmakers*, traveling exhibition organized by the Whitney Museum of American Art, New York; opens at Greenville County Museum of Art, Greenville, South Carolina.*

20 January–17 March *Colors on a Grid, Screenprint 1976* (cat. no. 140), *Nine Squares* (cat. no. 164), *Daffodil* (cat. no. 188), and *Wild Grape Leaf* (cat. no. 191) included in *Selections from Tyler Graphics*, Walker Art Center, Minneapolis, Minnesota.*

March Series of Plant and Flower Lithographs (cat. nos. 207–13) published by Gemini G.E.L.

13 April–23 June *Colored Paper Images IV, VI, VII, XIII, XV, XVIII, XIX, XX, and XXI* (cat. nos. 144, 146, 147, 153, 155, and 158–61) and *Nine Colors* (cat. no. 163) included in *Paperworks from Tyler Graphics*, traveling exhibition organized by and opening at the Walker Art Center, Minneapolis, Minnesota.*

6 June–13 October *Blue/Green* (cat. no. 65), *Spectrum* (cat. no. 90), and *Colored Paper Image VII* (cat. no. 147) included in *Ken Tyler: Printer Extraordinary*, Australian National Gallery, Canberra.*

17 November–15 December *Colored Paper Image VII* (cat. no. 147) included in *The Atelier in America: A Survey of the Collaboration of Artist and Printer*, Swen Parson Gallery, Northern Illinois University, Dekalb.*

1986

30 March–25 May *Green* (cat. no. 7) and *Grape Leaves II* (cat. no. 95) included in *After Matisse*, traveling exhibition organized by the Independent Curators Incorporated, New York; opens Queens Museum, Flushing, New York.*

1 August–20 September *Orient Beach* (cat. no. 205) included in *Graphics by Painters*, Laguna Beach Art Museum, South Coast Plaza, Laguna Beach, California.

5 November–4 January 1987 Included in *Paper Now: Bent, Molded, and Manipulated*, Cleveland Museum of Art, Cleveland, Ohio.

GLOSSARY

The glossary is adapted from Leonard Schlosser and Kenneth Tyler, *Paper and Papermaking Glossary* (privately published, 1978); Donald Saff and Deli Sacilotto, *Printmaking: History and Process* (New York: Holt, Rinehart and Winston, 1978); and André Béguin, "Glossary of Technical Terms," in Richard S. Field, Michel Melot, et al., *Prints* (Geneva: Editions d'Art Albert Skira; New York: Rizzoli, 1981).

Amberlith film A separable two-ply acetate film with a clear film base, used as a mask over artwork to be printed in flat color. The areas to be printed are outlined with a sharp knife, cutting only through the amber-colored layer, which is then used to prepare a **photo plate** or **photo screen**. (See also **hand-cut negative**

Aquatint An **intaglio** process used to produce a tonal or textural surface on a metal **plate**. A **ground** of resin, asphaltum powder, or other acid-resistant particulate material is applied to a metal **plate**, which is then heated, melting the powder so that it adheres to the metal surface. The plate is then placed in an acid bath as an **etching**, which bites around the acid-resistant particles, roughening the plate surface so that it will hold ink. (See also **etching, foul biting**.)

Ball-grained plate A metal **plate** prepared, or **grained**, for **lithographic** printing with the aid of a ball-graining machine. The plate is clamped to a flat, vibrating table and aluminum-oxide powder and water are applied to the surface. Steel balls are set in a tray over the plate. As the table vibrates, the rolling motion of the steel balls forces the oxide to abrade the plate evenly. The grit of the aluminum oxide determines the final plate grain.

Blind stamp A small, **embossed** mark impressed on a print, identifying the printer, workshop, or artist. It may also designate a make of paper, a copyright stamp, or collector's mark. Also called a dry stamp or chop mark.

Burnish In **embossing**, the process of manually rubbing or smoothing the paper against an embossing die to stretch or shape the paper's fibers to hold a three-dimensional pattern.

Collage From the French *coller*, "to paste." In traditional usage a work of art assembled from pieces of prosaic materials, frequently paper, which are adhered to a flat surface. In printmaking, collage prints can be assembled both from unprinted, torn pieces of paper or from printed paper sheets, which are cut or torn and adhered to another printed, paper support. In the production of editioned collage prints, the artist creates a template for cutting or tearing the collage elements, which the printmakers use in editioning the print. This process accounts for the very slight variations among collage impressions within a single edition.

Colored paper In contemporary hand-papermaking, the paper that results from the addition of dyes, pigments, colored rags, or a combination of these to paper **pulp**.

Crayon A hardened grease pencil or stick used to draw images on **plates** or **stones** for **lithographs**, and on **Mylar** in the preparation of a **photo plate** or **photo screen**. The crayon may be handled in such a way as to create full, **flat** areas of color or loose, smeared line textures.

Debossing A form of **embossing** in which the impressed image area is recessed below the paper surface, rather than raised in relief.

Deckle The rough, uneven edge on handmade paper, and on certain high-quality machine-made papers, that has been left untrimmed.

Edition A controlled number of uniform impressions of a given print, image, or series of prints, usually numbered, that have been pulled by or under the supervision of the artist and are authorized for distribution.

Element or **printing element** A generic term for the printing matrix, for example, a **plate, stone,** or **screen**.

Embossing or **inkless intaglio, blind embossing, gauffrage** A printing technique in which a design is impressed into paper without the use of ink, creating a raised surface area. In modern printmaking studios, embossing is often done on a **platen press**. In the case of Kelly's prints, uninked plastic dies are generally used for the embossed image areas. The print is placed face up over the die and **burnished** by hand, with the aid of a mechanical burnisher. In **relief** printing, the raised surfaces of the block or plate may also produce embossed (although inked) image areas.

Etching An **intaglio** technique in which an image is created on a metal plate through chemical rather than mechanical action. Traditionally, a **ground** preparation is applied to cover the **plate** surface. Using various tools, the artist draws through the ground, exposing the metal beneath. The plate is then placed in an acid bath, which removes uniform layers of exposed metal, producing recessed areas in the plate surface. The recessed areas of the plate are then inked for printing on an **intaglio press**. (See also **foul biting**.)

Flat An unvaried block application of ink.

Foul biting or **false biting** In **etching**, the accidental pitting or etching of a **plate** by acid in areas covered with **ground**. Foul biting is caused by any collapse of the etching ground, such as when lines are drawn in the ground too close together or the plate is immersed for too long in the acid bath.

Graining In **lithography**, to roughen the surface of a **stone** or **plate** to remove a previous greasy image; to level the surface; and to give the surface a new tooth or rough texture necessary for the adhesion of **crayon**, drawing ink, or printing ink. Aluminum **plates** are grained mechanically, on commercially available graining machines. (See also **ball-grained plate**.)

Ground In **etching** and **aquatint**, an acid-resistant substance used to protect the nonimage areas of a **plate** from the action of acid.

Hand-cut negative In the preparation of a **photo plate** or **photo screen**, a negative image is cut from **Mylar** or **Amberlith** from a positive image drawn by the artist. This negative is then used to burn a positive image on a photosensitized **plate** or **screen**.

Hand-cut positive A reversal of the process described above, under **hand-cut negative**.

Hand-cut stencil See **stencil**.

Hors Commerce Literally, "not for sale"; a *hors commerce* print is an **impression** produced outside of the edition, for presentation purposes. While not produced for sale, these prints occasionally find their way onto the market.

Impression A print taken by any method from a printing **element**.

Intaglio A generic term for printing processes in which the printing areas are recessed below the plate surface. A **plate** is incised either by mechanical or chemical action (see **etching**), ink is dabbed or rolled into the incisions, and the excess ink is wiped away. An **intaglio press** forces the dampened paper into contact with the incised recesses of the plate, and ink is deposited on the paper.

Linecut A **relief** print made from a **plate** in which the nonimage areas may be removed by photomechanical means and by **etching**. The linecut technique used by Kelly and his publishers is a fine-art process adapted from the commercial linecut process in letterpress printing.

Linocut or **linoleum cut, linoleum print** A type of **relief** print in which the printing **element** is cut from linoleum.

Lithography A planographic (flat-surface) printing process in which the image areas on a lithographic **stone** or metal **plate** are chemically treated to accept ink and repel water, while the nonimage areas are treated to repel ink and retain water. After the plate or stone is **grained**, a drawing is made with a greasy substance, such as **crayon** or **tusche**, or produced photographically (see **photo plate**). The dampened plate or stone retains printing ink only in the drawn areas. The image is transferred to paper on a direct or **offset lithographic press**. (See also **press**, **transfer lithograph**, **offset lithograph**, and **graining**.)

Mylar A sheet of clear synthetic material on which **crayon**, **tusche**, or other preparations can be applied to block out image areas in the preparation of a **photo screen**, or from which a negative can be cut in the preparation of a **photo plate**. (See also **hand-cut negative**.)

Offset lithograph A **lithograph** produced on an **offset press**. With Kelly's publishers, offset lithographs are printed on a hand-fed **flatbed offset press**, as distinguished from commercial offset lithographs printed on a **rotary press**. (See also **press**.)

Paper

Arches cover Manufactured by Arjomari at the Arches Mill in Arches, France, Arches Cover is a watermarked *(ARCHES)*, moldmade paper of 100 percent rag, available in white or a warm buff color. This paper has natural deckles on the long edges, while the short edges are torn to simulate a deckle. Arches Cover can print both etchings and lithographs and also takes embossing. Until recently it was commercially available in sheets of 250 grams per square meter, and in rolls or odd sheet sizes by special order. Now it is also produced in 270- and 300-gram sheets, and in 300-gram rolls. Arches Cover is also available in black, in 250-gram sheets.

Arches 88 (also called **Arches Silkscreen**) Manufactured by Arjomari at the Arches Mill in Arches, France, Arches 88 is a watermarked *(ARCHES)*, buffered, moldmade paper of 100 percent rag. Very similar to Arches hot-pressed 114-lb. watercolor paper, Arches 88 is not, however, sized and thus it absorbs ink freely. It is ideally suited to screenprinting, although it can also print lithographs and etchings well. It is available in sheets with four deckle edges, in weights of 300 or 350 grams per square meter; in rolls it is available in a 350-gram weight.

Chiffon de Mandeure A buff-colored, 100 percent rag paper, watermarked with three linked petals, manufactured in France, it is used for lithographic printing.

Duchene Handmade A 100 percent rag, lightly sized paper, handmade at the Agoumois Mill in Bordeaux, France, by Georges Duchene. The paper is produced in sheets of varying weights, with four deckled edges, and in a range of pigmented colors.

Mohawk Superfine Cover An American-made wood-pulp paper, most often used in commercial offset printing; it is also well suited to screenprinting. No deckles or watermark.

Rives BFK A smooth, 100 percent rag paper, moldmade by Arjomari at the Rives Mill, Rives, France, this paper is watermarked at the lower left edge *(BFK)* and lower right edge *(RIVES)*. It is available in white, cream, gray (see **Rives Newsprint**), and tan. This paper is lightly sized, although it can be specially ordered with increased sizing. It is ideally suited to lithography, etching, and screenprinting. With two natural and two torn deckle edges, it is or has been produced in sheets of 180, 230, 240, 250, 260, 270, and 280 grams per square meter. Larger sheets have three deckled edges. An unsized, white, 300-gram Rives BFK paper is also produced in rolls, known as Roll Rives.

Rives Newsprint (also called **Rives BFK Gray** or **Rives Velin Cuvé Teinte Papier**) A watermarked **Rives BFK** paper

manufactured by Arjomari at the Rives Mill, Rives, France, Rives Newsprint derives its name from its pigmented gray-buff coloration, similar to that of the newsprint on which printers proof their work. It weighs 280 grams per square meter and is produced in sheets of 22 × 30 inches, or 30 × 44 inches.

Rives Satine Manufactured by Arjomari at the Rives Mill in Rives, France, Rives Satine is a smooth, moldmade paper ideally suited to intaglio printing.

Special Arjomari A generic term for any paper manufactured by Arjomari, France, to the printer's specifications. No watermark.

Strathmore Fairfield Opaque Number 8 A paper produced in the United States by Strathmore, with no deckles and no watermark.

Photo plate A lithographic plate on which an ink-receptive image is produced by photographic means. A lithographic plate is treated with a photo-sensitive coating and exposed to light through a negative image on a film overlay. In the light-exposed areas the coating accepts ink, while the unexposed coating can be washed away. The plate can then be inked and printed. (See also **Mylar, hand-cut negative.**)

Photo screen A screen on which a design has been produced photographically by the action of light on photosensitive materials. (See also **Mylar.**)

Plate A sheet of metal, often zinc, copper, steel, or aluminum, on which an image is prepared for either lithographic, intaglio, or relief printing.

Plate tone or **surface tone** The soft tone that results from printing the partially wiped upper surfaces of an intaglio plate.

Press Traditionally, the three generic varieties of printing presses are: the relief press; the intaglio, or etching press, used for printing etchings, engravings, and other intaglio plates; and the planographic or lithographic press, used in printing lithographic plates or stones. Modern developments in printmaking techniques and press design have blurred the functional differences among these traditional printing presses, so that relief prints may be printed on a lithographic offset press or intaglio plates printed on a platen press, and so forth. Many of the press types discussed below are built in both manual and semiautomated versions, and sometimes are fully mechanized, for use in industry. Specific aspects of each press vary with the manufacturer and the period in which they were made.

Commercial offset press See rotary offset press.

Cylinder press A flat bed printing press composed of a motorized flat bed and a revolving cylinder. Paper is mounted on the cylinder and the inked plate or stone placed on the bed. During printing the motor-driven bed is pushed under the cylinder, which rotates across the surface of the plate or stone, picking up the inked image and transferring it to the paper.

Direct hydraulic lithographic press A direct process lithographic press that consists of a mechanized flatbed table and a scraper bar. The pressure applied by the bar during printing is exerted by a motor connected to a hydraulic pump. This press permits easy regulation of pressure during printing, as well as automating the forward and reverse movement of the bed, which carries the paper.

Direct lithographic press Any lithographic press in which the printing element is in direct contact with the paper during printing.

Direct printing press Any printing press in which the inked element is in direct contact with the paper during printing. Direct-process printing presses yield impressions that mirror the image drawn on the printing element.

Flatbed lithographic press Any lithographic press in which the plate or stone is held flat during printing.

Flatbed offset press An offset printing press in which the printing element—plate or stone—is held flat during printing, in contrast to a rotary offset press in which thin metal plates are mounted on a cylinder. For Kelly's publishers, the flatbed offset press is a motorized press with two fixed, horizontal flat beds, the first for the printing element, the second for the paper. The carriage, which consists of a series of rollers and a large cylinder covered with a rubber blanket, moves back and forth across the two beds, under light pressure, depositing ink and water onto the printing element on the first bed. On its return movement, the blanket lifts ink from the stone or plate, and then deposits it onto paper placed on the second bed. The flat-bed offset press can print lithographic plates and stones, as well as relief printing elements.

Indirect printing press See offset press.

Intaglio press or **etching press** For the printing of intaglio elements tremendous pressure is required to force the dampened paper into contact with the finely incised recesses of the plate. In the traditional intaglio press pressure is provided by two rollers or cylinders fitted above and below a movable bed. The inked intaglio plate is placed on the bed, and dampened paper is laid on top of the plate and covered with felt blankets. The impression is created when the bed, plate, paper, and blankets are forced between the cylinders, which squeeze the paper into contact with the inked recesses of the plate. (See also **direct process press** and **platen press.**)

Lithography press Any direct process planographic press in which the stone or plate is carried by a mobile bed beneath a scraper bar during printing. The scraper bar applies pressure directly against the printing element and paper. Lithography requires extreme pressure—often in excess of ten thousand pounds per square inch—along a thin edge, in order to impress ink into the paper's fibers from the thin surface image of a lithographic plate. This type of press forces ink uniformly into the paper surface, in effect fusing the ink with the paper fibers. The pressure of the manual lithographic press wears down the thin surface of a lithographic plate or stone more quickly than does an offset press.

Offset press Any printing press in which the inked image is transferred from the printing element to an intermediary rubber cylinder, and then to the paper. Because the impression is transferred from the stone or plate to the blanket before being deposited on the paper, the designs drawn on the printing elements do not read as mirror images. With the offset process, the elements are not printed under great pressure, and thus do not wear down as quickly as on a direct process lithographic press. The offset press yields impressions of great fidelity, sharpness, and detail, but unlike prints produced on the direct process lithographic press, the paper fibers are not broken down, and the resultant impression may resemble a screenprint. The offset press can print lithographic plates and stones, as well as relief printing elements. It is a type of indirect printing press.

Platen press A type of printing press, so named for the iron or steel platen that pushes the paper against the inked element during printing. The modern platen press is descended from the earliest relief-printing presses, which were constructed of wood. It is a hydraulic machine with two identically shaped horizontal flat beds. Like the relief-printing press, the platen press supplies uniform pressure over the entire surface of the printing element. The top bed is movable in a lateral direction, while the power-driven bottom bed can be moved vertically. During printing or embossing the printing element is placed on the bottom bed. The impression is created when the lower bed is raised, pressing the printing element and paper under great pressure into contact with the upper bed. This press can be used for printing relief elements and intaglio plates, and for embossing.

Rotary offset press or **commercial offset press, vertical offset press** A fully automated mechanical press comprising a series of vertically aligned rollers that feed the paper, ink the plate, and transfer the inked image to the sheet. In contrast to the flatbed offset press, in which the plate is placed on a flat bed, in the rotary press, the plate is wrapped around a cylinder during printing. Because the image is transferred from the plate to an intermediary rubber cylinder, the drawn image appears on the printed sheet without reversal. The rotary offset press is a commercial form of offset press; it can print planographic or lithographic plates, letterpress, and some engraved or gravure plates.

Pressed paper Paper into which foreign objects or materials have been incorporated. The process entails the embedding into the surface of a newly formed sheet of paper materials such as colored rags, threads, vegetable matter, or dyes. If placed in a press with the wet paper, the foreign material will become an integral part of the sheet, imparting the color, shape, and texture of the new object to the paper surface.

Proof An impression pulled outside the edition, and usually prior to it, to test the progress of the image or prove the work. A proof may be reserved for the artist, for the printers who edition the print, or for archival purposes. Proofs are traditionally signed by the artist and numbered with Roman numerals. (See also the Key to the Catalogue Raisonné.)

Pulp The basic ingredient of paper, consisting of cotton or vegetable fibers that have been chopped and beaten with water so that the fibers are properly hydrated.

Registration The alignment of inked plates, stones, or screens. A large number of elements may be used in printing, and these must be carefully adjusted to ensure their correct placement in the overall image. While registration methods vary with different printmaking techniques, in intaglio printing and lithography, needles are pierced through the paper into small holes in the plate or stone that were created especially for the purpose of aligning separate elements.

Relief printing A generic term for printmaking processes such as woodcut or linecut, in which the upper surfaces of a printing element are printed. The printing element is produced by cutting away nonimage areas from the matrix, either by hand, etching, or with mechanical or photomechanical means. The upper surfaces of the plate or block are inked, usually with a rubber roller or brayer, and printed to create the impression. The recessed areas are not inked, but during printing the paper is often pushed into these sunken areas, creating an embossed effect in the impression.

Rubylith See Amberlith.

Run The application of ink from a printing element to paper in a single pass through a press, or the alteration of the impression through embossing in a single operation.

Screen A fine mesh of silk or synthetic material stretched tightly across a frame that supports the stencil design for a screenprint.

Screenprint Also known as silkscreen or serigraph. A print produced when ink is forced through the unblocked portions of a screen.

State or **state print** Traditionally, this term refers to a print produced from a plate, stone, or screen (or these elements in combination) that may then be reworked at a later stage. As used by Kelly's publishers, state describes prints in a variant edition. State prints may involve varying combinations of reused elements, new color inkings, wipings, or a change in the printing sequence. Original elements are not reworked. (See also proof.)

Stencil A material used to block out the nonprinting areas of a screen in screenprinting. Stencils may be cut out of lacquer or synthetic resin-based film from a positive image drawn by the artist, which is then adhered to the screen; or the stencil can be applied directly to the screen with crayon, tusche, or other liquid preparations; or produced photographically. (See also photo screen.)

Stone The limestone element used in the creation of a lithograph. Because it accepts grease and water equally, limestone is ideally suited to lithography. Lithographic stones vary in size, hardness, and porosity, each of which provides the printed image with different textures.

Transfer lithograph A lithograph made from a drawing on transfer paper.

Transfer paper Paper with a water-soluble coating on one side. After a drawing is made on transfer paper, the paper is dampened and the image on the coated side can be released from the paper and transferred onto the printing element.

Tusche A grease-based ink used for drawing on a lithographic plate or stone, or in creating hand-drawn screens. Tusche can also be used to block out areas on Mylar in the preparation of a photo screen or photo plate, or as an acid-resistant material in preparing a plate for etching; this is usually called resist tusche.

Wipe The removal of excess ink remaining on the upper surfaces of an intaglio plate. If only the incised lines of an intaglio plate are to appear in the final impression the upper surfaces are wiped clean. A plate tone can be left in the final print by partially wiping the upper surfaces of the plate, with a rag or the palm of the hand (called hand wiping).

BIBLIOGRAPHY

Monographs

Baker, Elizabeth C. 1979. *Ellsworth Kelly: Recent Paintings and Sculpture*. New York: Metropolitan Museum of Art, 26 April–24 June.

Coplans, John. 1973. *Ellsworth Kelly*. New York: Harry N. Abrams, Inc.

Goossen, Eugene C. 1973. *Ellsworth Kelly*. New York: Museum of Modern Art.

Kelly, Ellsworth. 1984. *Ellsworth Kelly*. Los Angeles: Margo Leavin Gallery; New York: Leo Castelli Gallery.

Rose, Barbara, and Ellsworth Kelly. 1979. *Ellsworth Kelly: Paintings and Sculptures 1963–1979*. Amsterdam: Stedelijk Museum.

Schmidt, J. K., Barbara Rose, Ellsworth Kelly, et al. 1980. *Ellsworth Kelly: Paintings and Sculptures 1966–1977*. Baden-Baden: Staatliche Kunsthalle.

Sims, Patterson, and Emily R. Pulitzer. 1982. *Ellsworth Kelly: Sculpture*. New York: Whitney Museum of American Art.

Waldman, Diane. 1971. *Ellsworth Kelly: Drawings, Collages, Prints*. Greenwich, Connecticut: New York Graphic Society.

Printmaking Activity

Ackley, Clifford S., Thomas Krens, and Deborah Menaker. 1984. *The Modern Art of the Print: Selections from the Collection of Lois and Michael Torf*. Williamstown, Massachusetts: Williams College Museum of Art, 5 May–16 July; Boston: Museum of Fine Arts, 1 August–14 October.

Ackley, Clifford S., and Barbara Shapiro. 1977. *Prints of the Seventies*. Boston: Museum of Fine Arts. 10 September–4 December.

Antreasian, Garo Z. 1969. *Graphics '69: Lithographs*. Lexington: University of Kentucky Art Gallery. 17 November–21 December.

Armstrong, Elizabeth. 1984. *Prints from Tyler Graphics*. Minneapolis: Walker Art Center, 23 September 1984–17 March 1985.

Artists Salute Skowhegan. 1977. New York: Kennedy Galleries, 8–21 December.

August, Marilyn. 1986. "The House of Maeght." *Art News* 85: 6 (Summer), 93–97.

Baro, Gene. 1976. *Thirty Years of American Printmaking, Including the Twentieth National Print Exhibition*. Brooklyn: Brooklyn Museum, 20 November 1976–30 January 1977.

Beal, Graham. 1980. *Artist and Printer: Six American Print Studios*. Minneapolis: Walker Art Center, 7 December 1980–18 January 1981.

Bell, Tiffany. 1986. *After Matisse*. New York: Independent Curators, Incorporated, New York.

Bryant, Edward. 1968. *Graphics '68: Recent American Prints*. Lexington: University of Kentucky Art Gallery, 14 January–11 February.

Castleman, Riva. 1971. *Technics and Creativity: Gemini G.E.L.* New York: Museum of Modern Art, 5 May–6 July.

———. 1973. *Modern Art in Prints*. New York: Museum of Modern Art.

———. 1976. *Prints of the Twentieth Century: A History*. New York: Museum of Modern Art.

———. 1980. *Printed Art: A View of Two Decades*. New York: Museum of Modern Art, 14 February–1 April.

———. 1985. *American Impressions: Prints since Pollock*. New York: Alfred A. Knopf.

Coplans, John. 1970. *Kelly*. Los Angeles: Gemini G.E.L.

Curtis, Verna Posever. 1982. *American Prints 1960–1980*. Milwaukee: Milwaukee Art Museum, 5 February–21 March.

Davies, Hugh M. 1980. *Sculpture on the Wall: Relief Sculpture of the Seventies*. Amherst: University of Massachusetts, University Gallery, 29 March–4 May.

Debs, Barbara Knowles. 1972. "Ellsworth Kelly's Drawings." *Print Collector's Newsletter* 3: 4 (September–October), 73–77.

Derrière le miroir: Homage à Aimé et Marguerite Maeght. 1982. No. 250 (August).

Driesbach, David F. et al. 1985. *The Atelier in America: A Survey of the Collaboration of Artist and Printer*. Dekalb: Northern Illinois University, Swen Parson Gallery, 17 November–15 December.

Dückers, Alexander. 1981. *Druckgraphik: Wandlungen eines Mediums seit 1945*. Berlin: Staatliche Museen Preussischer Kulturbesitz, Kupferstichkabinett, Nationalgalerie, 17 June–16 August.

Eight by Eight to Celebrate the Temporary Contemporary. 1983. Los Angeles: Museum of Contemporary Art.

Eighteenth National Print Exhibition. 1972. New York: Brooklyn Museum, 22 November 1972–4 February 1973; San Francisco: California Palace of the Legion of Honor, 24 March–17 June 1973.

Ellsworth Kelly: Colored Paper Images. 1976. Bedford, New York: Tyler Graphics.

Ellsworth Kelly at Gemini: 1979–1982. 1982. Los Angeles: Gemini G.E.L.

Ellsworth Kelly: Leaves. 1974. Los Angeles: Gemini G.E.L.

Ellsworth Kelly: Third Curve Series. 1976. Los Angeles: Gemini G.E.L.

Ellsworth Kelly: Twelve Leaves. 1978. Los Angeles: Gemini G.E.L.

Farmer, Jane M. 1978. *Paper as Medium*. Washington, D.C.: Smithsonian Institution Traveling Exhibition Service.

Field, Richard S., Michel Melot, et al. 1981. *Prints*. Geneva: Skira; New York: Rizzoli.

Field, Richard S., and Daniel Rosenfeld. 1982. *Prints by Contemporary Sculptors*. New Haven, Connecticut: Yale University Art Gallery, 18 May–31 August.

Fine, Ruth E. 1984. *Gemini G.E.L.: Art and Collaboration*. Washington, D.C.: National Gallery of Art; New York: Abbeville Press, 18 November 1984–24 February 1985.

Finkelstein, Irving L. 1978. *Prints of the High Museum: Image and Process*. Atlanta, Georgia: High Museum of Art, 16 September–3 December.

Flint, Janet. 1977. *New Ways with Paper*. Washington, D.C.: National Collection of Fine Arts, Smithsonian Institution, 2 December 1977–20 February 1978.

Frackman, Noel. 1977. "Ellsworth Kelly." *Arts Magazine* 51: 7 (March), 31.

Gilmour, Pat. 1985. *Ken Tyler: Printer Extraordinary* (gallery brochure). Canberra: Australian National Gallery, 6 June–13 October.

———. 1986. *Ken Tyler—Master Printer—and the American Print Renaissance*. New York: Hudson Hills Press.

Gilmour, Pat, and Anne Willsford. 1982. *Paperwork*. Canberra: Australian National Gallery, 12 October 1982–30 June 1983.

Glaubinger, Jane. 1986. *Paper Now: Bent, Molded, and Manipulated*. Cleveland: Cleveland Museum of Art, 5 November 1986–4 January 1987.

Goldman, Judith. 1971. "Gemini Prints at the Museum of Modern Art." *Print Collector's Newsletter* 2: 2 (May–June), 30–31.

———. 1977a. *Art off the Picture Press*. Hempstead, New York: The Emily Lowe Gallery, 14 April–22 May.

———. 1977b. "The Master Printer of Bedford, N.Y." *Art News* 76: 7 (September), 50–54.

———. 1980. "Printmaking: The Medium Isn't the Message Anymore." *Art News* 79: 3 (March), 82–85.

———. 1984. *Print Acquisitions 1974–1984*. New York: Whitney Museum of American Art, 29 August–25 November.

———. 1985. *Twentieth-Century American Printmakers*. New York: Whitney Museum of American Art.

Goossen, Eugene C. 1958. "Ellsworth Kelly." *Derrière le miroir*. No. 110 (October).

Halbreich, Kathy. 1977. *Paper Forms Hand-Made Paper Projects*. Cambridge: Massachusetts Institute of Technology, Hayden Gallery, 2 September–5 October.

Harrison, Charles. 1967. "Transatlantic Graphics 1960/67, Camden Arts Centre." *Studio International* 174: 895 (December), 274–76.

Harvey, Donald. 1979. *Seven Artists at Tyler Graphics Ltd*. Athens, Ohio: Ohio University, Trisolini Gallery, 10 September–6 October.

Hoag, Joan. 1968. "Los Angeles" (review of Kelly print exhibition at Irving Blum Gallery). *Art News* 66: 9 (January), 52.

Johnson, Diana L. 1973. *Selection III: Contemporary Graphics from the Museum's Collection*. Providence: Rhode Island School of Design, Museum of Art, 5 April–6 May.

Knight, Christopher. 1985. *Ellsworth Kelly at Gemini, 1983–1985*. Los Angeles: Gemini G.E.L.

Konheim, Linda. 1978. *Prints from the Guggenheim Museum Collection*. New York: Solomon R. Guggenheim Museum and American Federation of Arts.

Larson, Philip. 1974. *Johns, Kelly, Lichtenstein, Motherwell, Nauman, Rauschenberg, Serra, Stella: Prints from Gemini G.E.L.* Minneapolis: Walker Art Center, 17 August–29 September.

Leering, Jan. 1971. *Experiment in Grafiek: Gemini G.E.L.* Eindhoven, Netherlands: Stedelijk van Abbemuseum, 8 October–21 November.

Livingston, Jane. 1968. "Los Angeles" (review of Kelly print exhibition at Irving Blum Gallery). *Artforum* 6: 5 (January), 62.

Long, Paulette, ed. 1979. *Paper—Art and Technology*. San Francisco: World Print Council.

McConathy, Dale. 1964. "Ellsworth Kelly." *Derrière le miroir*. No. 149 (November), 3–12.

———. 1965. *Ellsworth Kelly: Twenty-Seven Lithographs*. Paris: Maeght Editeur.

A New Consciousness: The Ciba-Geigy Collection. 1971. Yonkers, New York: Hudson River Museum, 6 February–7 March.

"New Editions: Ellsworth Kelly's 'Colored Paper Images.'" *Art News*. 1977. 76: 3 (March), 110.

"New Editions: Ellsworth Kelly's 'Twelve Leaves.'" *Art News*. 1978. 77: 7 (September), 106.

Newland, Amy Reigle. 1985. *Paperworks from Tyler Graphics*. Minneapolis: Walker Art Center, 13 April–23 June.

"News of the Print World, People and Places, Benefit Portfolio." *Print Collector's Newsletter*. 1982. 12: 6 (January–February), 177.

1981 Invitational Exhibition. 1981. Pittsfield, Massachusetts: Berkshire Museum, 9 June–9 August.

Petlin, Irving B. 1965. "An Exhibition of Recent Lithography Executed in France by the Artist Ellsworth Kelly." *Artforum* 3: 8 (May), 16.

Perrone, Jeff. 1977. "Ellsworth Kelly: *Colored Paper Images*" (review of exhibition at Castelli Graphics), *Artforum* 15: 8 (April), 62.

"Prints and Photographs Published: Ellsworth Kelly *Third Curve Series* (1976)." *Print Collector's Newsletter.* 1976. 7: 2 (May–June), 54.

"Prints and Photographs Published: Ellsworth Kelly *Colored Paper Images* (1976)," *Print Collector's Newsletter.* 1977. 7: 6, (January–February), 181.

"Prints and Photographs Published: Ellsworth Kelly *Twelve Leaves* (1978)." *Print Collector's Newsletter.* 1979a. 9: 6 (January–February), 193.

"Prints and Photographs Published: Ellsworth Kelly *Woodland Plant* (1979)." *Print Collector's Newsletter.* 1979b. 10: 2 (May–June), 55.

"Prints and Photographs Published: Ellsworth Kelly *Wall* (1979)." *Print Collector's Newsletter.* 1979c. 10: 3 (July–August) 93.

"Prints and Photographs Published: Ellsworth Kelly *Daffodil, Mulberry Leaf, Sarsaparilla, Wild Grape Leaf* (1980), *Seven Lithographs* (1980)." *Print Collector's Newsletter.* 1980. 11: 3 (July–August), 102.

"Prints and Photographs Published: Ellsworth Kelly *Orient Beach* (1984), *Bai Rouge, Cul de Sac* and *Cupecoy.*" *Print Collector's Newsletter.* 1984. 15: 5 (November–December), 177.

"Prints and Portfolios Published: Ellsworth Kelly *Untitled.*" *Print Collector's Newsletter.* 1970. 1: 4 (September–October), 87.

"Prints and Portfolios Published: Ellsworth Kelly *Blue, Yellow and Red Squares* (1971), *Four Panels* (1971)." *Print Collector's Newsletter.* 1971. 2: 2 (May–June), 35.

"Prints and Portfolios Published: Ellsworth Kelly *Blue, Green, Black and Red* (1971)." *Print Collector's Newsletter.* 1972. 2: 6 (January–February), 128.

"Prints and Portfolios Published: Ellsworth Kelly *Leaves* (1973–74)." *Print Collector's Newsletter.* 1974a. 5: 3 (July–August), 65.

"Prints and Portfolios Published: *For Meyer Schapiro* (1973–74)." *Print Collector's Newsletter.* 1974b. 5: 5 (November–December), 125.

"Prints and Portfolios Published: Ellsworth Kelly *Large Black Curve* (1974)." *Print Collector's Newsletter.* 1975a. 6: 2 (May–June), 44.

"Prints and Portfolios Published: Ellsworth Kelly *Black Variation I, Red Curve (Radius of 8')* (1975)." *Print Collector's Newsletter.* 1975b. 6: 3 (July–August), 73.

Ratcliff, Carter. 1981. "Spectrum of Experience." *Art in America* 69: 6 (Summer), 98–100.

———. 1982. *Ellsworth Kelly at Gemini 1979–1982.* Los Angeles: Gemini G.E.L.

Russell, John. 1966. *Gravures Maeght Editeur.* London: The Redfern Gallery, 29 November 1966–7 January 1967.

Schiller, Marlene. 1977. "Footnotes: The Cover." *American Artist* 41: 421 (August), 6, 12, 14.

Shalkop, R. L. 1974. *National Invitational: Prints II.* Anchorage: Anchorage Historical and Fine Arts Museum, 4–29 October.

Sharp, Ellen. 1972. *Detroit Collects Prints and Drawings.* Detroit: Detroit Institute of Arts, 13 April–21 May.

Skoggard, Ross. 1977. "Ellsworth Kelly, Leo Castelli Graphics." *Artforum* 15: 7 (March), 62–63.

Stein, Donna. 1969. *American Contemporary Prints: One.* Bath: American Museum in Britain.

Stetson, Daniel E. 1979. *Portfolios: In and Out of the 1960s.* Syracuse: Syracuse University, Joe and Emily Lowe Art Gallery, 18 November 1979–27 January 1980.

Stubbe, Wolf. 1971. *Graphik der Welt: Internazionale Druckgraphik der letzten 25 Jahre.* Nürnberg: Kunsthalle Nürnberg, 28 August–28 November.

Tyler Graphics Ltd.: Catalogue Raisonné. 1987. Minneapolis: Walker Art Center; New York: Abbeville Press.

Tyler Graphics Ltd.: The Extended Image. 1987. Minneapolis: Walker Art Center; New York: Abbeville Press.

Wember, Paul. 1973. *Blattkünste Internazionale Druckgraphik seit 1945.* Krefeld: Kaiser Wilhelm Museum.

Wilde, E. de, and W. A. L. Beeren. 1966. *Vormen van de Kleur/New Shapes of Color.* Amsterdam: Stedelijk Museum, 20 November 1966–15 January 1967.

INDEX

Where the medium is not given, the work is a print.
Page numbers printed in *italics* refer to illustrations.

Abrams (Harry N.) Inc., New York, 86
Abstract Expressionism, 14, 18
abstraction, 13–14, 20, 34
Acacia, 65, *65*
Ailanthus Leaves I, 68, *68*
Ailanthus Leaves II, 68, *68*
Albers, Josef, 20
Albright-Knox Art Gallery, Buffalo, 183, 189
Aldrich Museum of Contemporary Art, Ridgefield,
 Connecticut, 191
Alechinsky, Pierre, 179
Alexander (Brooke) Inc., 19, 82, 189
Algue, 65, *65*
Amden, 27, 145, *145*
Amden (State), 145, *145*
American Federation of Arts, 190
"American Print Renaissance," 20
Anchorage Historical and Fine Arts Museum, Alaska, 189
Angers, 107, *107*
Arakawa, Shusaku, 179
Arjomari-Prioux paper mill, France, 28
Arp, Jean, 14, 187
Art of the Real, The: USA 1948–1968, The Museum of
 Modern Art (poster), 182, *182*, 188
L'Art vivant aux Etats-Unis, Fondation Maeght (poster), 183,
 183, 188
Atlantic (painting), 187
Australian National Gallery, Canberra, 191

Baie Rouge, 25, 161, 164, *164*; original study for (drawing), *25*;
 template for, *21*
Baie Rouge, State I, 164, *164*
Baie Rouge, State II, 164, *164*
Bandol, 141, 148, *148*
Bandol (State), 141, 148, *148*
Beckett, Samuel, 174
Bengtz, Ture, 187
Berkshire Museum, Pittsfield, Massachusetts, 190
Bianchini (Paul), New York, 78, 188
Bi objects, Chinese, 32
biomorphic tradition, 13–14, 22, 23, 187
bisected-parallelogram paintings, 72, 79
bisected-rectangle works, 95, 97, 98, 102, 120, 121, 124
black, Kelly's use of, 27–28, 33, 175
Black (I.1. Black), 18, 19, 40, *40*, 41
Black and White Bar II (painting), 85
Black and White Pyramid, 84, *84*
Black/Brown, 27, 80, *80*
Black Curve, 30, 80, *80*
Black Curve I (White Curve I), 31, 92, *92*, 93, 180
Black Curve I (painting), 103, 106
Black Curve III (painting), 92
Black Curve IV (painting), 105, 108
Black Curve VII (painting), 98
Black Curves (painting), 40
Black Form, 69, *69*
Black/Green, 74, *74*, 79
Black Green (painting), 75, 79
Black/Green II, 74, 79, *79*
Black over Yellow (IX.21. Black over Light Yellow), 50, *50*
Black Triangle with White (painting), 142
Black, Two Whites (painting), 83
Black Variation I, 95, 97, 98, *98*
Black Variation II, 99, *99*, 100, 101
Black Variation III, 99, *99*, 100, 101
Black Variation IV, 99, 100, *100*, 101
Black Variation V, 100, *100*, 101
Black Variation VI, 100, 101, *101*
Black White (painting, 1962), 69
Black White (painting, 1963), 40
Black White (two paintings, 1966), 40, 84
Black White (painting, 1967), 72
Black White (painting, 1968), 125, 154
Black White (painting, 1970), 84

Black White (sculpture), 141
Black/White/Black, 31, 72, *72*
Black with Red Bar (painting), 76
Black with White (VI.6. Black with White), 42, *42*
Black with White Triangle (painting), 144
Black/Yellow, 82, *82*
Black Yellow (painting), 82
Bleu Clair avec Orange (Série VI, No. 11), 45, *45*
Bleu Clair et Vert sur Orange (Série XI, No. 26), 52, *52*
Bleu Clair sur Vert Clair (Série X, No. 23), 51, *51*
Bleu et Jaune Clair et Rouge-Orange (Série VII, No. 14), 46, *46*
Bleu et Orange (Série V, No. 5), 42, *42*
Bleu Foncé avec Rouge (Série VI, No. 7), 43, *43*
Bleu Foncé et Orange et Vert Clair (Série VII, No. 13), 39, 46, *46*
Bleu Foncé et Rouge (Série VIII, No. 15), 47, *47*
Bleu sur Orange (Série IX, No. 18), 48, *48*
Blue I, 95, 96, *96*, 100, 101
Blue II, 96, *96*, 100, 101
Blue and Green over Orange (XI.26. Light Blue and Green
 over Orange), 52, *52*, 53
Blue and Orange (V.5. Blue and Orange), 42, *42*, 117
Blue and Orange and Green (VII.13. Dark Blue and Orange
 and Light Green), 46, *46*
Blue and Yellow and Red-Orange (VII.14. Blue and Light
 Yellow and Red-Orange), 46, *46*
Blue/Black, 74, *74*
Blue/Black/Brown, 126, *126*
Blue Black Curves, 118, *118*
Blue Curve (painting), 96, 100, 101
Blue Curves, 119, *119*
Blue Curve with Brown and Gray, 123, *123*
Blue/Green, 73, *73*
Blue Green (painting), 51
Blue/Green/Black/Red, 78, *78*
Blue/Green/Yellow/Orange/Red, 21, 128, *128*
Blue/Green/Yellow/Orange/Red (painting, larger version,
 1968), 128
Blue/Green/Yellow/Orange/Red (painting, smaller version,
 1968), 128
Blue on Blue (relief sculpture), 37
Blue over Green (X.23. Light Blue over Light Green),
 19, 51, *51*
Blue over Orange (IX.18. Blue over Orange), 48, *48*
Blue Panel (painting), 184
Blue Red (painting, 1964), 178
Blue Red (painting, 1965), 186
Blue Red Green (oil-on-newsprint), 46
Blue/Red-Orange, 81, *81*
Blue/Red-Orange/Green, 78, *78*
Blue-Violet Curve I (painting), 160
Blue White (painting), 123
Blue/White/Red, 77, *77*
Blue with Black I, 90, *90*
Blue with Black II, 90, *90*
Blue with Gray, 122, *122*
Blue with Yellow (Untitled), 42, 53, *53*, 181
Blue Yellow (painting, 1968), 75
Blue Yellow (painting, 1971), 183
Blue, Yellow and Red Squares, 24, 77, *77*
Blue/Yellow/Red (Colored Paper Images series), 125, *125*
Blue/Yellow/Red (Ten Lithographs Series), 20, 71, *71*, 125
Blue Yellow Red (painting, 1968), 182
Blue Yellow Red (painting, larger version, 1972), 86, 125
Blue Yellow Red (painting, smaller version, 1971), 86, 125
Blue/Yellow/Red (Untitled), 86, *86*
Bonies, 180
Bontecou, Lee, 86
Bordrouant, 147, *147*
Bordrouant (State), 147, *147*
Branche de Citron, 67, *67*
Brancusi, Constantin, 14, 187
Braque, Georges, 19, 174
Braunwald, 146, *146*
Braunwald (State), 146, *146*
Breer, Robert, 86
Brier, 19
Brioude, 113, *113*
Brooklyn Museum, New York, 189
Brown/Blue/Black/Green/Violet, 127, *127*
Brown Square with Blue, 127, *127*

Cabernet Sauvignon wine label, 186, *186*
Caen, 106, *106*
Calder, Alexander, 14, 180, 187
calla-lily leaf sequence, in Twelve Leaves series, 130–36,
 130–36, 168
Calla Lily I, 170, *170*
Calla Lily II, *26*, 170, *170*
Calla Lily III, *168*, 171, *171*
Camden Arts Center, London, 188
Camellia I, 59, *59*
Camellia II, 60, *60*
Camellia III, 16, 60, *60*
Canigou, 108, *108*
Carnegie Institute, 187, 188
Castelli (Leo) galleries, New York, 184, 189, 190, 191
Catalpa Leaf, 16, *17*, 66, *66*
Central Trust Company, Cincinnati, 151, 190
Chagall, Marc, 19, 174, 179, 180
Chamberlain, John, 86
Change, Inc., 130
Chardonnay wine label, 186, *186*
Chatham Paintings, 90
Chatham Series, The: Paintings by Ellsworth Kelly (exhibition),
 183, 189
Chatham XII (painting), 184
Chauvigny, 105, *105*
Chillida, Eduardo, 179, 180
Citron, 56, *56*
City Island (painting), 175
Cleveland Museum of Art, 191
Colburn, Ralph, 187
collage prints of Kelly, 21, 22, 189
collages of Kelly, 16, 18, 22, 23, 24, 26, 175, 187
color, Kelly's use of, 13, 14, 18, 23, 25, 26–28, 31, 33, 34, 175
Colored Paper Image I, 117, *117*
Colored Paper Image II, 117, *117*
Colored Paper Image II, State, 118, *118*
Colored Paper Image III, 118, *118*
Colored Paper Image IV, 119, *119*
Colored Paper Image V, 119, *119*
Colored Paper Image VI, 120, *120*
Colored Paper Image VII, 116, 120, *120*, 124
Colored Paper Image VIII, 121, *121*
Colored Paper Image IX, 121, *121*
Colored Paper Image IX, State, 121, 122, *122*
Colored Paper Image X, 122, *122*, 158
Colored Paper Image XI, 123, *123*
Colored Paper Image XII, 123, *123*
Colored Paper Image XIII, *31*, 124, *124*
Colored Paper Image XIV, 120, 124, *124*
Colored Paper Image XV, 125, *125*, 154
Colored Paper Image XVI, 86, 125, *125*
Colored Paper Image XVII, 125, 126, *126*
Colored Paper Image XVIII, 126, *126*, 153
Colored Paper Image XIX, 127, *127*
Colored Paper Image XX, 127, *127*
Colored Paper Image XXI, 128, *128*
Colored Paper Image XXII, 128, *128*
Colored Paper Image XXIII, 129, *129*
Colored Paper Images, 21–22, 24, 25, 27, 28, 31, 93, 97,
 116–29, *116–29*, 150, 152, 161, 189–90
Color Field painting, 13, 20
Color Panels for a Large Wall (painting), 151
Colors for a Large Wall (painting), 22, 115, 187
Colors on a Grid, Screenprint, 24, 25, 115, *115*
Committee to Endow a Chair in Honor of Meyer Schapiro at
 Columbia University, 93, 189
Concorde I, 152, 155, *155*
Concorde I (painting), 122, 152
Concorde I (State), 152, 155, *155*
Concorde II, 152, 155, 156, *156*
Concorde II (State), 156, *156*
Concorde III, 152, 157, *157*
Concorde III (State), 157, *157*
Concorde IV, 122, 152, 158, *158*
Concorde IV (State), *13*, 158, *158*
Concorde V, 122, 152, 158, 159, *159*
Concorde V (State), 159, *159*

Concorde Angle (sculpture), 158
Concorde motif and variations, 33, 122, 152, 155, 157, 158
Concorde Relief (sculpture), 122, 152
Concorde Relief II (sculpture), 122, 158
Concorde Relief III (sculpture), 157
Concorde Series, 24, 25, 30, 122, 125, 126, 152–59, 152–59, 161, 190
Conques, 103, 103
Constructivism, 14
Coplans, John, 14; Ellsworth Kelly, 34, 86, 188, 189
Corneilla, 104, 104
Cornell, Joseph, 82
Cowboy (painting), 18, 176
Cramer, Douglas, 150, 186
crossbar paintings, 76, 85
Cul de Sac, 163, 163
Cul de Sac, State I, 163, 163
Cul de Sac, State II, 163, 163
Cupecoy, 31, 161, 162, 162
Cupecoy, State I, 162, 162
Cupecoy, State II, 162, 162
Curve II (sculpture), 92
Curve XIII (sculpture), 118
Curve XIV (sculpture), 118
Curve XXXIII (sculpture), 184
curved shapes, 13–14, 23, 161
curve-sectioned rectangle works, 95, 97, 98, 102, 120, 121, 124
Cutout in Wood (wood cutout), 37
Cuxa, 111, 111
Cyclamen (drawing), 59
Cyclamen I, 57, 57
Cyclamen II, 57, 57
Cyclamen III, 58, 58
Cyclamen IV, 58, 58
Cyclamen V, 59, 59

Daffodil, 17, 149, 149
Dark Blue and Red (VIII.15. Dark Blue and Red), 47, 47
Dark Blue with Red (VI.7. Dark Blue with Red), 43, 43
Dark Gray and Blue, 125, 125
Dark Gray and White, 27, 138, 140, 140
Dark Gray with White Triangle I (painting), 148
Dark Gray with White Triangle II (painting), 143
Dark Gray with White Triangle III (painting), 146
Dark Green Curves, 42, 117, 117
David, 17, 28, 38, 38, 188
Davis, Gene, 37
Davis, Ronald, 21
Dayton Art Institute, Ohio, 190
de Kooning, Willem, 69
de Maria, Walter, 86
Denver Art Museum, 190
Derrière le miroir (art journal), 17–18, 19, 34, 173, 174, 179; Kelly lithographs, 18, 175–79, 175–79, 187, 188, 191
De Stijl, 13, 187
Detroit Institute of Arts, 189
diagonal circle-section works, 160
Diagonal with Black, 125, 154, 154
Diagonal with Black (State), 154, 154
Diagonal with Curve III (painting), 183
Diebenkorn, Richard, 160
Dine, Jim, 86, 182
di Suvero, Mark, 86
Doorway, Belle-Isle, 13
double-horizontal panel paintings, 86
double-rectangular panel paintings, 82
Douglas Vineyards, 186
Dracena I, 171, 171
Dracena II, 172, 172
drawings of Kelly, 16, 22, 24, 26; see also plant drawings
Durassier, Marcel, 19, 24, 54, 188

Ecole des Beaux-Arts, Paris, 17, 37, 187
Editions Pierre à Feu, 174, 175
Eight by Eight to Celebrate the Temporary Contemporary (portfolio), 160, 191
Eight Color Pairs (collage), 151
"18 Colors (Cincinnati)," 27, 27, 28, 151, 151
Eight Lithographs to Benefit the Foundation for Contemporary Performance Arts, Inc. (portfolio), 151, 190
Ellsworth Kelly (Coplans), 34, 86, 188, 189
Ellsworth Kelly (Goossen), 34, 92; cover, 180
Ellsworth Kelly Albright-Knox Art Gallery (poster), 183, 183
Ellsworth Kelly Betty Parsons Gallery (announcement), 185, 185
Ellsworth Kelly: Drawings, Collages, Prints (Waldman), 78, 188

Ellsworth Kelly Galerie Denise René Hans Mayer Düsseldorf (poster), 183, 183
Ellsworth Kelly Galerie Maeght (poster), 181, 181, 188
Ellsworth Kelly Painting and Sculpture Betty Parsons Gallery (announcement), 185, 185
Ellsworth Kelly: Painting and Sculpture 1963–1979 (exhibition), 190
Ellsworth Kelly Paintings 1951–1956 (announcement), 185, 185
Ellsworth Kelly Paintings/Paintings and Sculpture/Plant Drawings (poster), 184, 184
Ellsworth Kelly: Recent Paintings and Sculptures (exhibition), 137, 183, 190; poster, 183, 183
Ellsworth Kelly Retrospective (exhibition), 189
Ellsworth Kelly: Sculpture (Sims/Pulitzer), 34
Ellsworth Kelly: Sculpture, Whitney Museum of American Art (exhibition), 191; poster, 184, 184
Ellsworth Kelly Staatliche Kunsthalle Baden-Baden (poster), 184, 184
etching, 20, 21, 22, 24, 25, 30, 189
exhibitions, 187–91 passim; first (1950), 187; first one-man (1951), 181, 187; first one-man in U.S. (1956), 187; first one-man museum (1963), 188; first retrospective (1973), 180, 189; Kelly's posters and announcements for, 181–86, 181–86
Experiments in Art and Technology, Inc., New York, 19, 86, 189
Exposition des peintures de Ellsworth Kelly, Galerie Maeght (invitation), 185, 185

Fahlstrom, Oyvind, 86
Felsen, Sidney, 14, 20, 21, 27, 188
Feuille, 66, 66
Feuille de Melon, 61, 61
Feuilles, 55, 55
Fig Branch, 64, 64
Figue, 64, 64
figure-ground relationship and compositions, 22, 28–31, 32, 70, 175, 177; parabola paintings, 69; single ellipse paintings, 119
First Curve Series, 91–94, 91–94, 95, 97, 98, 102, 120, 124, 180, 184
flattened-ovoid works, 31, 97, 99, 100, 101
Flavin, Dan, 86
Flint Institute of Arts, Michigan, 189
Fontenay, 107, 107
Fontevrault, 114, 114
Formalism, 13, 14, 20
For Meyer Schapiro (portfolio), 93, 189
Foundation for Contemporary Performance Arts, 151, 190
Four Grays with Black I, 121, 121
Four Grays with Black II, 122, 122
Four Panels, 24, 76, 76
Francis, Sam, 69, 151, 160
Frankenthaler, Helen, 182

Galerie Adrien Maeght, Paris, 53, 174, 188; Kelly exhibition poster, 181, 181
Galerie Arnaud, Paris, 181, 187
Galerie Denise René and Hans Meyer, Düsseldorf, 183, 189
Galerie Maeght, Paris, 17, 19, 34, 38, 39, 42, 174, 175, 187; Kelly exhibition poster and invitations, 181, 181, 185, 185, 186, 186; Kelly's exhibitions at, 17, 39, 175, 177, 181, 185, 186, 187, 188
Gallery of Modern Art, Washington, D.C., 188
Geldzahler, Henry, 16, 82
Gemini G.E.L. (Graphics Editions Limited), Los Angeles, 16, 17, 18, 20–21, 21, 24, 25, 27, 34, 76, 77, 78, 79, 80, 81, 82, 83, 84, 85, 90, 151, 160, 188, 190–91; Kelly at, 20, 34; publisher of Concorde Series, 152–59, 190; publisher of First Curve Series, 92–94, 189; publisher of Leaves Series, 87, 88–89, 130, 189; publisher of Saint Martin Series, 161–67, 191; publisher of Second Curve Series, 96–101, 189; publisher of Series of Plant and Flower Lithographs, 87, 130, 168–72, 191; publisher of Series of Ten Lithographs, 28, 70–75, 188–89; publisher of Seven Lithographs Series, 142–48, 190; publisher of Third Curve Series, 103–14, 189; publisher of Twelve Leaves Series, 87, 130–36, 190
geometric abstraction, 13–14, 22–23, 175
geometric joined-panel paintings, 22–23, 47, 70
Germigny, 110, 110
Giacometti, Alberto, 19, 174
Goossen, Eugene C., 33, 175; Ellsworth Kelly, 34, 92, 180
Gottlieb, Adolph, 82
Grand Case, 143, 143
Grand Case (State), 143, 143
Grapefruit, 55, 55
Grape Leaves I, 88, 88, 186
Grape Leaves II, 87, 89, 89, 186
Grape Leaves III, 17, 87, 89, 89, 186
Graves, Maitland, 187
Gravures Maeght Editeur (exhibition), 180, 188
Gray Curve I (painting), 93

Gray Curve II (painting), 93
Gray Curve with Brown, 123, 123
Gray Curve with Blue, 121, 121
Gray Variation, 31, 99, 100, 101, 101
Green (IV4. Green), 14, 41, 41
Greenberg, Clement, 188
Green/Black, 79, 79
Green Black (painting), 79
Green Black Red Blue (painting), 76
Green Blue (painting), 16, 73, 80
Green Blue (sculpture), 73, 80
Green Blue Black (painting), 176
Green Blue Red (painting), 52
Green Curves, 42, 118, 118
Green Curves (collage), 42, 117
Green Curve with Radius of 20', 34, 91, 93, 93
Green Disk on Blue (painting), 41
Green Red (painting), 181, 186
Green Square with Dark Gray, 126, 126
Green/White, 81, 81
Green White (painting, 1961), 41
Green White (painting, 1967), 180
Green/White (painting, 1968), 81
Green with Red (VI.8. Green with Red), 43, 43
Grinstein, Stanley, 20, 188
Grooms, Red, 86
Grosman, Tatyana, 18–19, 20, 34
ground, see figure-ground relationship
Grünewald, Matthias, Isenheim Altarpiece, 33, 187; Resurrection, 33, 33
Guggenheim (Solomon R.) Museum, New York, 190
Guston, Philip, 151

Haacke, Hans, 86
hard-edge abstraction, 13, 20, 24
Haricot Vert I, 63, 63
Haricot Vert II, 63, 63
Haricot Vert III, 64, 64
Hay, Alex, 86
Hayter, Stanley William, 93
Held, Al, 14
High Museum of Art, Atlanta, 190
HMP Paper Mill, Woodstock, Connecticut, 21, 116, 150, 189–90; Kelly at, 21
Hockney, David, 22, 82, 151, 160
Hofstra University, Emily Lowe Gallery, 189
Hollander, Irwin, 19, 188
Hollander Workshop, New York, 19, 69, 188
Holoubek, Alan, 21, 34
Hudson River Museum, Yonkers, New York, 189
Hultén, K. G. P., 86

Idaho State University, Pocatello, 190
illusionistic cube paintings, 75
Imprimerie Arte, Paris, 54, 174
Imprimerie Maeght, Levallois-Perret, 54, 174, 180, 188; see also Maeght Editeur
Independent Curators Incorporated, 191
Indiana, Robert, 37, 187
inscribed circle works (squared paintings), 91, 93
Intaglio/Lithograph Series, 95
Isenheim Altarpiece (Matthias Grünewald), 33, 33, 187
Ives-Sillman workshop, New Haven, 19

Jacmel, 142, 142
Jacmel (State), 142, 142
Jaune (Série II, No. 2), 40, 40
Jaune Clair avec Bleu Foncé (Série VI, No. 12), 45, 45
Jaune sur Bleu Foncé (Série IX, No. 19), 49, 49
Jaune sur Jaune Clair (Série IX, No. 22), 50, 50
Jaune sur Noir (Série IX, No. 20), 49, 49
Jewish Museum, New York, 188
Johns, Jasper, 16, 18, 20, 25, 93, 151, 189
joined-panel paintings, 22–23, 30, 47, 70, 85, 121
joined-vertical-stripes prints, 124, 127, 128
Judd, Donald, 86

Kandinsky, Wassily, 14, 174
Katz, Alex, 82
Kelly Lithographies Galerie Adrien Maeght (poster), 181, 181, 188
Kelly peintures & reliefs, Galerie Arnaud (poster), 181, 181
Kitaj, R. B., 82
Klee, Paul, 14
Klüver, Billy, 86
Koller, John and Kathleen, 21, 116
Korean ceramics, 32; Yi dynasty porcelain jar, 32
Kosuth, Joseph, 160
Kunsthalle Nürnberg, 189

Laguna Beach Art Museum, California, 191
Large Black Curve, 25, 93, *93*, 94
Large Gray Curve, 25, *28*, 93, 94, *94*
Leaf I, 131, *131*
Leaf II, 132, *132*
Leaf III, 132, *132*
Leaf IV, 133, *133*
Leaf V, 133, *133*
Leaf VI, 134, *134*
Leaf VII, 134, *134*
Leaf VIII, 135, *135*
Leaf IX, 135, *135*
Leaf X, 136, *136*
Leaf XI, *130*, 136, *136*
Leaves (Series), 87–90, *87–90*, 130, 189
Leaves (Suite of Plant Lithographs, 1964–65), 55, *55*
Leaves (Twelve Leaves series, 1978), 131, *131*
Leaves (two drawings), 55 .
Lemon, *54*, 56, *56*
Lemon Branch, 26, 67, *67*
Lemon Branch (drawing), 26, 67
LeWitt, Sol, 86
Liberman, Alexander, 93
Lichtenstein, Roy, 20, 37, 69, 86, 93, 182, 189
light, Kelly's sense of, 32–33
Light Blue with Orange (VI.11. Light Blue with Orange), 24, 45, *45*
Limbour, Georges, 174
Lindner, Richard, 69
Line, Form, Color (Kelly book project), 117
line, Kelly's use of, 26, 28, 31, 34; embossed vs. debossed line, 30–31, 34
List (Albert A.) Foundation, Poster Program, 182
lithography, 19–20, 22, 24, 25, 26, 29, 30, 34; direct (transfer) vs. offset, 24, 34; *see also* plant lithographs
Locust, 65, *65*
Los Angeles County Museum of Art, 188, 189
Lotus, 179, *179*
Lotus (drawing), 179
Lozingot, Serge, *21*, 27, 34, 151

McConathy, Dale, 34, 38, 39, 177, 188
McCorkle, David, 38, 188
McPherson, Ron, 34
Maeght, Adrien, 53, 174
Maeght, Aimé and Marguerite, 17–18, 19, 24, 39, 54, 61, 63, 64, 65, 174, 179, 180; *see also* Galerie Maeght
Maeght Editeur, Paris, 16, 17, 18, 19, 24, 87, 180, 181, 183; publisher of *Derrière le miroir*, 174, 175, 177, 179; publisher of Suite of Plant Lithographs, 19, 28, 34, 54–68, 168, 188; publisher of Suite of Twenty-Seven Color Lithographs, 19, 22, 24, 29–30, 39–53, 188
Magnolia, 67, *67*
Magnolia (drawing), *13*
Mandarine, 56, *56*
Mangold, Robert, 14
Marden, Brice, 14
Marigot, 144, *144*
Marigot (State), 144, *144*
Martin, Agnes, 187
Massachusetts Institute of Technology, Hayden Gallery, 190
Masson, André, 93
Matisse, Henri, 16, 19, 27, 28, 34, 174, 187
Melon (drawing), 61
Melon Leaf, 61, *61*
Metal Wall Reliefs, 20, 34, 161
Metropolitan Museum of Art, New York, 16, 82, 189; *Ellsworth Kelly: Recent Paintings and Sculptures* exhibition, 137, 183, 190; poster, 183, *183*
Midland Art Center, Michigan, 190
Milwaukee Art Museum, 190
Minimalism, 13, 14, 19
Miró, Joan, 14, 19, 174, 179, 180
Mirrored Concorde (sculpture), 20, 152
Mitchell, Fred, 187
Moderna Museet, Stockholm, 86
Moissac, 112, *112*
Mondrian, Piet, 14, 187
Monet, Claude, 27, 187
monochrome panel paintings, 22, 28, 151
Montmorillon, 112, *112*
Morris, Robert, 86
Motherwell, Robert, 37, 69, 93, 182, 189
Moulin à Papier Richard de Bas, France, 21
Mulberry Leaf, 150, *150*
Munson-Williams-Proctor Institute Museum of Art, Utica, New York, 188

Museo de Arte Moderna, Bogota, Colombia, 190
Museum of Contemporary Art, Los Angeles, 160, 191
Museum of Fine Arts, Boston, 33, 187, 190
Museum of Fine Arts, Houston, 190
Museum of Modern Art, New York, 34, 180, 189; *The Art of the Real: USA 1948–1968* exhibition, 182, 188; *Ellsworth Kelly Retrospective* of 1973, 180, 189; *Paperworks by Ellsworth Kelly* exhibition, 190; *Printed Art: A View of Two Decades* exhibition, 190; *The Responsive Eye* exhibition, 188; *Sixteen Americans* exhibition, 187; *Technics and Creativity: Gemini G.E.L.* exhibition, 189

Narkiewicz, Paul, 19
National Collection of Fine Arts, Smithsonian Institution, 190
National Gallery of Art, Washington, D.C., 190, 191
National Print Exhibitions, Brooklyn Museum: of 1972, 189; of 1976, 189
Nauman, Bruce, 151, 189
Negret, Edgar, 187
Nevelson, Louise, 69, 86
New York Collection for Stockholm, 86, 189
New York Painting and Sculpture: 1940–1970 (exhibition), 16
Nine Colors, 129, *129*
Nine Colors on White (collage), 129
Nine Squares, 24, 129, *129*
Noir (Série 1, No. 1), 40, *40*
Noir avec Blanc (Série VI, No. 6), 42, *42*
Noir sur Jaune Clair (Série IX, No. 21), 50, *50*
Noland, Kenneth, 86
Northern Illinois University, Swen Parson Gallery, 191
Nose/Sailboat (postcard collage), 138

Oeuvres récentes de Ellsworth Kelly (exhibition), 188; invitation, 186, *186*
Ohio State University, 190
Oldenburg, Claes, 20, 86, 93, 182
Op art, 13
Opsut, Mr. and Mrs. Edward, 187
Orange and Blue over Yellow (XI.27. Orange and Blue over Yellow), 52, 53; *53*
Orange avec Bleu (Série VI, No. 9), 44, *44*
Orange avec Vert Clair (Série VI, No. 10), 44, *44*
Orange/Blue/Black/Green/Brown, 128, *128*
Orange et Bleu sur Jaune (Série XI, No. 27), 53, *53*
Orange/Green, 70, 72, *72*, 79
Orange Green (painting), 178
Orange over Blue (X.25. Orange over Blue), 51, 52, *52*
Orange over Green (X.24. Orange over Light Green), 51, *51*
Oranges, 66, *66*
Oranges (drawing), 66
Orange sur Bleu (Série X, No. 25), 52, *52*
Orange sur Vert Clair (Série X, No. 24), 51, *51*
Orange White (painting), 46
Orange with Blue (VI.9. Orange with Blue), 44, *44*
Orange with Green (VI.10. Orange with Light Green), 44, *44*
Orient Beach, 14, 161, 165, *165*
Orient Beach (State I), 161, 166, *166*
Orient Beach (State II), 161, 166, *166*
Orient Beach (State III), 161, 165, *165*
Orient Beach (State IV), 161, 165, *165*
Ortman, George, 37

Padien, Bill, 168
Pages and Fuses series (Robert Rauschenberg), 21
Paik, Nam June, 86
Painted Wall Sculptures, 20, 190
painting of Kelly, 14, 16, 19, 22, 23, 25, 27–32; relationship to prints, 16, 18, 23–24, 25, 28, 31, 32, 33
Paintings by Ellsworth Kelly (London exhibition, 1962), 188; invitation for, 186, *186*
Palm (painting), 185
Pamplemousse, 55, *55*
paper: choice of, 28; handmade, 21–22
paper pieces of Kelly, 21–22, 24
Paper Pools series (David Hockney), 22
Paperworks by Ellsworth Kelly (exhibition), 190
Paris Review, The (poster), 182, *182*, 188
Parsons (Betty) Gallery, New York, 34, 185, 187, 188
Pasadena Art Museum, 189
Peach Branch, 87, 88, *88*
Pear I, 61, *61*
Pear II, 62, *62*
Pear III, 62, *62*
Pearson, Henry, 69
Persche, Henry, 188
Pfahler, Georg-Karl, 180
Philipsburg (postcard collage), 140
Philodendron I, 169, *169*
Philodendron II, 169, *169*
Phoenix House, 82
photographs of Kelly, 16–17

Picabia, Francis, 14, 187
Picasso, Pablo, 16
Pissarro, Camille, 34
Pittsburgh International Exhibitions of Contemporary Painting: of 1958, 187; of 1961, 187; of 1964, 188
Plant and Flower Lithographs, Series of, 87, 130, 168–72, *168–72*, 191
plant drawings, 16, 20, 24, 26, 186
plant lithographs, 14, 20, 21, 24, 26, 28, 34, 186
Plant Lithographs, Suite of, 19, 28, 39, 53, 54–68, *54–68*, 168, 188
Poire I, 61, *61*
Poire II, 62, *62*
Poire III, 62, *62*
Poitiers, 102, 103, *103*
Poons, Larry, 37, 187
Pop art, 20
postcard collages, 16, 138
posters of Kelly, 181–84, *181–84*
Pratt Institute, 187
Preliminary Study for "Wall" (drawing), 137
Premier Salon des Jeunes Peintres, Paris, 187
Prints for Phoenix House (portfolio), 82, 189
Project for a "Folding Painting" (drawing), 33, *33*

Queens Museum, Flushing, New York, 191

Rauschenberg, Robert, 18, 20, 21, 86, 93, 130, 151, 160, 182, 189
Rebound (painting), 123
Red/Blue, 17, 19, *20*, 29–30, 37, *37*
Red Blue (painting, 1964), 37
Red Blue (painting, 1968), 73, 80
Red Blue and Blue Red (study), 24
Red Blue Yellow (painting), 178
Red Curve, 119, *119*
Red Curve (Radius 8'), 30, 95, 97, *97*, 98
Red Curve VII (painting), 97
Redfern Gallery, London, 180, 188
Red Green (painting), 23
Red-Orange (III.3. Red-Orange), *18*, 40, 41, *41*
Red-Orange over Black, 20, 76, *76*, 85
Red-Orange over Blue (IX.17. Red-Orange over Blue), 48, *48*
Red Orange White Green Blue (painting), 121, 124, 127, 128
Red-Orange/Yellow/Blue, 71, *71*
Red over Yellow (IX.16. Red over Light Yellow), 19, 47, *47*
Red Panel (painting), 12
Red White (painting, 1962), 176
Red White (painting, 1963), 40
Red White (painting, 1966), 41
Red White Blue (painting), 71, 72, 77, 78
Red Yellow (painting, 1968), 75
Red Yellow (painting, 1970), 183
Red Yellow Blue (painting), 71, 72, 78
Red Yellow Blue III (painting), 77
Red Yellow Blue, Angers (oil-on-newsprint), 46
Reid, James, *21*, 34
Reinhardt, Ad, 37
Renoir, Pierre-Auguste, 34
Responsive Eye, The (exhibition), 188
Resurrection (Matthias Grünewald), 33, *33*
Rhode Island School of Design, Museum of Art, 189
right-angled circle-section paintings (1972), 92
Rivers, Larry, 86
Rockburne, Dorothea, 14
Rose, Barbara, 20
Rosenquist, James, 82, 86, 182, 187
Rouge-Orange (Série IX, No. 3), 41, *41*
Rouge-Orange sur Bleu (Série IX, No. 17), 48, *48*
Rouge sur Jaune (Série IX, No. 16), 47, *47*
Running White (painting), 185
Russell, John, 180, 188

Saint Martin Landscape, 16, *17*, 24, 138, *138*
Saint Martin Landscape, IA, 139, *139*
Saint Martin Landscape, IB, 139, *139*
Saint Martin Landscape, IC, 140, *140*
Saint Martin Series, 14, *21*, 25, 31, 34, 161–67, *162–67*, 168, 191; original study for, *25*
Saint Martin Triptych, 14, 28, 161, 163, 167, *167*
Saint Martin Tropical Plant, 151, *151*
Saint-Phalle, Niki de, 160
Saint-Savin, 111, *111*
Sarsaparilla, 137, 149, *149*
Sartre, Jean-Paul, 174
scale of Kelly's prints, 13, 23, 25, 28–29
Schapiro, Meyer, 93
screenprinting, 19, 20, 22, 24–25, 30, 34
sculpture of Kelly, 14, 16, 20, 22, 24, 25, 27–32, 187; relationship to prints, 16, 25, 28, 30, 31, 33, 34

Seaweed, 65, *65*
Second Curve Series, 91, 93, 95–101, *95–101*, 102, 103, 106, 109, 112, 113, 120, 124, 189
Segal, George, 86
Selections from Tyler Graphics exhibitions (1984, 1985), 191
Senanque, 110, *110*
Serra, Richard, 86, 151, 189
Serrabone, 104, *104*
Seven Lithographs, Series of, 24, 28, 34, 141–48, *141–48*, 190
shape, Kelly's use of, 13, 14, 22–23, 25, 26, 27, 28–29, 30–31, 32, 34
Simmelink, Doris, 34
Sisley, Alfred, 34
Sixteen Americans (exhibition), 187
slope-cornered square prints, 95
Smithsonian Institution, 190
Sonnier, Keith, 86
Souillac, 114, *114*
South Ferry (painting), 185
Spectrum, 25, *26*, 85, *85*
Spectrum II (painting), 14
Spectrum IV (painting), 14
Spectrum paintings, 85
squared-ovoid prints, 95
squared paintings, *see* inscribed-circle works
Square with Black, 126, 153, *153*
Square with Black (State), 153, *153*
Staatliche Kunsthalle, Baden-Baden, 184, 190
stacked-ovoid paintings, 46
Stankiewicz, Richard, 86
Stedelijk Museum, Amsterdam, 180, 188; Kelly retrospective at, 190
Stedelijk van Abbemuseum, Eindhoven, 189
Stein, Gertrude, 187
Steinberg, Saul, 69, 93, 179, 180
Stele II (sculpture), 97, 99, 100, 101
Stella, Frank, 16, 19, 20, 21, 25, 34, 37, 93, 182, 189
Stock, Mark, 34
straight-edge style, 22–23
String Bean Leaves I, 63, *63*
String Bean Leaves II, 63, *63*
String Bean Leaves III, 64, *64*
Studies for Window Frame Sculptures (drawings), 37
Study for a Lithograph (drawing), 80
Study for a Lithograph (oil-on-newsprint), 46
Study for "Black Curve I" (drawing), 103, 106
Study for Black Curves (drawing), 40
Study for Black Green (collage), 79
Study for "Green Blue Red" (oil on paper), 52
Study for Hollander Lithograph (collage), 69
Study for "Painting in Two Panels" (collage), 127
Study for Print (collage and ink), 138
Study for "Spectrum" (collage), 85
Study for "Three Color Panels" (collages), 86
Study for "Train Landscape" (collage), 86
Study for "Yellow White" (collage), 97
Styria Studio, New York, 19
Surrealism, 13, 14
Syracuse University, Joe and Emily Lowe Art Gallery, 190

Taeuber-Arp, Sophie, 187
Takis, 179
Tal-Coat, Pierre, 180
Talmont, 105, *105*
Tamarind Lithography Workshop, Los Angeles, 20
Tangerine, 56, *56*
Tavant, 109, *109*
Tawney, Lenore, 187
Ten Lithographs, Series of, 16, 70–76, *70–76*, 77, 78, 79, 80, 81, 82, 188–89, 190
Ten Works x Ten Painters (portfolio), 17, 19, 37, 188, 190
texture, Kelly's late interest in, 14, 24, 25, 31
Third Curve Series, 31, 34, 91, 95, 98, 102–14, *102–14*, 121, 189
Thoronet, 106, *106*
Tinguely, Jean, 160
Toklas, Alice B., 187
"toned plate," 95
Tooth (Arthur) and Sons, London, 186, 188
Tournus, 108, *108*
Train Landscape (painting), 125
Transatlantic Graphics 1960/67 (exhibition), 188
trisected-parallelogram paintings, 71, 72, 77, 78
Turnbull, William, 180
Twelve Leaves (Series), 87, 130–36, *130–36*, 168, 190
Twentieth-Century American Printmakers exhibition, 191

Twenty-Seven Color Lithographs, Suite of, *18–19*, 19, 22, 24, 29–30, 34, 39–53, *39–53*, 54, 117, 188, 189
Two Blacks and White, 83, *83*
Two Curves: Blue Red (sculpture), 42
Two Grays III (painting), 125, 154
Twombly, Cy, 86
Two Oranges and Yellow (oil-on-newsprint), 47
Two Whites and Black, 83, *83*
Two Yellows, 95, 98, *98*, 102
Tyler, Kay, 20
Tyler, Kenneth, 20, *20*, 21–22, 28, 34, 116, 188, 190
Tyler Graphics Ltd., Bedford, New York, 17, 18, 21–22, 24, 25, 87, 115, 116, 137, 138, 139, 140, 149, 150, 189, 190, 191; publisher of Colored Paper Images, 21–22, 116–29, 189–90

Ubac, Raoul, 180
Universal Limited Art Editions (ULAE), 18–19, 20
University of Bridgeport, Carlson Gallery, 191
University of Kentucky Art Gallery, 188
University of Lethbridge Art Gallery, Canada, 190
University of Massachusetts, 190
Untitled (several lithographs from *Derrière le Miroir*), 18, 175–79, *175–79*
Untitled (1949 lithograph), *17*, 37, *37*, 187
Untitled (1972 lithograph), 82, *82*
Untitled (1973 screenprint), 28, *28*, 86, *86*
Untitled (1978 sculpture), *31*
Untitled (1983 lithograph), 27, 28, 160, *160*

Vantongerloo, George, 187
Venice Biennale of 1966, 188
Vernis du Japon I, 68, *68*
Vernis du Japon II, 68, *68*
Vert (Série IV, No. 4), 41, *41*
Vert avec Rouge (Série VI, No. 8), 43, *43*
Vic, 113, *113*
Vivian Beaumont Theater, Lincoln Center (poster), 182, *182*
Vormen van de Kleur/New Shapes of Color (exhibition), 180, 188

Wadsworth Atheneum, Hartford, Connecticut, 17, 18, 19, 37, 188
Wagstaff, Samuel, Jr., 19, 34
Waldman, Diane, 78, 188
Walker Art Center, Minneapolis, 189, 190, 191
Wall, 21, 24, 25, *26*, 30, 137, *137*, 161
Wall (collage with pencil drawing), 137
Wall (painting), 137
Wall Study (painting), 137
Warhol, Andy, 37, 86, 93, 160, 182
Wayne, June, 20
West Coast Landscape (painting), 78
West Side (painting), 181
Whistler, James McNeill, 34
White and Black, 84, *84*
White Bar with Black, *30*, 31, 76, 85, *85*
White Blue (painting), *22*, 141
White Curve I (Black Curve I), *30*, 31, 92, *92*, 93
White Curve I (painting), *23*
White Curve II (painting), 92
White Curve III (painting), 92, 103
White Curve V (painting), 92
White Curve VII (painting), 117, 120
White Curve VIII (painting), 106
White Curve with Black I, 117, *117*
White Curve with Black II, 120, *120*
White Dark Blue (painting), *29*
White Disk I (painting), 41
White Disk II (painting), 41
White Disk III (sculpture), 41
White Square with Black (painting), 126, 153
White Triangle with Black (painting), 147
White, Two Blacks (painting), 83
Whitman, Robert, 86
Whitney Museum of American Art, 34; *Ellsworth Kelly: Sculpture* exhibition, 34, 184, 191; *Recent Acquisitions 1974–1984* exhibition, 191; *Twentieth-Century American Printmakers* exhibition, 191; *Young America 1957* exhibition, 187
Wilde, E. de, 180
Wild Grape Leaf, 150, *150*, 186
Wild Sarsaparilla, 178
Williams, Tennessee, 174
Williams College Museum of Art, 191
Window V (painting), 187
wine labels of Kelly, 186, *186*
woodcut printing, 20
Woodland Plant, 137, *137*, 149
working methods of Kelly, 16, 20, 23–26, 30–31
Works by Artists in the New York Collection for Stockholm (portfolio), 86, 189

Yale University Art Gallery, 190
Yellow, *32*, 97, *97*, 99, 100, 101
Yellow (II.2. Yellow), 40, *40*, 41
Yellow/Black, 75, *75*
Yellow Black (painting), 184
Yellow Blue (painting), 37
Yellow Curve, 124, *124*
Yellow Curve II (painting), 124
Yellow Curve with Gray, 116, 120, *120*
Yellow/Green/Black/Blue/Orange, 124, *124*
Yellow/Orange, 75, *75*
Yellow over Black (IX.20. Yellow over Black), 49, *49*
Yellow over Dark Blue (IX.19. Yellow over Dark Blue), *19*, 49, *49*
Yellow over Yellow (IX.22. Yellow over Light Yellow), 50, *50*
Yellow/Red-Orange, *26*. 73, *73*
Yellow White (painting), 97, 99, 100, 101
Yellow with Dark Blue (VI. 12. Light Yellow with Dark Blue), 45, *45*
Young America 1957 (exhibition), 187
Youngerman, Jack, 187

Zepeda, Anthony, *21*
Zerbe, Karl, 187
Zumsteg, Gustav, 187

Photograph Credits and Copyrights

For most of the prints listed in the Catalogue Raisonné as published by Gemini G.E.L. and Tyler Graphics Ltd., the photographs have been supplied by those workshops. Many additional photographs—including a number taken by Jerry Thompson—were supplied by the artist. The illustrations listed below have been taken and/or supplied by the photographer or owner credited:

© Gemini G.E.L., Los Angeles, California, 1987: fig. 23

Ellsworth Kelly: fig. 23

Malcolm Lubliner, Los Angeles: fig. 22

Eric Pollitzer, New York: figs. 6, 26

Jack Shear: fig. 56

Frank J. Thomas, Hollywood, California: fig. 44

Ken Tyler: fig. 24

Tyler Graphic Archives, Walker Art Center: cat. nos. 140, 147, 164, 177, 179, 179a, 179c, 188

Ron Vickers, Toronto: fig. 27

O. Zimmermann, Colmar: fig. 54